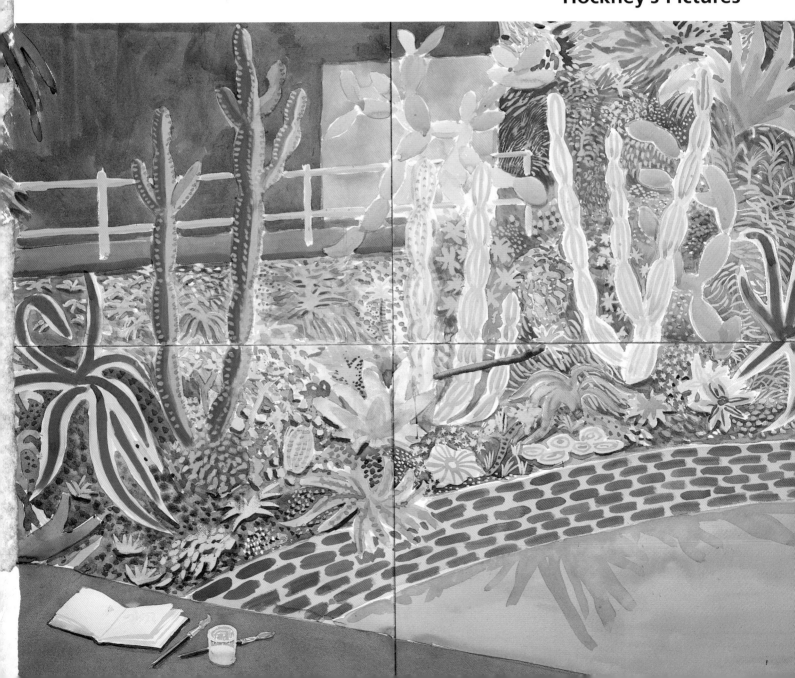

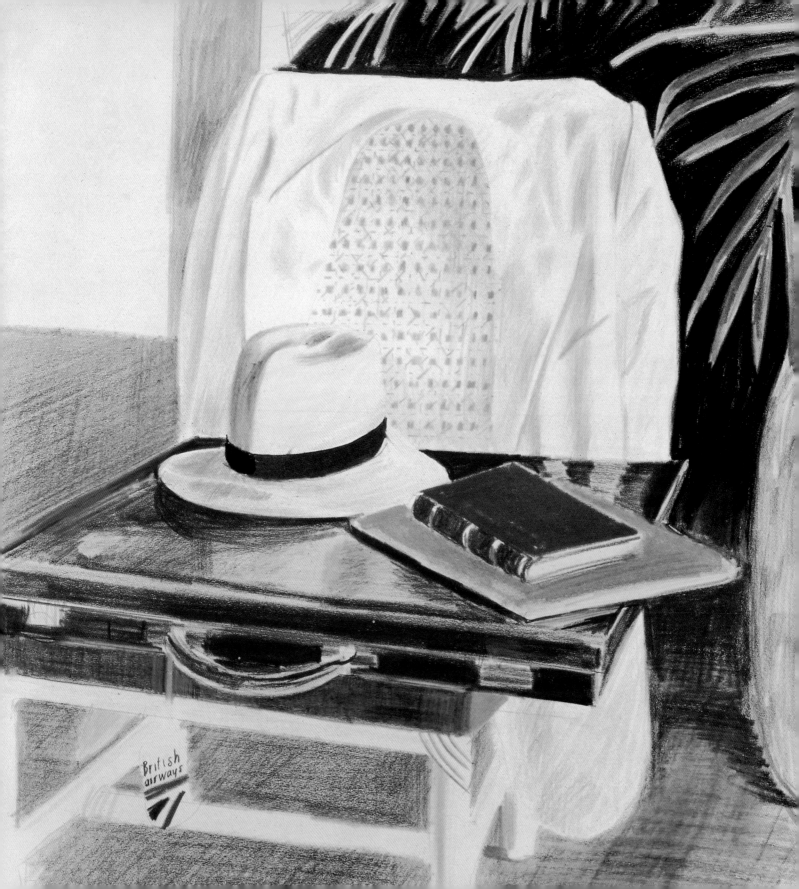

Hockney's Pictures

with 325 illustrations, 277 in colour

The publishers would like to thank Gregory Evans and
David Graves for their help in the preparation of this book.

First published in the United Kingdom in 2004 by Thames & Hudson Ltd,
181A High Holborn, London WC1V 7QX

www.thamesandhudson.com

British Library Cataloguing-in-Publication Data
A catalogue record for this book is available from the British Library

ISBN 0-500-09314-8

Design by Maggi Smith

Printed and bound in Singapore by CS Graphics

Page 1: Cactus Garden III 2003

Page 2: Still Life, Taj Hotel Bombay 1977

Contents

Introduction: Loving the world with new eyes 7

Problems of Depiction 9
 Looking at Pictures 10 A Marriage of Styles 22 Stages 40
 Water 62 Movement 87 Moving Viewpoint 96

Life Stilled 111
 Life and Love 112 Lives 124 Still Life 144 Home 176

Portraits 209
 Friends 210 Family 262 Self 272

Space and Light 279
 South 280 West 298 East 314 North 324
 London 340 Yorkshire 344

Lists of Illustrations 360

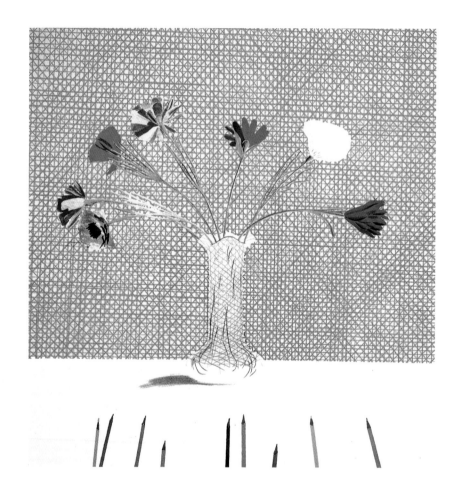

Flowers Made of Paper and Black Ink 1971

Introduction: Loving the world with new eyes

'People don't really think about pictures or how they're made. But I do, that's what I spend my time doing. And in a way they're subversive, I'm well aware. But I don't expect all that to be understood right away.'

As the French poet, novelist and art dealer Jean Frémon has observed, David Hockney's story is one of passion: passion for seeing, passion for telling, passion for images. But to these three passions should be added a fourth: the passion for living. One of Hockney's favourite sayings is 'Love life!', and for forty-five years his art has been fêted across the world because it is a celebration of what it is to be alive. All of his pictures – sometimes tender, as when he draws close friends and family; sometimes playful, as in his paintings of lazy, carefree days in the pool; sometimes awe-inspiring, as with his monumental images of the Grand Canyon – convey what it means to be in the world, to see it, to move in it, to love it. For Hockney, pictures are the perfect vehicles for communicating such feelings, and his life has been a constant exploration of how to make them in ever more vital ways.

This is a picture book. Using his images and a few words of explanation, it tracks Hockney's lifelong experiments in ways of looking and depicting. It is by no means a comprehensive account, and nor is it a simple narrative. There are many threads to Hockney's work. Various themes and subjects have been periodically revisited and explored afresh in different media and with developing insights. This book considers his art in the context of those themes.

The first chapter, 'Problems of Depiction', looks at some of the pictorial problems faced by image-makers – problems addressed in Hockney's work from the outset. How can the three-dimensional world, changing in time and coloured by what we bring to it ourselves, be represented by a still image on a flat surface? This is, of course, the central question for any painter, and is the implicit subject matter of the art throughout the book. This chapter highlights works where variations on this question are examined more explicitly.

'Life Stilled', the second chapter, examines the artist's engagement with his own intimate world, and his observation of the worlds of the people closest to him. In the third chapter, entitled 'Portraits', friends, family and the artist himself are the subject of his restless scrutiny.

The final chapter, 'Space and Light', is a journey in search of both of these elements, so important to Hockney as an artist and a person. From a smoky Bradford of the 1950s, he has ventured south to work in Egypt, France and Spain; west to America, in particular California and the American West; east to Japan and China; and north to the midnight sun of Norway and Iceland, each time capturing the sights and sensations of wherever he has been. In later life, he has returned time and again to his native Yorkshire, drawn back to the landscape of his childhood and the memories it holds for him.

Each chapter is subdivided into sections, which are identified in the headings to each page. These sections are described in more detail at the beginning of each chapter. Apart from these brief introductions, and a few quotations from the artist, the pictures are allowed to speak for themselves, to show us the world as Hockney sees and loves it.

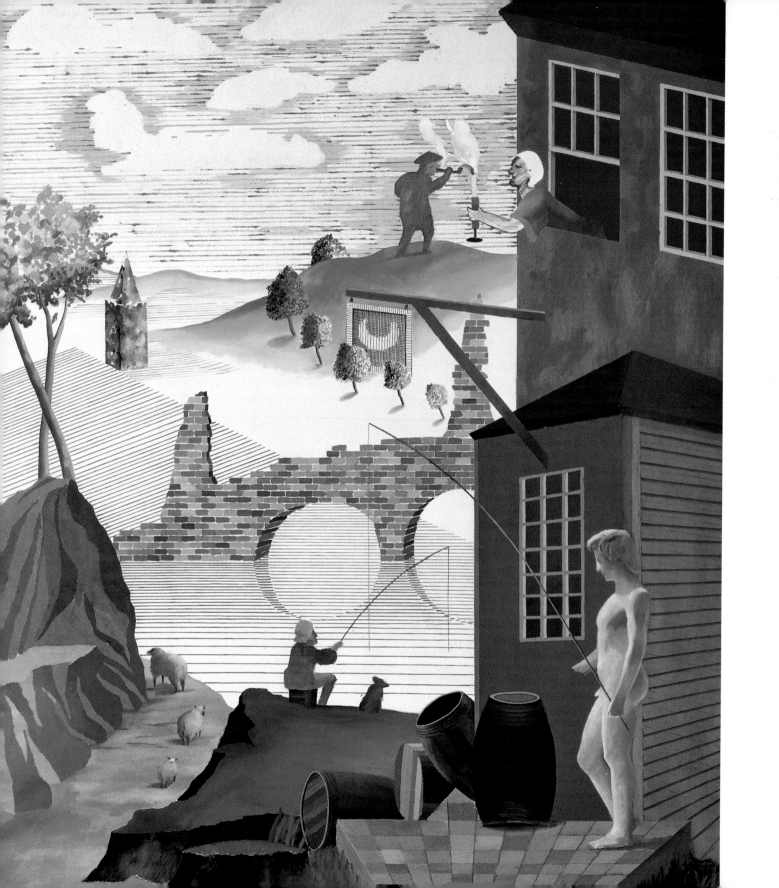

Problems of Depiction

'Given that depicting, the urge to depict, is part of human nature, how do we go about it? What methods do we use and what assumptions do we make about depicting in this or that way?'

'*Kerby (After Hogarth). Useful Knowledge* is the result of the research I did on Hogarth for *The Rake's Progress* opera sets. I got the idea from a satirical frontispiece Hogarth created for an 18th-century treatise on perspective. The treatise was published and popularized by Hogarth's friend Joshua Kirby, whose name I misremembered when I did my picture. The painting is about space, using it, or making it, depicting pictorial space in different ways, breaking the rules of literalism.'

How do you represent a changing, three-dimensional world, through which we move, and by which we are moved; and how can you achieve that in a still image on a flat surface? How, indeed, do we see the world? How do we represent it to ourselves, inside our own heads? How can an artist convey that internal representation to others?

Pictures are pictures first of all, before they are pictures of or about anything else, and the way pictures have been made influences other pictures. The opening section of this chapter, 'Looking at Pictures', traces some of the direct artistic influences on Hockney himself: Masaccio, Hogarth, Piero della Francesca, and, above all, Picasso. It includes a detail from the vast 'Great Wall' of pictures he constructed in his studio as he embarked on his two-year investigation of the use of optical projections in Western art, resulting in his acclaimed book *Secret Knowledge*. The wardens at the National Gallery, London, who end this section were drawn during his research with the aid of a camera lucida, following a method employed by the nineteenth-century French painter Jean-Auguste-Dominique Ingres.

'A Marriage of Styles' explores different 'styles' of representation that are open to the artist, and presents some of Hockney's experiments with combinations of styles within a single picture. The next section, 'Stages', develops this possibility within the formal framework of a theatrical proscenium and curtain. Here paintings presage his many opera designs, which in turn lead to new departures in painting.

'Water' is a more specific problem: it is rarely completely still, its surface is a constantly changing pattern of reflections and highlights, and you can sometimes see things below the surface. Hockney has returned over and over, with a variety of mediums, to the task of capturing such fleeting effects. The problems of how to depict 'movement' within the constraints of a still picture, and of how best to represent our own 'moving viewpoint', are the subjects of the last two sections of the chapter.

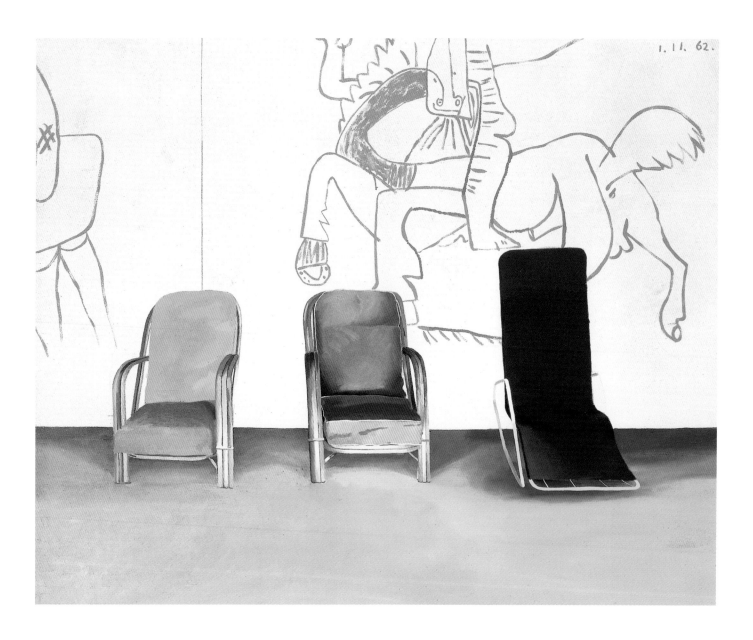

'I had always had a great interest in Picasso, but I never quite know how to deal
with it – like most artists. He seemed too big and his forms were too idiosyncratic.
How do you learn? How do you use them?'

Three Chairs with a Section of a Picasso Mural 1970

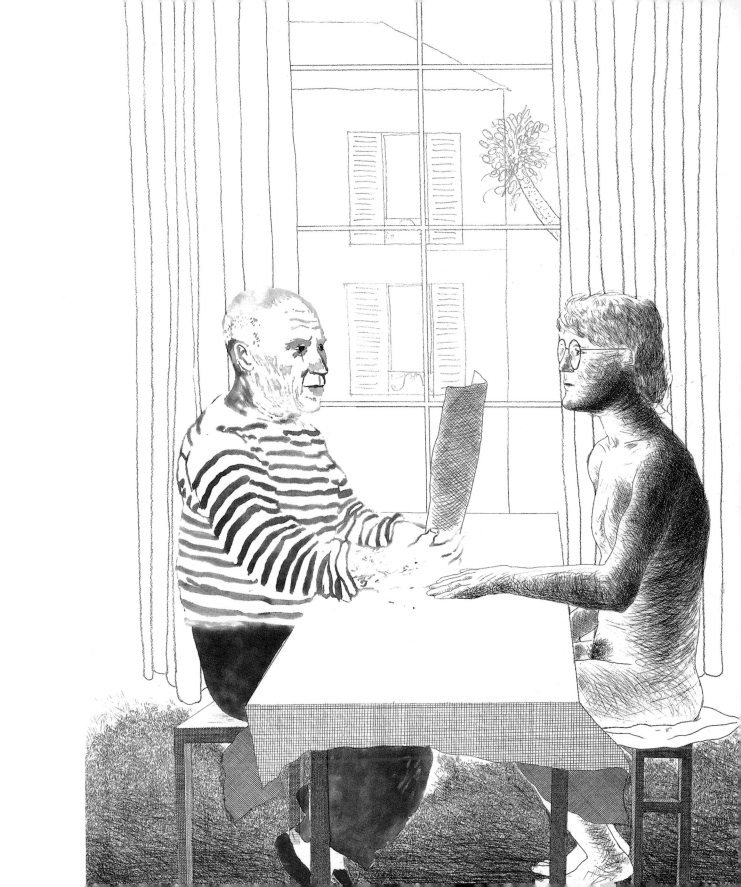

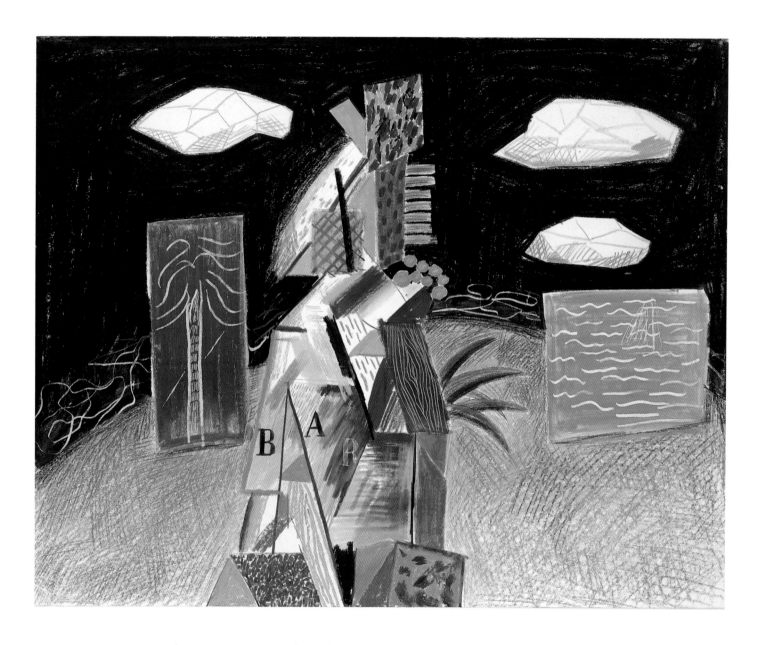

'The moment you realize what Picasso is doing … you become aware,
perhaps more than ever before, that there are different forms
of realism and that some are more real than others.'

Cubistic Bar 1980 from Les Mamelles de Tiresias

'In the Musée d'Art Moderne in Paris there's a room full of cubistic sculpture by Julio Gonzalez. The idea of cubist sculpture was for me much more difficult to grasp than cubist painting.... Because the room was artificially lit, there were strong shadows cast by the sculpture. These shadows with their completely flattened forms seemed to contradict the idea of cubist sculpture.'

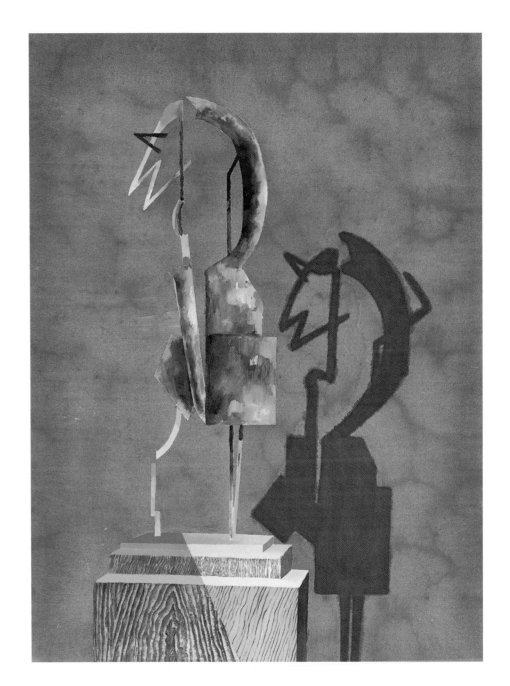

Gonzalez and Shadow 1971

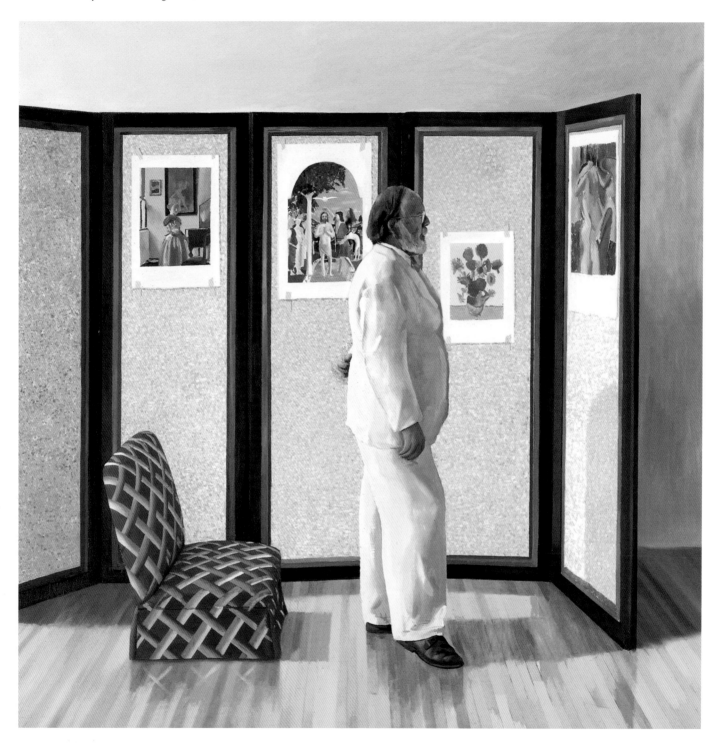

Looking at Pictures on a Screen 1977

'All the reproductions pinned up on a screen were of paintings in the National Gallery. I had bought the posters there and I always had them pinned up on the studio wall. For this picture of Henry Geldzahler we pinned them on a screen and had Henry looking at them.'

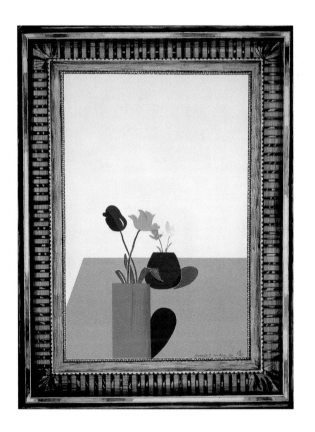

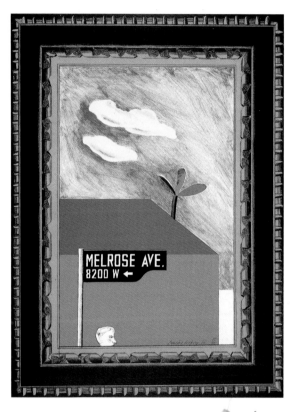

Picture of a Still Life that has an Elaborate Silver Frame
1965 from A Hollywood Collection

Picture of Melrose Avenue in an Ornate Gold Frame
1965 from A Hollywood Collection

15

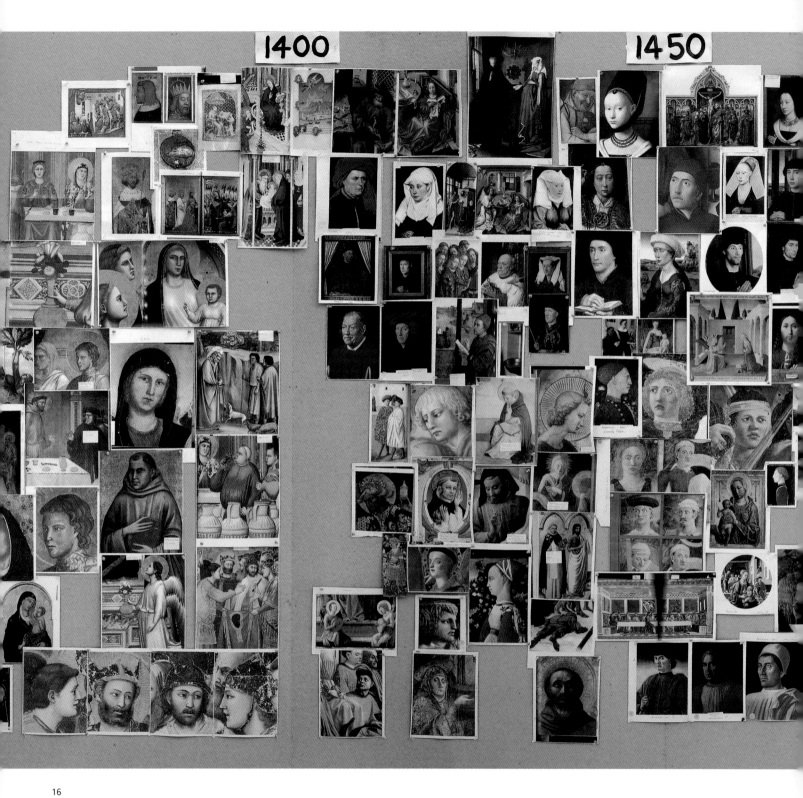

1400 1450

16

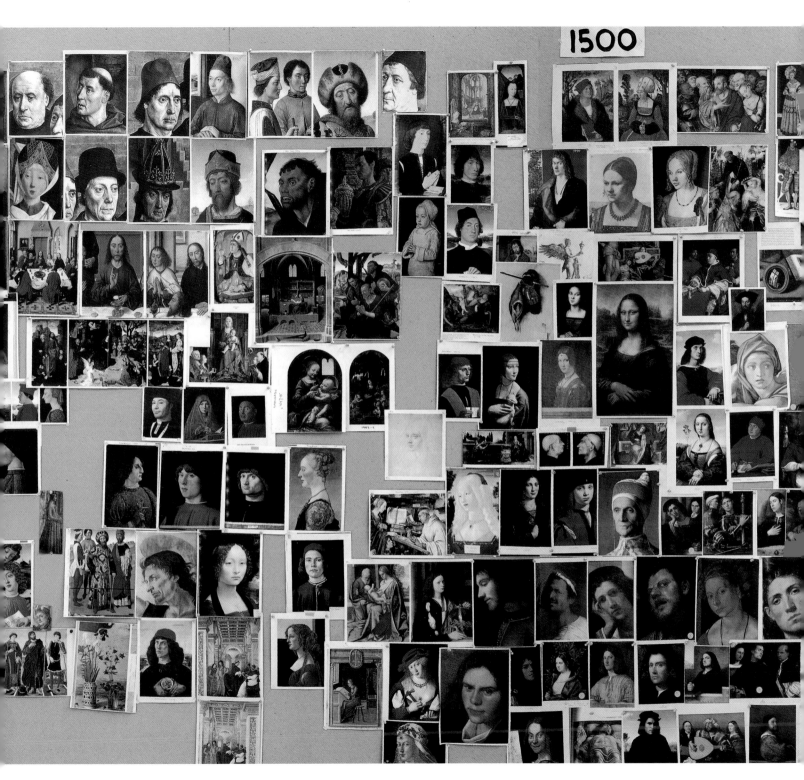

The Great Wall (detail) 2000

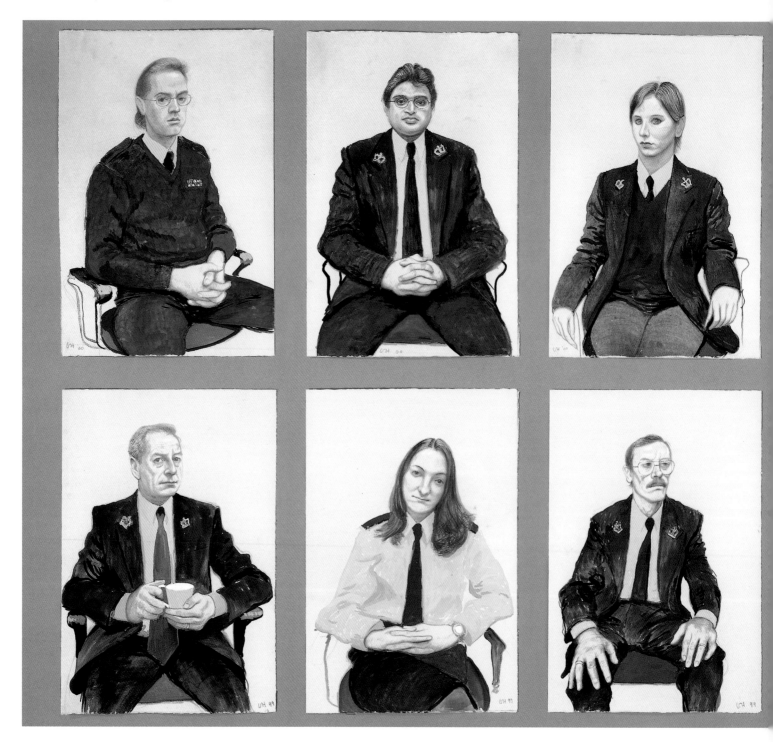

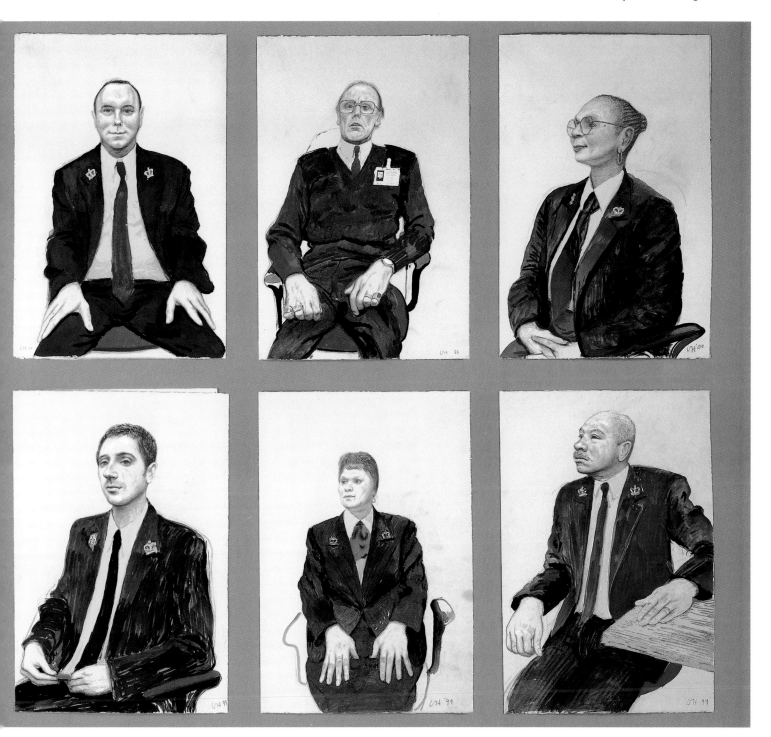

12 Portraits After Ingres in a Uniform Style 1999/2000

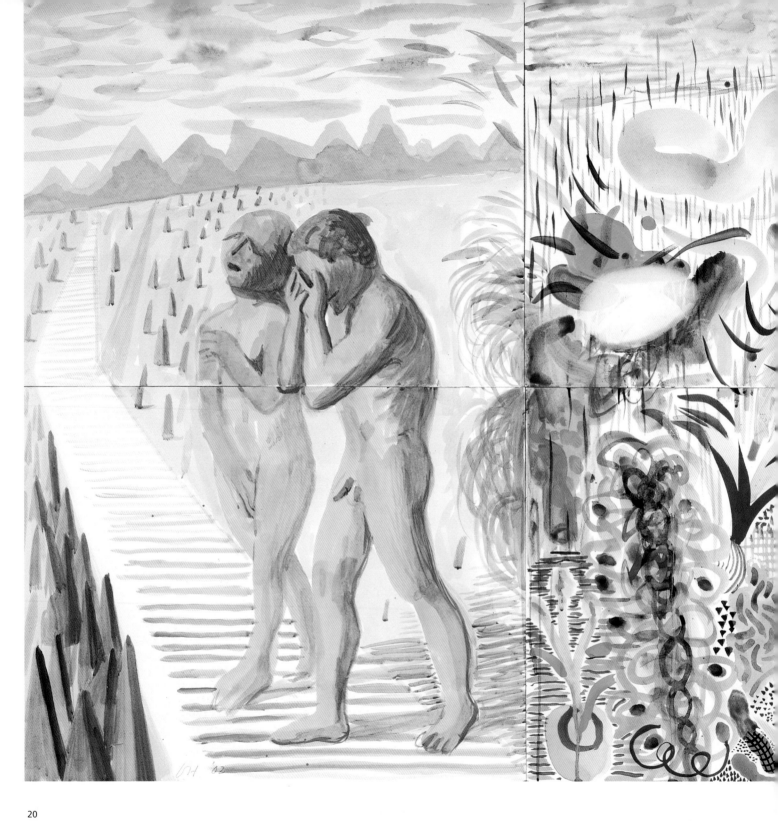

The Expulsion from the Garden of Eden 2002

'The first figure is meant to be ecclesiastical-looking. The second figure is a soldierlike person; he's got medals on him. The third person is full of little workers inside his body … he's an industrialist, or something…. I called the style "semi-Egyptian" because there is a true Egyptian style with rules. All styles in a sense have some rules, and if you break them it's a semi-style, I thought; the Egyptian style of painting, of course, is flat and, since I was breaking the rules of flatness, it was the semi-Egyptian style. The curtain at the top is the first time I used the curtain motif; I wanted it to look theatrical.'

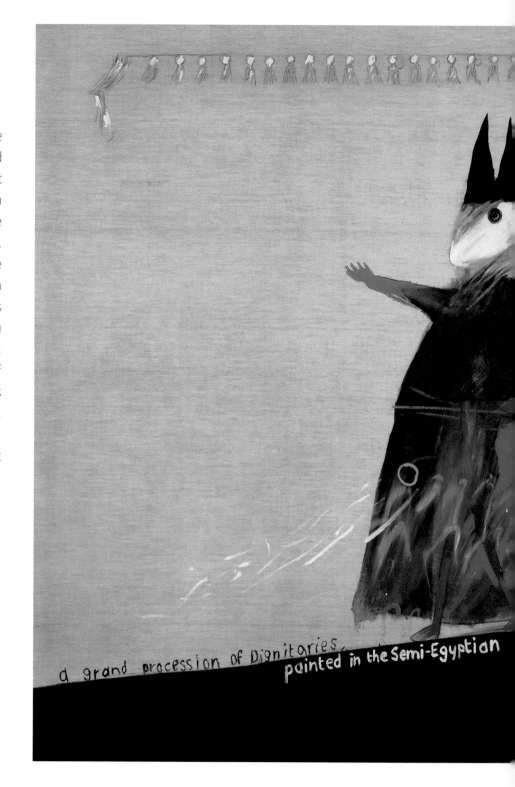

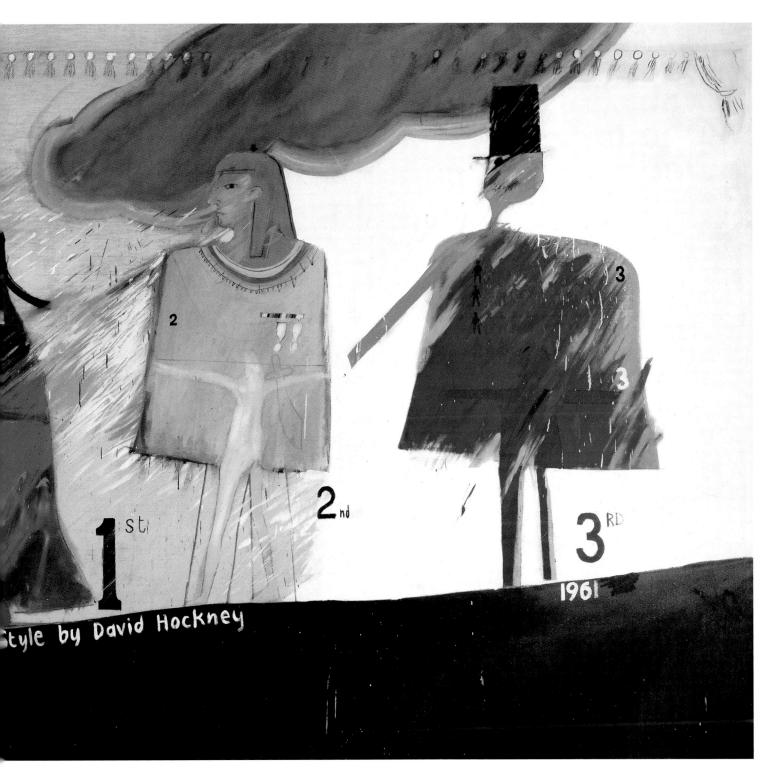

A Grand Procession of Dignitaries in the Semi-Egyptian Style 1961

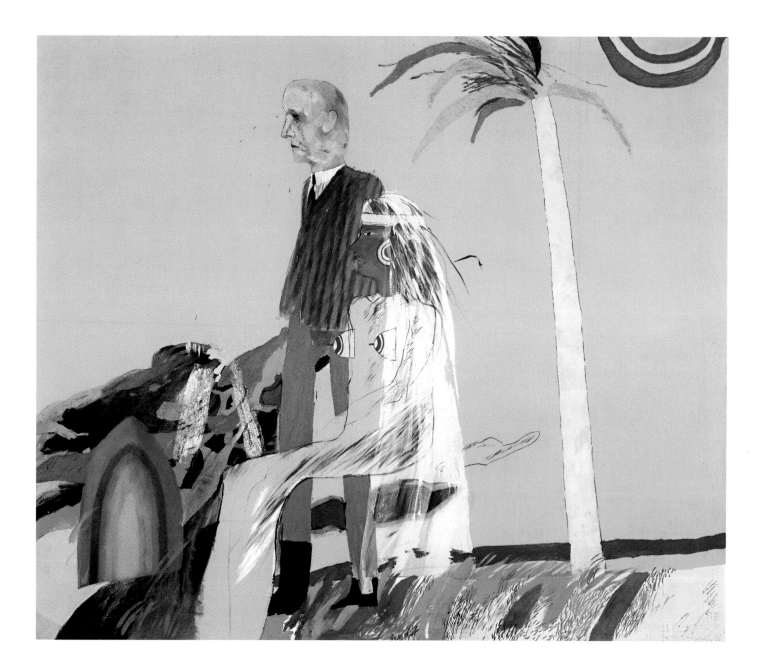

The First Marriage (A Marriage of Styles I) 1962

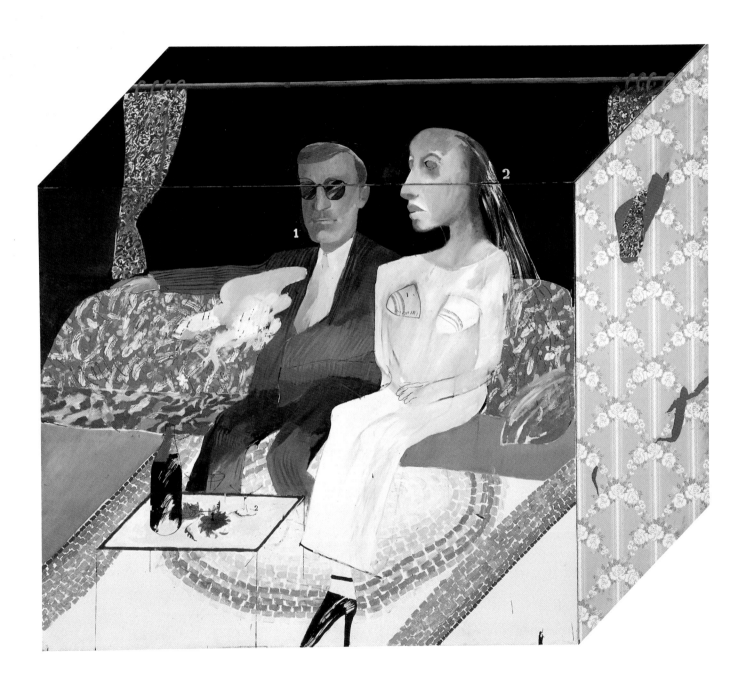

The Second Marriage 1963

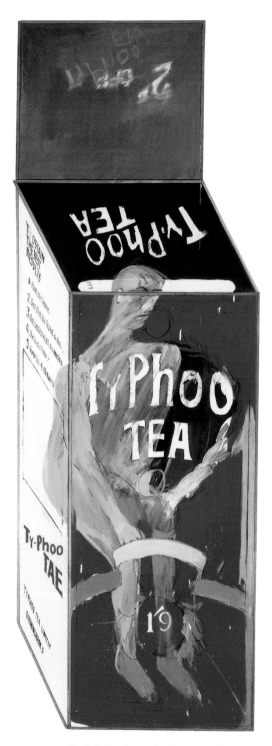

Tea Painting in an Illusionistic Style 1961

'In my studio at the Royal
College, I had a little teapot
and a cup, and I bought a
bottle of milk and packets of
tea – it was always Typhoo
tea, my mother's favourite.
The tea packets piled up
with the cans and tubes of
paint and they were lying
around all the time…. This
is as close to pop art as
I ever came.'

'To make a painting of a
packet of tea more
illusionistic, I hit on the idea
of "drawing" it with the
shape of the canvas….
It meant the blank canvas
was itself already illusionistic
and I could ignore the
concept of illusionistic
space and paint merrily
in a flat style.'

The Second Tea Painting 1961

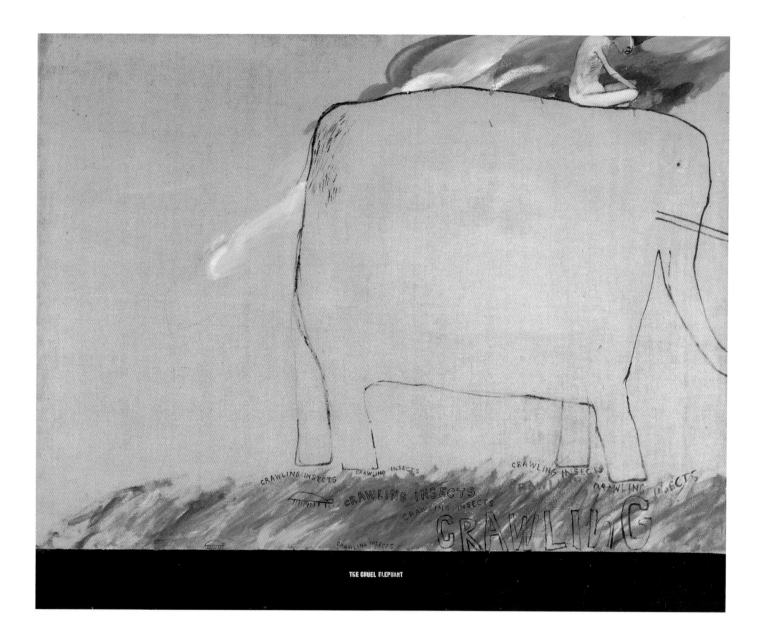

The Cruel Elephant 1962

'I put the words "crawling insects", which the elephant is forced to tread on, flattening them. I put a man on top of the elephant, so it's as though the man's weighing the elephant down and the elephant didn't after all intend to kill the crawling insects – it's the extra weight of the man that is the cruelty.'

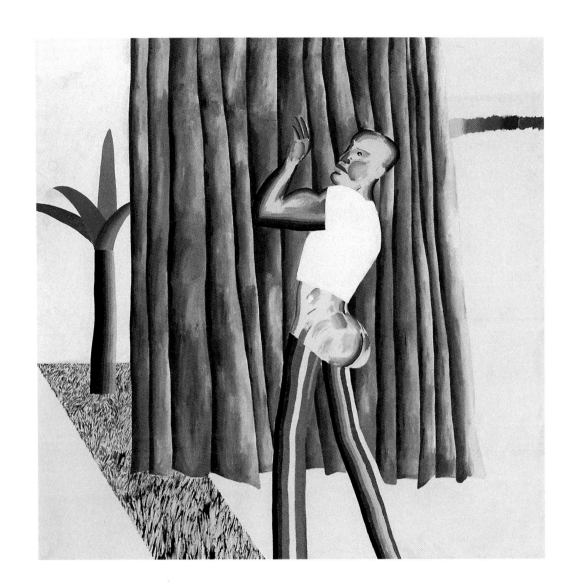

Cubist Boy with Colourful Tree 1964

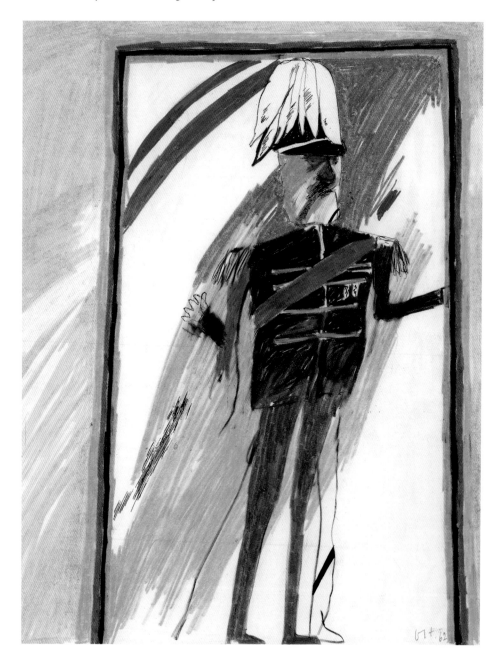

'*Man in a Museum* has the same theme as the *Marriage* pictures [pages 24 and 25]…. When I went to the Pergamon Museum in Berlin in 1962 with a friend we got separated. Suddenly I caught sight of him standing next to an Egyptian sculpted figure…. Both figures were looking the same way, and it amused me that in my first glimpse of them they looked united.'

Colonial Governor 1962

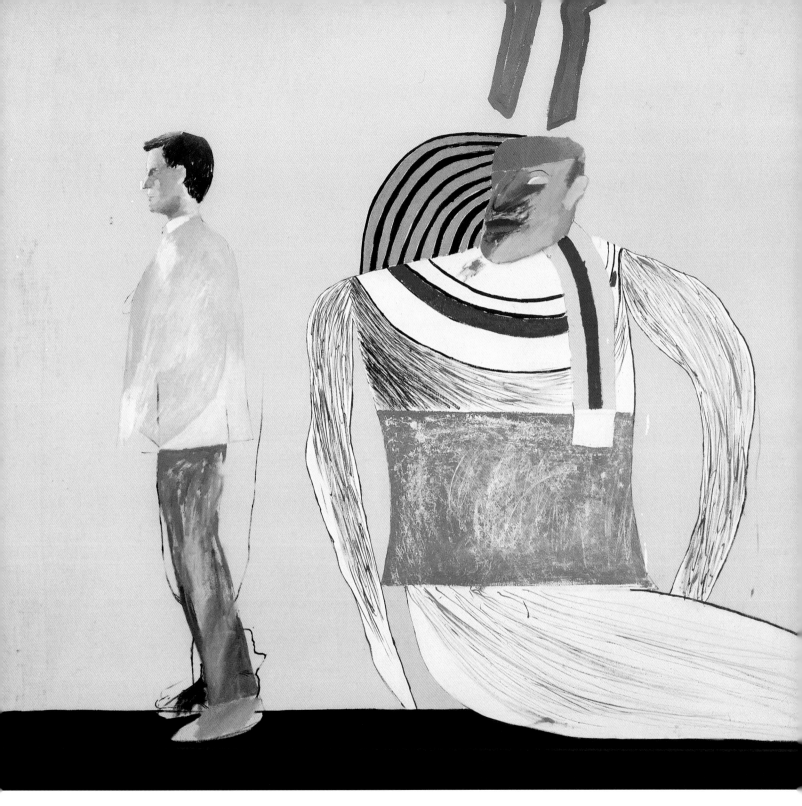

Man in a Museum (or You're in the Wrong Movie) 1962

TREE

TREE

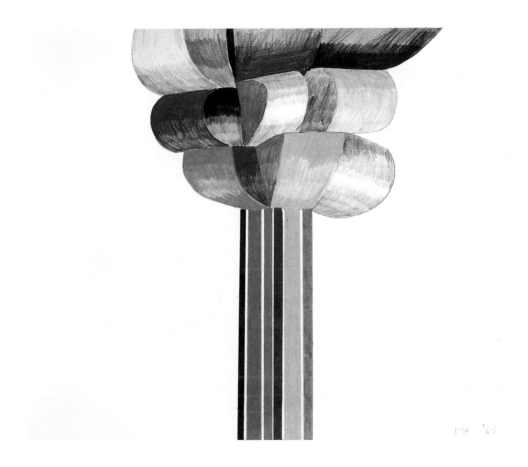

'I am very conscious of all that has happened in art during the last seventy-five
years. I don't ignore it; I feel I've tried to assimilate it into my kind of art.'

Cubistic Tree 1965

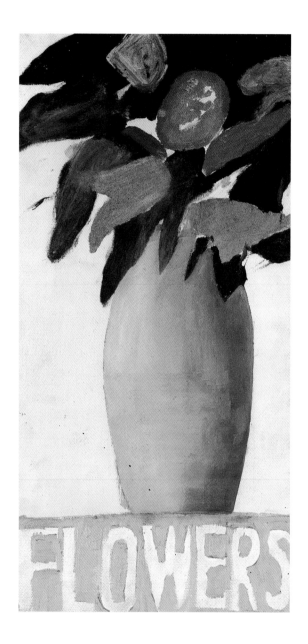

'I'd become interested in the still life or the arrangements of still life…. *A Realistic Still Life* is a pile of cylinders, made more realistic by the suggestion of shadow and other elements to create space.'

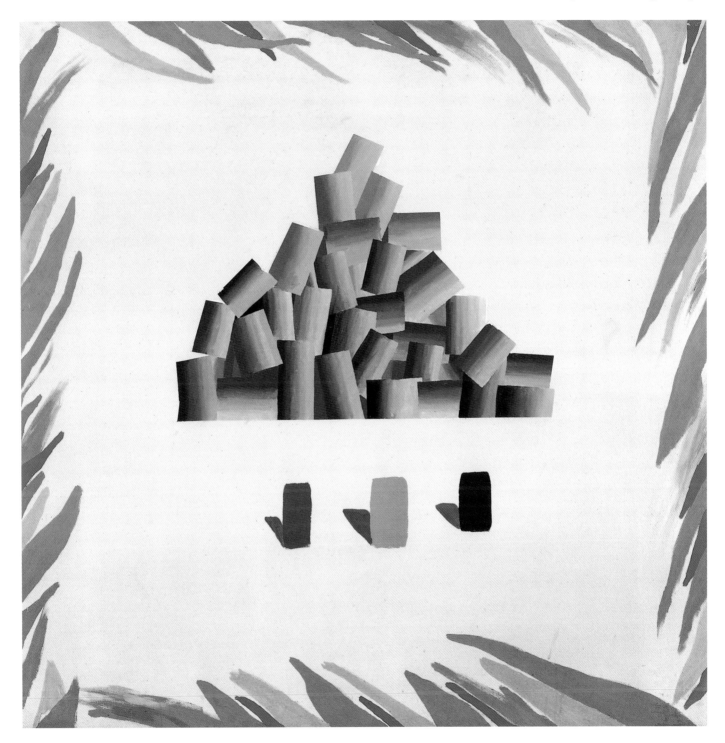

A Realistic Still Life 1965

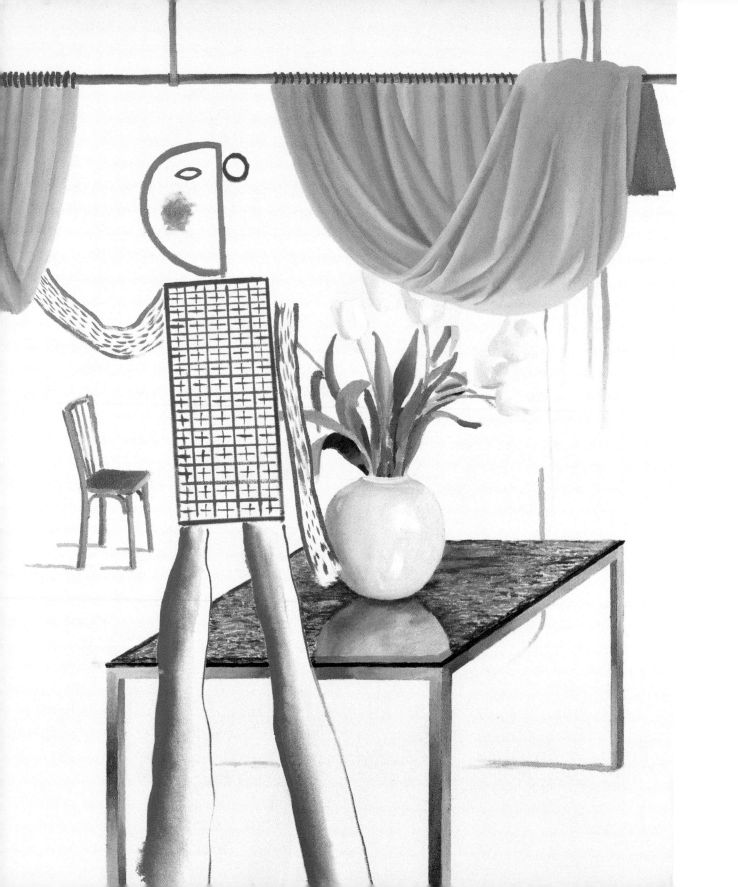

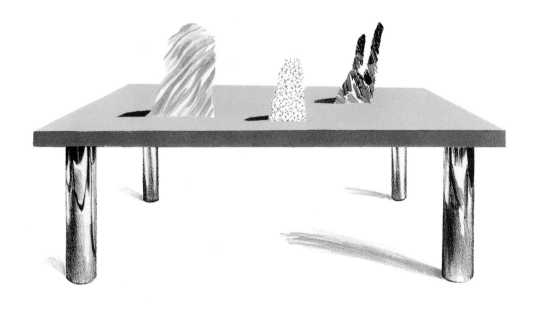

'*Invented Man Revealing Still Life* was painted
before *Kerby* [page 8]. The figure is invented, but
the still life is real. The curtain the man is holding
is lifted straight from Fra Angelico's *Dream of the
Deacon Justinian* [c. 1440]. These pictures were
for me a release from naturalism.'

Glass Table with Objects 1969

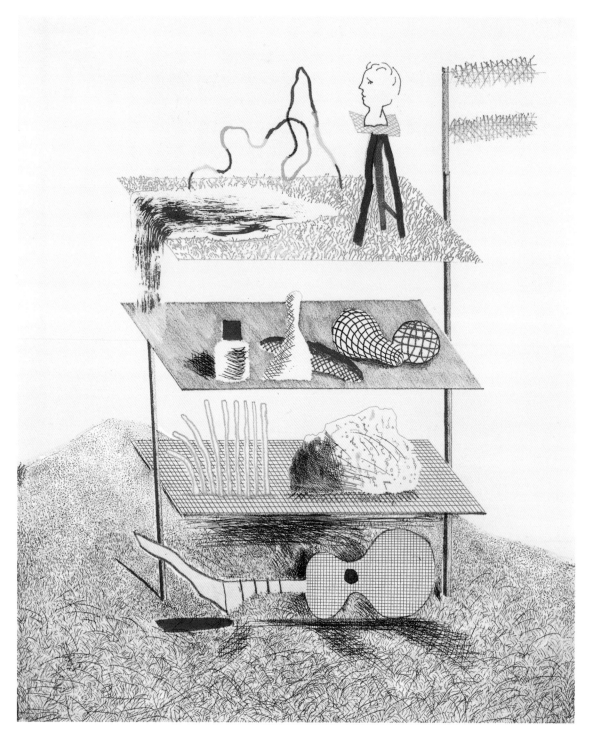

Serenade 1976–7 from The Blue Guitar

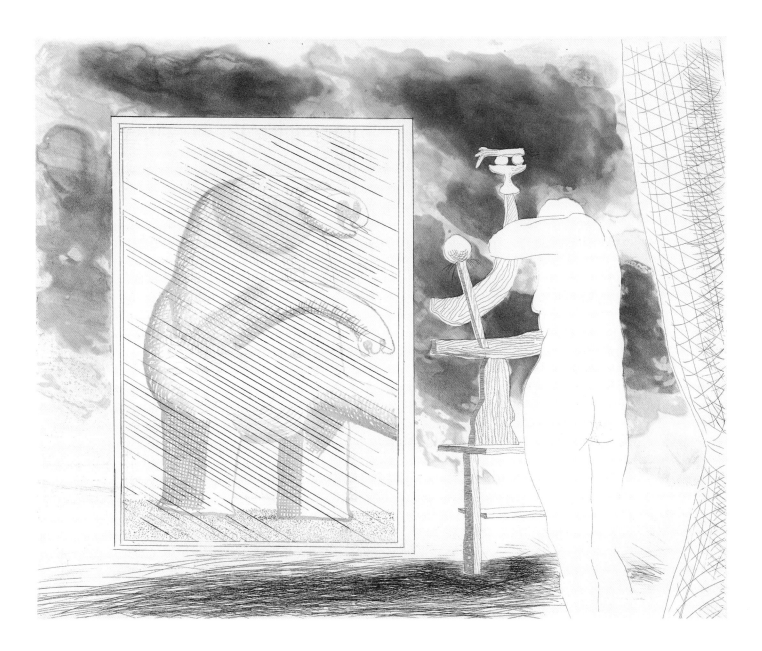

A Picture of Ourselves 1976–7 from The Blue Guitar

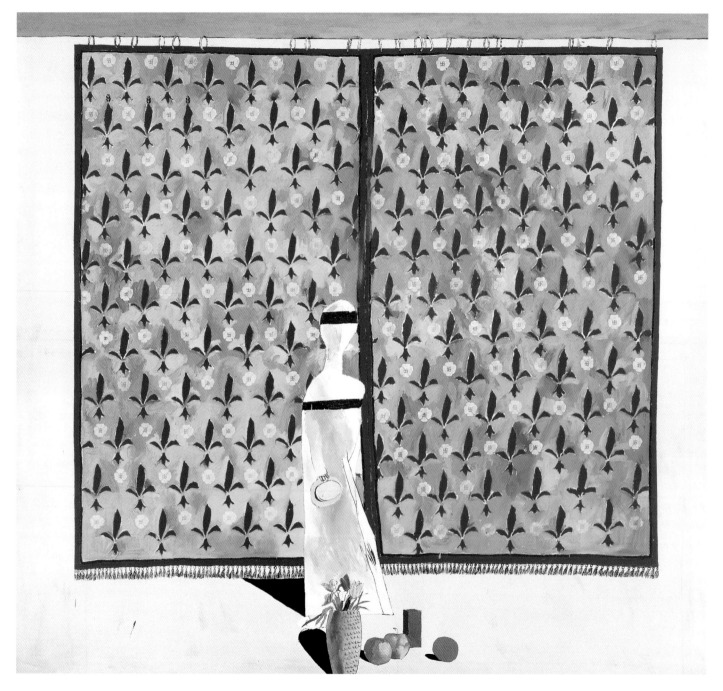

Still Life with Figure and Curtain 1963

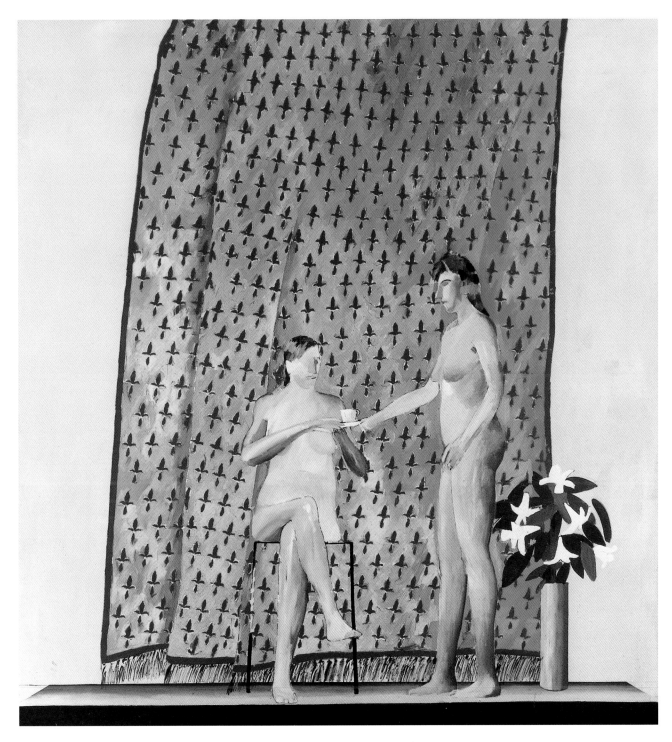

Seated Woman Drinking Tea, Being Served by a Standing Companion 1963

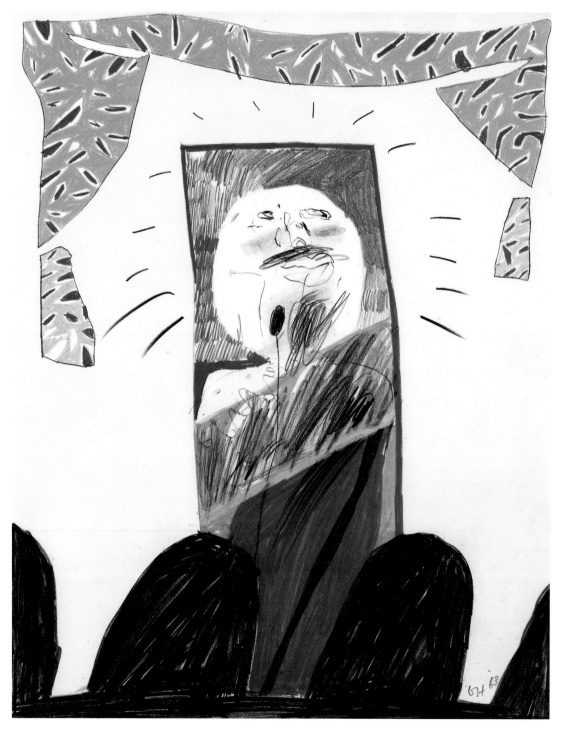

The Singer 1963

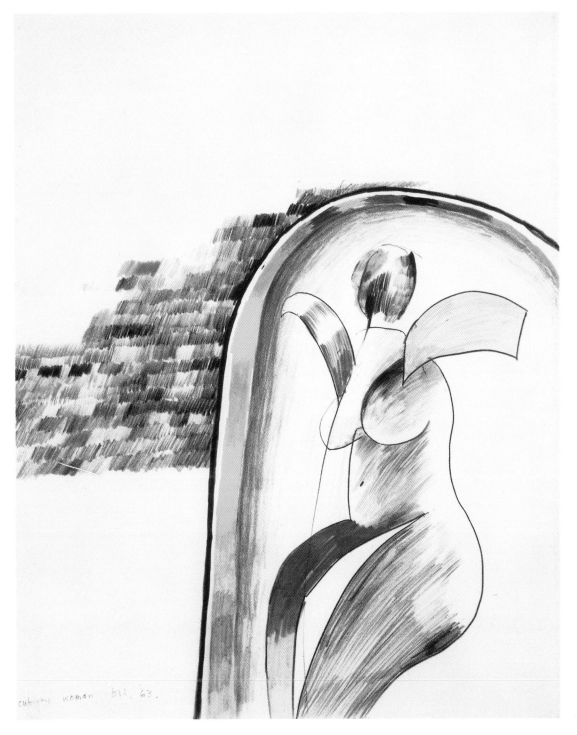

cubistic woman bij. 63.

Cubistic Woman 1963

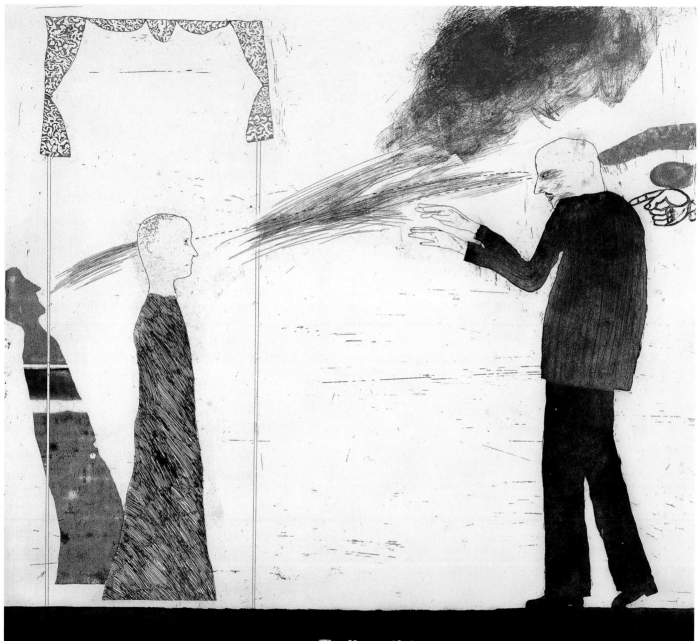

The Hypnotist

The Hypnotist 1963

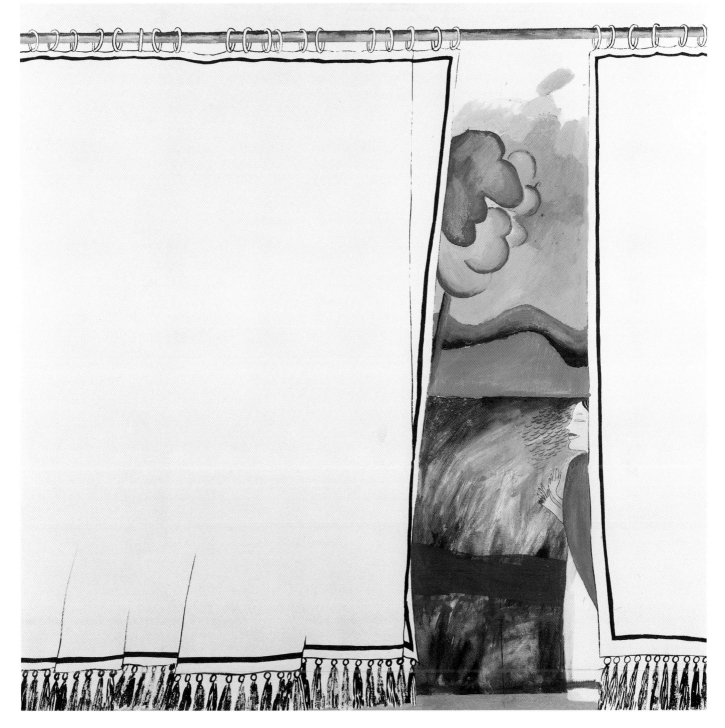

Closing Scene 1963

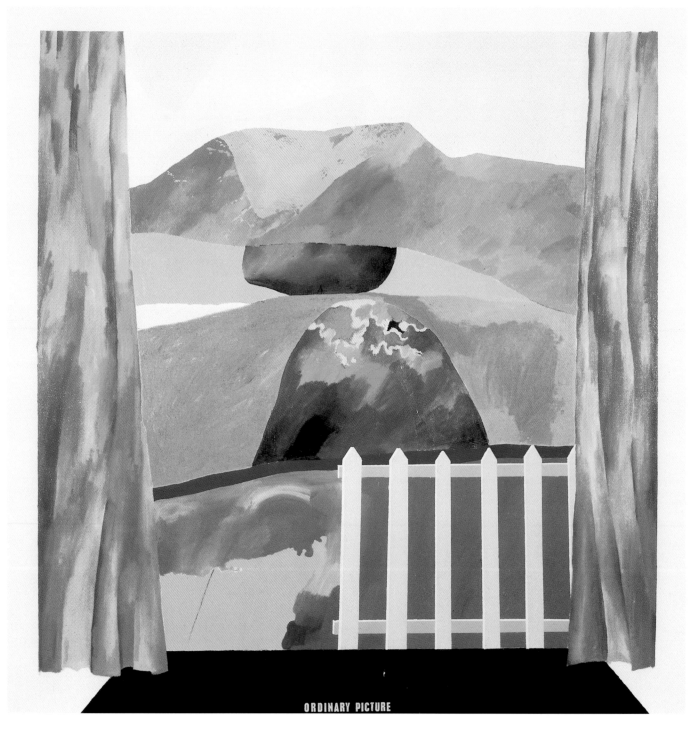

Ordinary Picture 1964

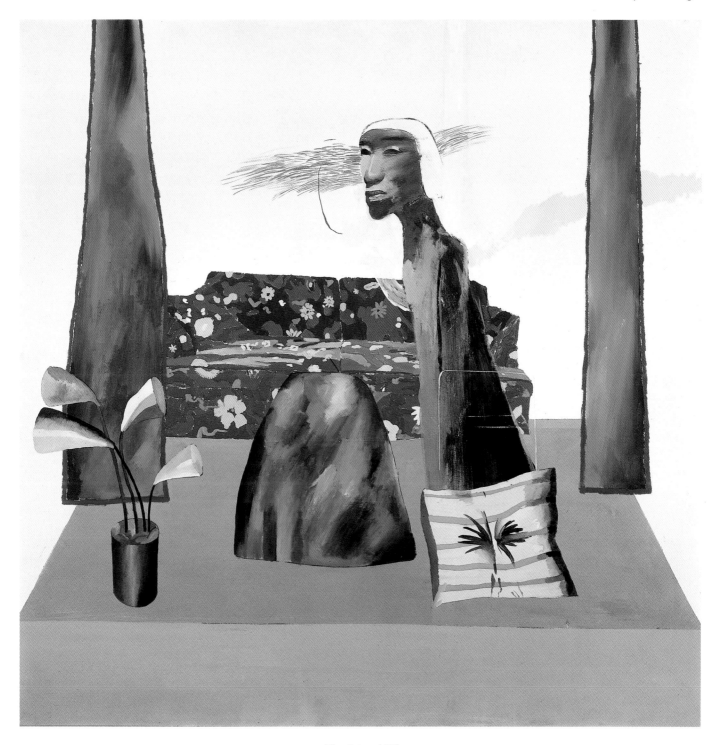

The Actor 1964

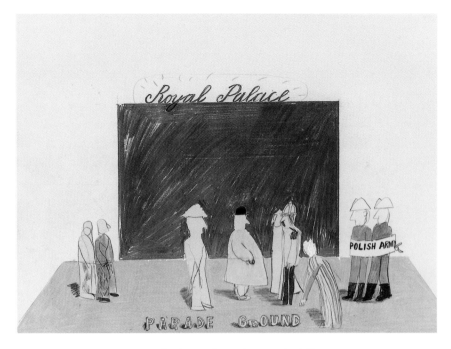

Royal Palace and Parade Ground 1966

'I worked a lot in the theatre. The kind of theatre I was working in, the opera, is Italian theatre, that is, it is deeply concerned with perspective, it is illusionistic theatre beyond a plane, it is a box.... Working in the theatre certainly makes you think about illusions, illusions of space within space.'

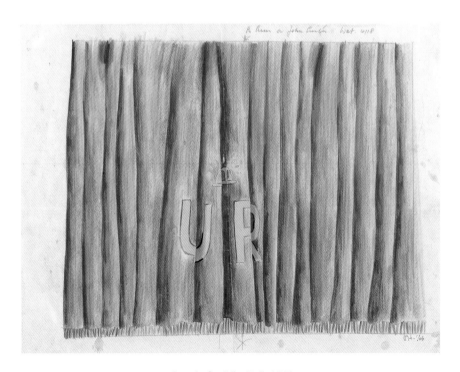

Curtain for 'Ubu Roi' 1966

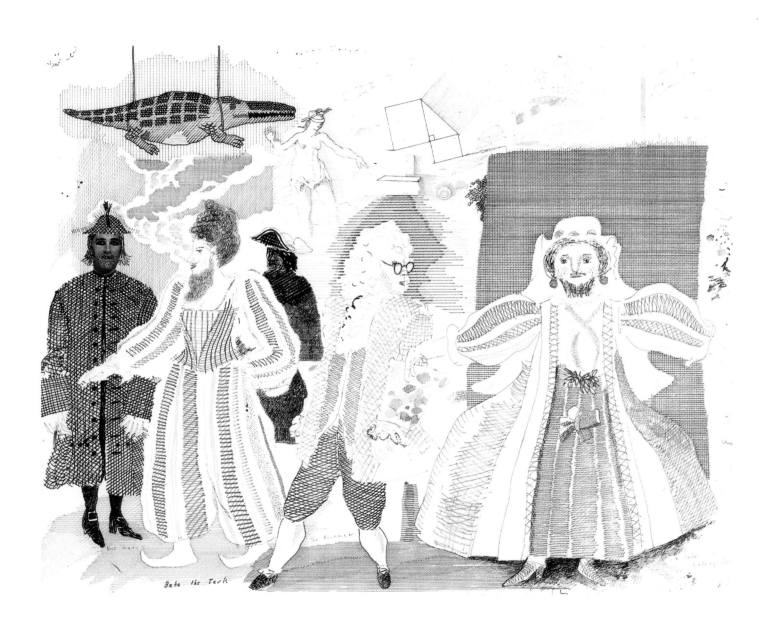

'I began my own *Rake's Progress*, a series of prints, in 1961, after my trip to New York.
I set the story there and updated it. It was partly because of this series that I was
asked to design Stravinsky's *The Rake's Progress* for the Glyndebourne Opera.'

An Assembly 1975 from The Rake's Progress 49

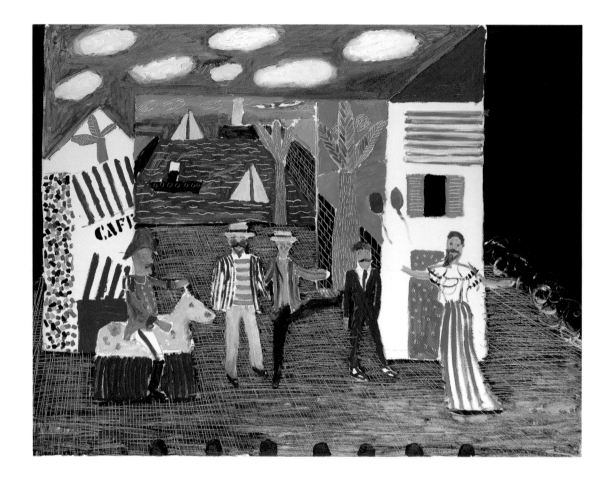

'In 1979, John Dexter, the British director, approached me about designing a triple bill for the Metropolitan Opera House in New York: Eric Satie's ballet *Parade*, which provided the title for the whole programme, and two short operas, Francis Poulenc's *Les Mamelles de Tirésias* and Maurice Ravel's *L'Enfant et les sortilèges*.'

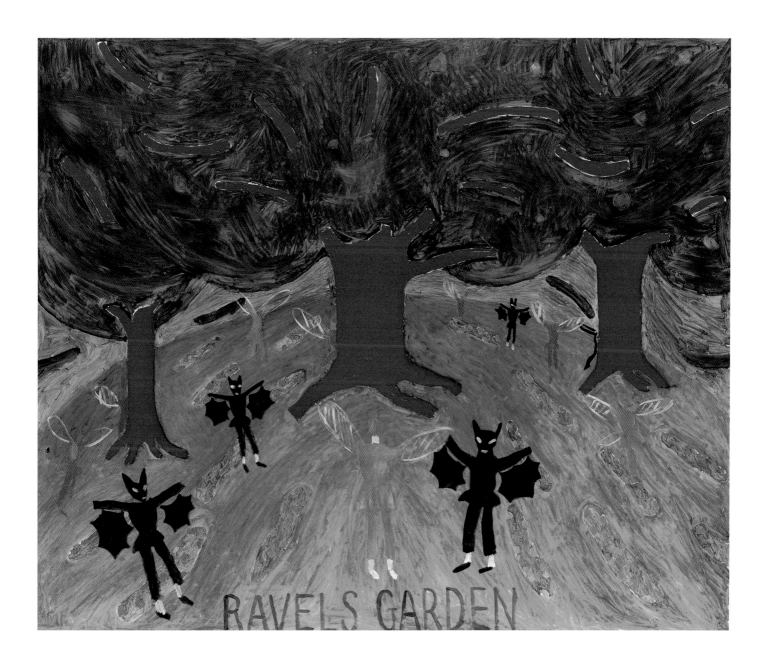

Ravel's Garden with Night Glow 1980 from L'Enfant et les sortilèges

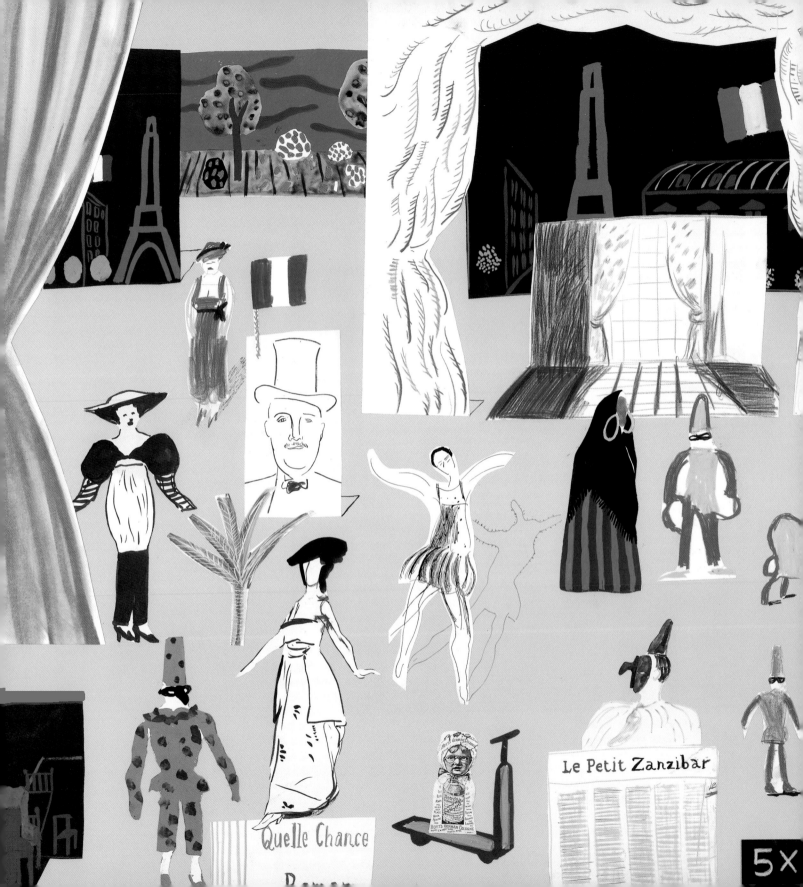

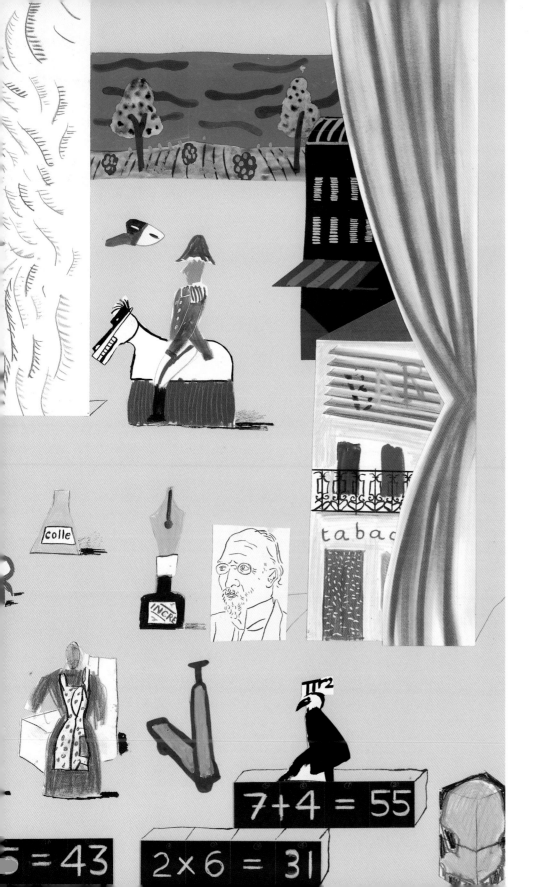

Parade Collage 1980

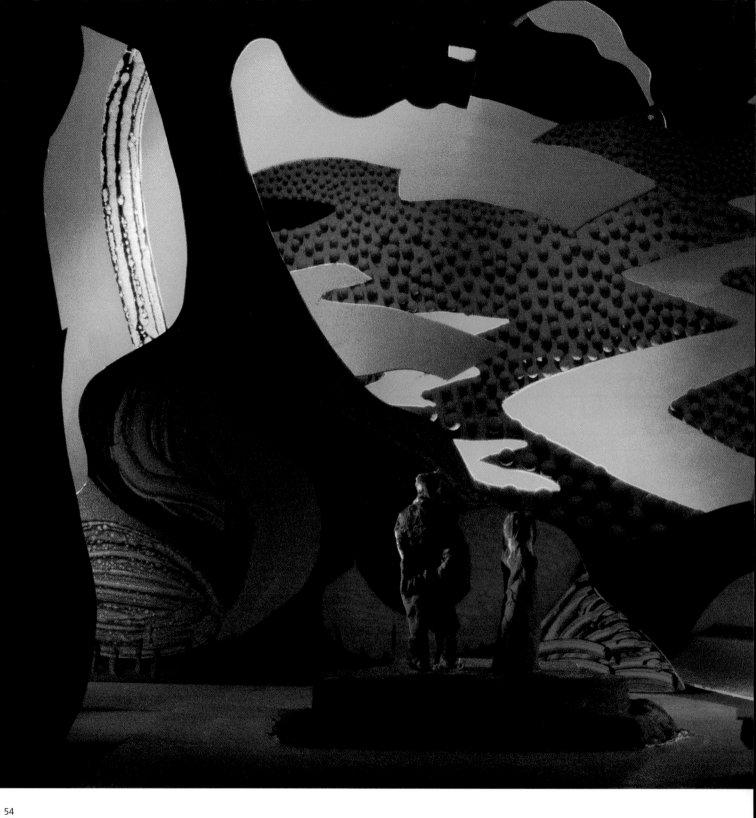

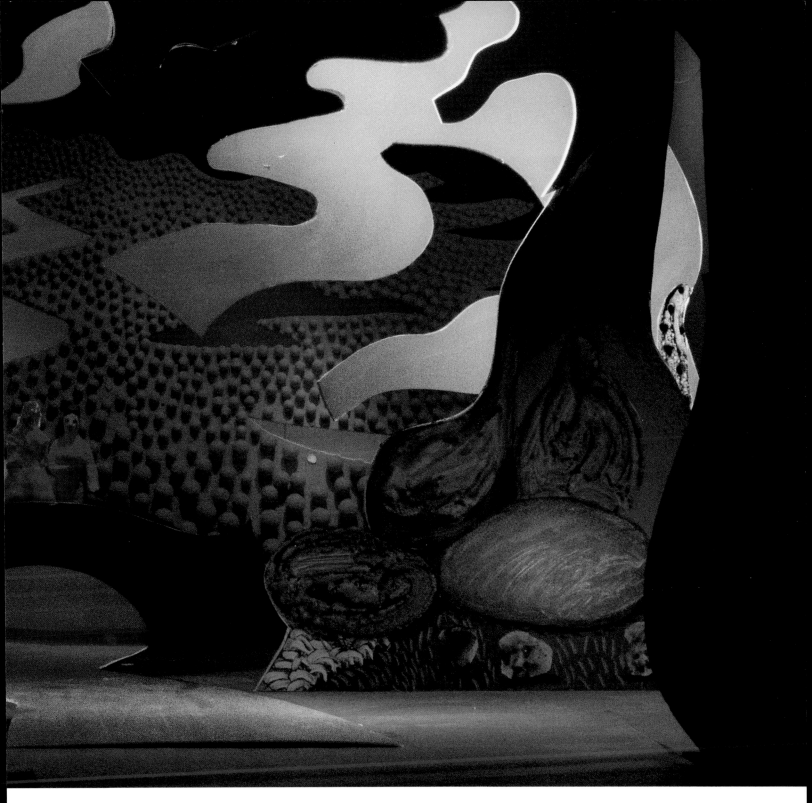

Die Frau ohne Schatten, Act 3, Scene 4 (scale model) 1992

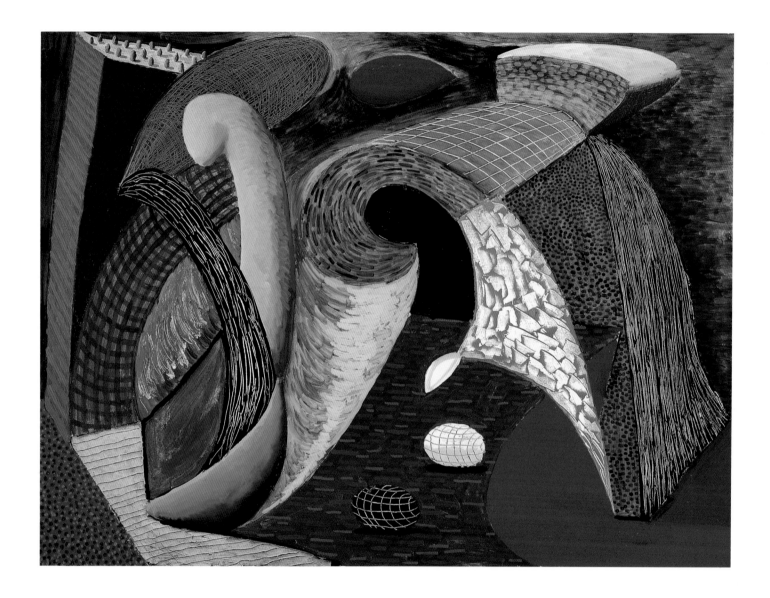

The Sixteenth V. N. Painting 1992

'I started the group called "Some Very New Paintings" in 1992 after I had finished my set designs for *Die Frau ohne Schatten*. These started simply and grew more and more complex. I soon realized that what I was doing was making internal landscapes, using different marks and textures to create space, so that the viewer wanders around.'

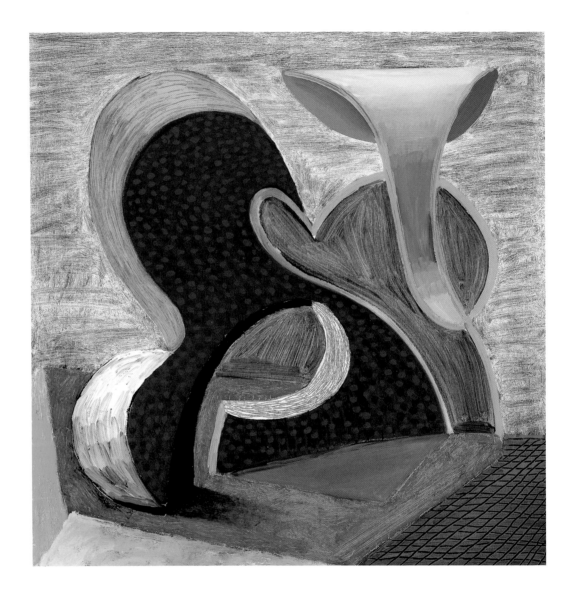

The Fourth V. N. Painting 1992

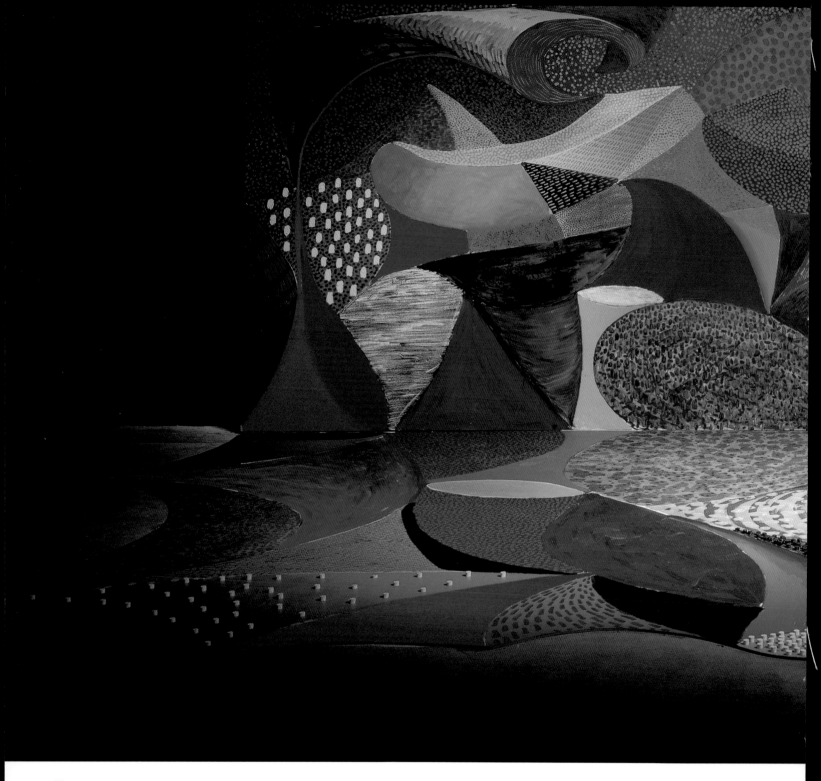

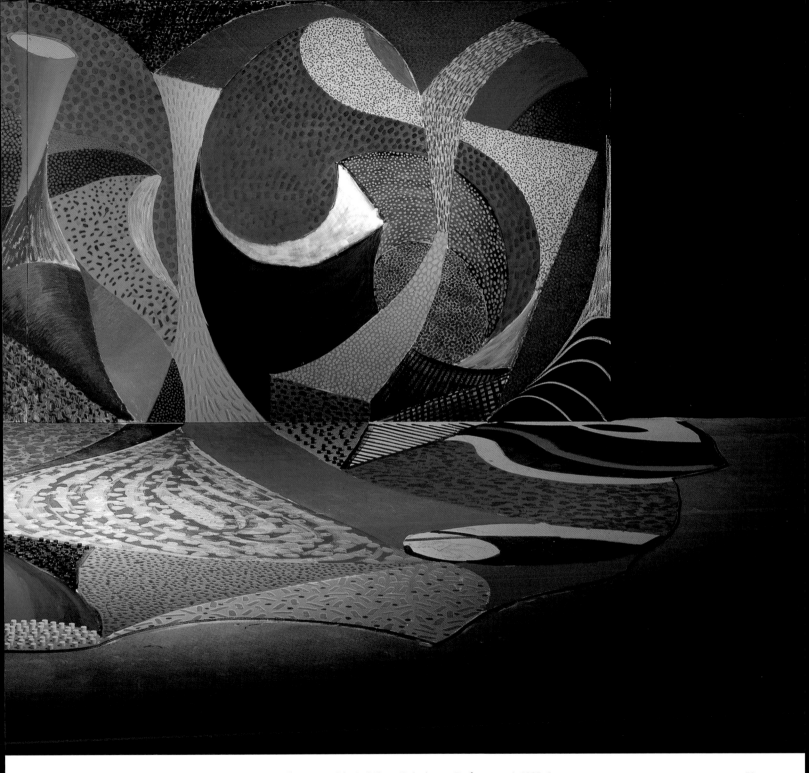

Snails Space with Vari-Lites, 'Painting as Performance' 1995–6

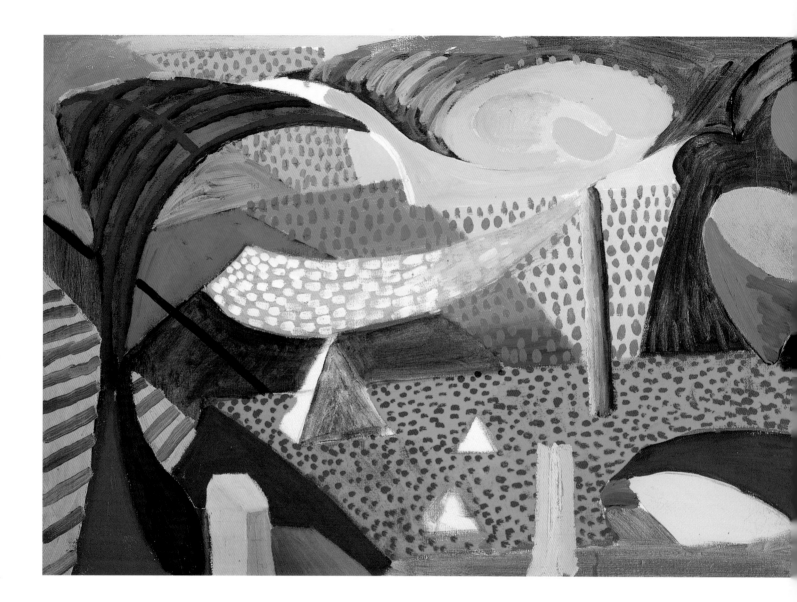

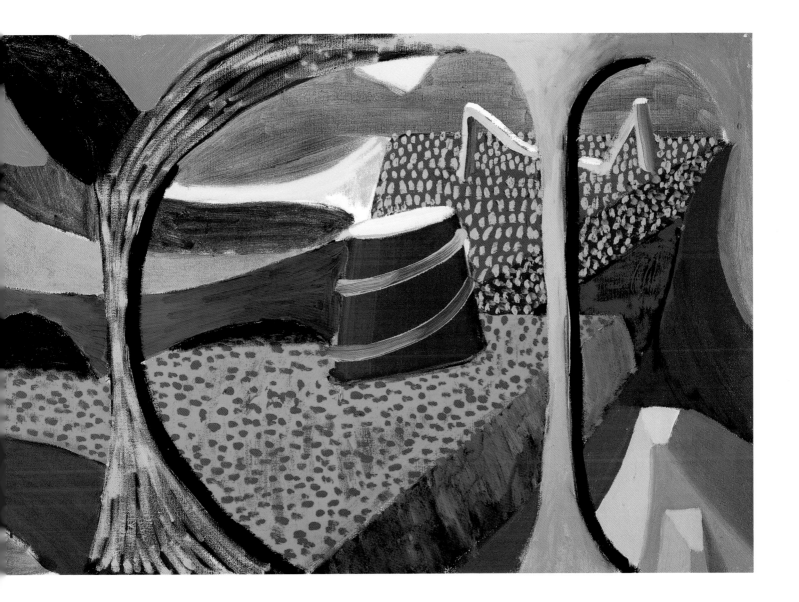

Near Bruges 1995

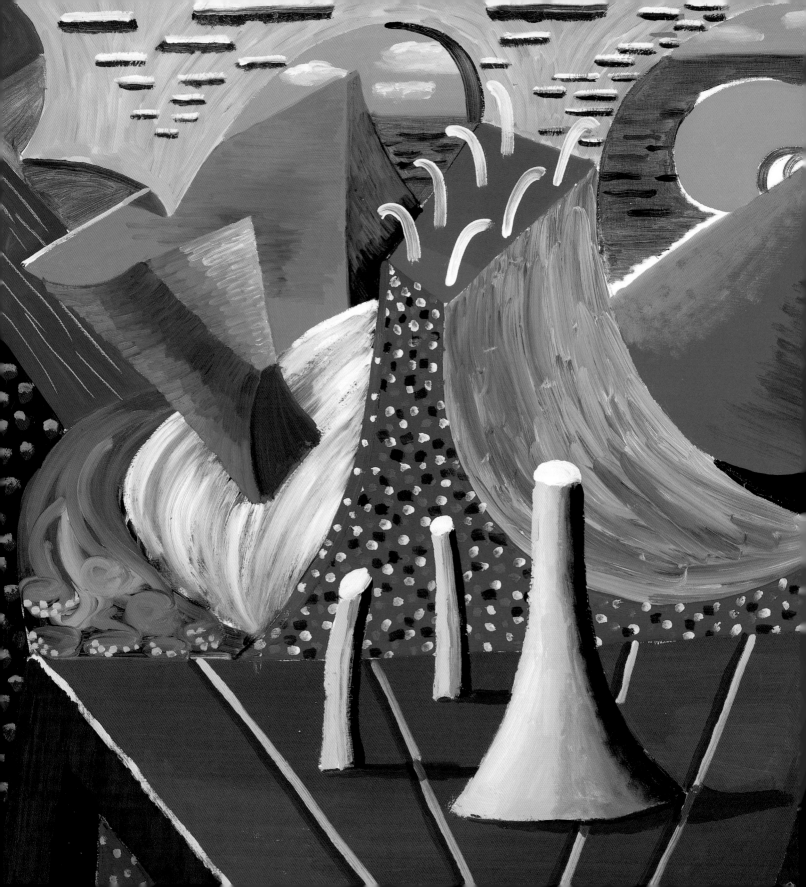

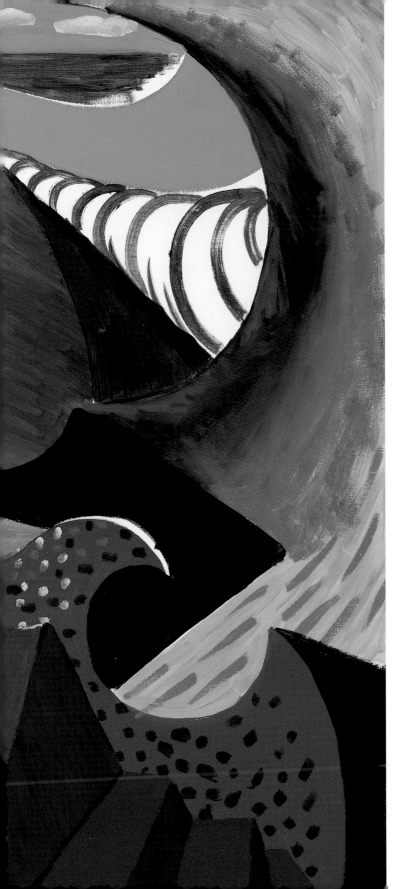

'At one side of my house in Malibu is
the Pacific Coast Highway; at the other
is the beach. I step out of my kitchen
door and there, right there, is the sea.
So when I'm painting in my studio I am
very aware of nature, in its infinity, and
of the sea endlessly moving.'

The Sea at Malibu 1988

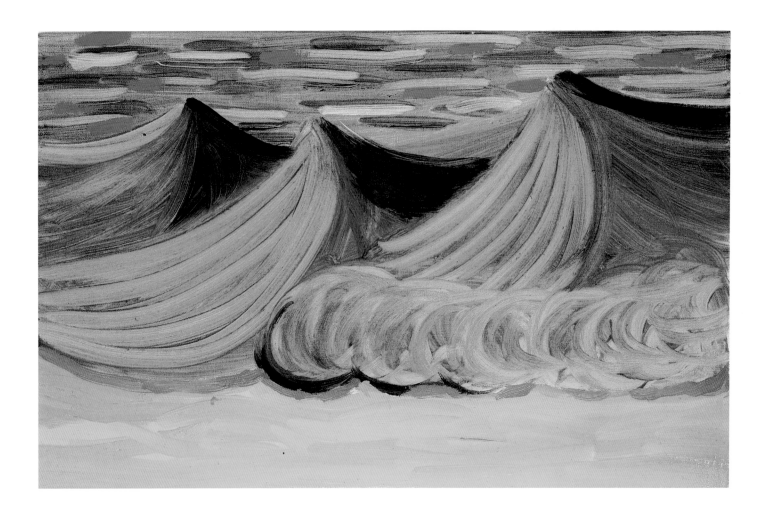

Three Green Waves with Orange Sand 1989

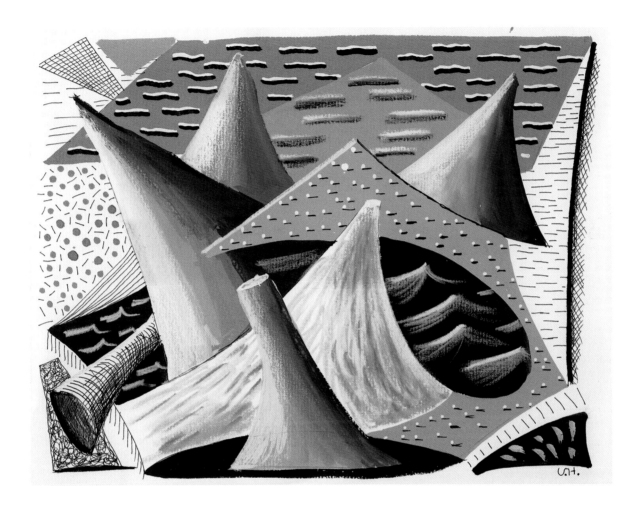

Geometric Waves 1989 1989

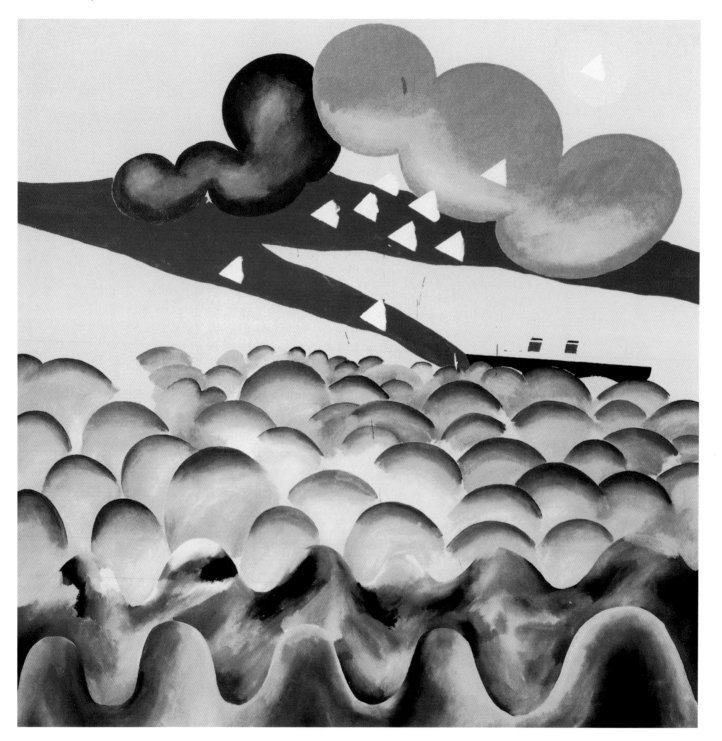

Atlantic Crossing 1965

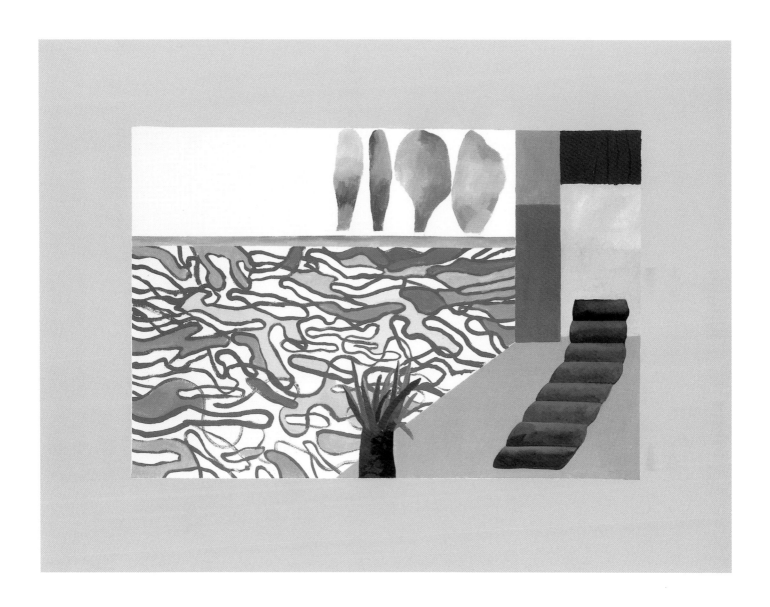

'In the swimming pool pictures, I had become interested in the more general problem
of painting the water, finding a way to do it. It is an interesting formal problem,
really, apart from its subject matter … because it can be anything –
it can be any colour, it's movable, it has no set visual description.'

Picture of a Hollywood Swimming Pool 1964

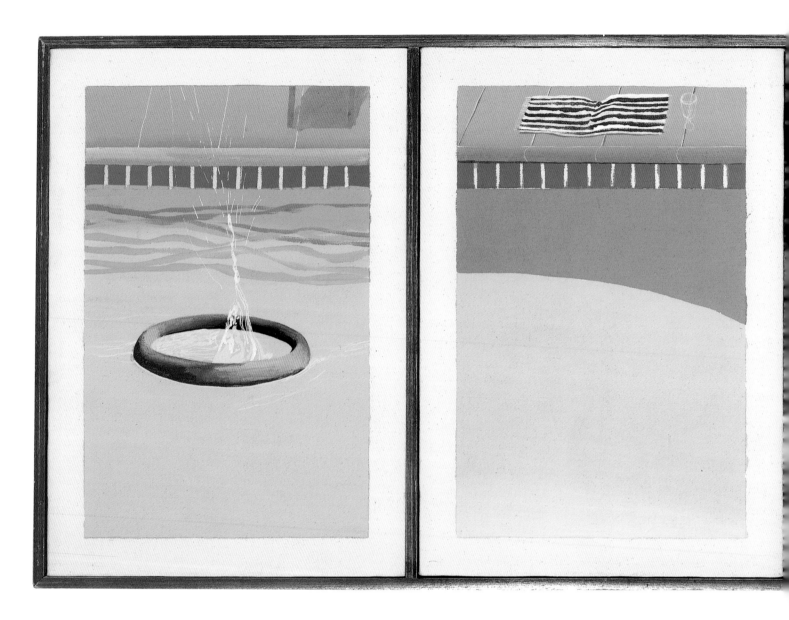

'I believe that the problem of how you depict something is a formal problem.
It's an interesting one and it's a permanent one; there's no solution to it.
There are a thousand and one ways you can go about it. There's no set rule.'

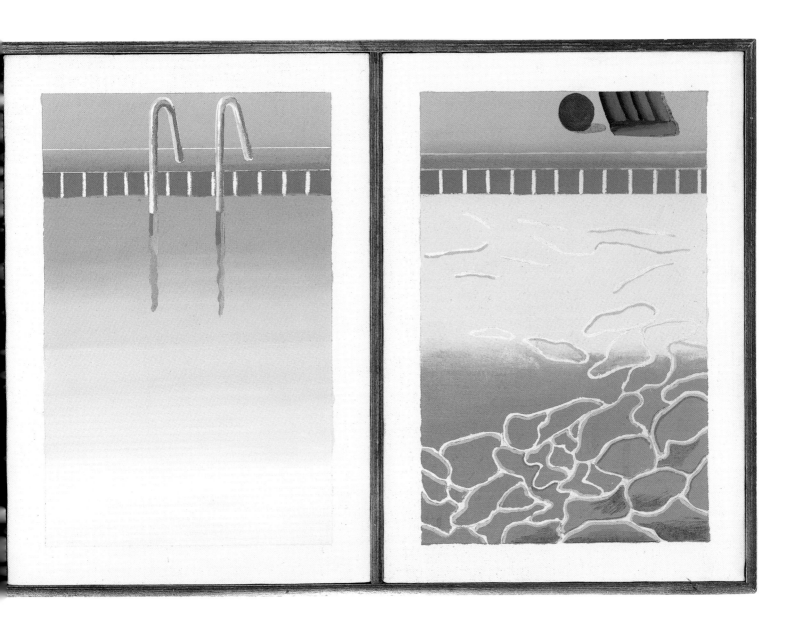

Four Different Kinds of Water 1967

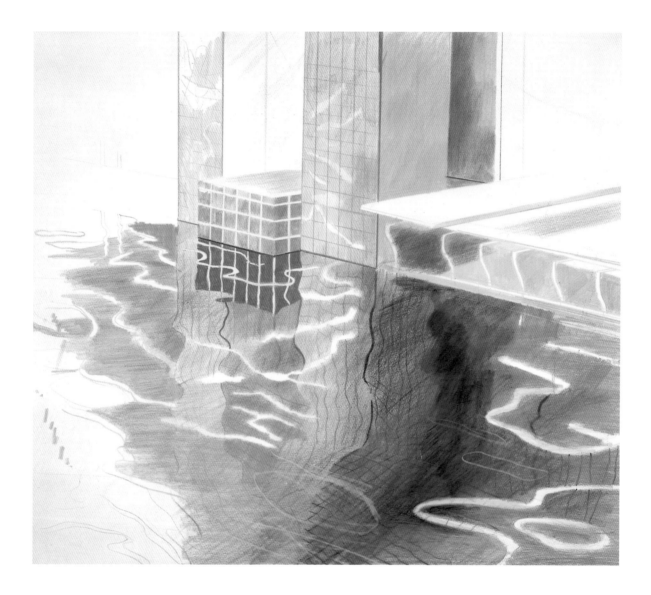

Study of Water, Phoenix, Arizona 1976

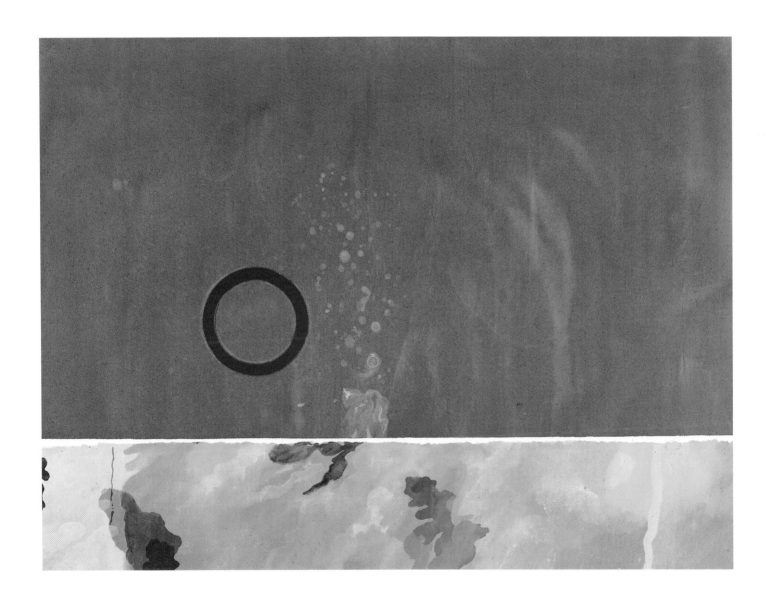

Rubber Ring Floating in a Swimming Pool 1971

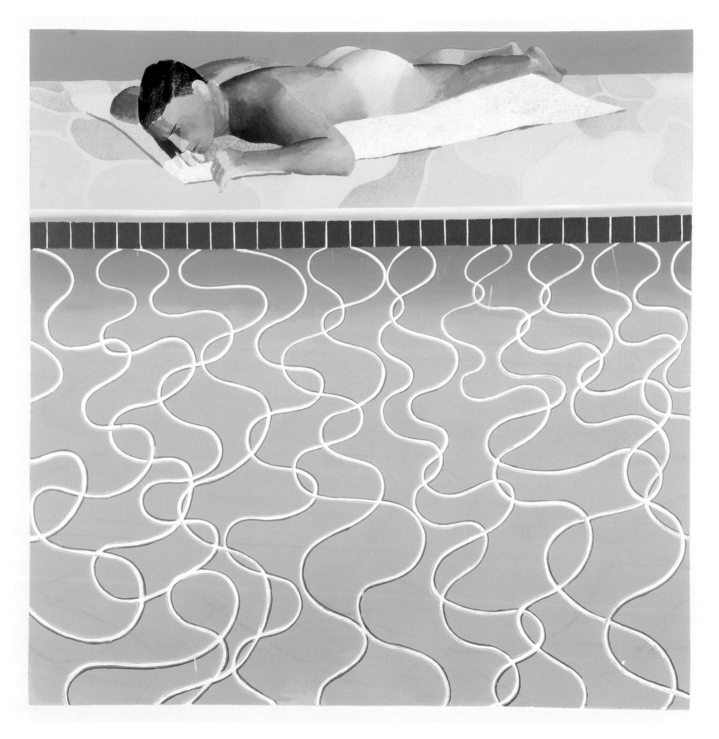

Sunbather 1966

Pool Study II 1978

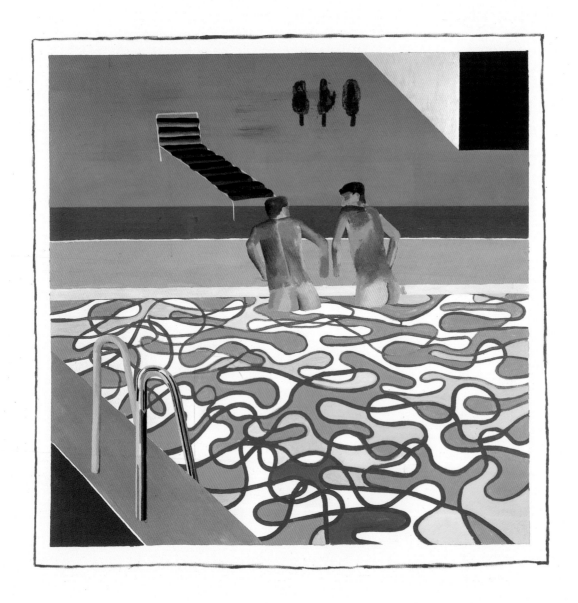

Two Boys in a Pool, Hollywood 1965

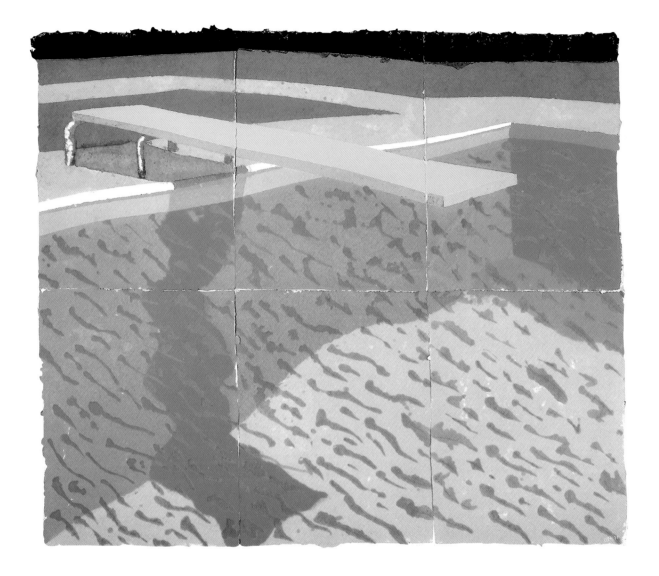

'The process involved making a piece of paper from scratch, from chewed-up rags and water.…
You can press the pulp, and when all the moisture has gone, it becomes a piece of paper.…
You could add dyes to the pulp and the colour would be more vivid and stronger than applying
paint on the surface.… Gradually I realized that you could work with moulds, as if "drawing"
the form with little metal moulds, and pour all the colours next to one another.'

Plongeoir avec Ombre (Paper Pool 13) 1978

'*A Bigger Splash* is a balanced composition; it's worked out that way, very consciously. It's an inventive picture. The architecture is very typical southern Californian architecture; you can probably find a building like it anywhere there.'

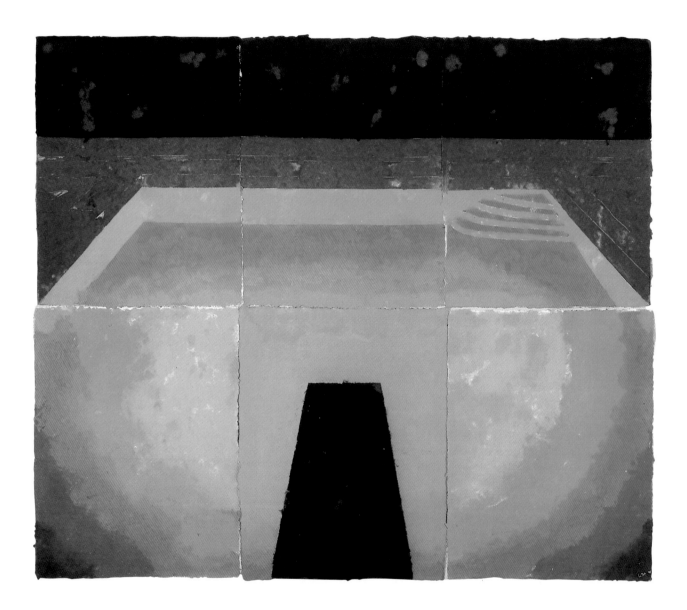

Schwimmbad Mitternacht (Paper Pool 11) 1978

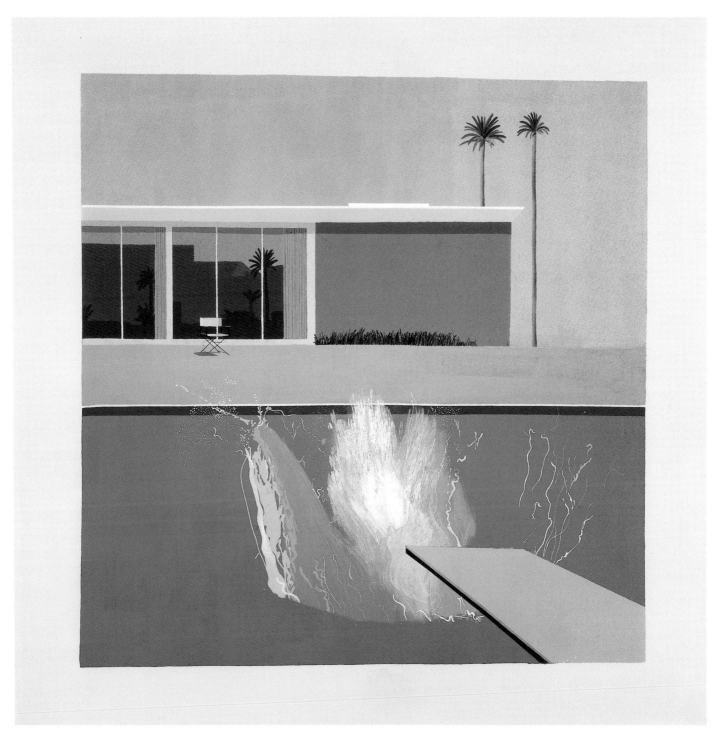

A Bigger Splash 1967

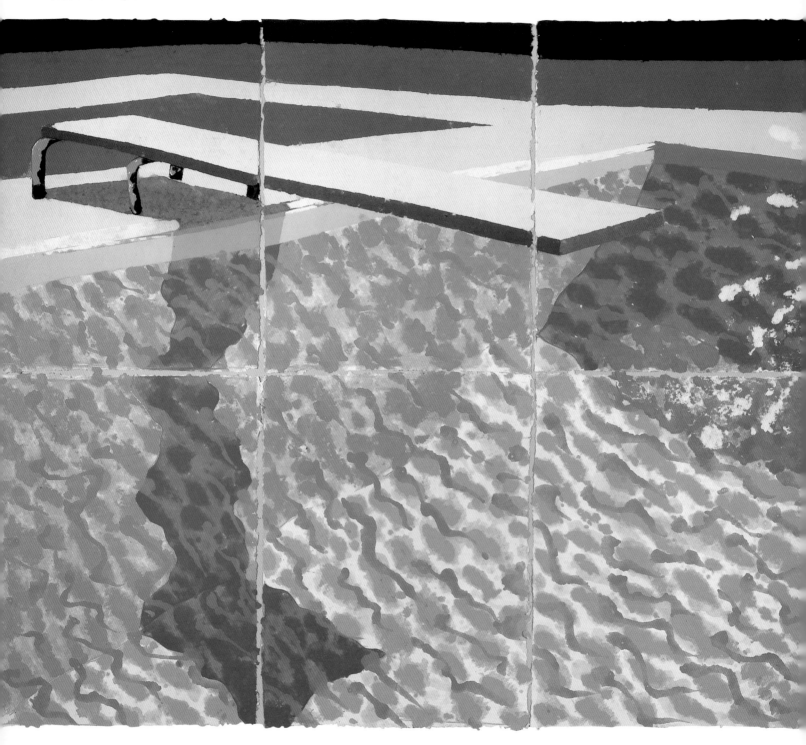

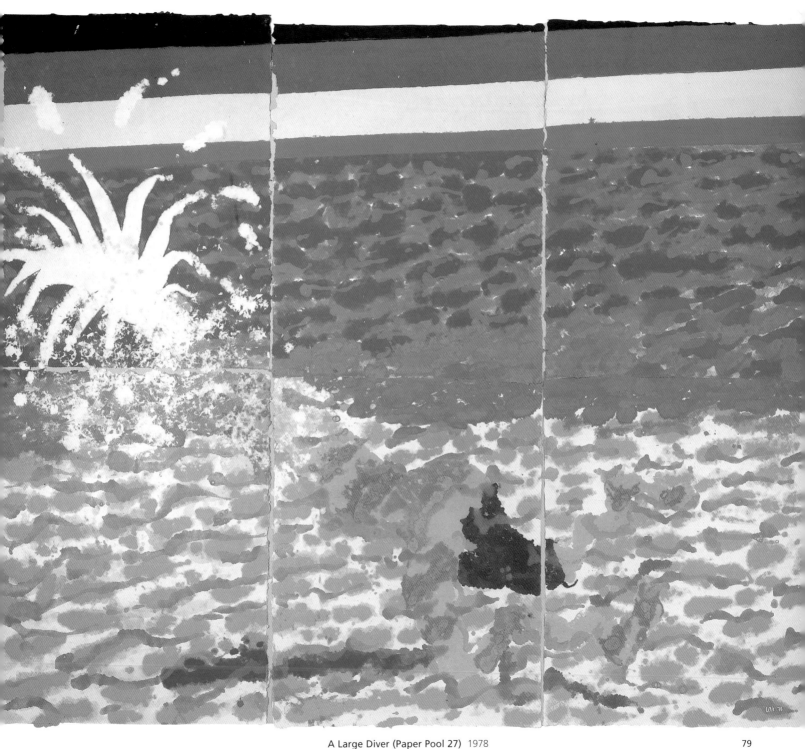

A Large Diver (Paper Pool 27) 1978

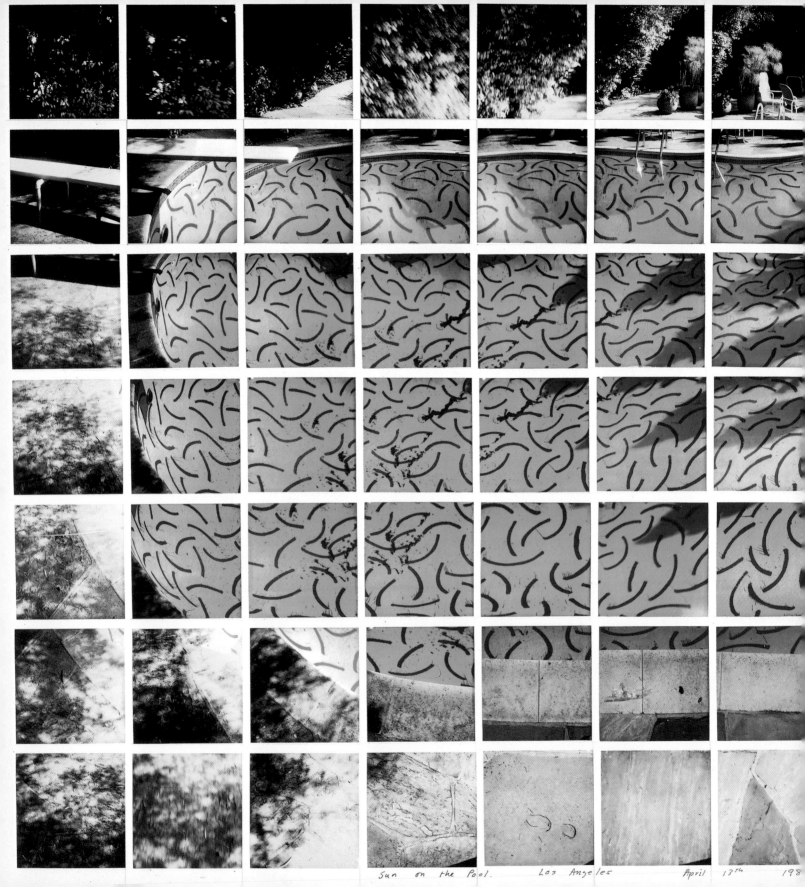

Sun on the Pool. Los Angeles April 13th 198

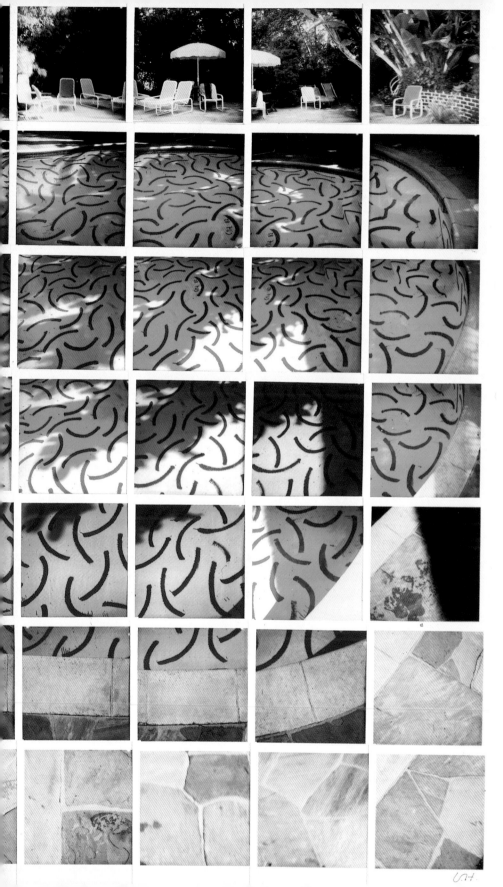

Sun on the Pool, Los Angeles,
April 13th 1982 1982

81

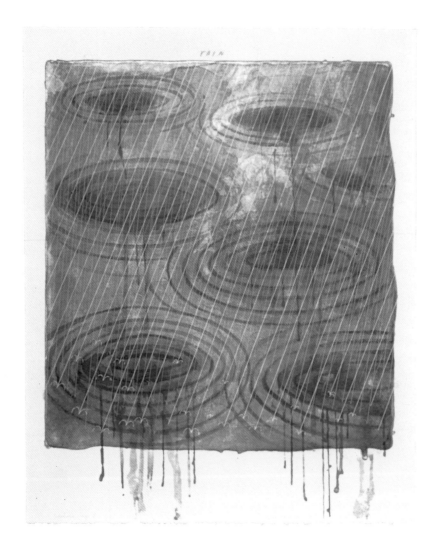

Rain 1973 from The Weather Series

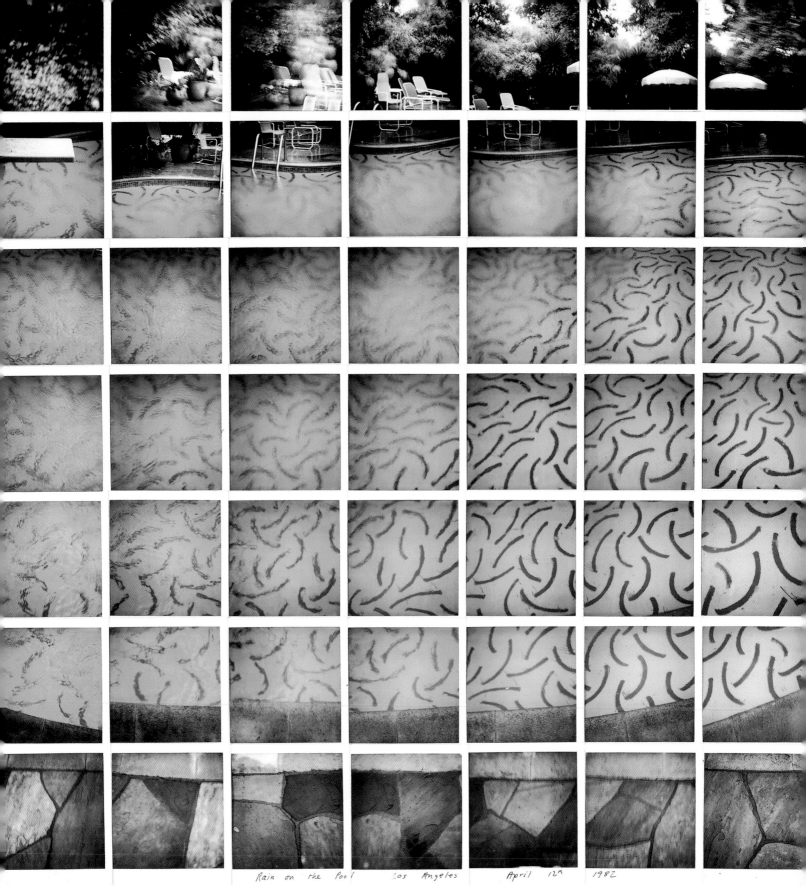

Rain on the Pool Los Angeles April 12th 1982

Cold Water about to Hit the Prince 1969 from Illustrations for Six Fairy Tales from the Brothers Grimm

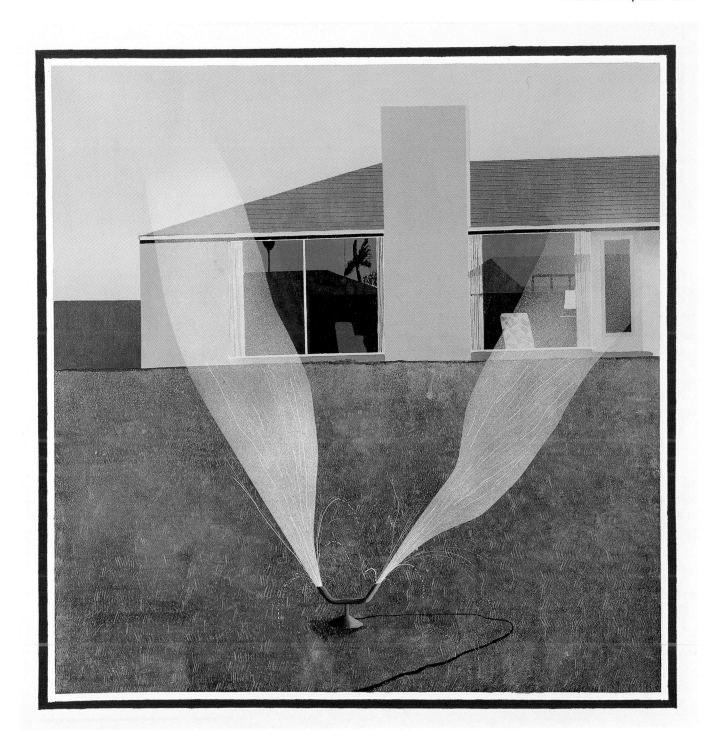

A Lawn Sprinkler 1967

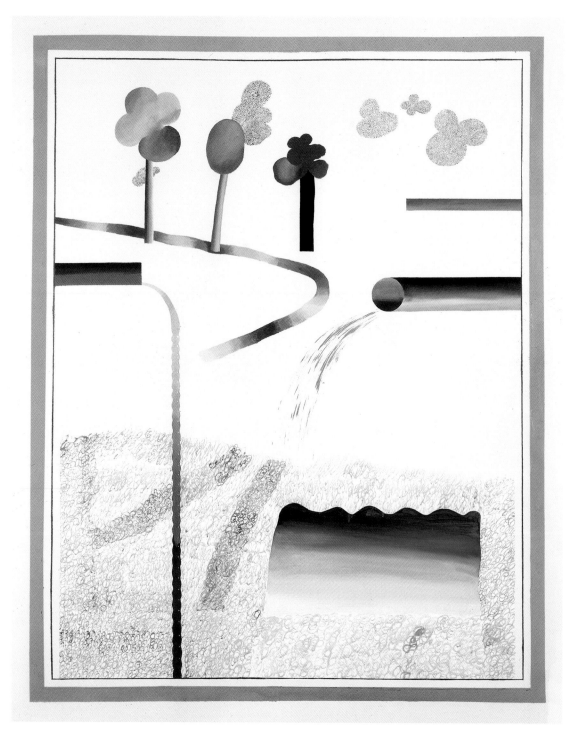

Different Kinds of Water Pouring into a Swimming Pool, Santa Monica 1965

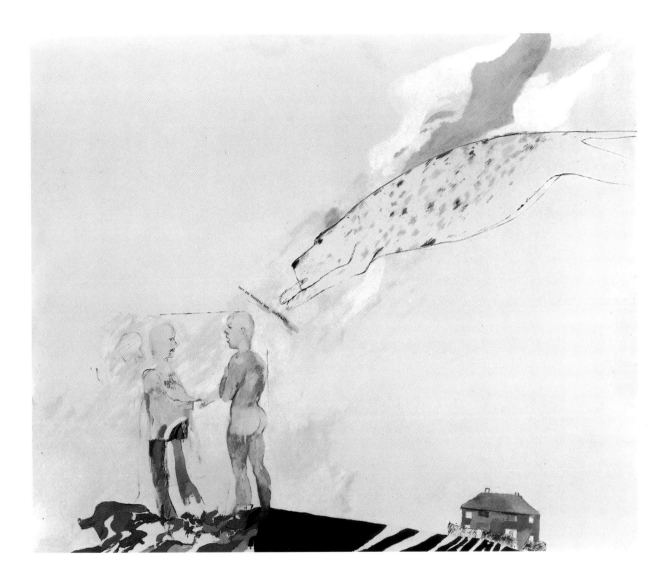

'One reason for writing on paintings is that it makes you go and look at the picture in another way. It's a technique I used especially in 1962 in *Picture Emphasizing Stillness*, where from a distance it looks like a leopard leaping on two men who were just having a quiet talk, having taken a walk from a little semi-detached house…. As you walk closer to the picture, you notice a line of type … which says: "They are perfectly safe, this is a still." … Although it looks as though it's full of action, it's still; a painting cannot have any action.'

Picture Emphasizing Stillness 1962

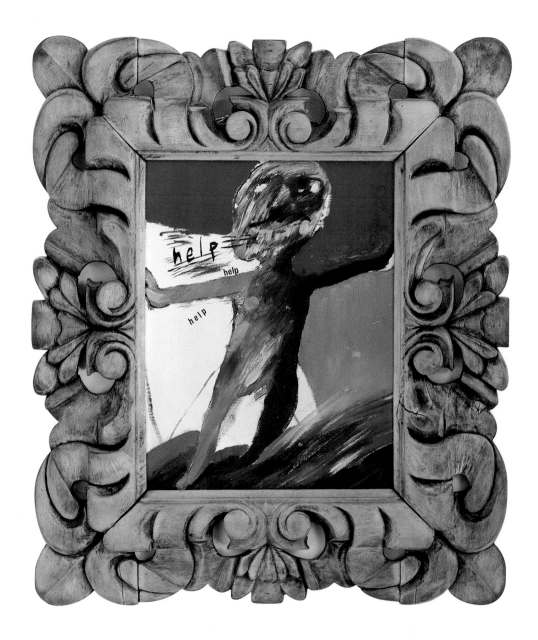

Help 1962

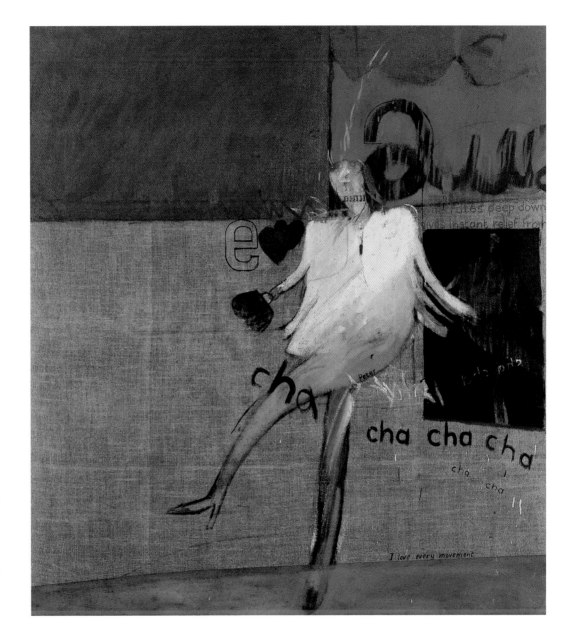

'*The Cha-Cha* was a real event. A very beautiful boy who was a student at the Royal College of Art danced the cha-cha especially for me because, although I didn't know him very well, he knew I thought he was stunningly beautiful. It had such an impact on me, I thought, maybe here's another thing I can make a picture of.'

The Cha Cha that was Danced in the Early Hours of 24th March, 1961 1961

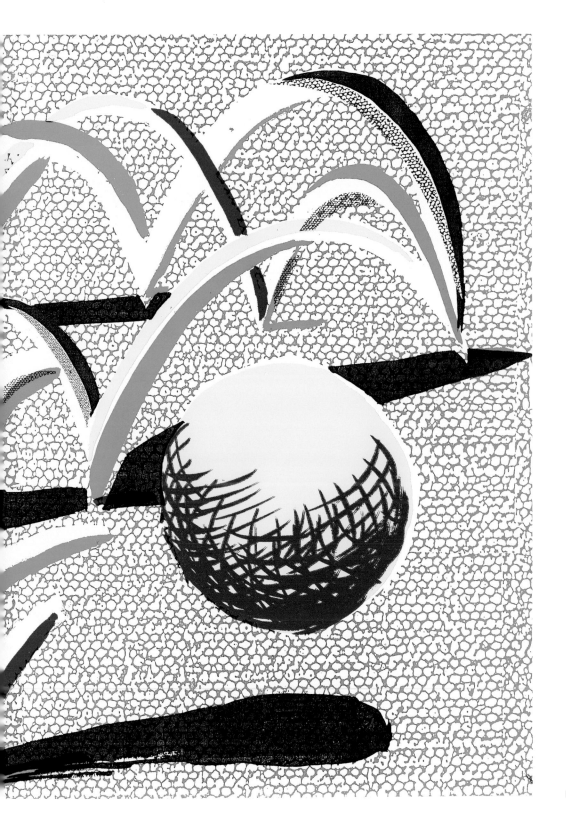

Bradford Bounce, Feb. 1987 1987 91

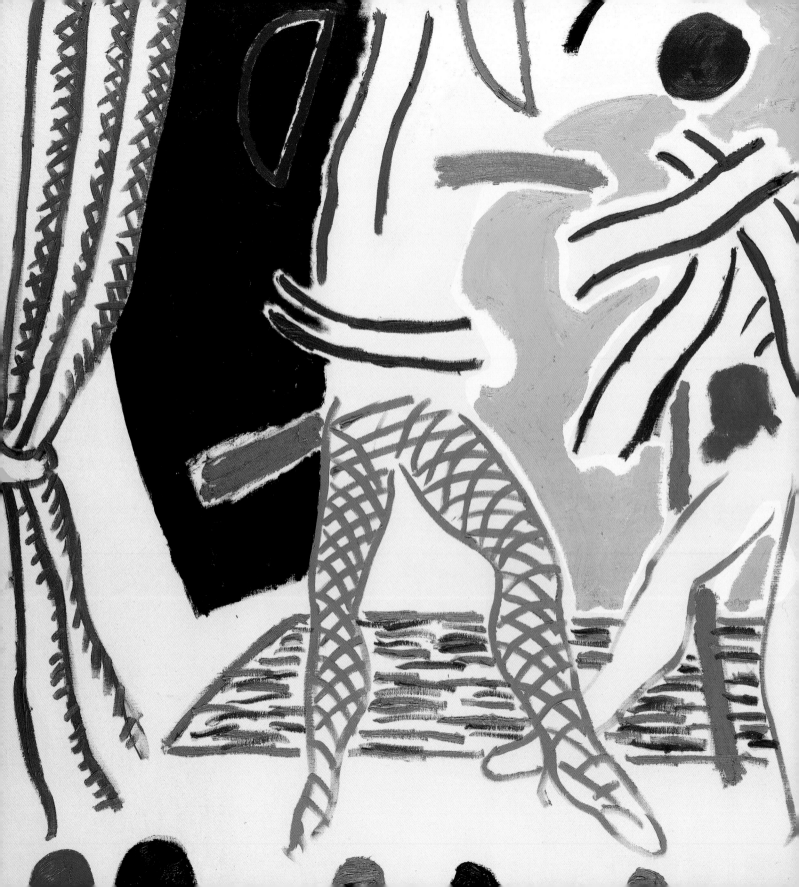

Two Dancers 1980

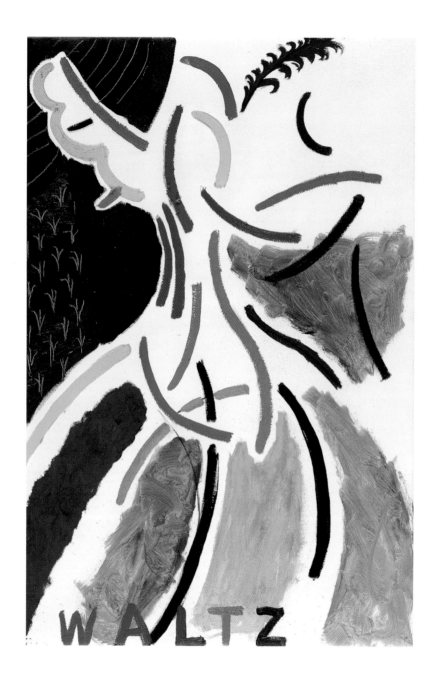

Waltz 1980

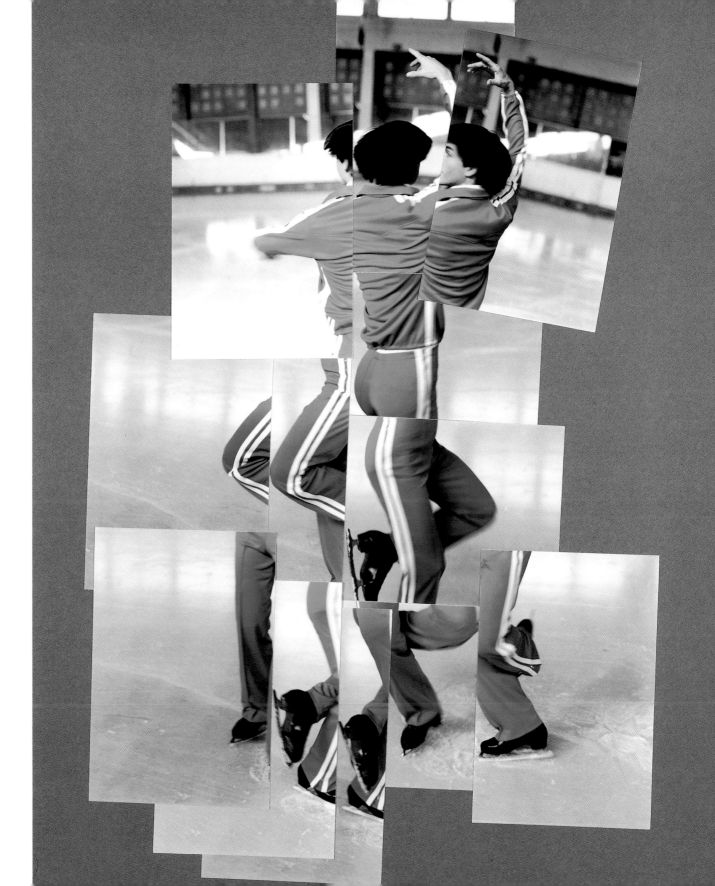

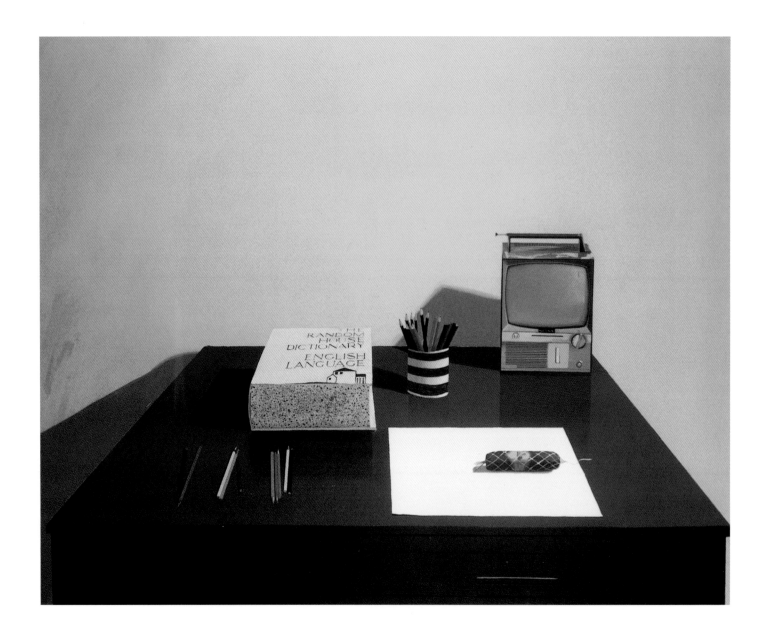

Still Life with T.V. 1969

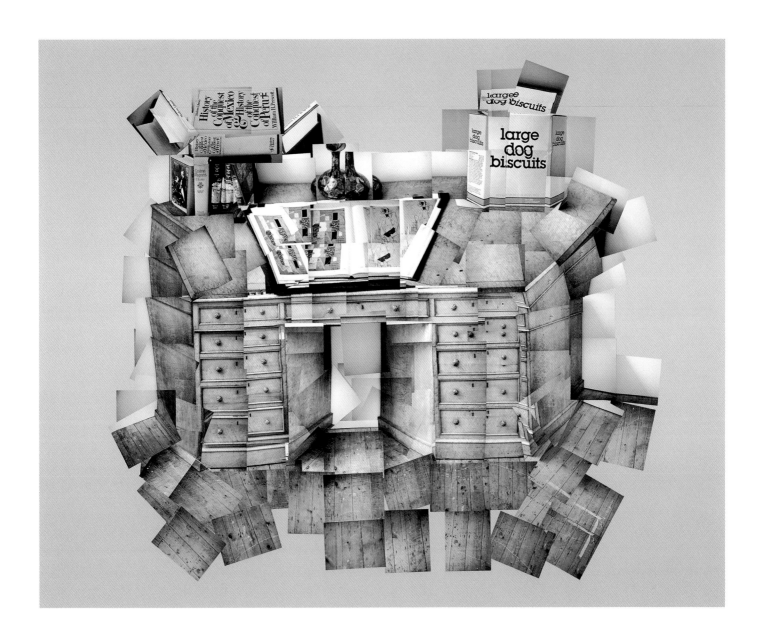

The Desk, July 1st 1984 1984

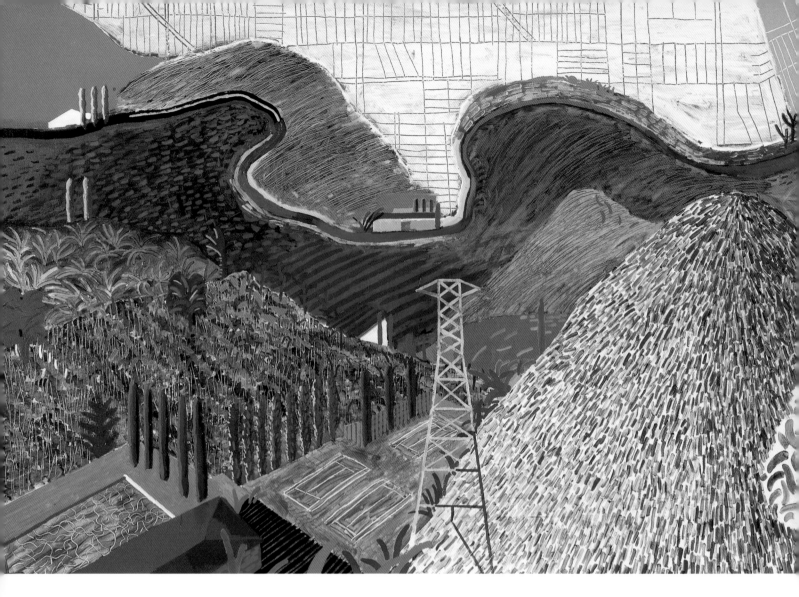

'In the Renaissance, the invention of a new way of depicting space, using the vanishing point, seemed to make the depiction more real.... Then a point was reached, perhaps in the nineteenth century, when the Renaissance depiction of space was seen as not at all real. Perceptive people began to realize that space could be rendered in a different way.'

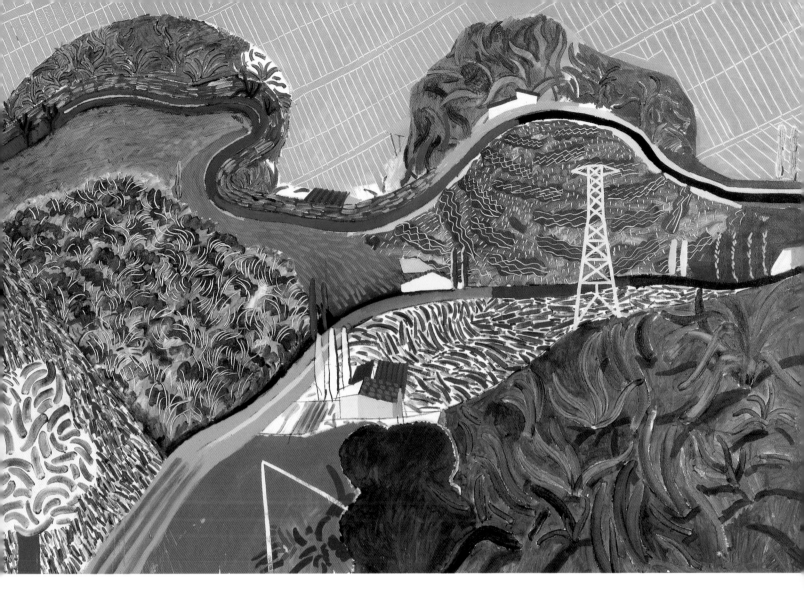

'When I started living up in the Hollywood Hills, I drove every day down to my studio. I became fascinated by all these wiggly lines and they began to enter the paintings. From the hills, Los Angeles is a completely different experience. In fact, these pictures are more realistic than you might think. When you look at *Mulholland Drive* – and *Drive* is not the name of the road, but the act of driving – your eye moves around the painting at about the same speed as a car drives along the road.'

Mulholland Drive: The Road to the Studio 1980

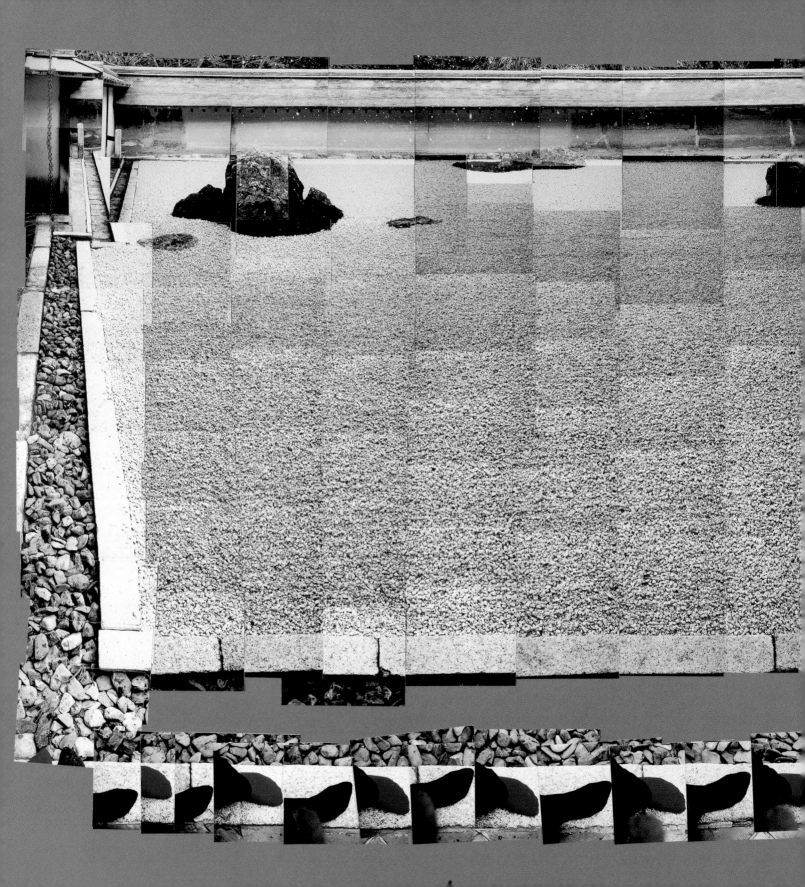

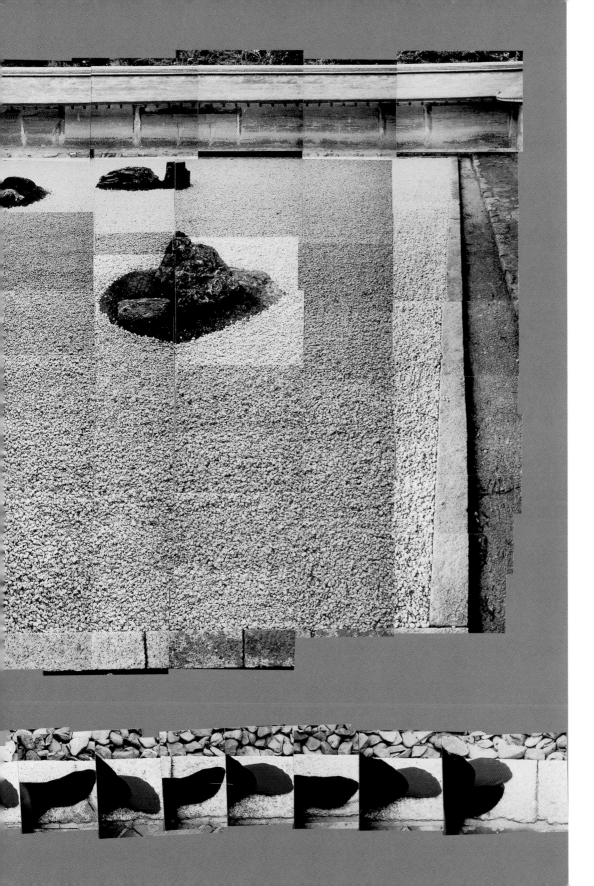

'For *Walking in the Zen Garden*, I took more than 160 photographs…. It was then and only really then that I began to realize that one of the areas I was really examining was perspective, that this was what you could alter in photography. When I first pieced them together I thought I had made a photograph without perspective.'

Walking in the Zen Garden
at the Ryoanji Temple,
Kyoto, Feb. 1983 1983

'Cubism was about the destruction of a fixed way of looking. A fixed position implies we are standing still, that even the eye is still. Yet we all know our eyes move constantly, and the only time they stop moving is when we're dead – or when we're staring. And if we're staring, we're not really looking. That is the problem with the single-frame photograph: all you can actually do is stare at it. Your eyes cannot wander around in it, because of its inherent lack of time. When I realized that my new conception of photography was related to cubism, I made two deliberate pastiches of a cubist still life – I set up a guitar, tobacco can, wooden table, and so on – all the elements of a cubist still life. I thought the result told you far more about the presence of objects in the world than one single picture would.'

Photography Eyes (detail) 1985

'In 1981 I started to play with the Polaroid camera and began making collages. Within a week, very quickly, I made them quite complex. This intrigued me and I became obsessed with it. I made about 150 collages with Polaroids.... This very strongly rekindled my interest in Cubism, and in Picasso's ideas, so that in a sense it was photography that got me into thinking again about Cubist ways of seeing.'

Yellow Guitar Still Life,
Los Angeles, 3rd April 1982
1982

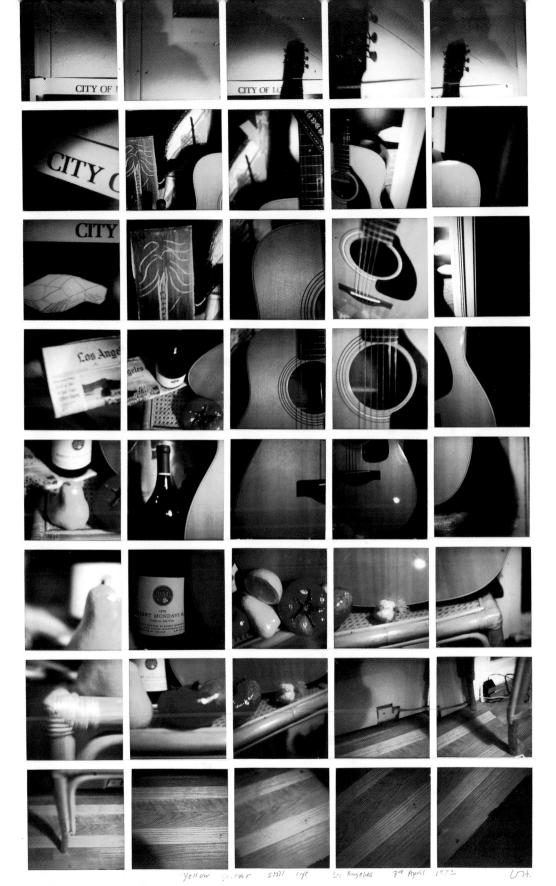

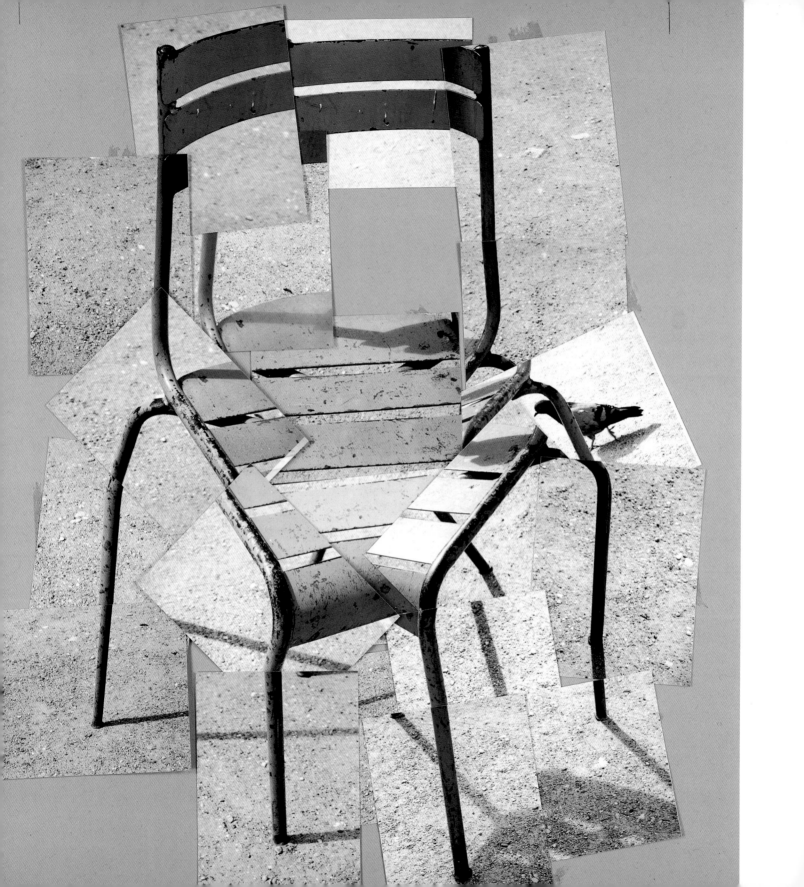

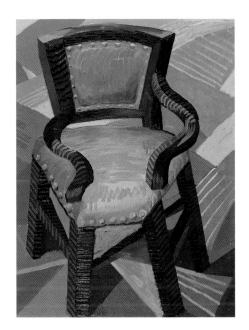 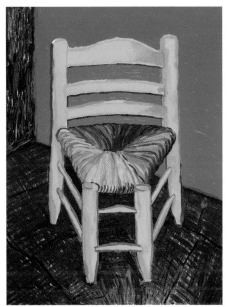 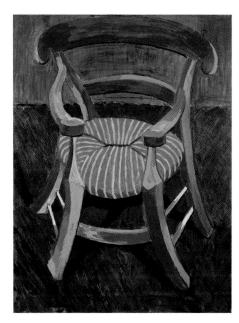

'In these paintings I was still exploring the spatial ideas of perspective....
Because of the many viewpoints in these pictures, the eye is forced to
move all the time. When the perspective moves, the eye moves, and as
the eye moves through time, you begin to convert time into space.
As you move, the shapes of the chairs change and the straight lines
of the floor also seem to move in different ways.'

The Chair 1985 Van Gogh Chair 1988 Gauguin's Chair 1988

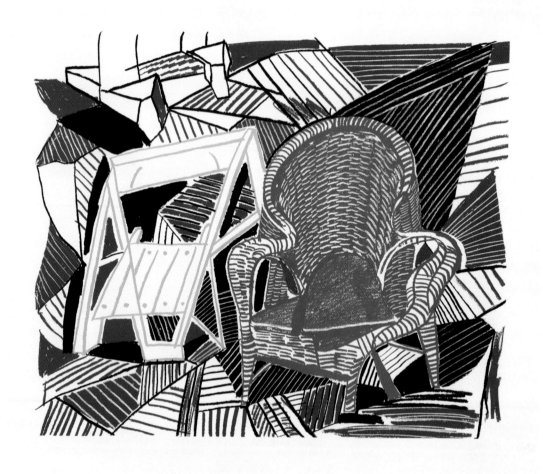

'It is moving the space about that deeply interests me, and how to do it,
and I have a feeling there is a way you can do it now, starting from
Picasso's achievement but pushing it further so that eventually it
doesn't look like Picasso, but will look incredibly real.'

Two Pembroke Studio Chairs 1984

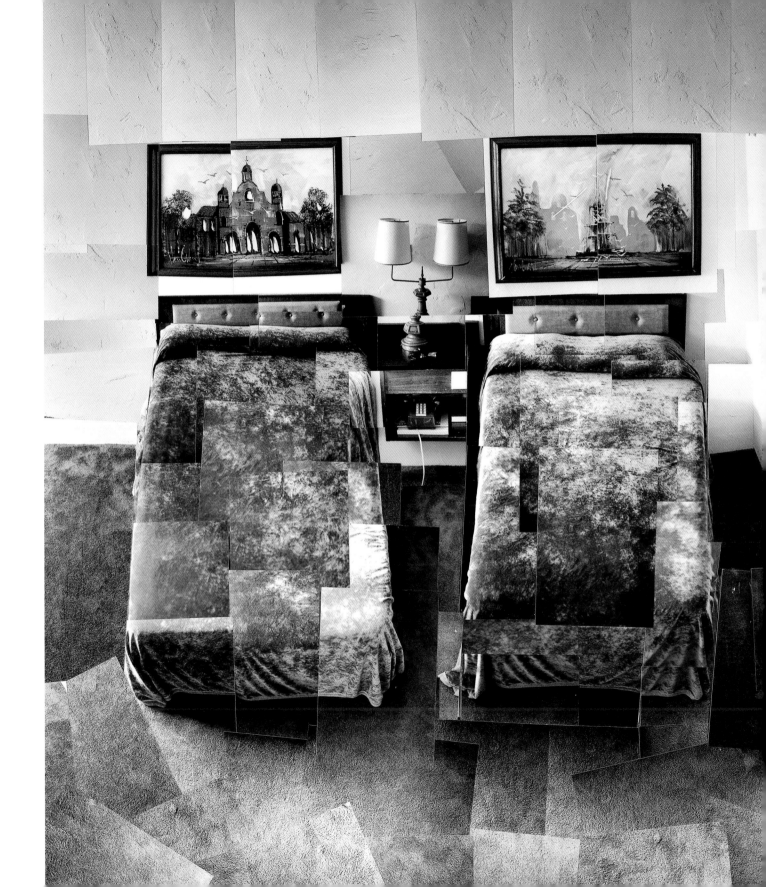

'Multiple viewpoints create a far bigger space than can be achieved by one…. I moved about the landscape, slowly constructing it from different viewpoints. The stop sign was taken head on, indeed from a ladder, the words "stop ahead" on the ground were seen from above (using a tall ladder), and everything was brought together by "drawing" to create a feeling of wideness and depth, but at the same time everything was also brought up to the picture plane.'

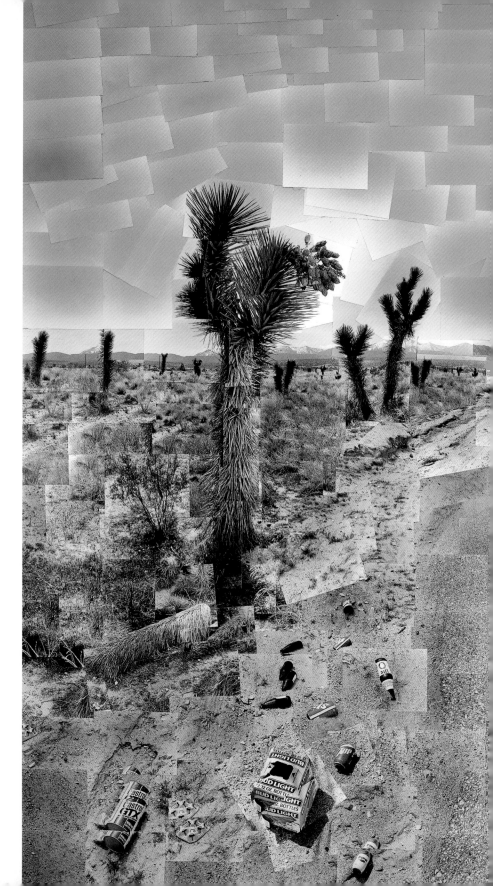

Pearblossom Highway,
11th–18th April 1986
(Second Version) 1986

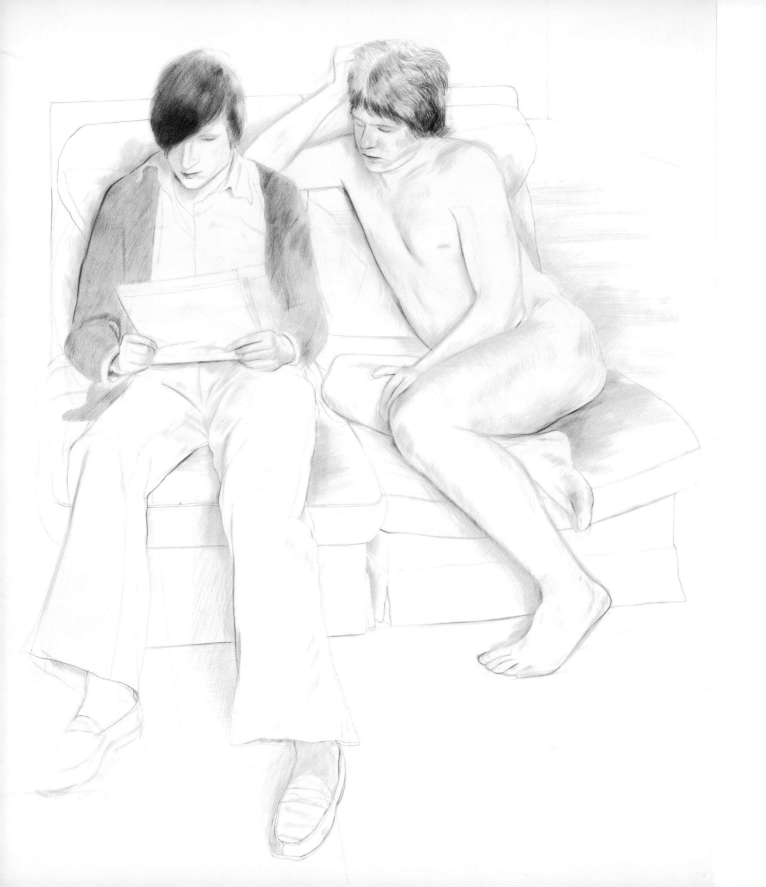

Life Stilled

To distil life and put it down on paper or canvas; to capture the special bond that exists between two people; to combine activities so that time may appear to stand still; to depict one's own intimate surroundings and make them speak to all – these are just some of Hockney's artistic achievements over the past five decades. Perhaps more than any other artist alive today, Hockney has brought his life and those of his close friends and family into his work. In that sense, his art can be considered autobiographical, for it reflects his environment, his intimate circle, and his own emotional involvement at any given moment.

From the heady student days of the early sixties, through his first visits to California and travels abroad, to his later scenes of domestic life in Los Angeles and London, Hockney has always sought inspiration in what and whom he sees around him. Imagination, at least in the form of memory (as with *My Garden in L.A., London, July 2000*, painted when the artist was in his London studio; page 192), may occasionally make an appearance, but more often than not Hockney works directly from life, sometimes carefully and deliberately, as with his figures showering (pages 112–15) or with his highly planned double portraits that portray the unique characteristics of a relationship (pages 125, 127, 130–1, 134–5); and sometimes spontaneously, as with his sketch of a sunny afternoon in the garden (pages 142–3) or his delicate watercolour of cigarettes and an ashtray (page 172).

Records of happy times with friends, memories of holidays, views of his own home, studio and garden: we know that whenever we look at Hockney's work we are getting a special glimpse into his own private world.

Yves-Marie and Mark, Paris, Oct 1975 1975

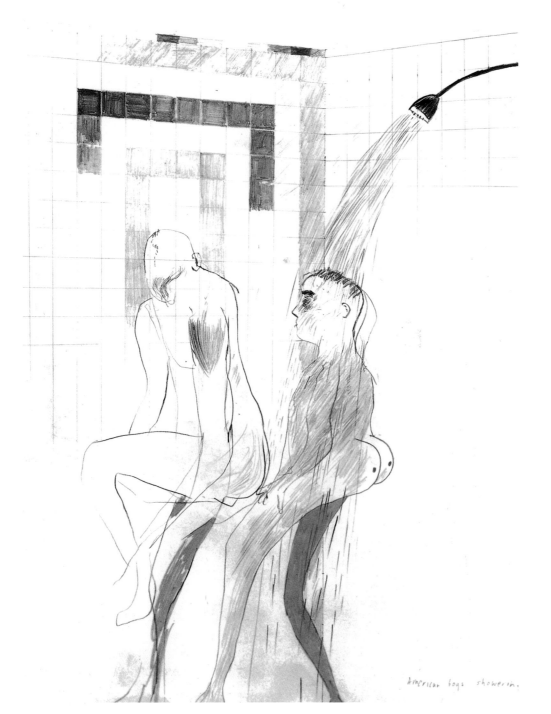

American Boys Showering 1963

'In *Two Men in a Shower*, the figure on the left is painted from a magazine; the figure in the shower is done from life. I had a shower curtain like that and I had Mo stand in it and take a shower so I could see through it and paint it.'

'Americans take showers all the time – I knew that from experience and physique magazines…. Beverly Hills houses seemed full of showers of all shapes and sizes – with clear glass doors, with frosted glass doors, with transparent curtains, with semi-transparent curtains. They all seemed to me to have elements of luxury.'

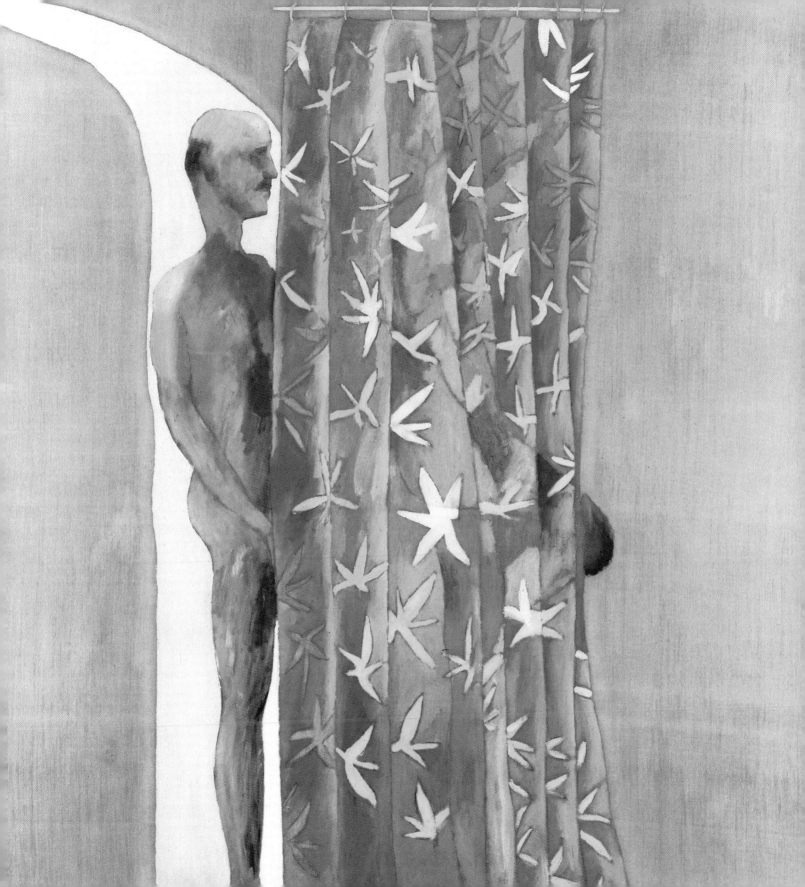

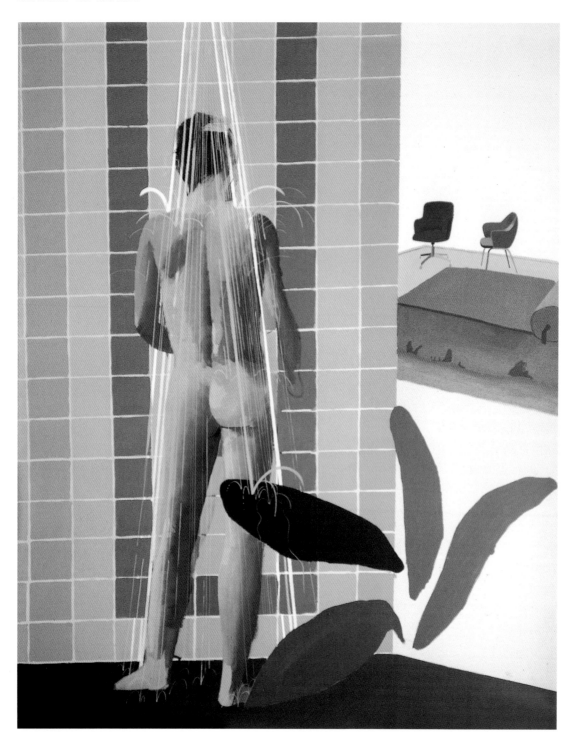

Man Taking Shower 1965

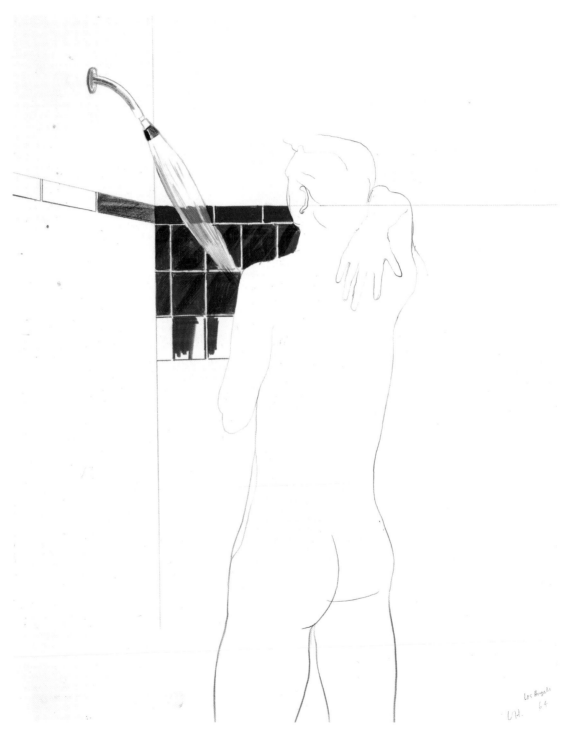

'I thought why not paint from life again? The figure had once more begun to dominate the pictures. I felt I needed to fit doing something from life into this pattern.'

Nude Boy, Los Angeles 1964

115

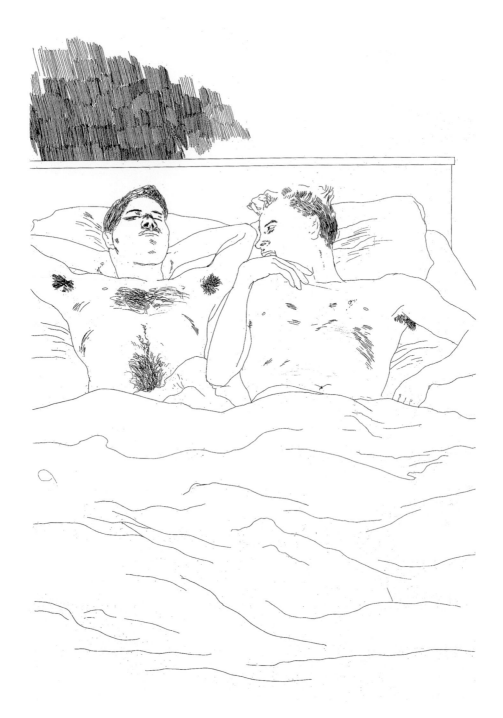

In the Dull Village 1966–7 from Illustrations for Fourteen Poems from C. P. Cavafy

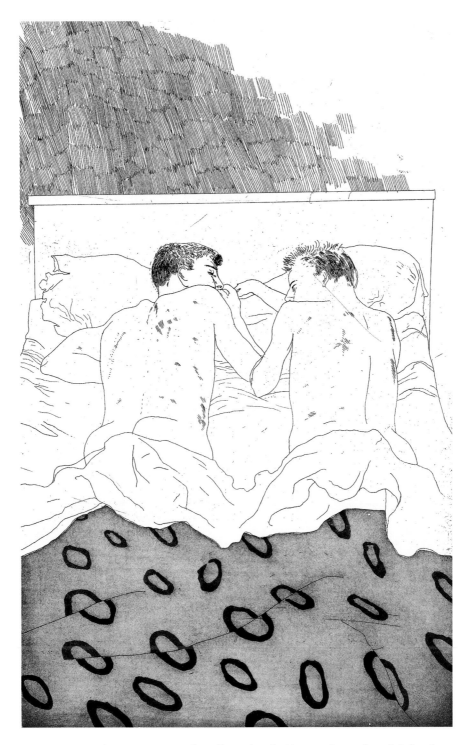

Two Boys Aged 23 or 24 1966–7 from Illustrations for Fourteen Poems from C. P. Cavafy 117

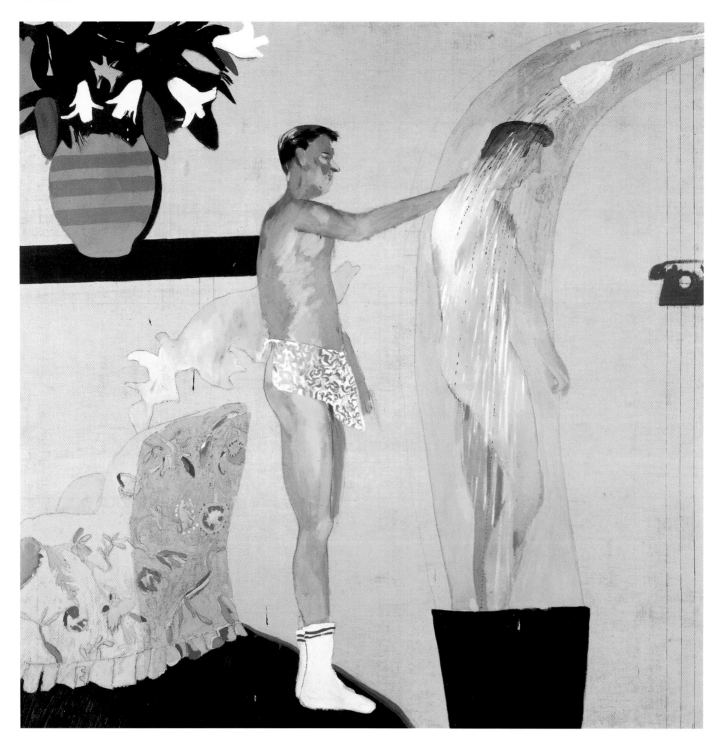

Domestic Scene, Los Angeles 1963

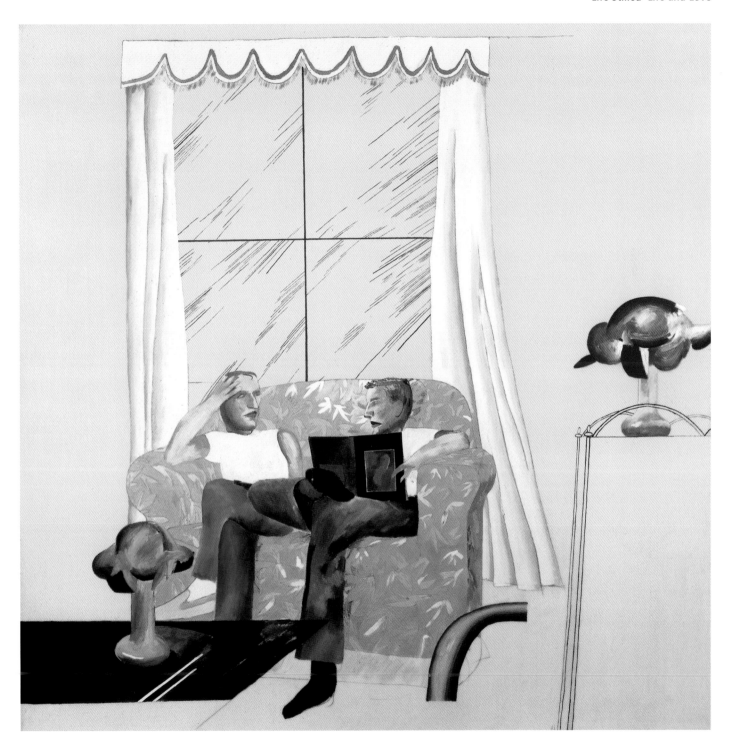

Domestic Scene, Broadchalke, Wilts 1963

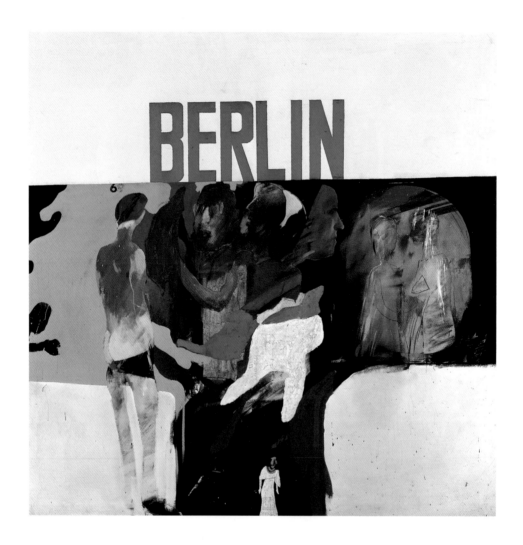

'A lot of the early paintings have quite strong colour. I suppose it was the naturalism that muted it. As you move away from naturalism, you do get more involved in colour.'

Berlin: A Souvenir 1962

'I used to think that pictorial space wasn't that important. Slowly I began to realize it is much more important than we think – than I had thought previously, anyway – because it makes the viewer begin to see the world in another way, perhaps a clearer way. We can't all be seeing the same thing; we are all seeing something a bit different.'

Going to be a Queen for Tonight 1960

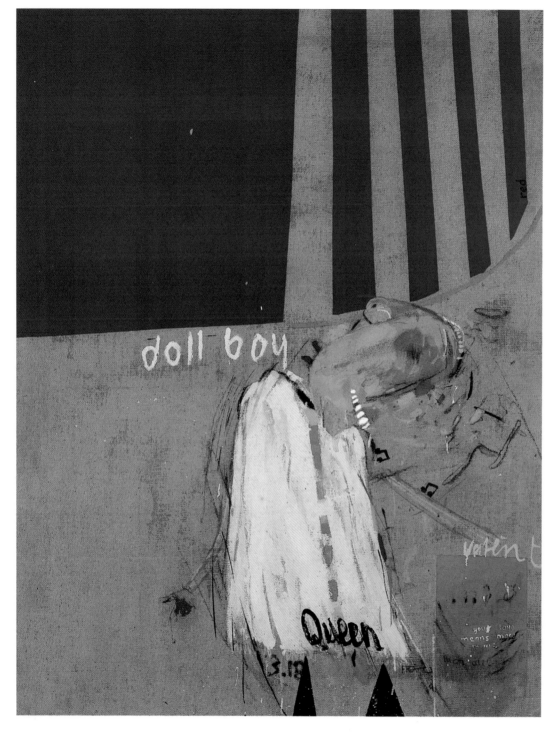

'*Doll Boy* was a reference to the pop singer Cliff Richard, who was very attractive, very sexy.... He had a song in which the words were, "She's a real live walking talking living doll", and he sang it rather sexily. The title of this painting is based on that line. He's referring to some girl, so I changed it to a boy.'

Doll Boy 1960–1

I will love you at 8 pm next Wednesday

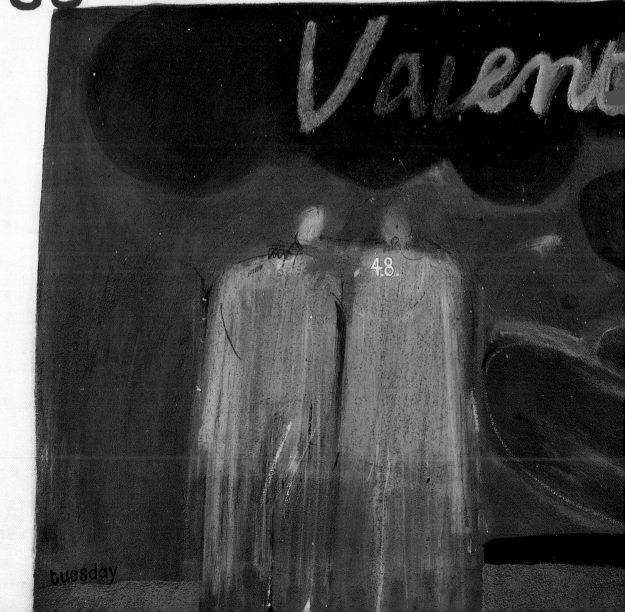

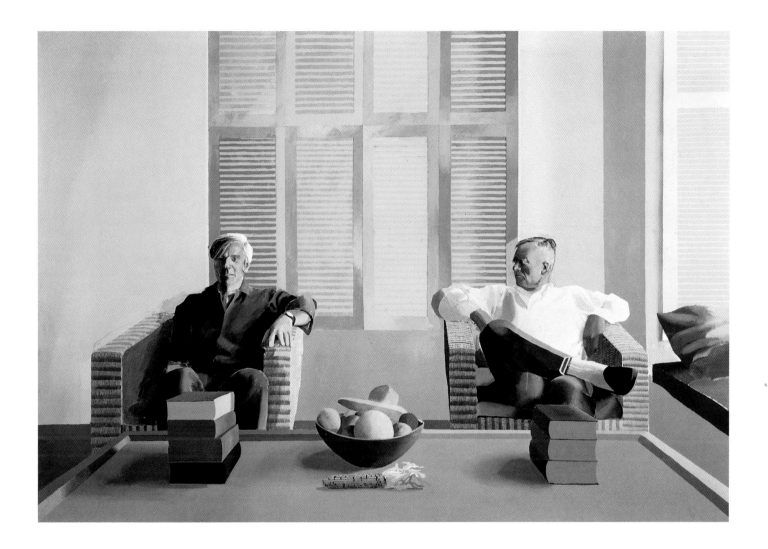

'I met Christopher Isherwood and we instantly got on. He was the first author I'd met that
I really admired. I got to know him and Don Bachardy, with whom he lived, very well; they
would invite me out, take me around to dinner; we had marvellous evenings together.
Christopher was always interesting to talk to about anything and I loved it.'

Christopher Isherwood and Don Bachardy 1968

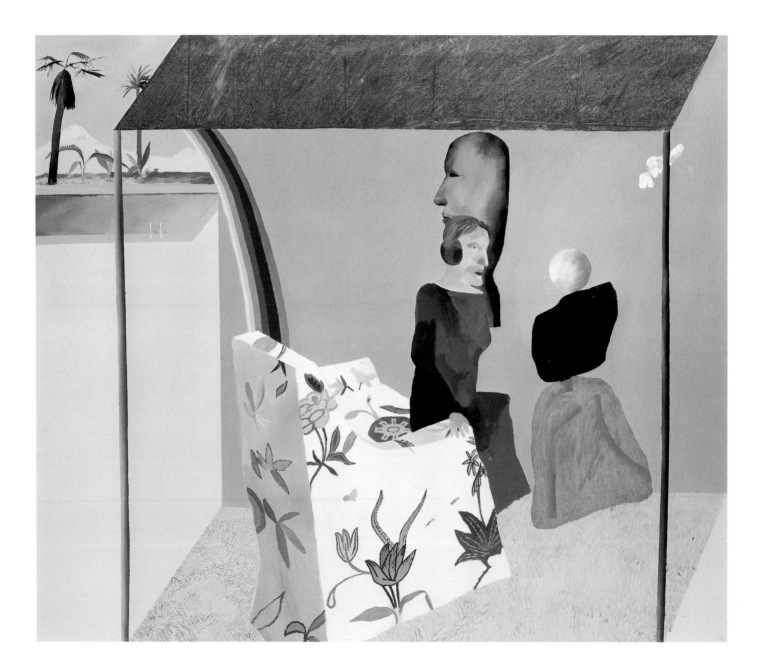

California Art Collector 1964

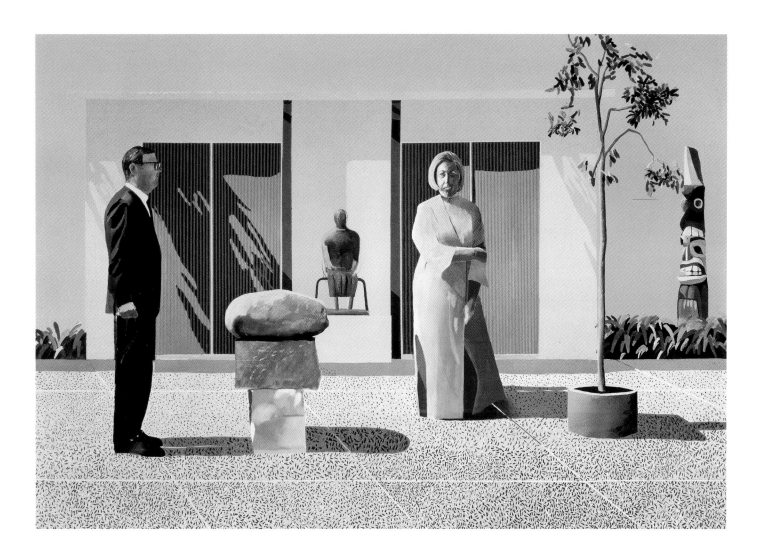

'Fred and Marcia Weisman didn't come to sit for *American Collectors*. I thought in that picture it wasn't as necessary because in a sense their garden with the art in it is part of the portrait of them, whereas in the painting of Christopher and Don there are just those books and some fruit, the only objects in the room.'

American Collectors (Fred and Marcia Weisman) 1968

Frederick Ashton and Wayne Sleep 1968

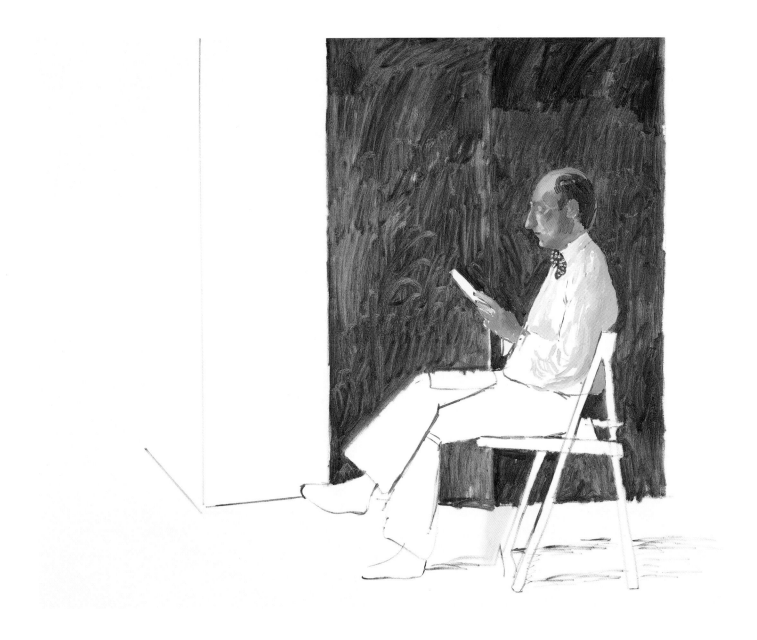

Study of George Lawson 1977

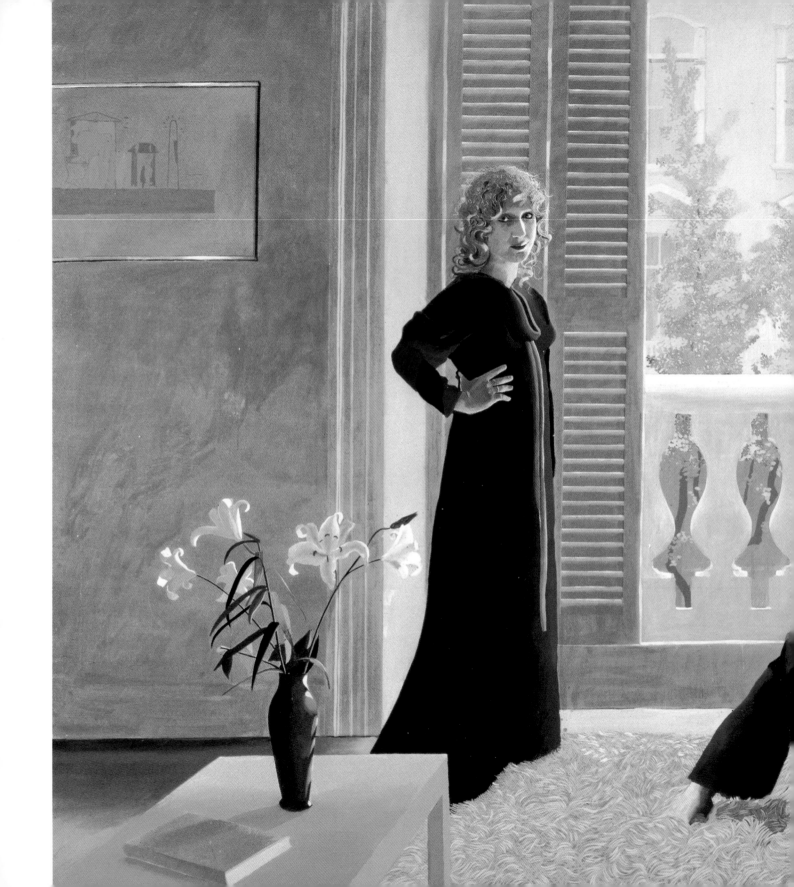

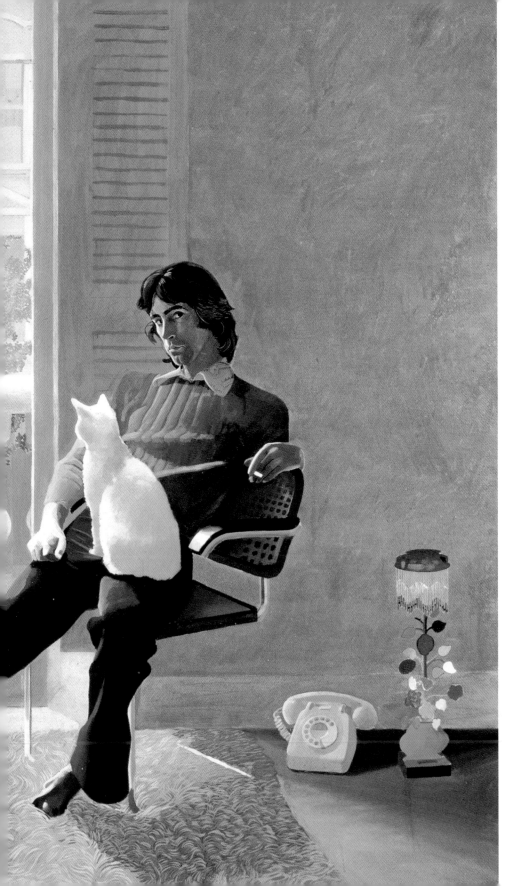

'This is the painting that comes closest to naturalism; I use the word naturalism as opposed to realism. The figures are nearly life-size; it's difficult painting figures like that, and it was quite a struggle. They posed for a long time. Ossie was painted many, many times; I probably painted the head alone twelve times.... The one great technical problem in it is that it's contre-jour; the source of light is from the middle of the painting, which does create problems.... If you can see it, it has to be the lightest thing in the painting, and so it creates problems about tone.... All the technical problems were caused because my main aim was to paint the relationship of these two people.'

Mr and Mrs Clark and Percy 1970–1 131

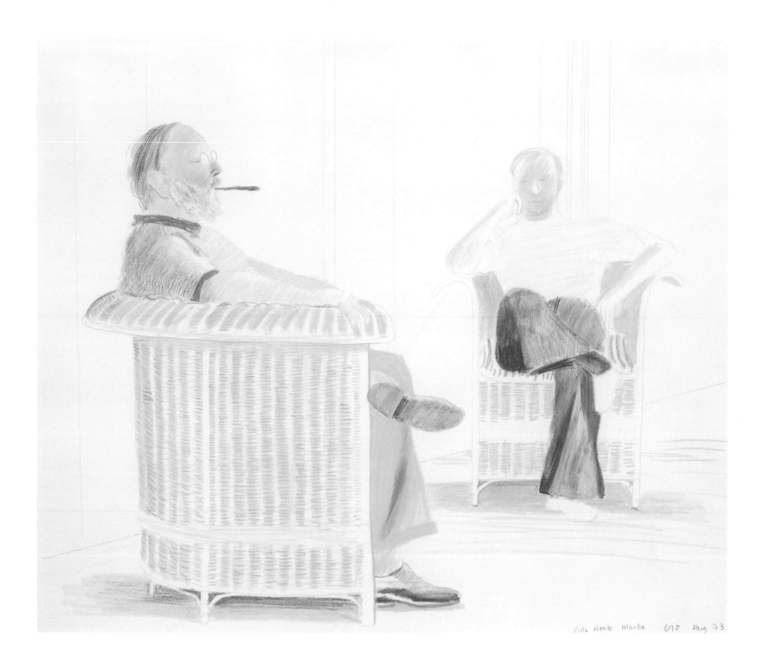

Henry and Mo, Villa Reale 1973

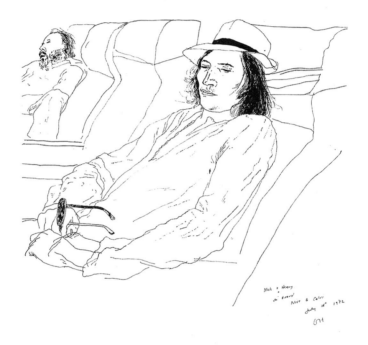

Nick and Henry on Board. Nice to Calvi, July 18th 1972 1972

'Gregory and Shirley
are Americans who
had lived in Paris
for twenty years.
They're both artists,
but Shirley doesn't
paint much; she
wanders around
Paris, and spends a
lot of time sitting in
the Café de Flore….
I was struck by the
small studios they
lived in, two tiny
little rooms; they're
incredibly tiny….
Their relationship is
a weird subject: he
can't go out of the
building without her
seeing, but she can.
They are married,
but they are apart.'

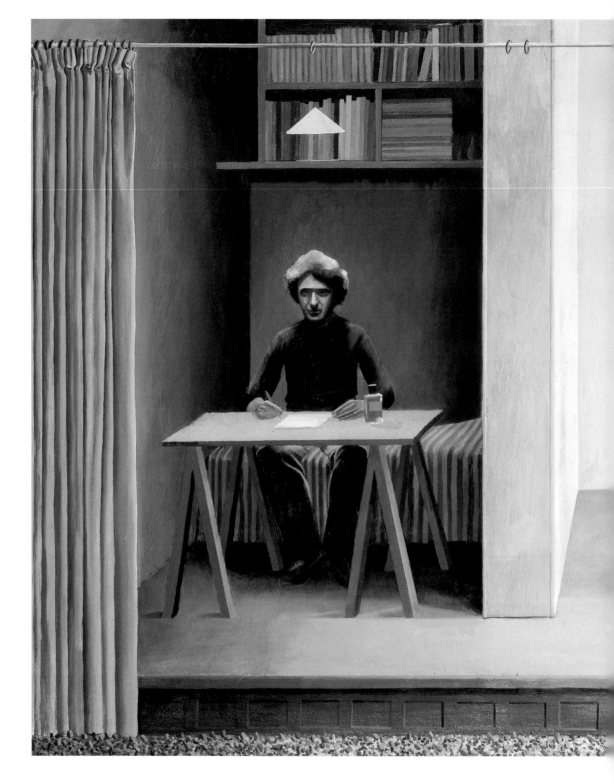

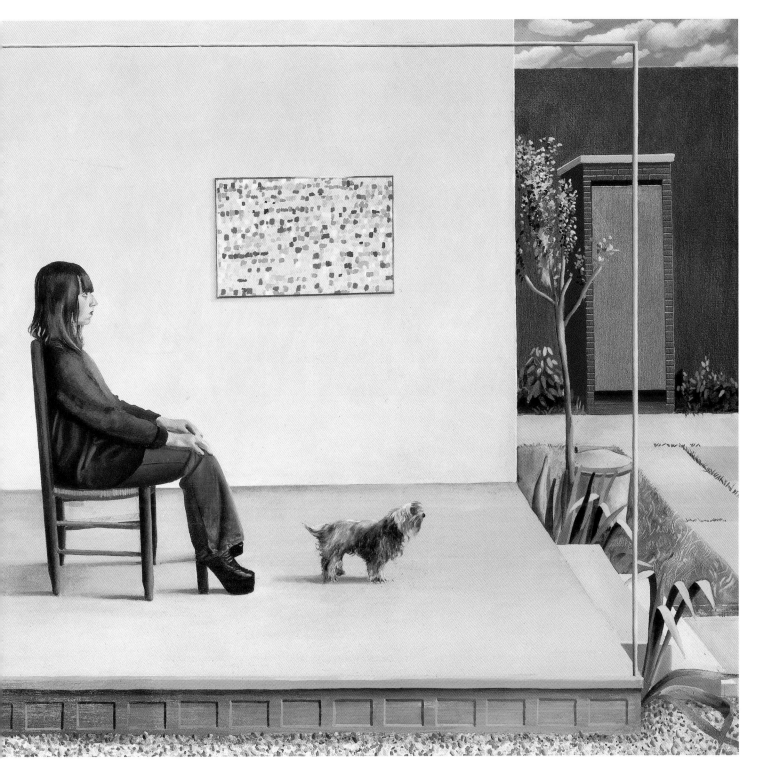

Shirley Goldfarb and Gregory Masurovsky 1974

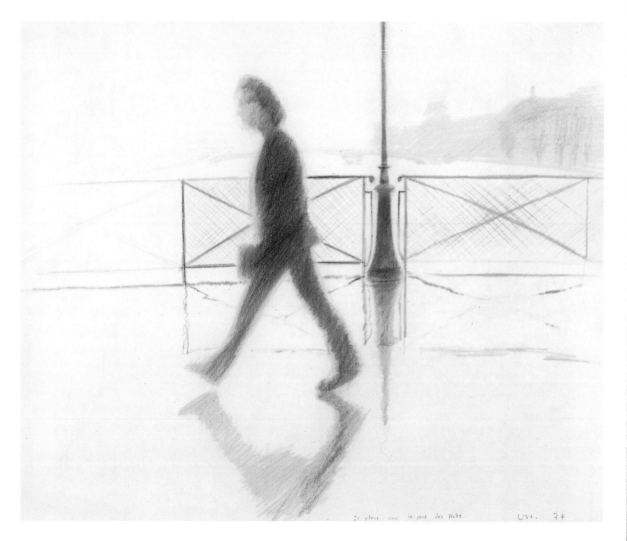

Il Pleut sur le Pont des Arts 1974

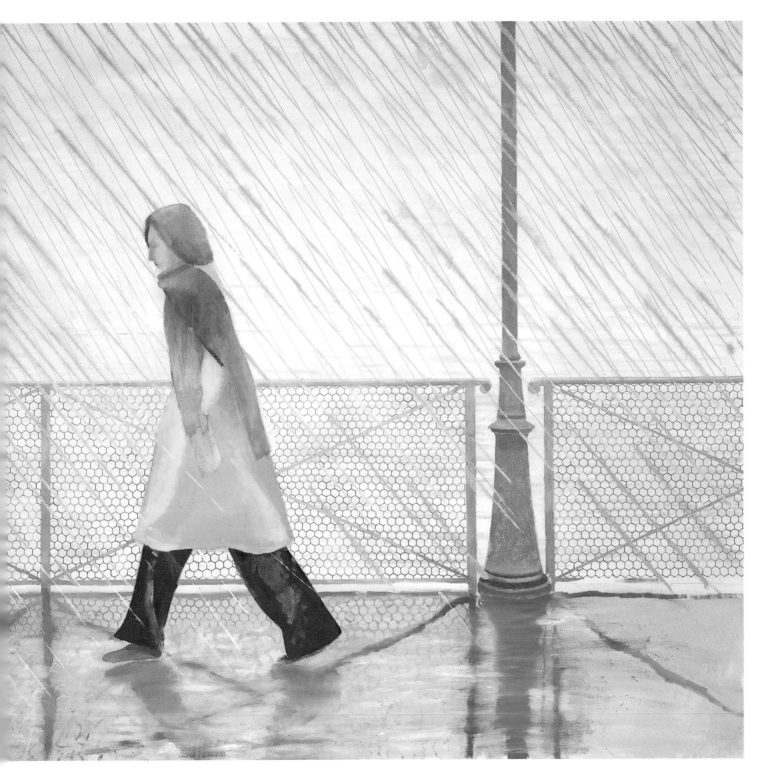

Yves-Marie in the Rain 1973

'What an artist is trying to do for people is bring them closer to something, because of course art is about sharing: you wouldn't be an artist unless you wanted to share an experience, a thought. I am constantly preoccupied with how to remove distance so that we can all come closer together, so that we can all begin to sense we are the same, we are one.'

Sketchbook page: 'Taxi, Kensington' 2002

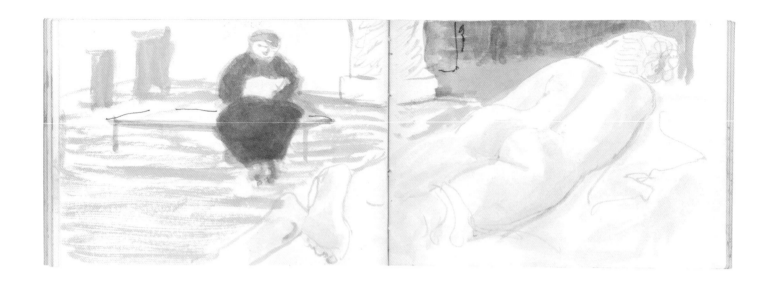

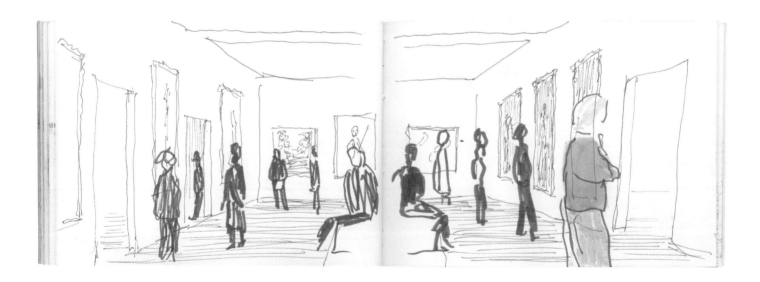

(top) Sketchbook page: 'V & A' 2002 (bottom) Sketchbook page: 'Gainsborough exhibition Tate' 2002

(top) Sketchbook page: 'People on the Street' 2003 (bottom) Sketchbook page: 'People on the Street' 2003

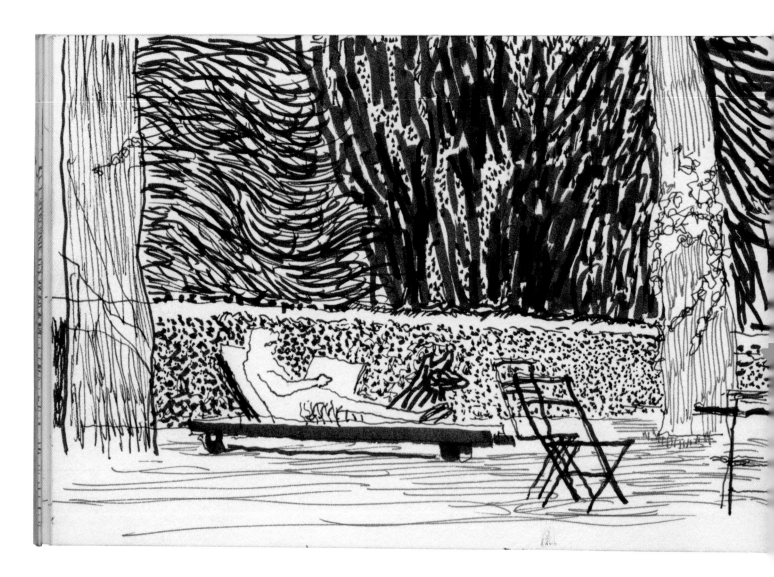

'I am an artist who is always working. I know some people think I spend
my time just swimming around or dancing in nightclubs. That's fine.
But I don't actually. I work most of the time.'

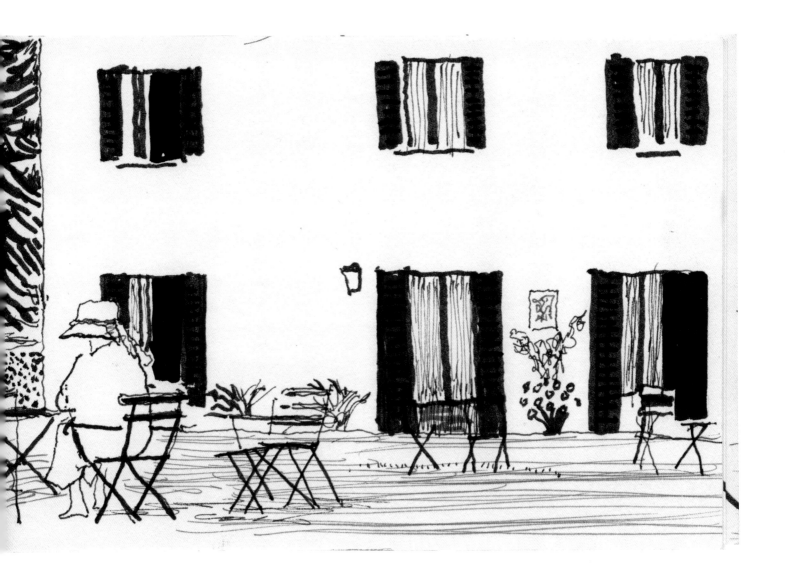

Sketchbook page: 'Como' 2003

Mirror, Casa Santini 1973

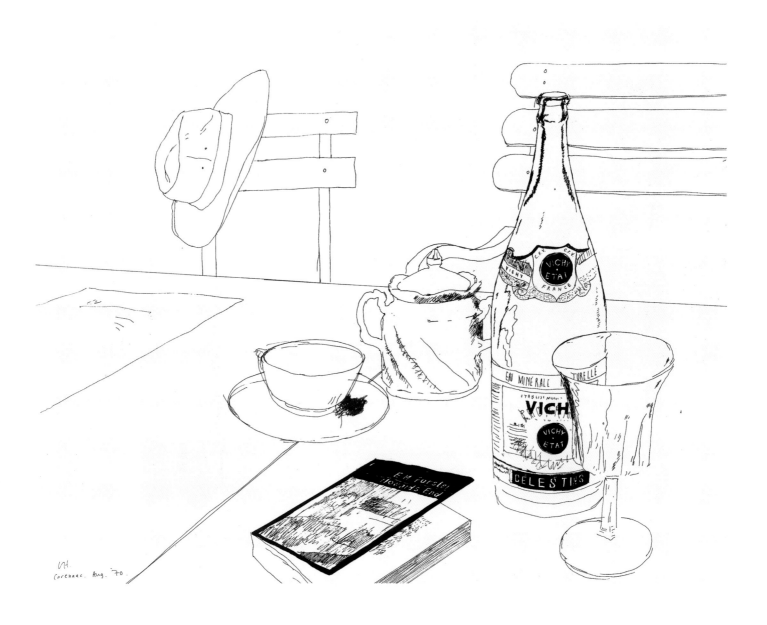

Vichy Water and 'Howard's End', Carennac 1970

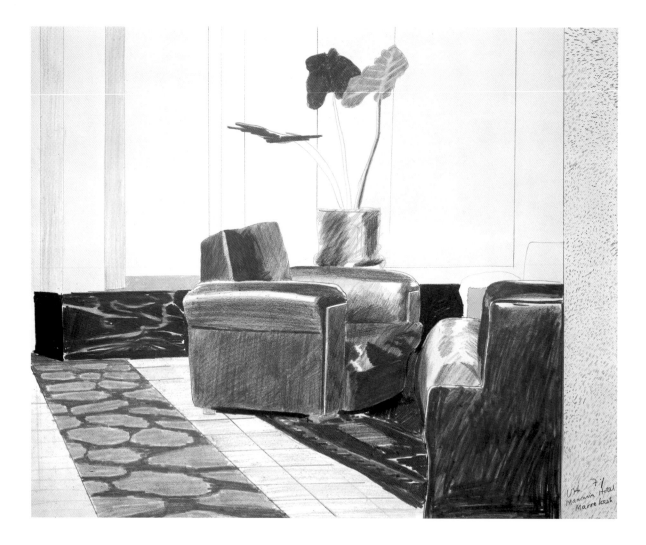

Chairs, Mamounia Hotel, Marrakesh 1971

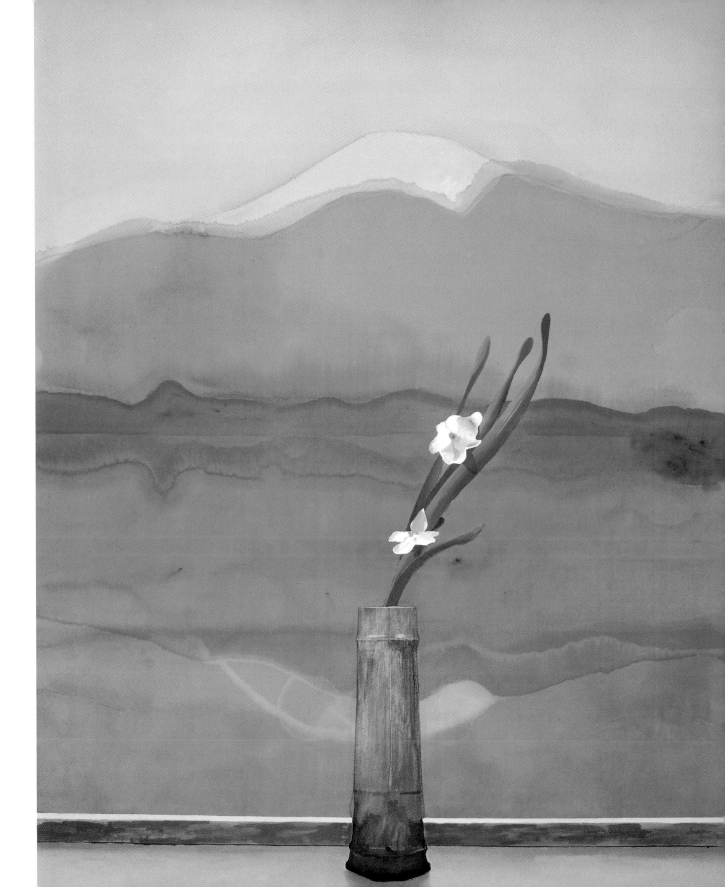

Sketchbook page: 'Still Life with Matisse' 1985

'Whatever your medium is you have to respond to it. I have always enjoyed swapping mediums about. I usually follow it, don't go against it. I like using different techniques. If you are given a shabby brush you draw in a different way. That's what I do often: I deliberately pick up a medium which forces me to change direction.'

'With watercolour, you can't cover up the marks. There's the story of the construction of the picture, and then the picture might tell another story as well.'

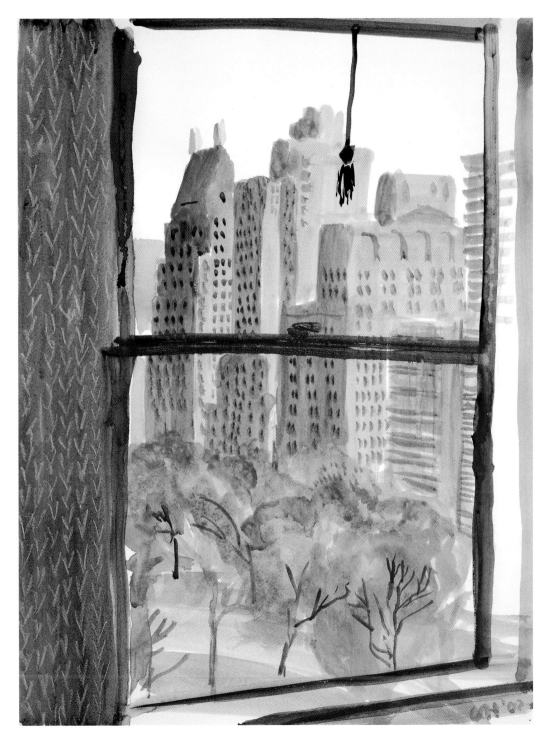

View from Mayflower Hotel, New York (Evening) 2002

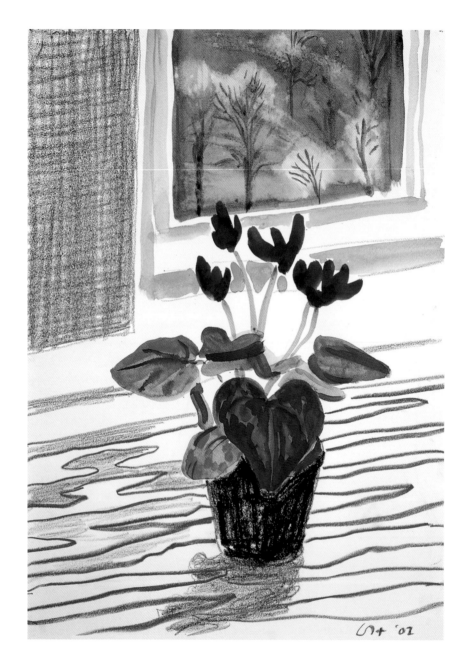

Cyclamen, Mayflower Hotel, New York 2002

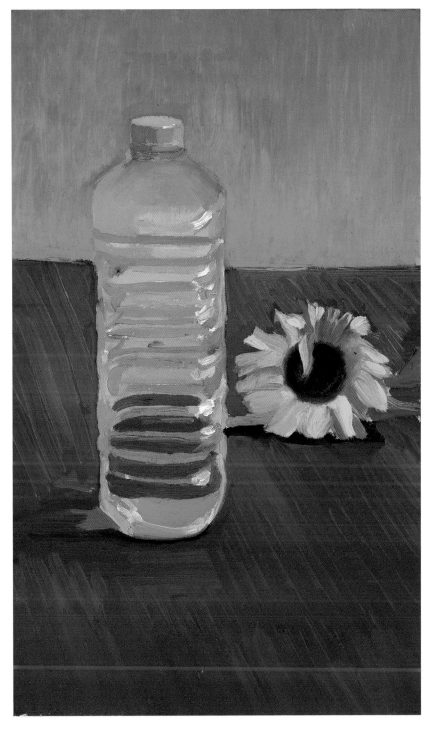

The Vittel Bottle 1995

Still Life with Book 1973

Dancing Flowers, May 1986 1986

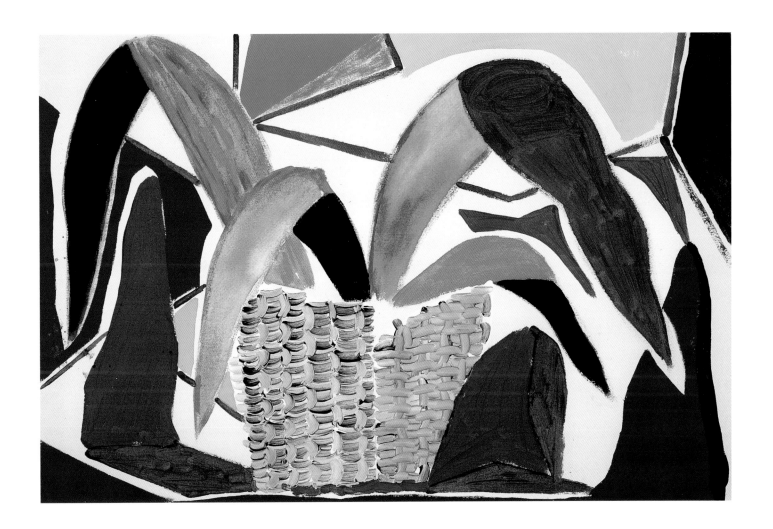

Green and Blue Plant 1987

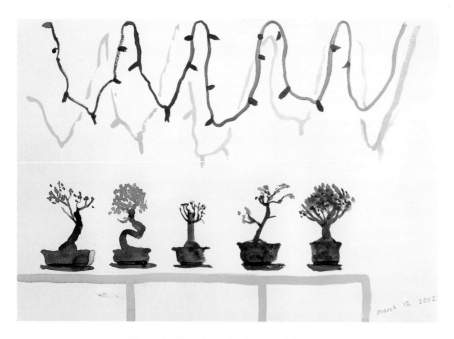

5 Bonsai with Fairy Lights (Mountains) 2002

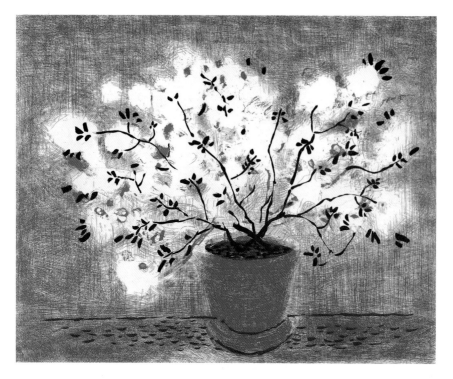

Red Wire Plant 1998

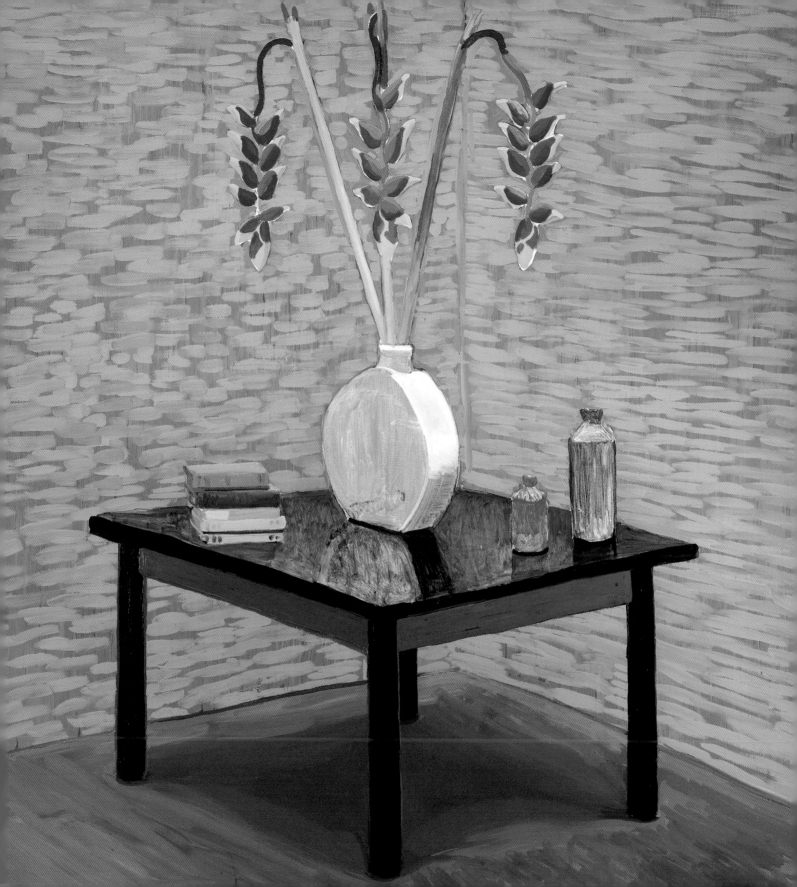

'When you are making prints your mind starts thinking in layers; you are separating colours and thinking in layers.... When I made the discovery of how to use copying machines to make prints from no pre-existing image I was very, very excited.... Most of those that I call "Home Made Prints" were done in a period of about six months and they developed from very simple things to very complex prints, complex in the sense that sometimes a piece of paper went through the machine as many as twelve times.'

Three Black Flowers, May 1986 1986

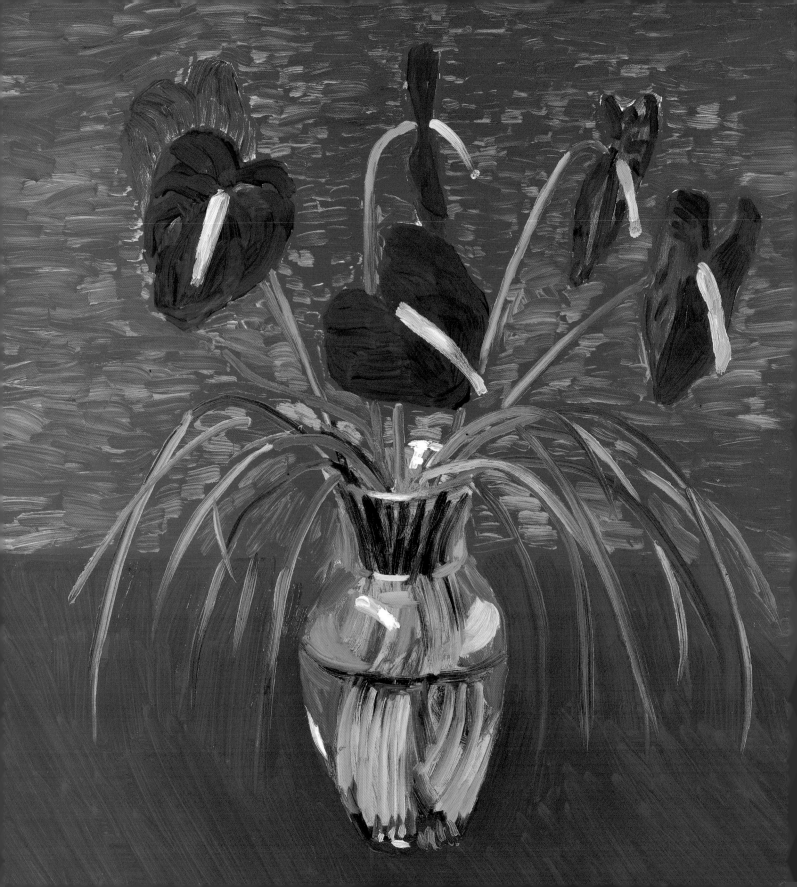

Two Pink Flowers 1989

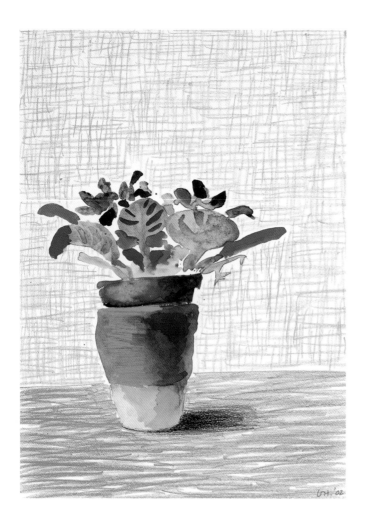

A Pot of Violets 2002

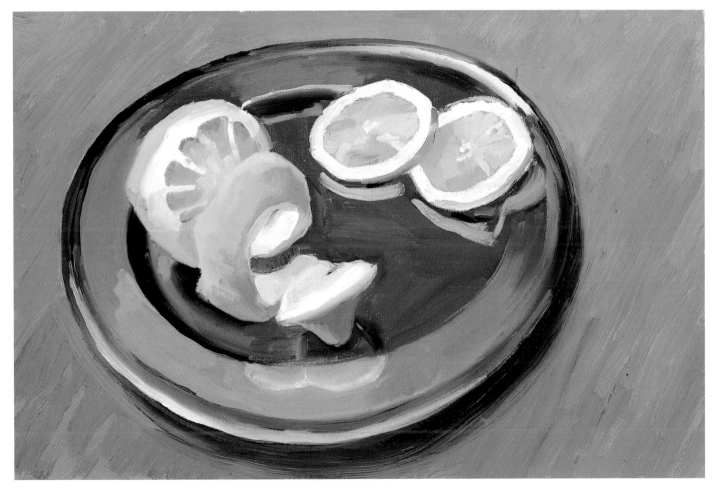

Peeled Lemon with Slices 1995

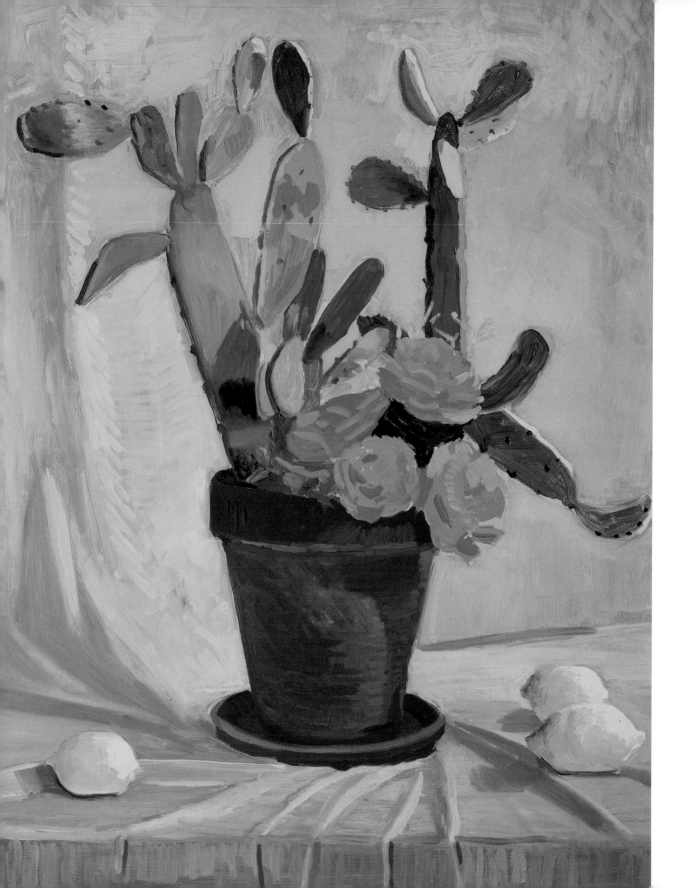

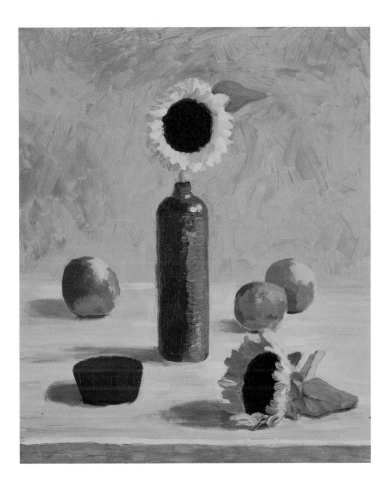

Sunflower in Bottle with Ashtray and Oranges 1996

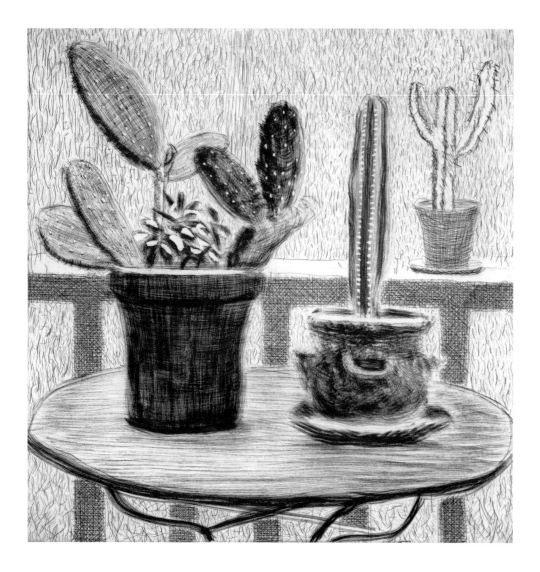

Cacti on Terrace 1998

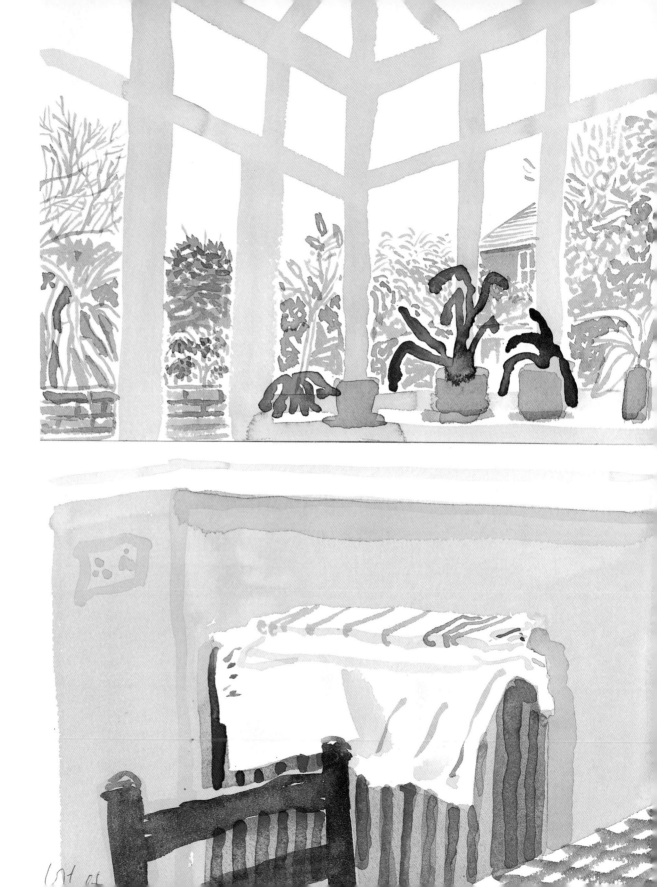

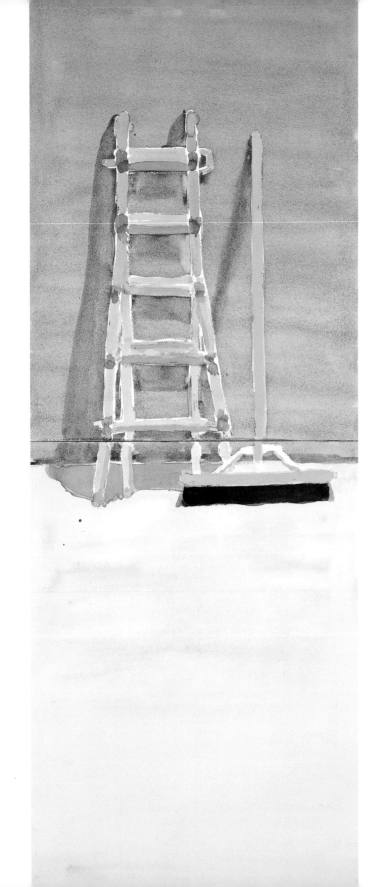

Ladder and Broom II 2003

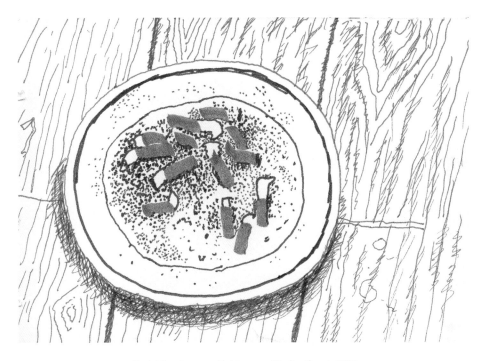

Sketchbook page: 'Ashtray on Studio Floor' 2002

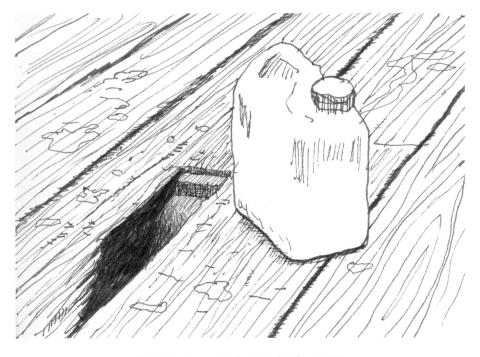

Sketchbook page: 'Hole in Studio Floor' 2002

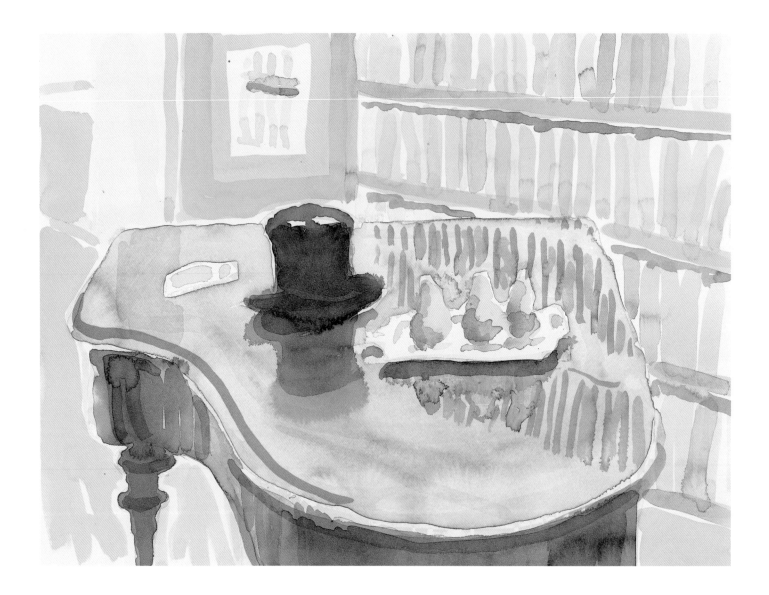

Top Hat and Pears on Piano 2003

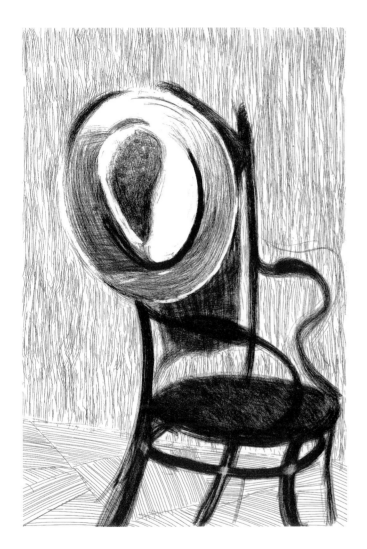

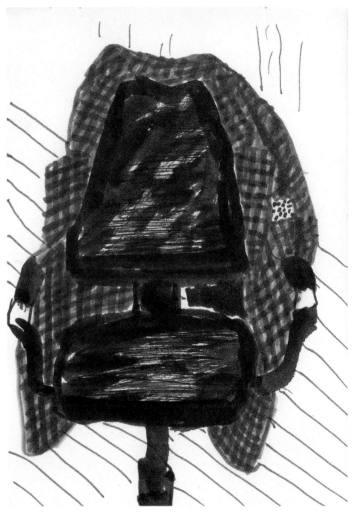

Hat on Chair 1998

Sketchbook page: 'Jacket on Chair' 2002

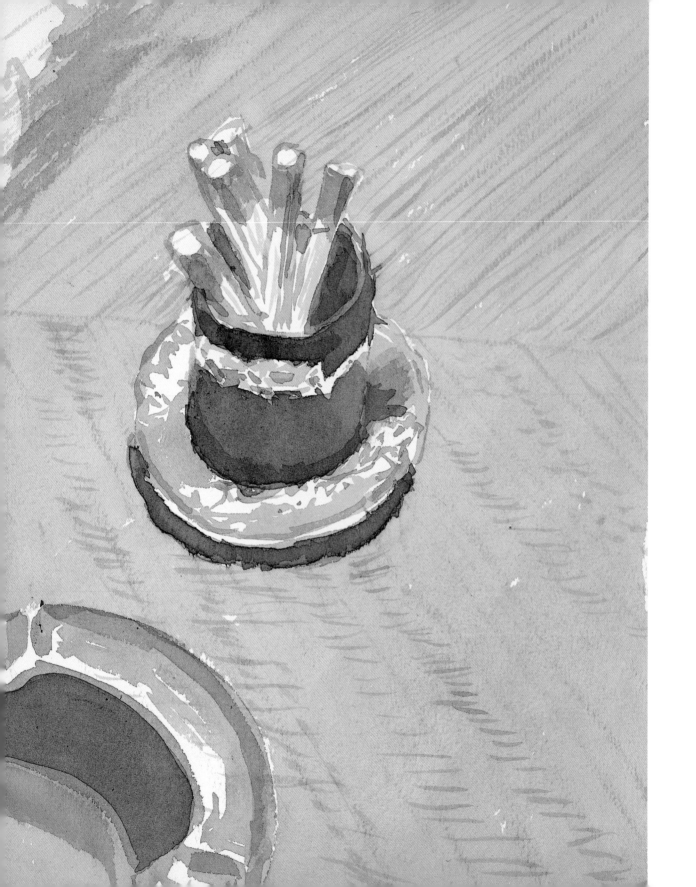

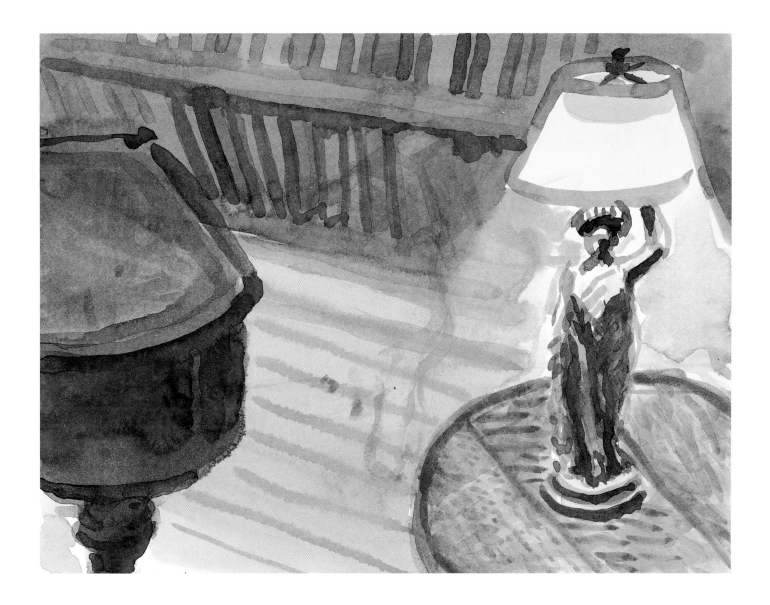

Piano and Lamp 2003

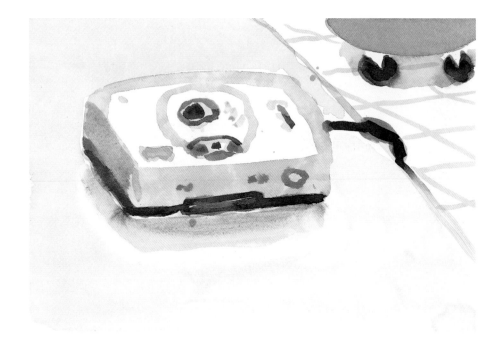

Used Chair 1988

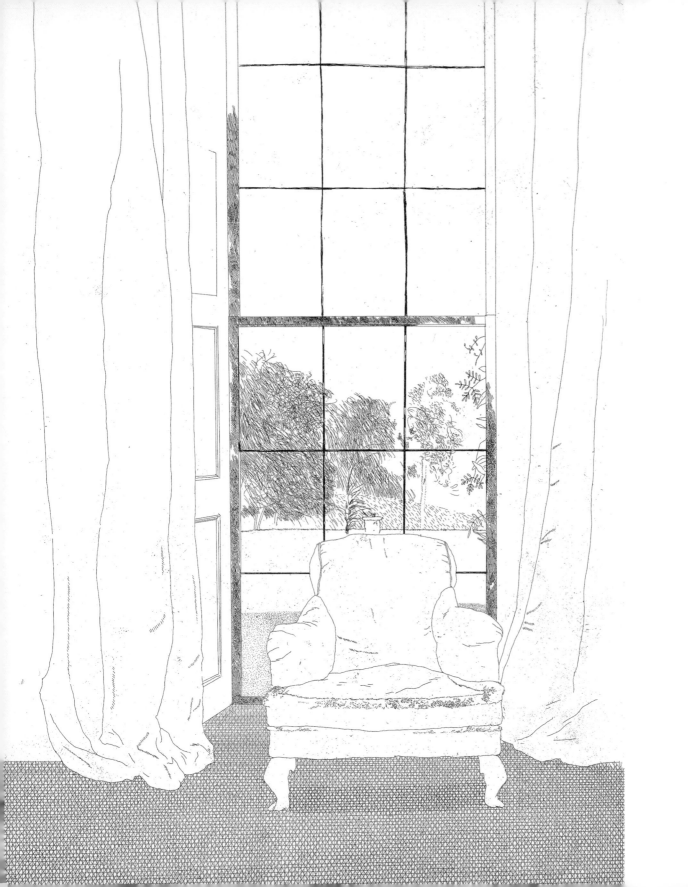

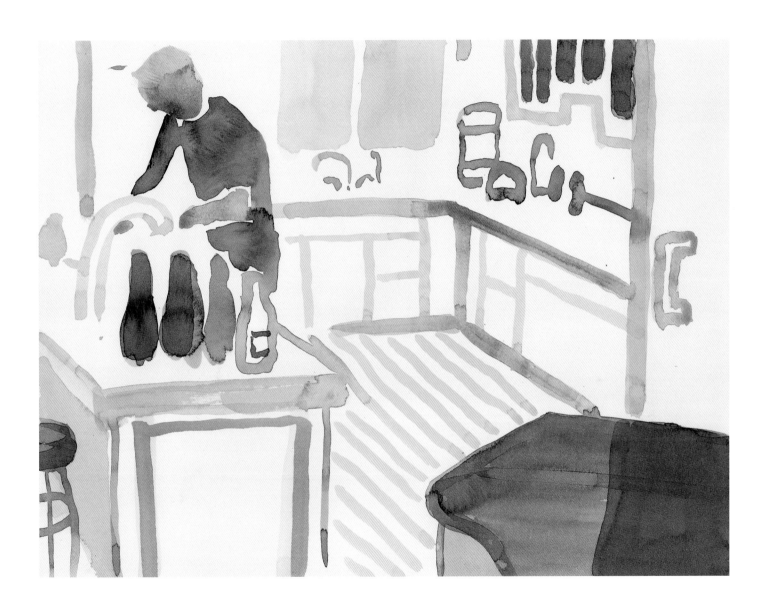

John Cooking II 2003

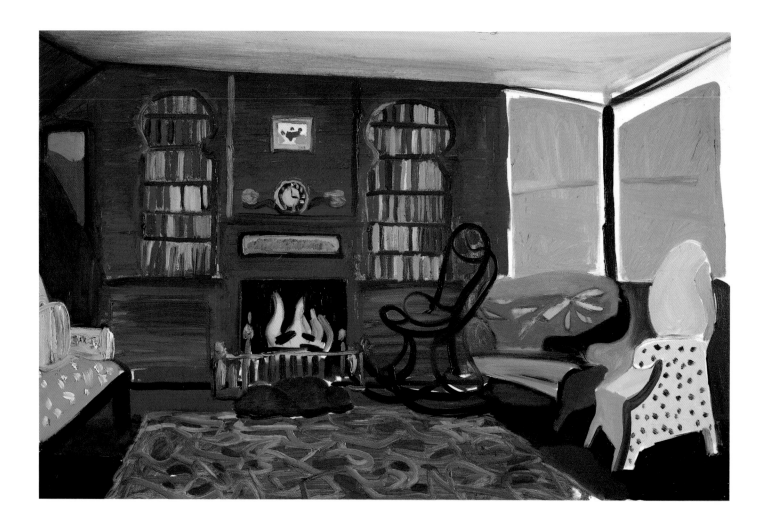

Beach House by Day 1990

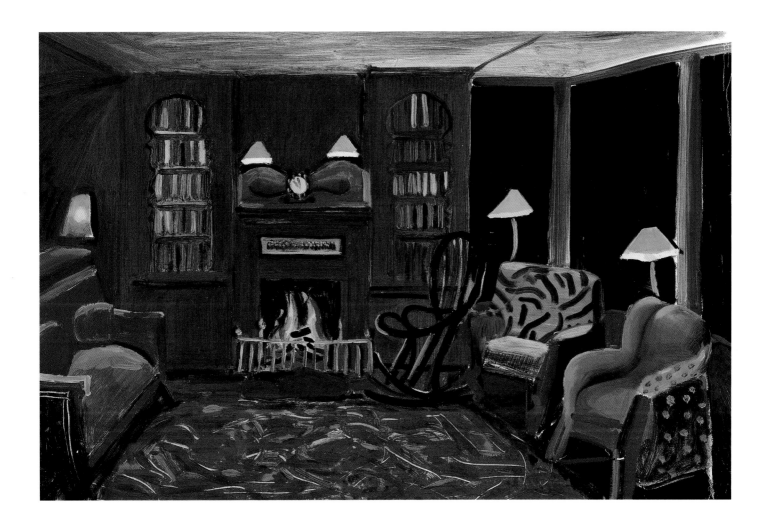

Beach House by Night 1990

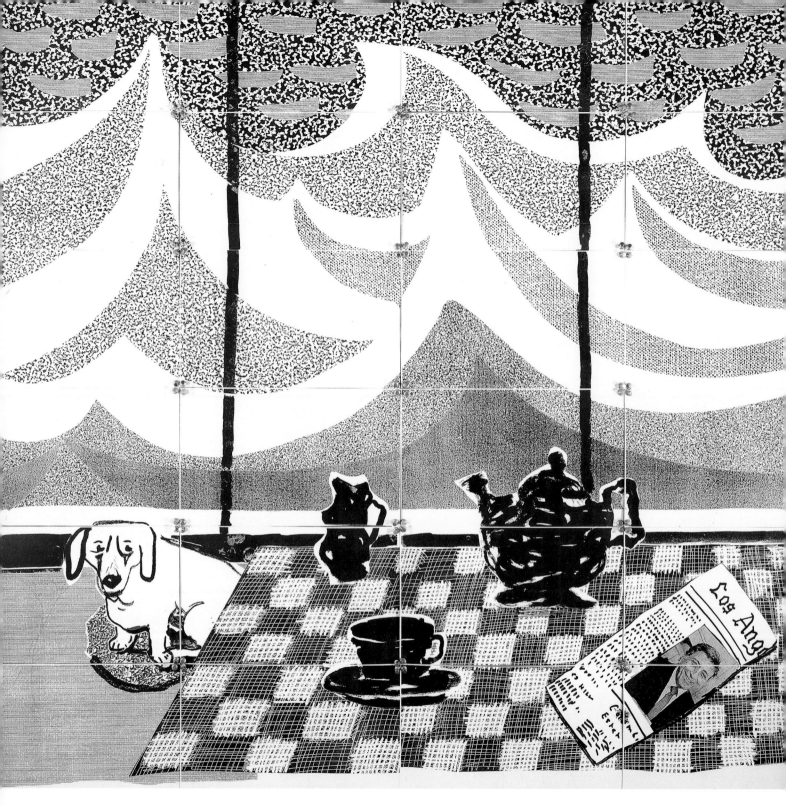

Breakfast with Stanley in Malibu, Aug 23rd 1989 1989

'I started the faxes in about October 1988, in Malibu. Many of them were made from paintings of the sea stretched on one machine, reduced in another way, crammed in, pasted up, made into a collage and then faxed.'

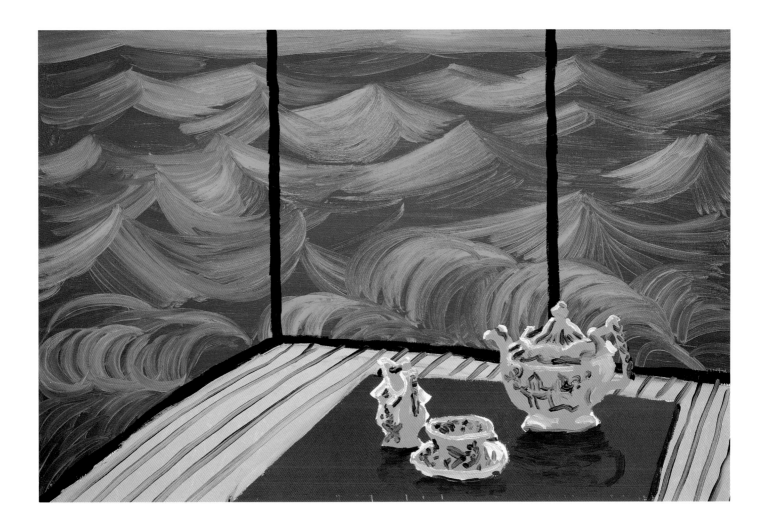

Breakfast at Malibu, Sunday 1989 1989

'It shows everything about the house. Making that picture gave me the idea to paint the house itself. I had it painted red and blue, the colours of my designs for the Ravel *L'Enfant et les sortilèges* – and the green was the green of nature outside the house.'

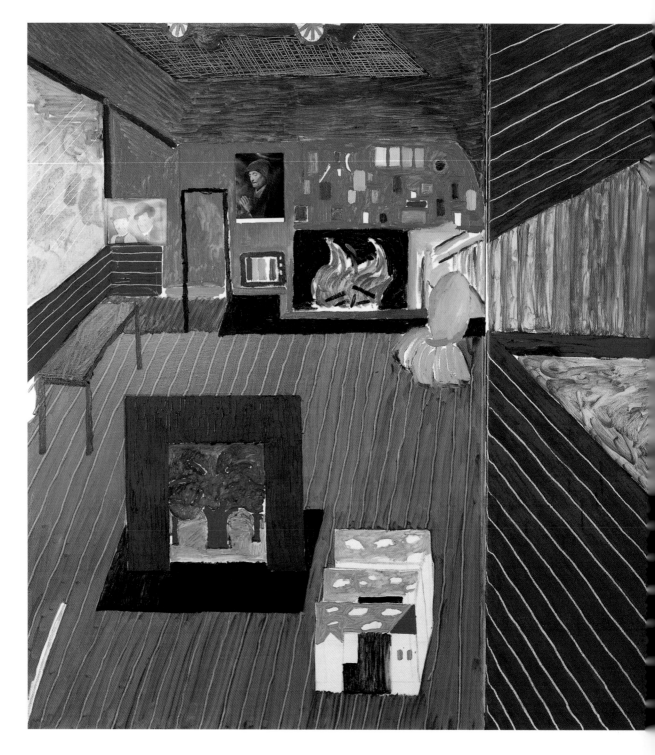

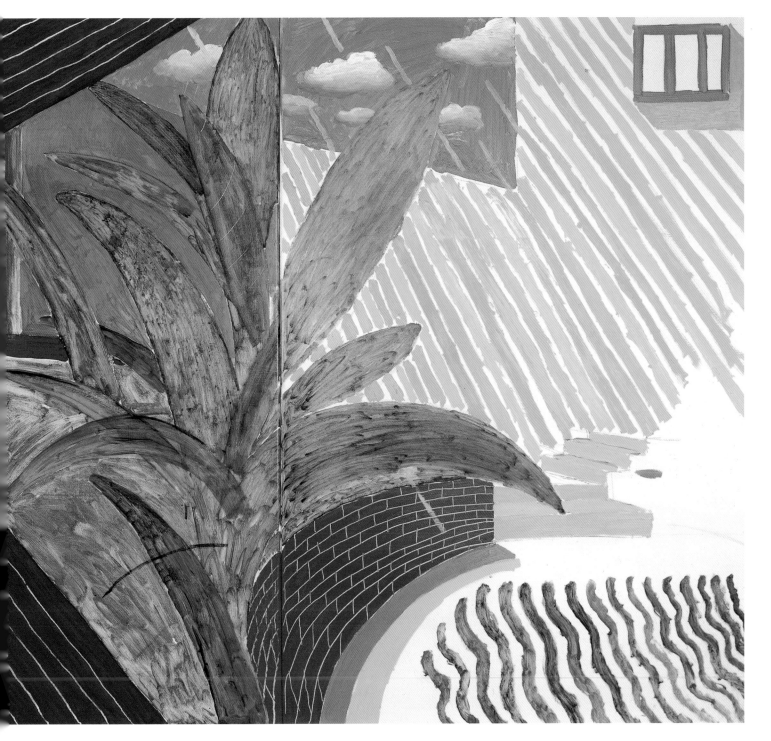

Hollywood Hills House 1981–2

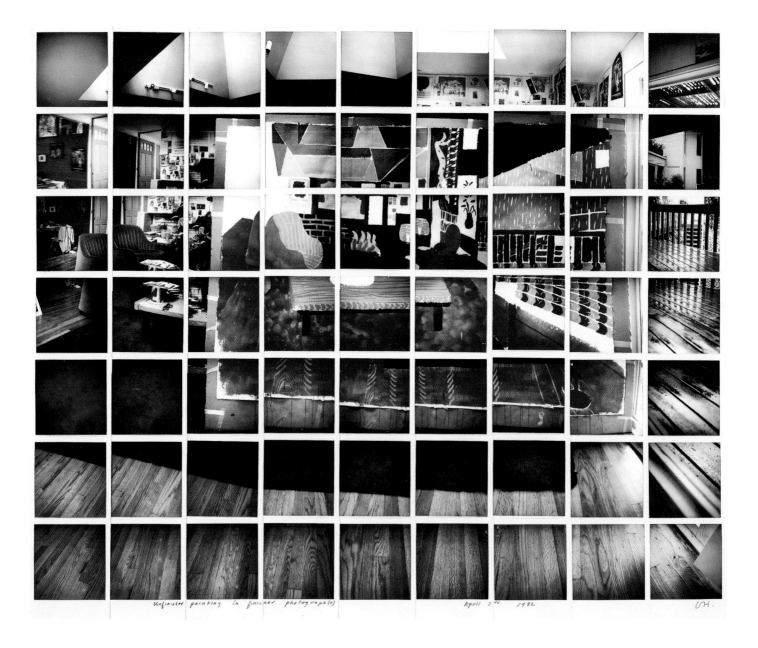

Unfinished Painting in Finished Photograph(s), April 2nd 1982 1982

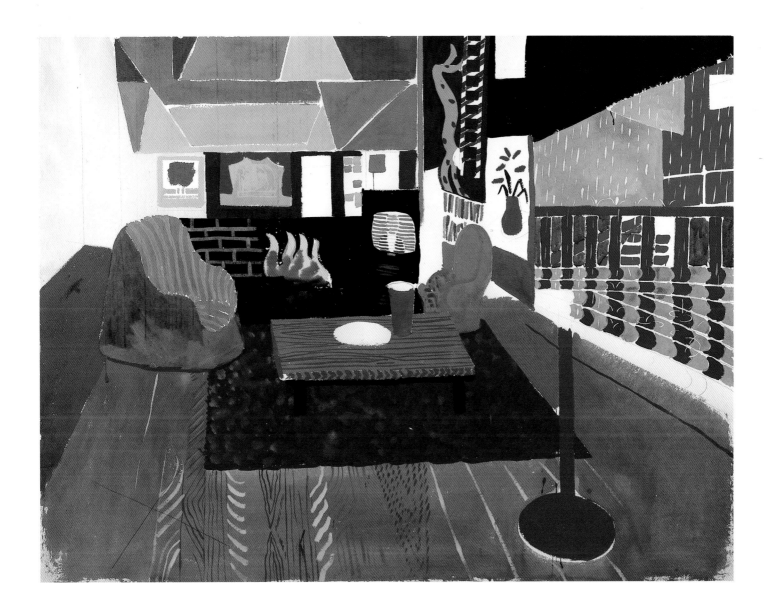

Studio, Hollywood Hills House 1982

'I've often thought about the way I see. For years, I've thought my eyes are funny or something. I kept thinking how much can you really see and what is it you really take in as your eye moves about focusing.'

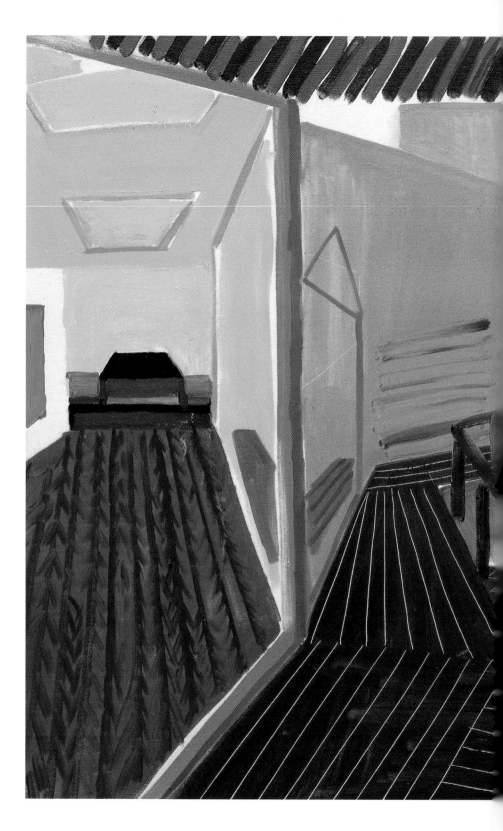

Terrace, Pool and Living Room,
Feb. 1984 1984

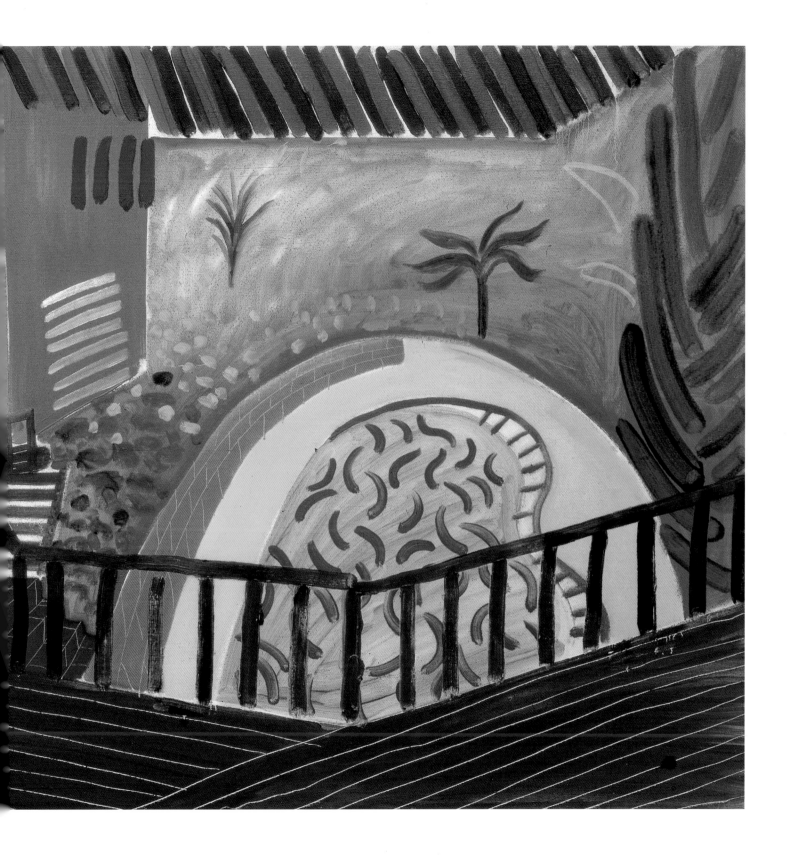

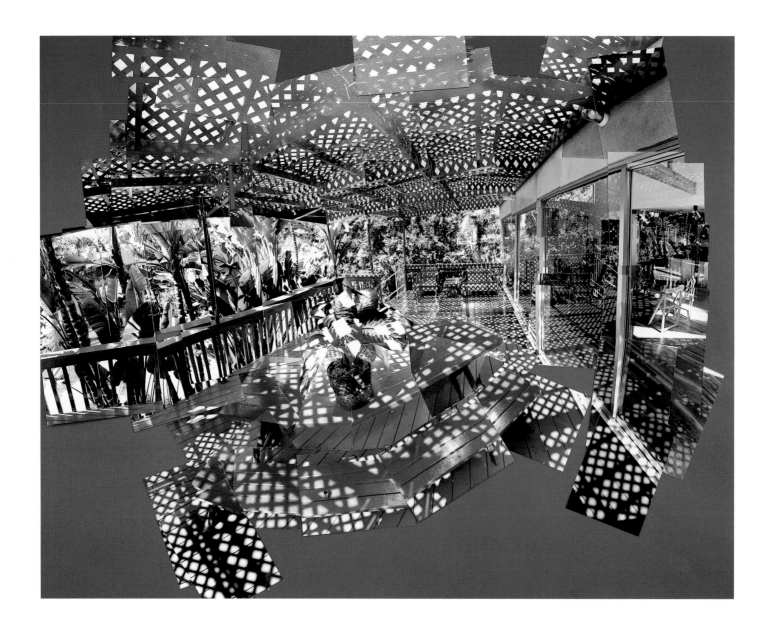

Terrace with Shadows, 1985 1985

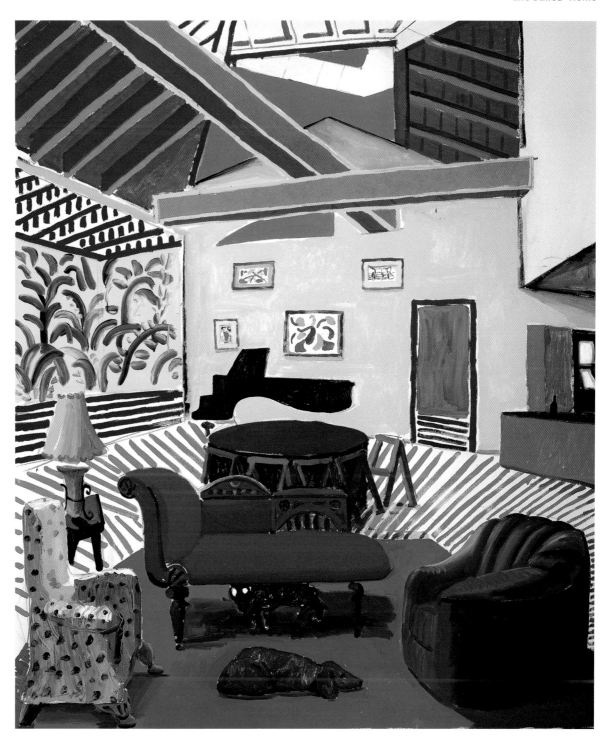

Montcalm Interior with Two Dogs 1988

'These interiors are all of my house up in the Hollywood Hills. When I did them, I was still exploring the spatial ideas of perspective, as I had been in the chair paintings.'

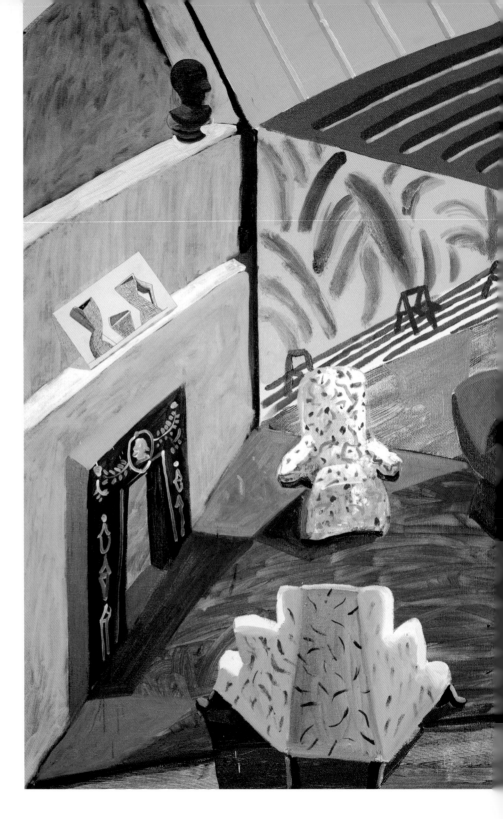

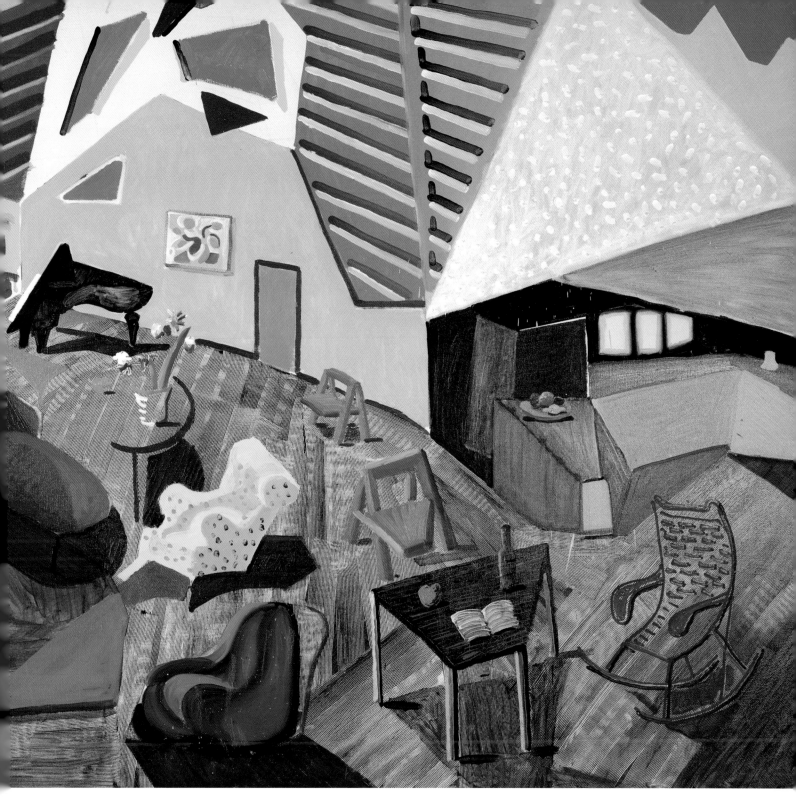

Large Interior, Los Angeles, 1988 1988

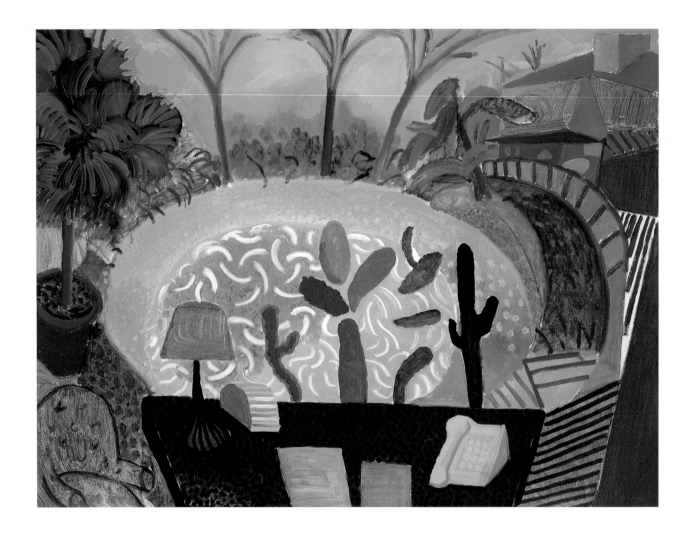

My Garden in L.A., London, July 2000 2000

Saturday Rain II 2003

The Red Chair, April 1986 1986

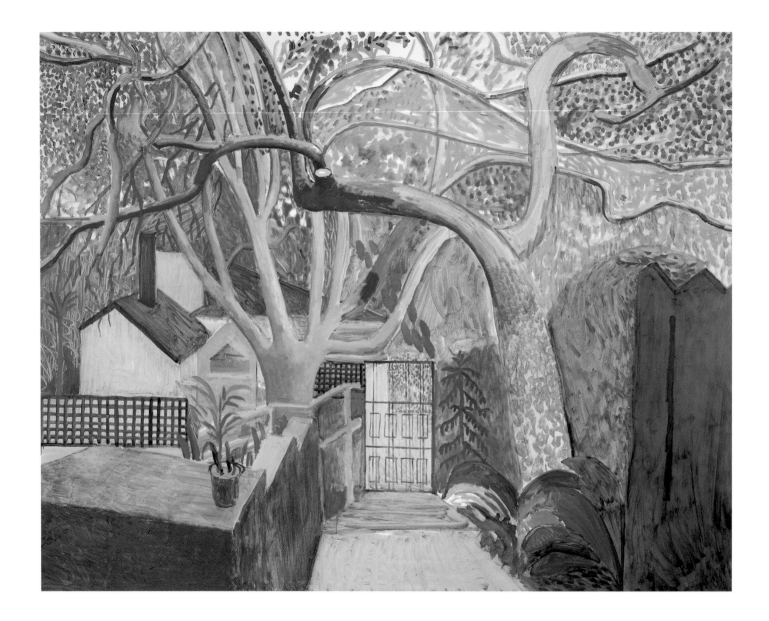

The Gate 2000

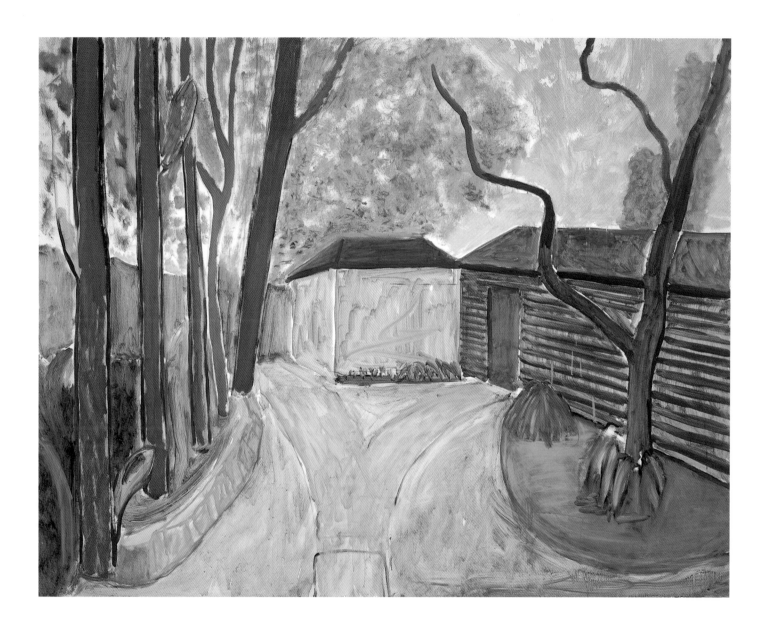

Guest House Garden 2000

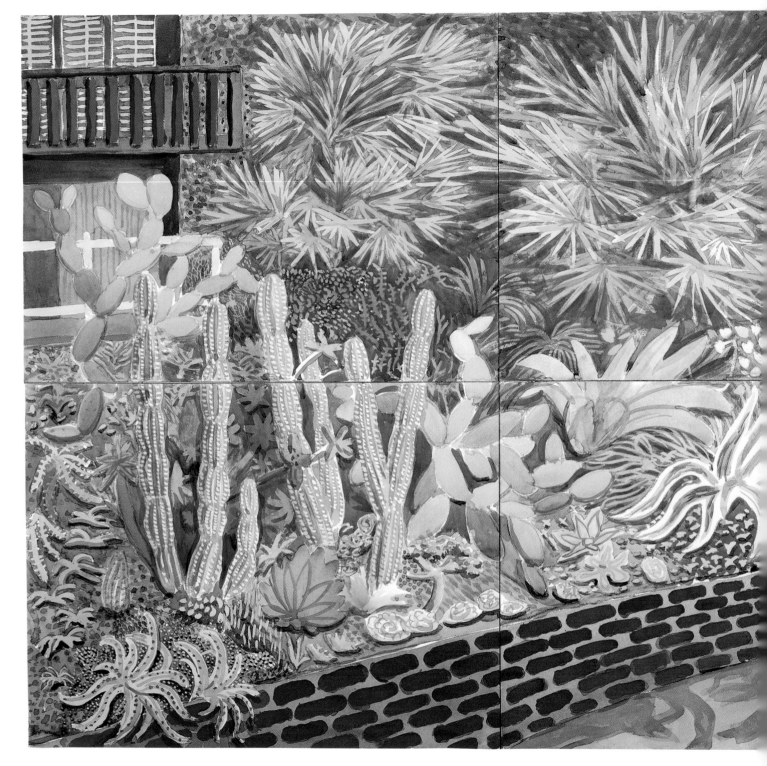

Cactus Garden IV 2003

'It is difficult to say why I decided I wanted to be an artist. Obviously, I had some facility, more than other people, but sometimes facility comes because one is more interested in looking at things, examining them, and making a representation of them, more interested in the visual world, than other people are.'

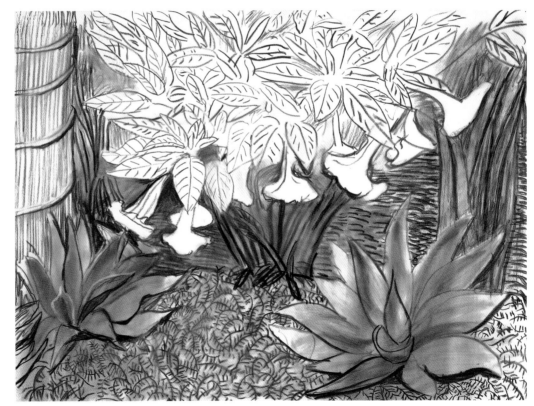

Angel Trumpet and Succulents 2000

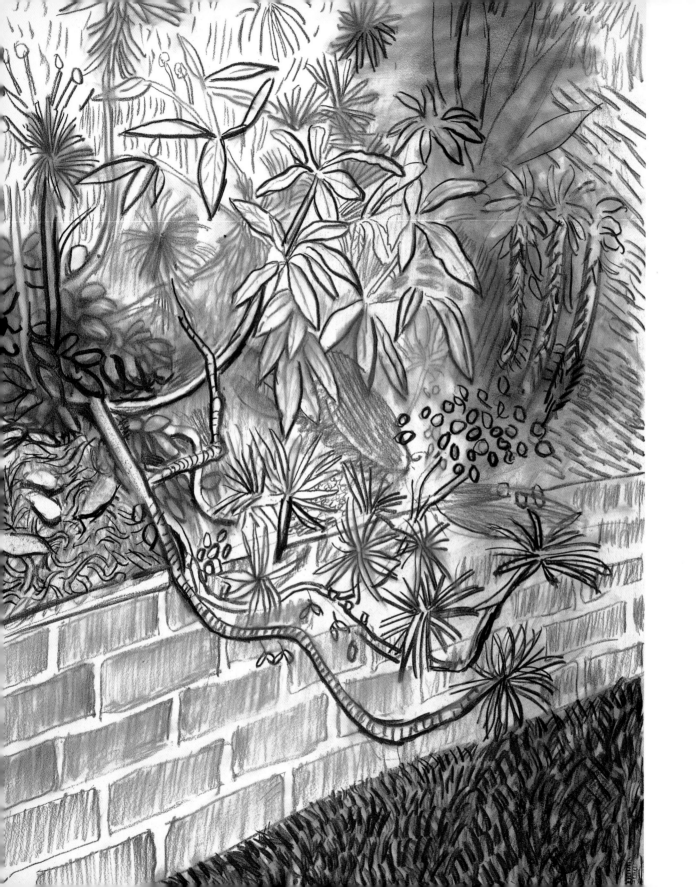

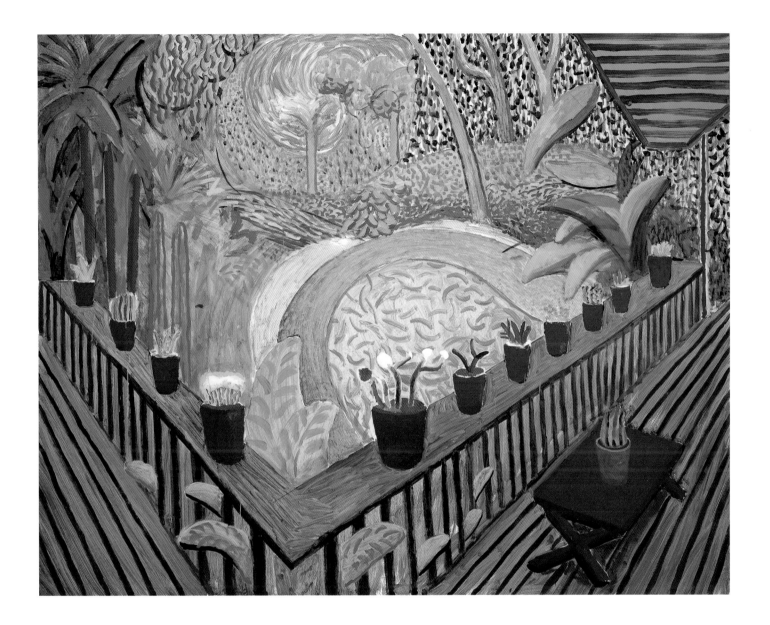

'In art, new ways of seeing mean new ways of feeling; you can't divorce the two, as,
we are now aware, you cannot have time without space and space without time.'

Red Pots in the Garden 2000

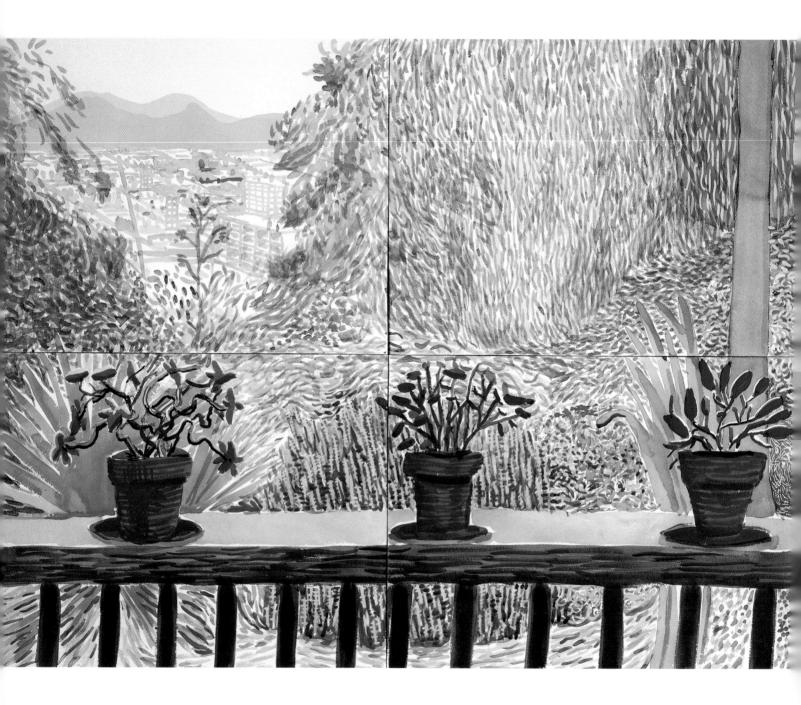

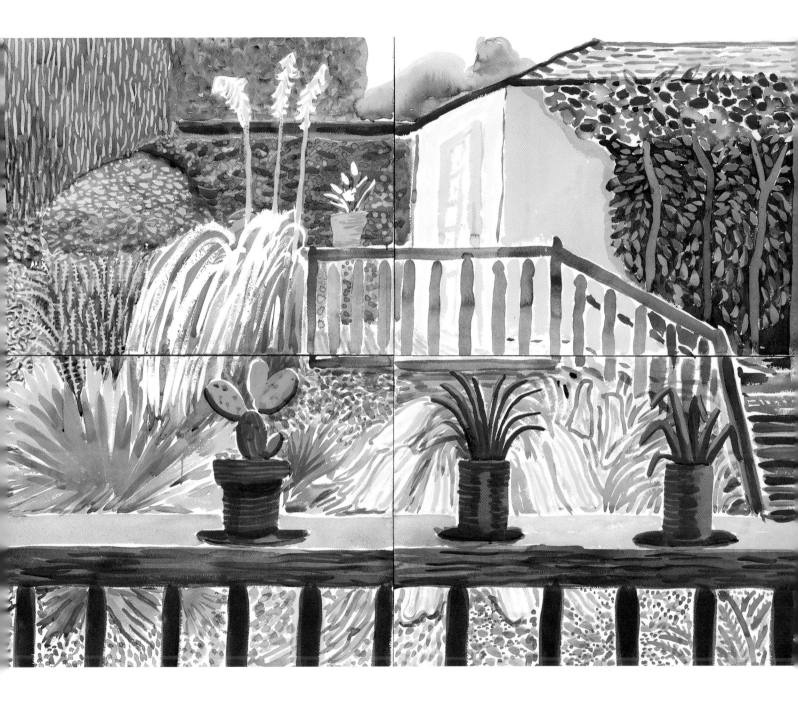

View from Terrace II 2003

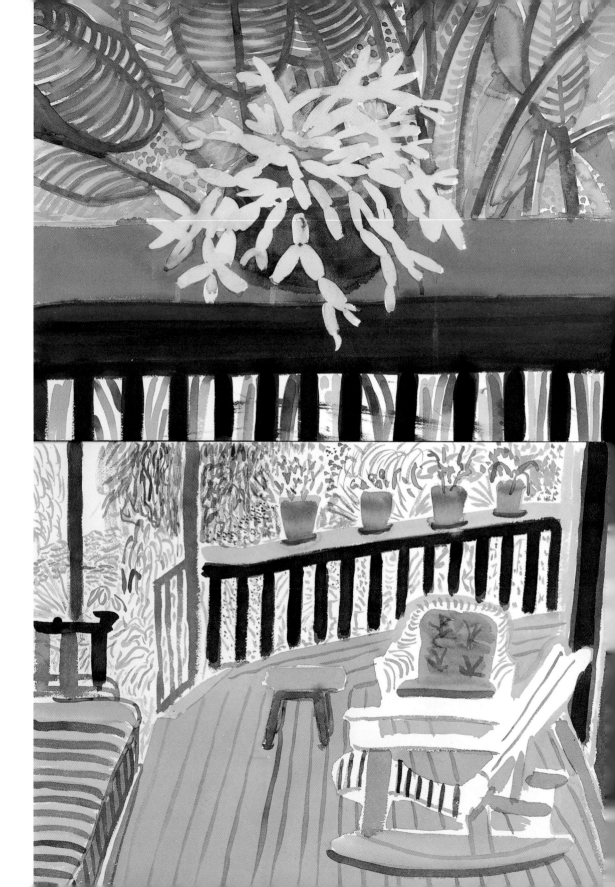

Four Views of Montcalm
Terrace 2003

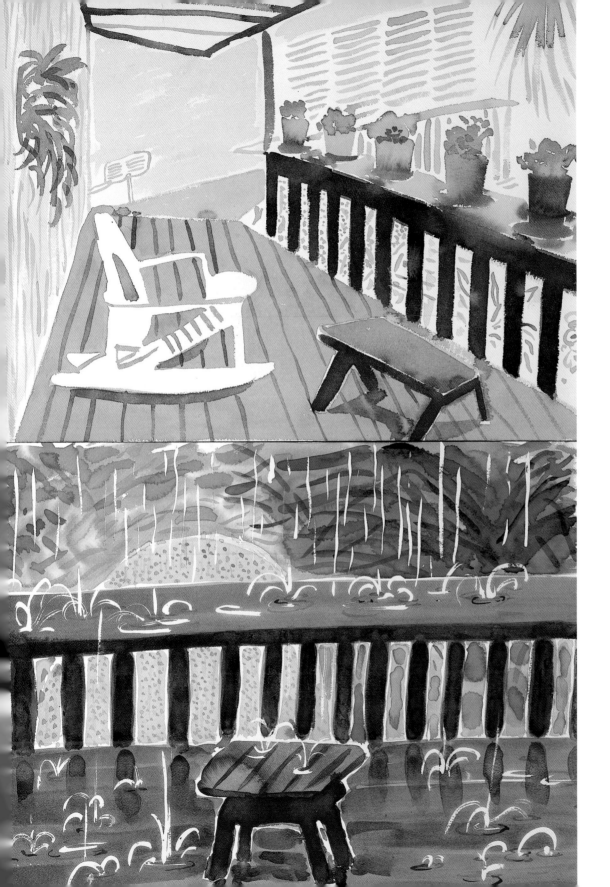

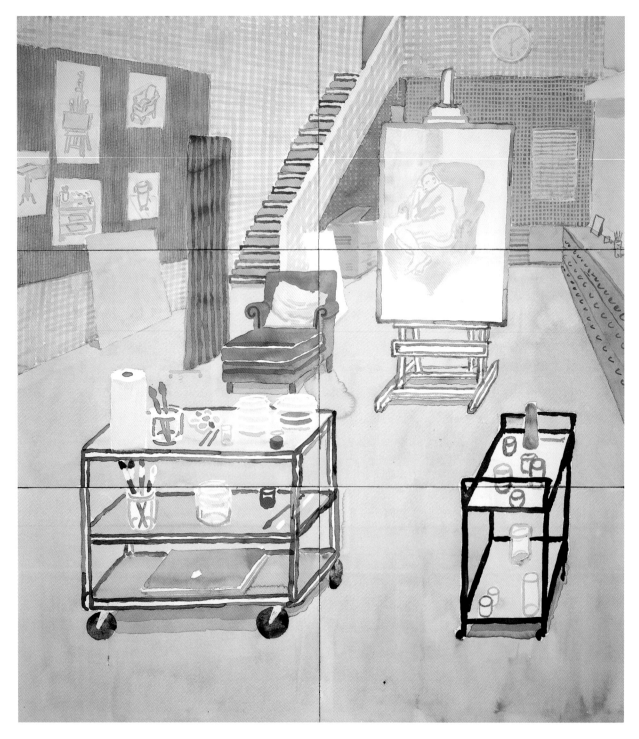

L.A. Studio 2003

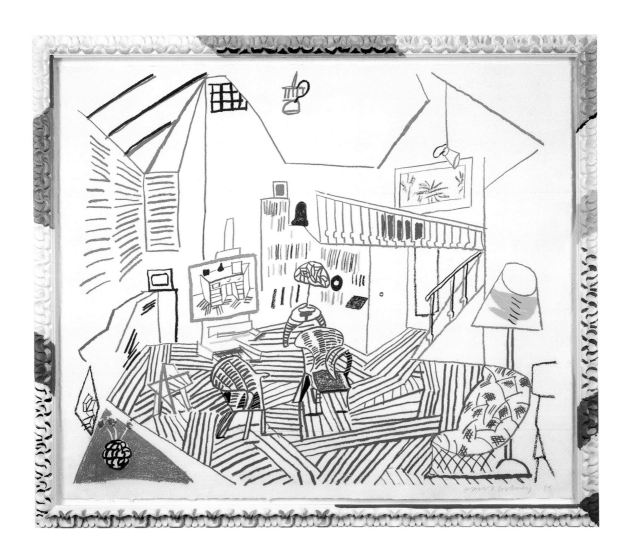

Pembroke Studio Interior 1984

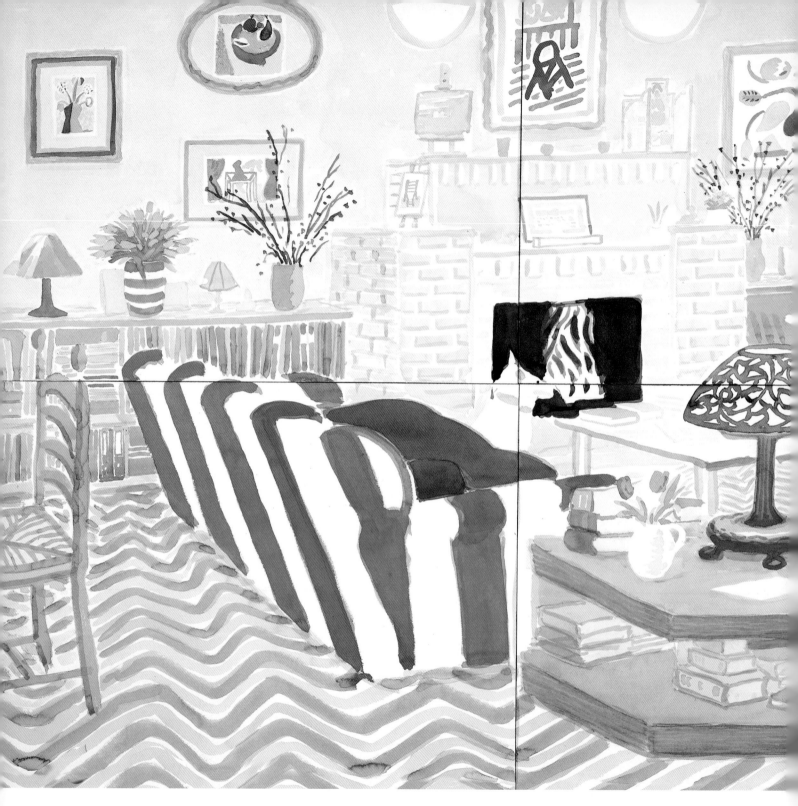

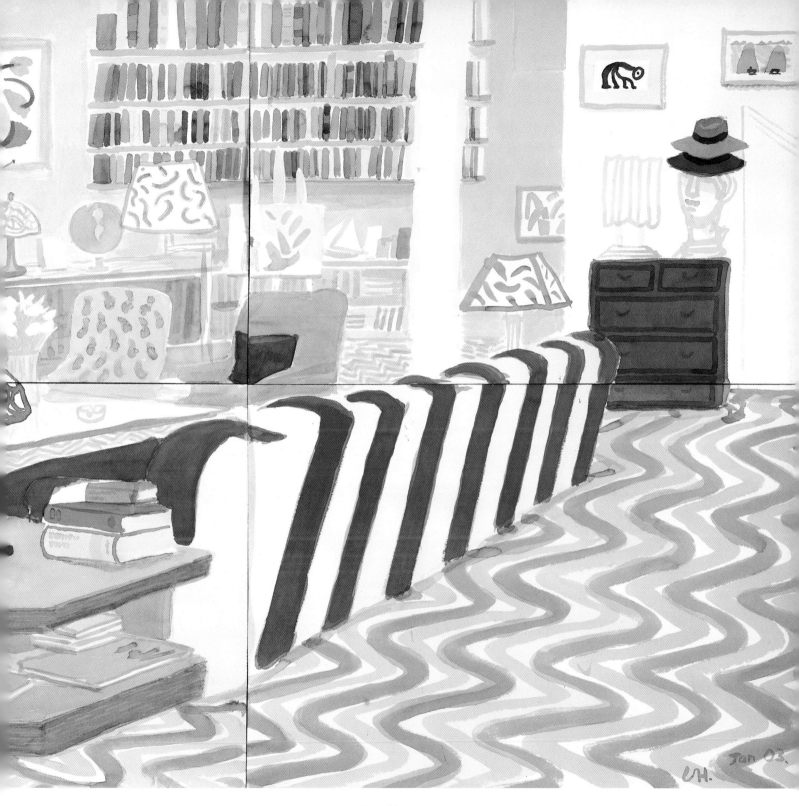

Interior with Lamp 2003

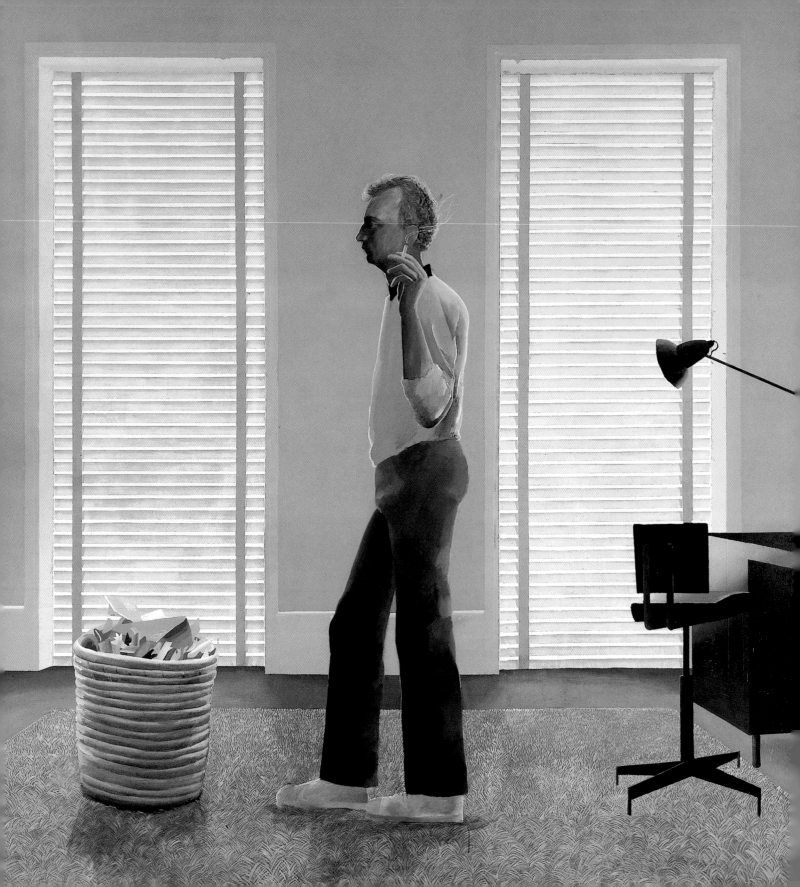

Portraits

Ever since he made his first portraits and self-portraits as a teenager, Hockney has been fascinated by people and how they can be represented in art. This chapter explores the many ways in which he has depicted the people around him, be they famous names such as Man Ray or lifelong friends such as Christopher Isherwood, Henry Geldzahler, Celia Birtwell and Jonathan Silver. Here we find the story of the artist's relationships with family, friends and lovers, with works ranging from the intimate and moving studies of his parents, partners and beloved dogs to his recent large-scale double portraits in watercolour.

It was in the late sixties, after having painted and drawn the human figure in a variety of different styles, that Hockney turned towards a more naturalistic form of representing the world around him. He now sought to re-educate himself as a draughtsman and test his powers of observation, skills he had acquired as a student in Bradford. Portraiture was the perfect opportunity for him to do so, and ever since then he has produced many series of portraits, each time exploring new methods and techniques of depiction. In particular, he is celebrated for his trademark pen-and-ink life studies, which are some of the most beautiful and radically economical portraits of the twentieth century. The self-portrait, too, has played an important role for Hockney. In recent years, especially, he has produced a prolonged series, often showing himself in reflective mood.

In paint, print, pencil, pen and ink, and photography, Hockney has embraced, invigorated and often subverted the traditional portrait, making it a central concern of his art. Depicting people has also been a way of finding solutions to other artistic problems, too. As he says, 'I tend to do that at times when I feel a little lost, searching around.' Always revealing and engaging, his portraiture brings us back again and again to our own humanity.

'It is a portrait of Patrick Prockter in his studio. In 1967 Patrick's studio looked clean, neat and office-like. The next year it looked like a den in the Casbah.... I recorded the changes in photographs, and this painting was made from drawings, life and photographs.'

The Room, Manchester Street (detail) 1967

'People don't understand these paintings. They haven't understood that they're about love and nothing else.'

Boodgie 1993

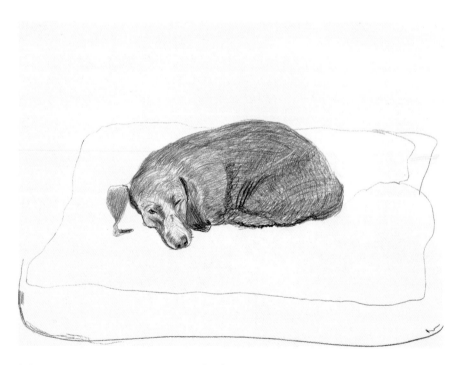

Stanley 1993

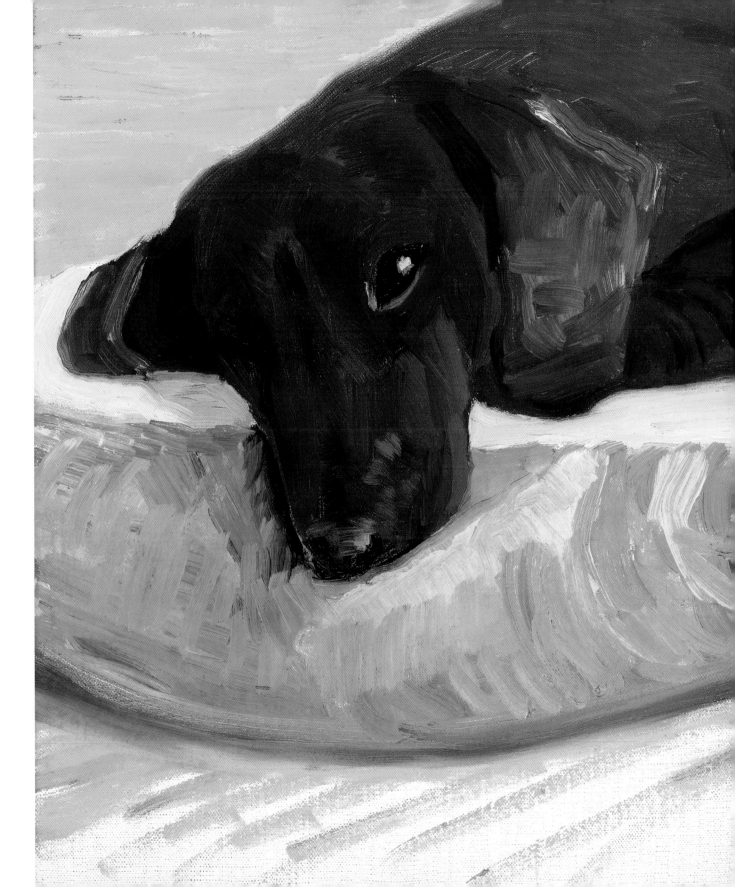

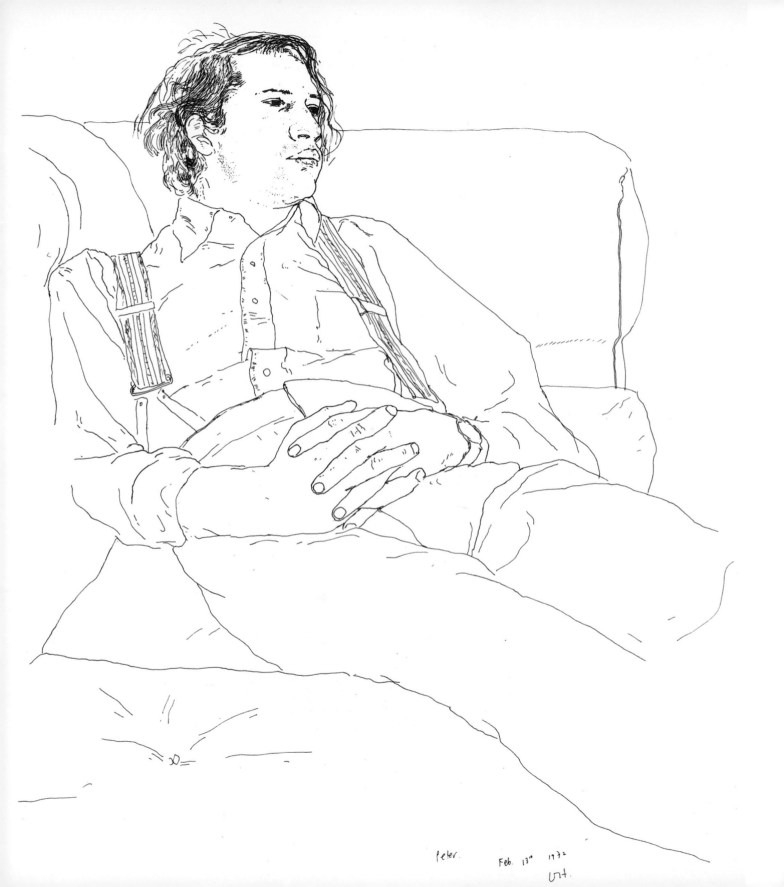

Peter. Feb. 13ᵗʰ 1972

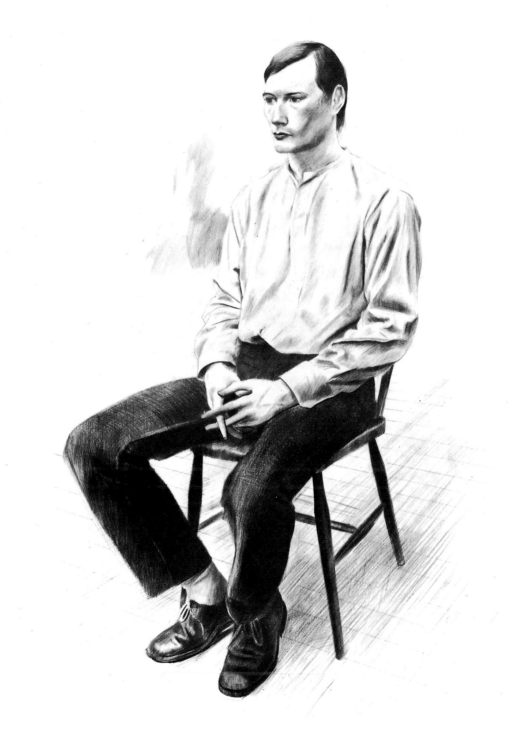

Nicky Rea 1975

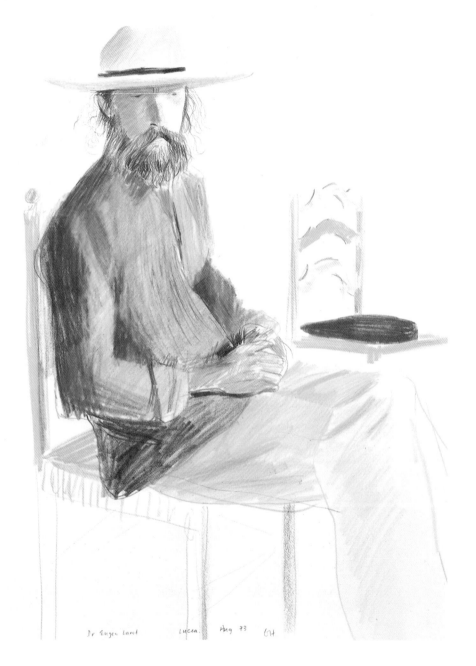

'From 1973 to
1975, I lived
mostly in Paris.…
I spent a lot of
time doing quite
big portrait
drawings. I did
them slowly.
I would spend
two or three
days drawing
the person
slowly, rather
academically,
sort of
"accurately"
in an ordinary
sense.'

Dr Eugene Lamb 1973

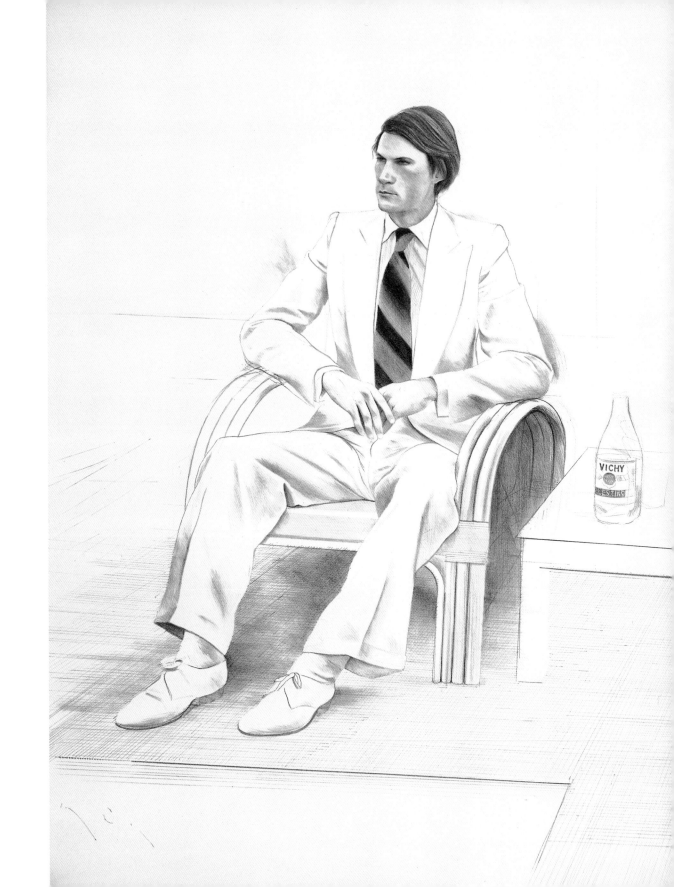

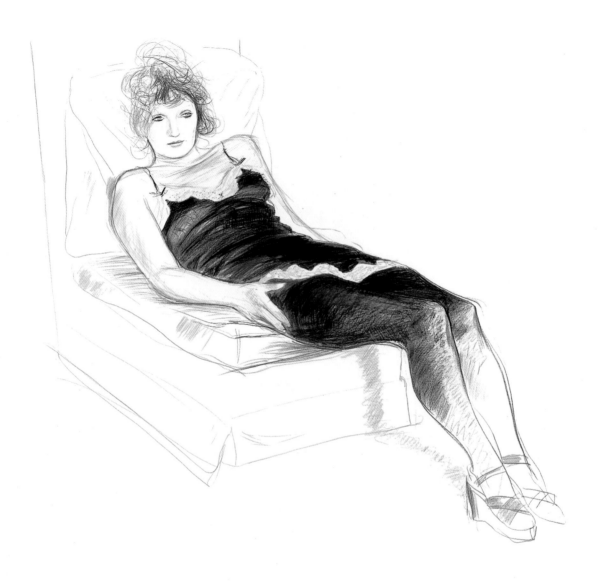

'I began to enjoy Paris, and I started drawing a great deal; that's when I started drawing very big. Celia came over on a few visits, and I started doing big drawings of her.'

Celia in a Black Slip Reclining, Paris, December 1973

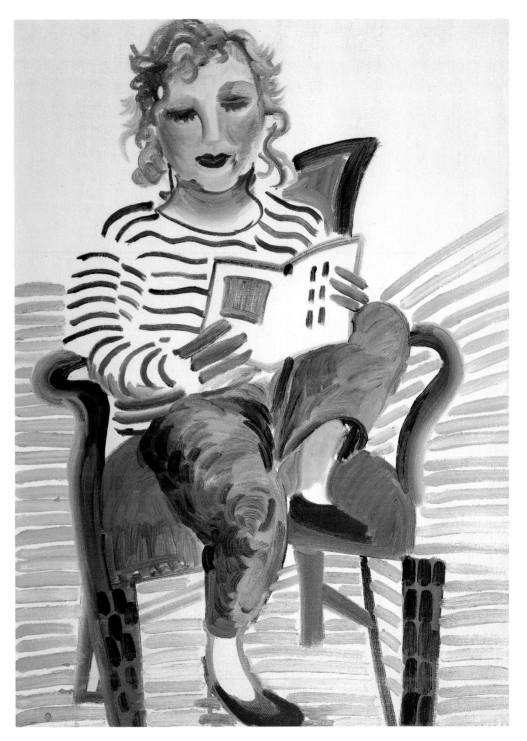

Celia with Her Foot on a Chair 1984

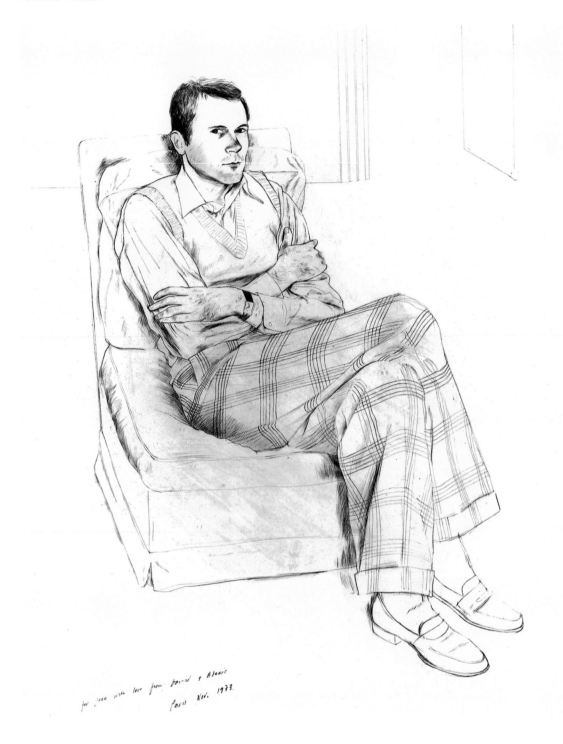

for Jean with love from David + Alexis
Paris Nov. 1973.

'I'll make some drawings of my friends; I'll make them slowly, accurately, have them sit down and pose for hours, and so on. I tend to do that at times when I feel a little lost, searching around.'

Portrait of Jean Léger 1973

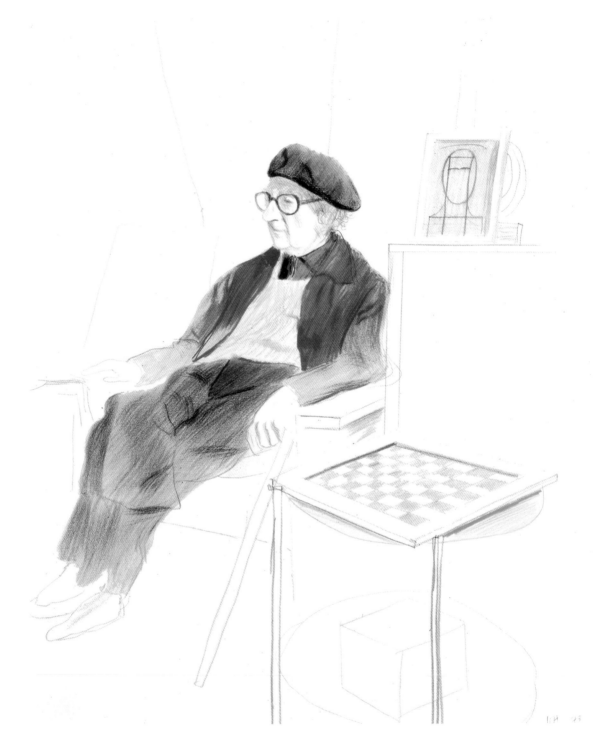

Man Ray 1973

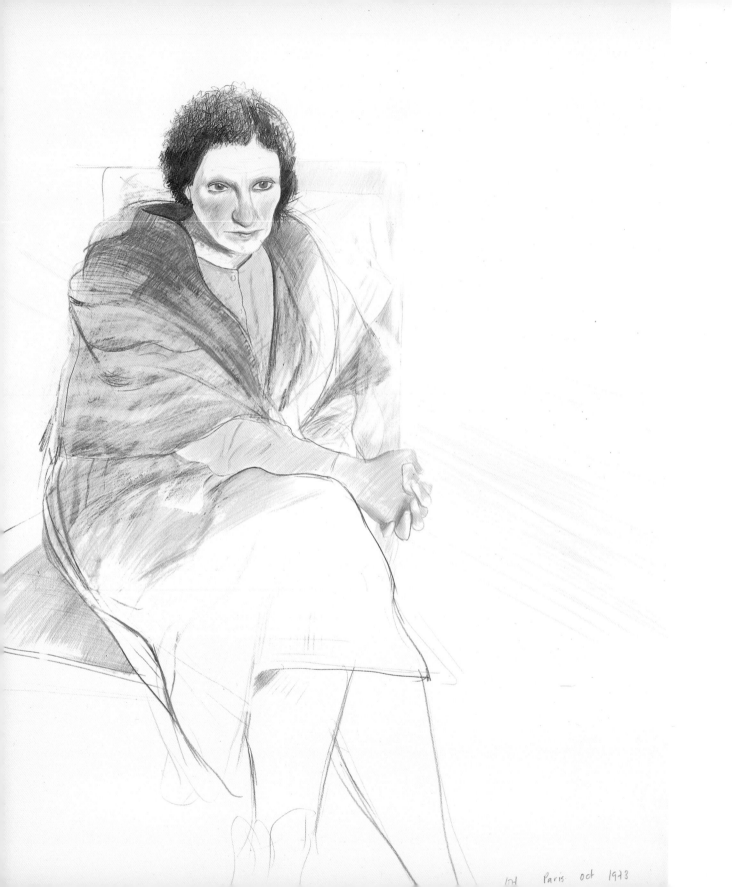

Paris Oct 1973

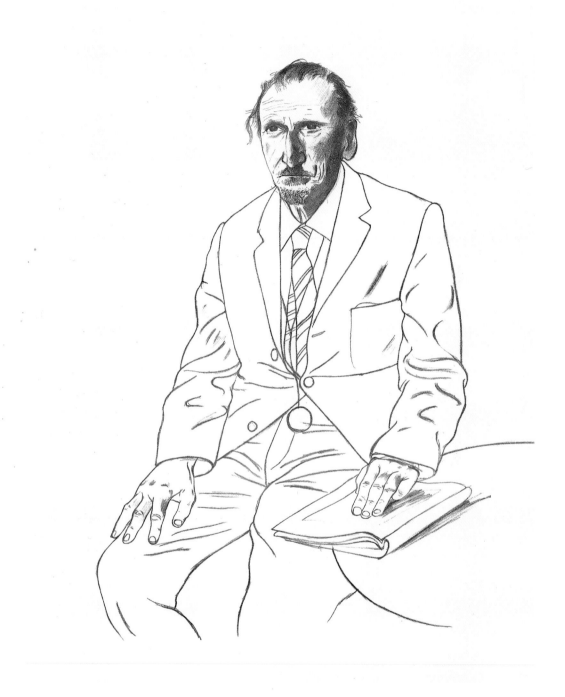

The Connoisseur 1969

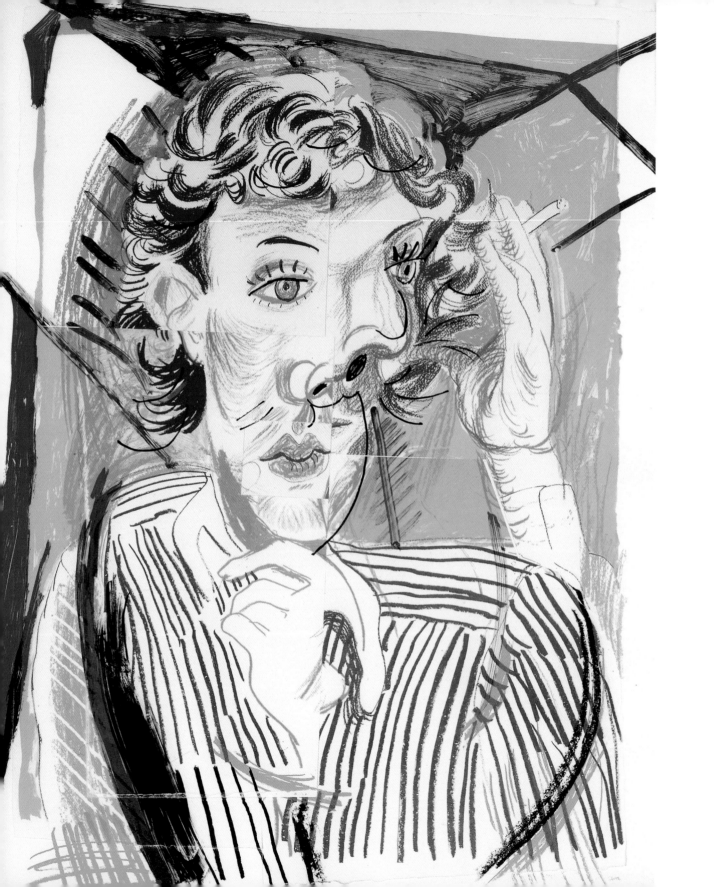

'When I moved to the new studio upstairs in Powis Terrace in 1977 Gregory visited often when he came over from Spain, where he'd been living. I painted him and drew him a lot.'

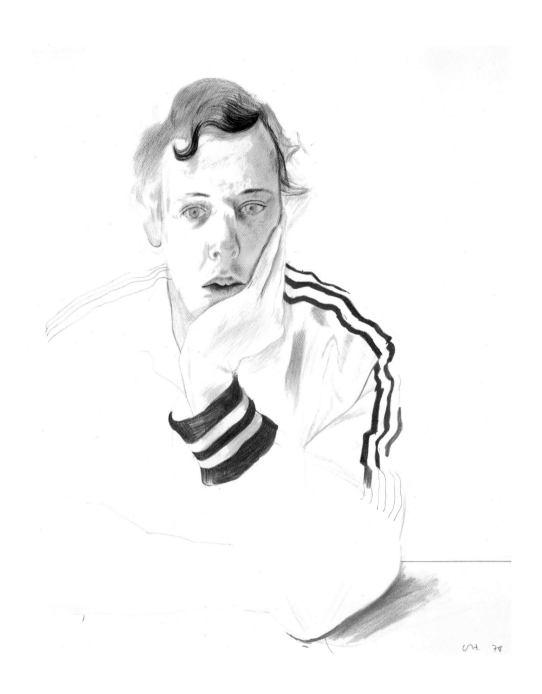

Gregory 1978

Pierre Saint-Jean,
London, June 2000 2000

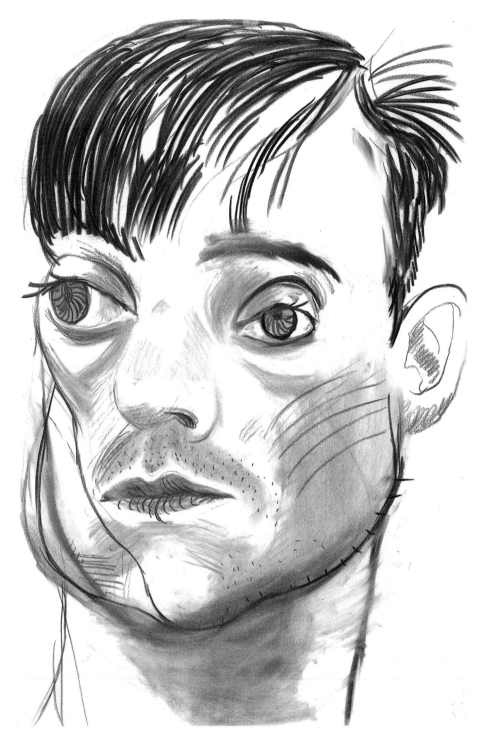

Pierre Saint-Jean No. 3 1984

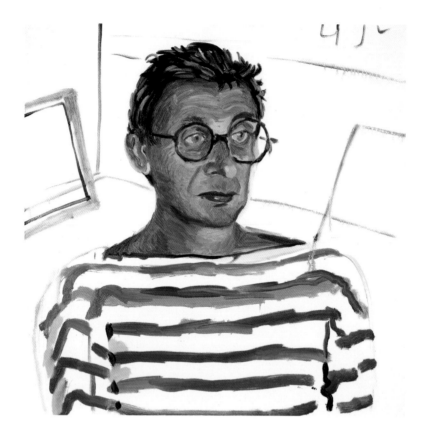

'I'd met Kasmin in about January 1961, when he was working
for Marlborough Fine Art. He was interested in my pictures;
he said, "Bring some more into the Marlborough", and I did,
and they *hated* them … thought they were awful.'

Kasmin 1988

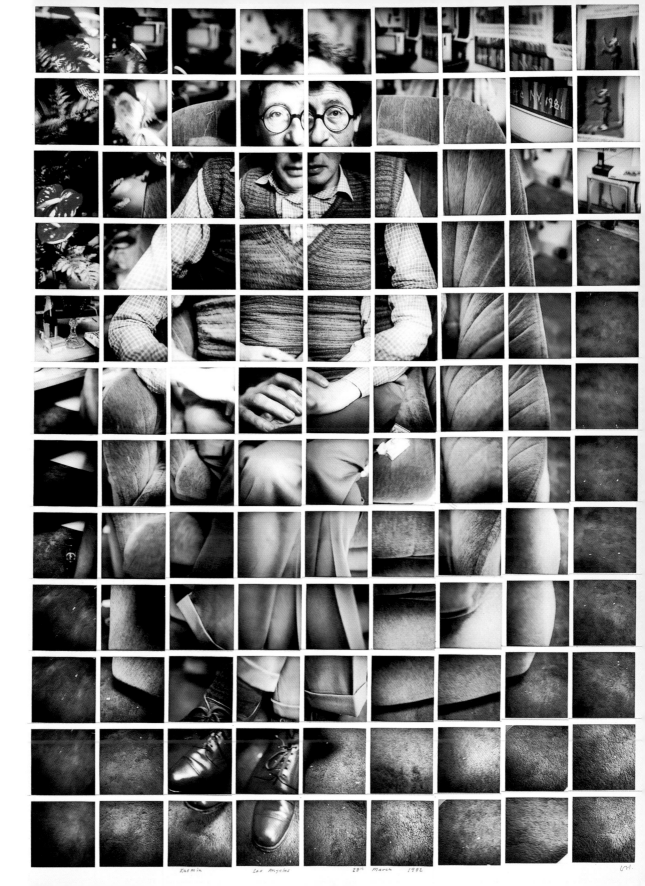

Kasmin Los Angeles 28th March 1982

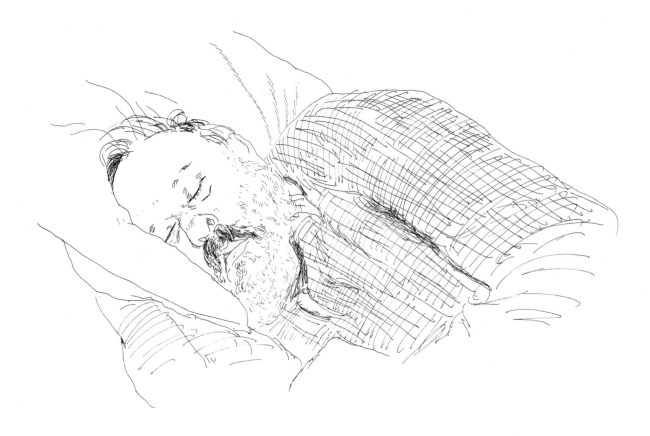

'I can't just paint the figure theoretically. If it is not there you deal with
the fact that it's not there, you deal with the absence.'

Henry Sleeping 1978

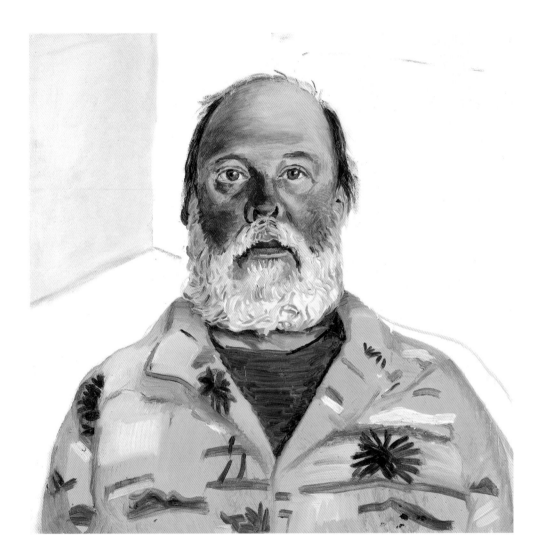

Henry 1988

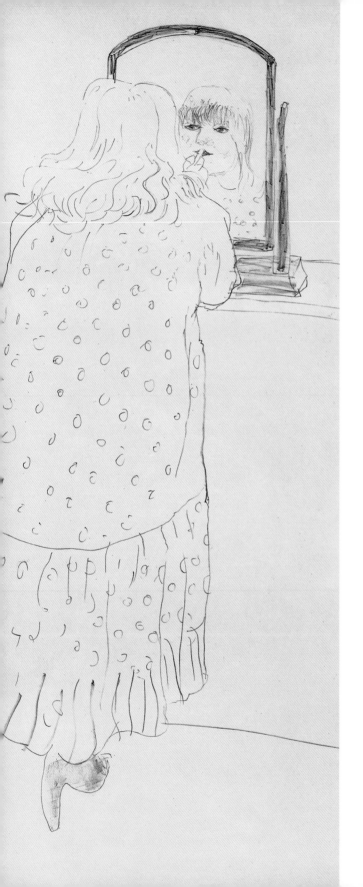

'Once my hand has drawn
something my eye has observed,
I know it by heart, and I can
draw it again without a model.'

Ann Putting on Lipstick 1979

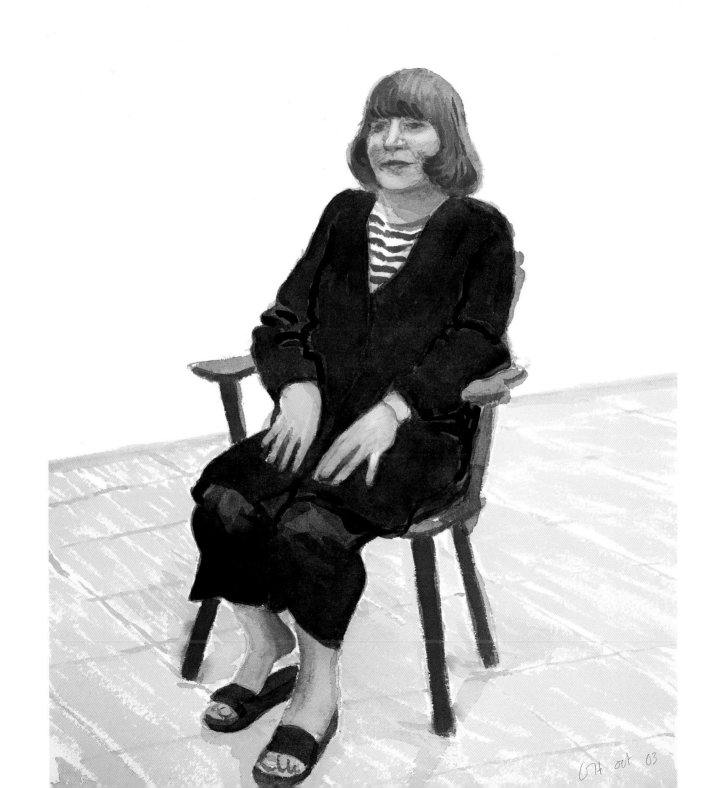

15 Feb 1994 Ont.

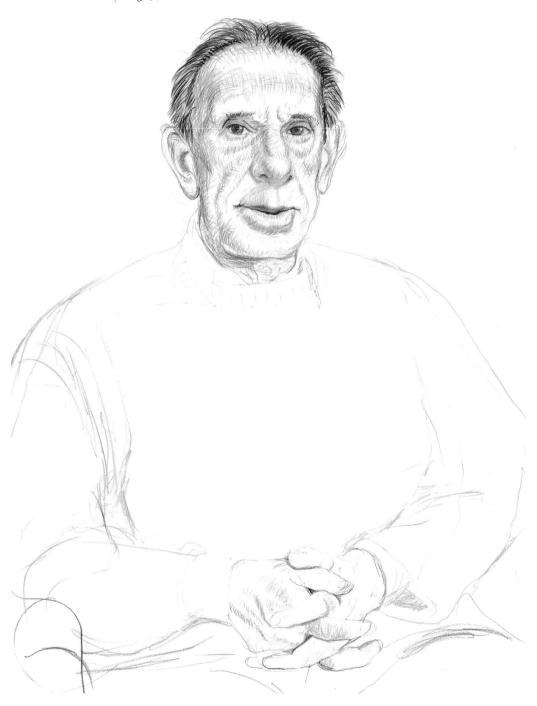

Dr Wilbur Schwartz, 15th Feb 1994 1994

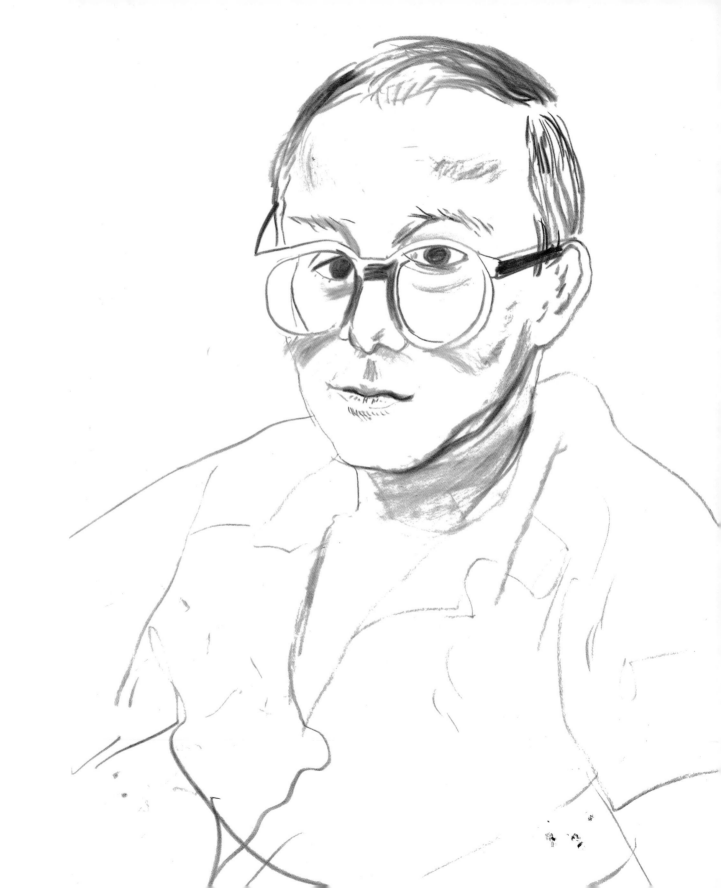

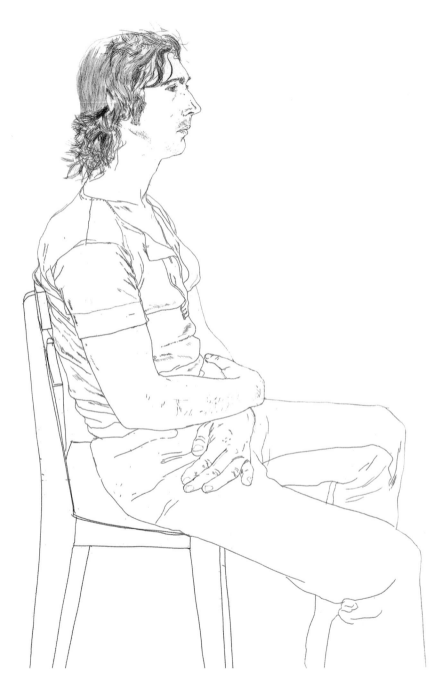

Maurice Payne 1971

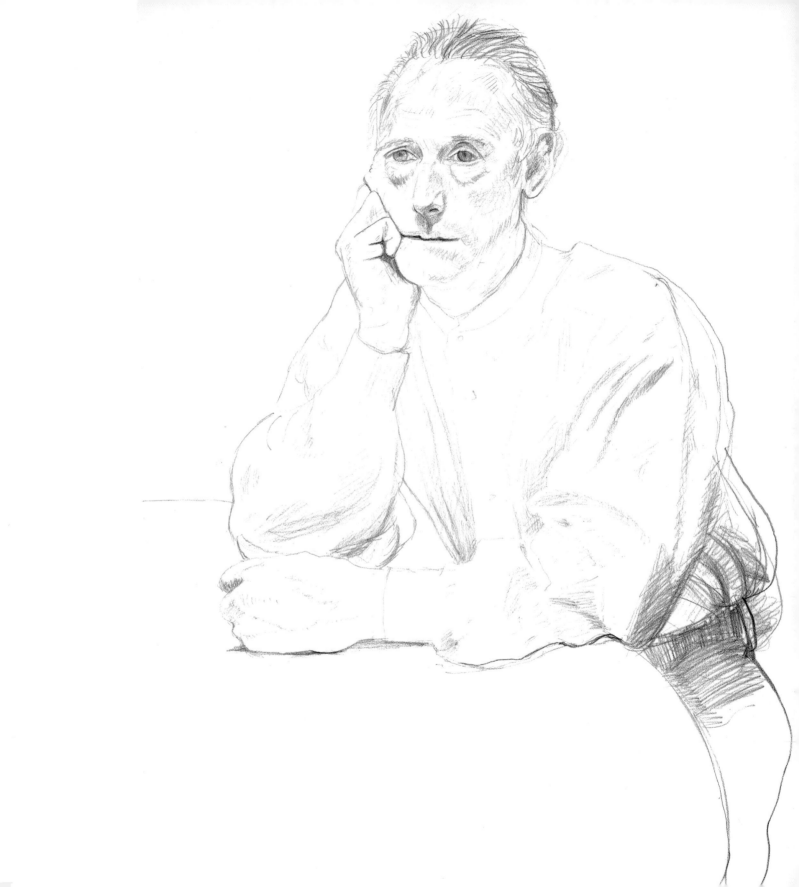

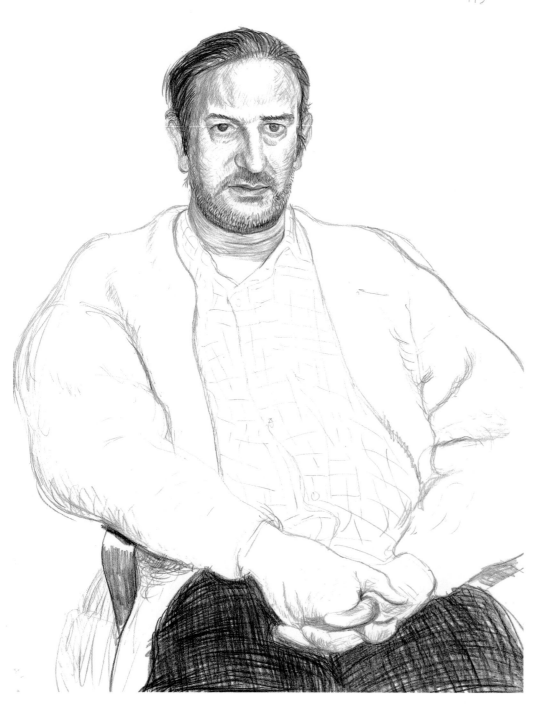

crt. Dec 30 1993

Jonathan Silver, Dec 30th 1993 1993

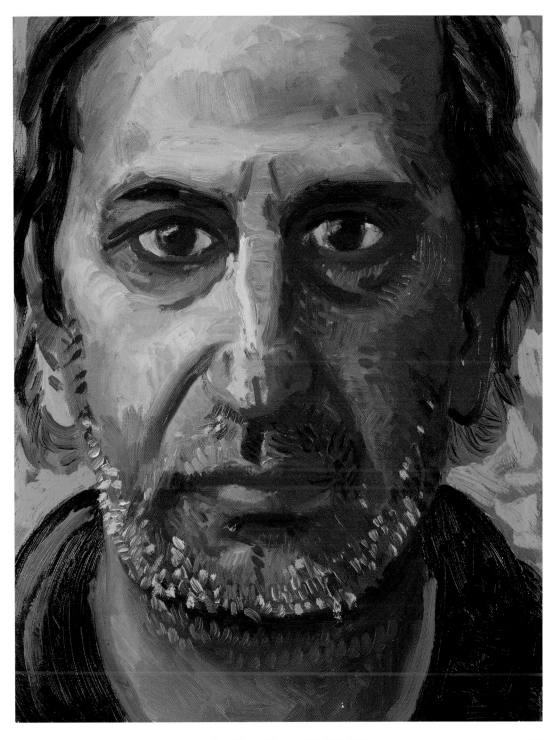

Jonathan Silver, February 27, 1997 1997

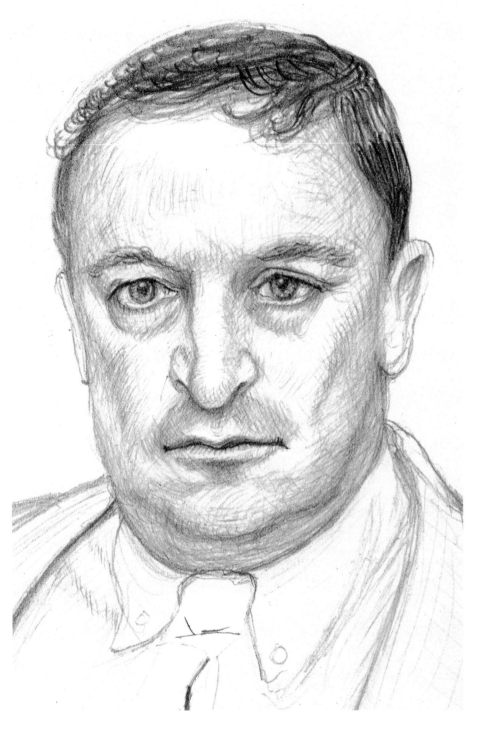

'In early 1999 I made a drawing using a camera lucida. It was an experiment, based on a hunch that Ingres, in the first decades of the nineteenth century, may have occasionally used this little optical device, then newly invented.... At first, I found it very difficult to use. It doesn't project a real image of the subject, but an illusion of one in the eye. When you move your head everything moves with it, and the artist must learn to make very quick notations to fix the position of the eyes, nose and mouth to capture "a likeness". It is concentrated work. I persevered and continued to use the method for the rest of the year – learning all the time.'

Norman Rosenthal. London. 29th May 1999 1999

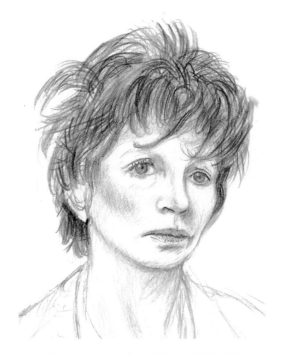

Edna O'Brien. London. 28th May 1999 1999

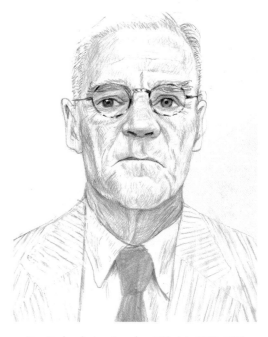

Don Bachardy. Los Angeles. 28th July 1999 1999

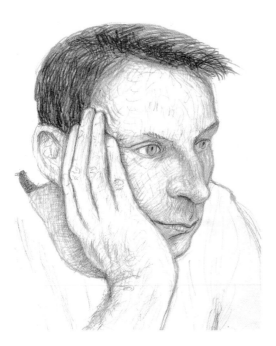

Richard Schmidt. Los Angeles. 16th July 1999 1999

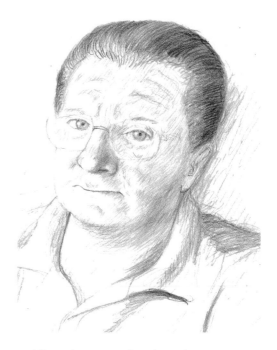

Philip Hockney. Australia. 7th October 1999 1999

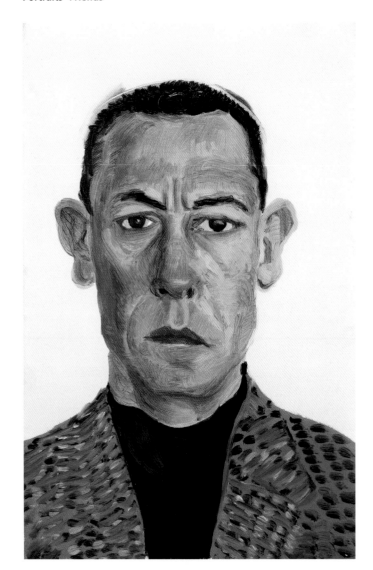 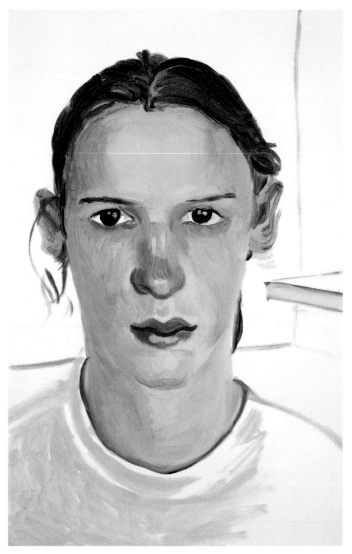

'In 1988 I started doing a series of small portraits, painted very quickly, most of them on the same size canvas.... I felt I wanted to look at my friends' faces again and I painted them rather quickly and crudely, but, as the paintings accumulated, they seemed quite interesting. Most of the people I had painted didn't like them – I don't think I'm that much of a flatterer. If the best ones are of my mother, it is perhaps because I know her best.'

240 Nikos Stangos 1989 George Clark II 1989

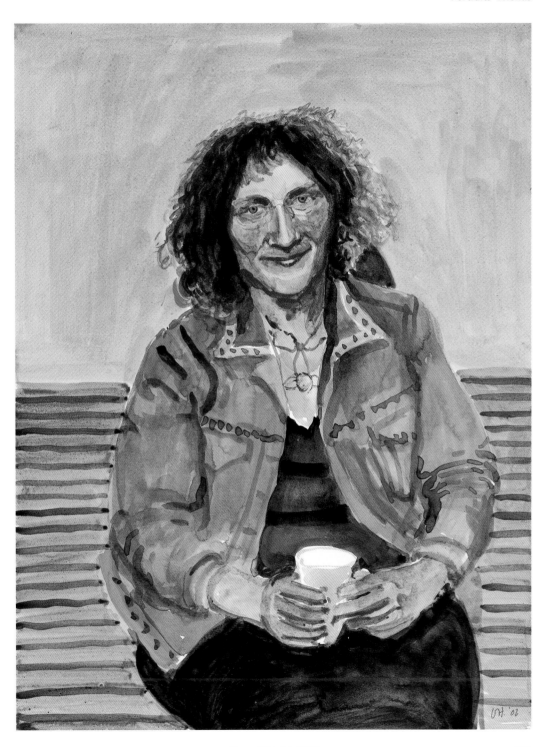

Karen Wright 2002

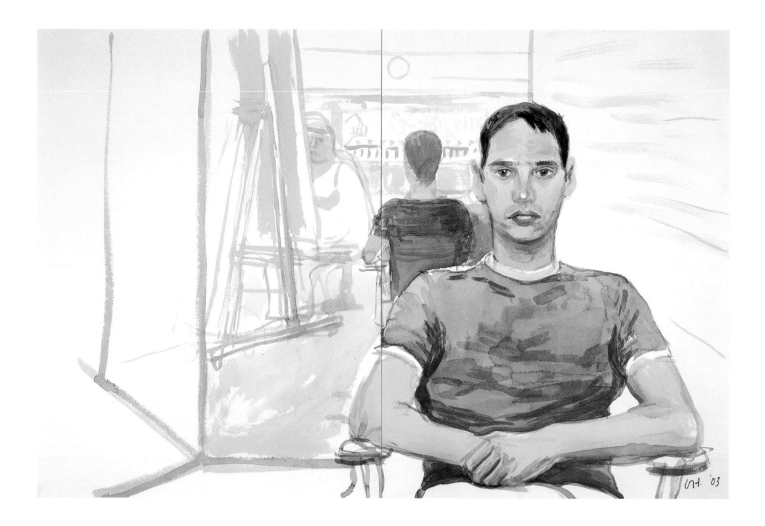

'Watercolour was a medium I had been exploring for a few months, for the first time in my life. It required speed and discipline. Perhaps two people could be painted fast enough for them actually to sit together. After some single portraits, stretching them on to two sheets of paper I worked out a method to use and developed it. There are losses and gains in any medium, but I thought the gains here far surpassed the losses.'

Mike Izzo IV 2003

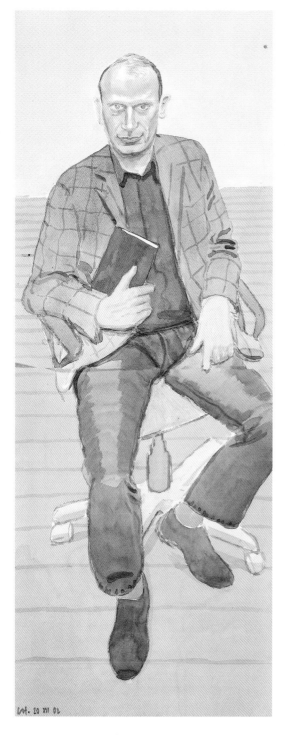

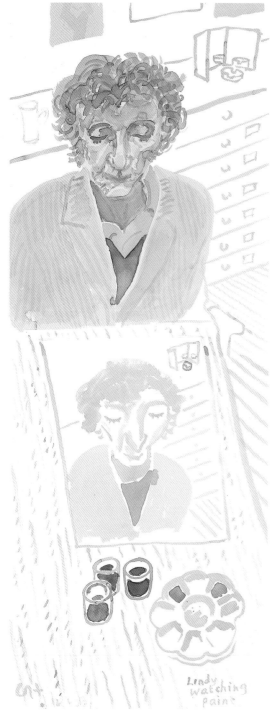

Andrew Marr 2002

Lindy Watching Paint Dry 2003 243

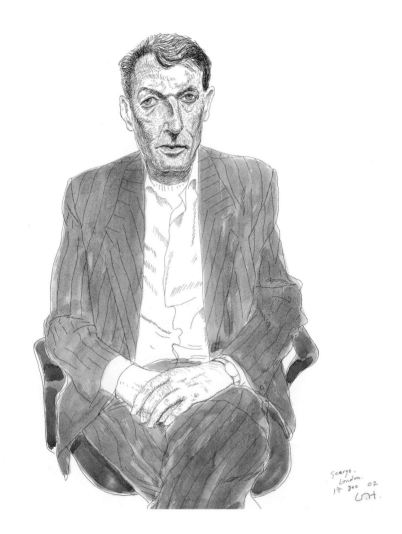

George Mulder 2002

'The watercolours are made with the sitters in front of you.... Right from the beginning, I go from one face to the other.... If one becomes aware you're working on the other, that person might relax a bit.... I'm aware of all that, I'm observing all the time. So it's also about duration.'

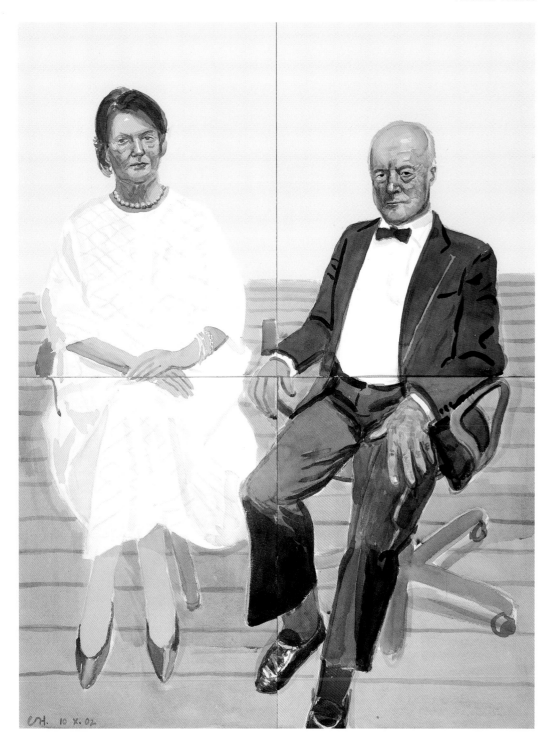

George and Mary Christie 2002

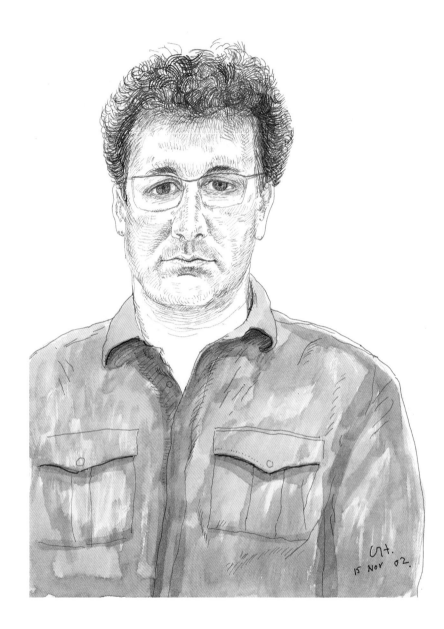

Randall Wright 2002

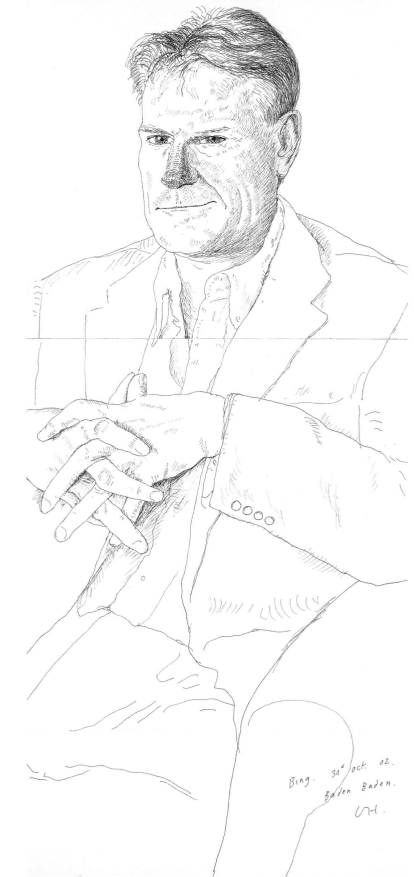

Bing, 30ᵗʰ oct. 02.
Baden Baden.

Bing, Baden Baden 2002

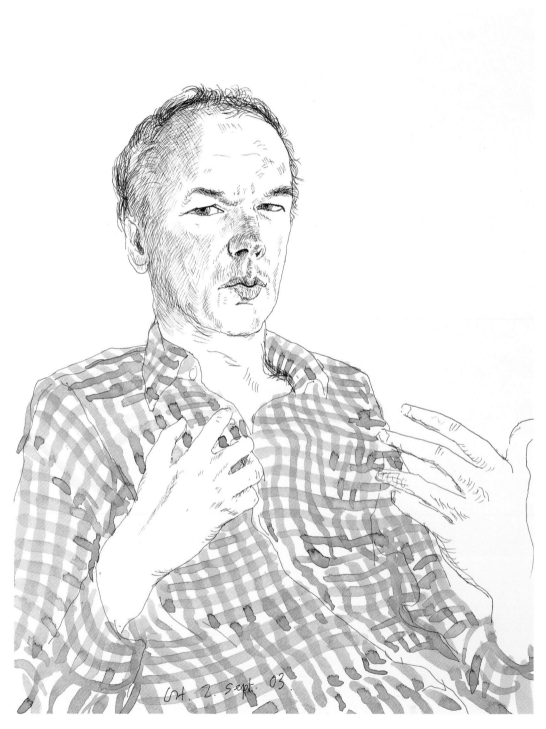

Francis Russell 2003

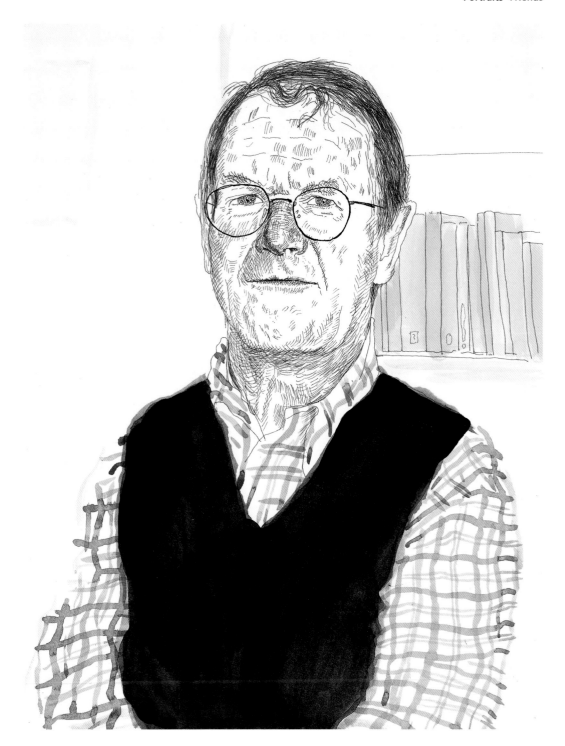

Jeremy Lewis, Como, April 2004 2004

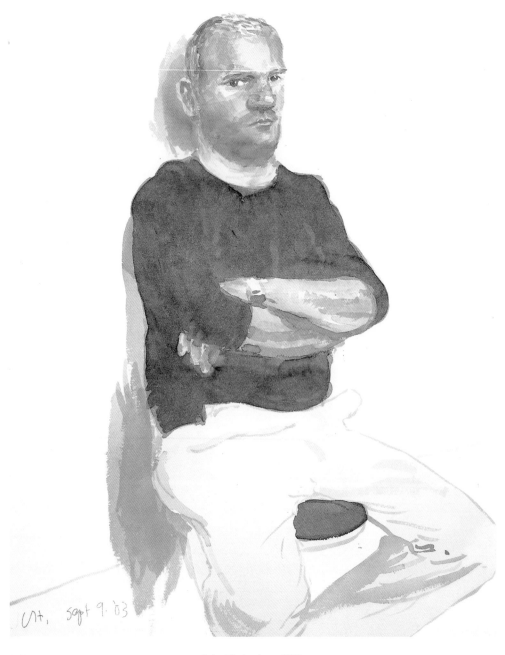

John Fitzherbert 2003

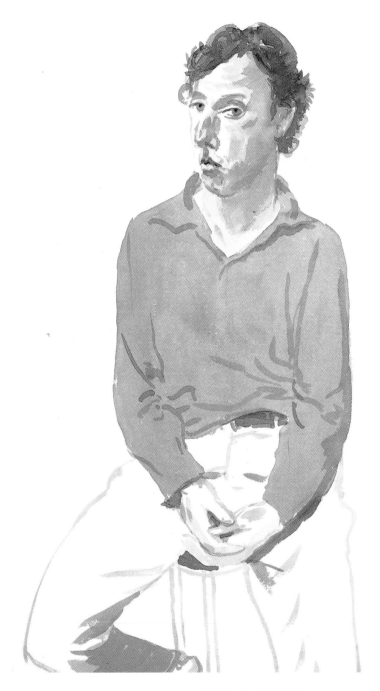

UTH. 8 sept 03

Gregory Evans II 2003

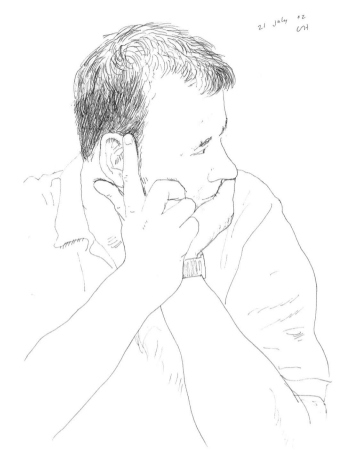

'I never talk when I'm drawing a person,
especially if I'm making line drawings.
I prefer there to be no noise at all
so I can concentrate more.'

John Fitzherbert 2002

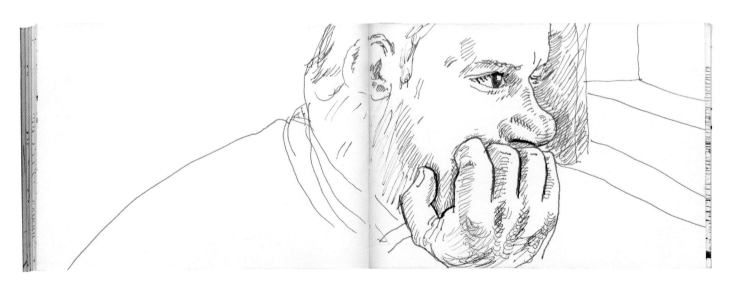

Sketchbook page: 'John' 2003

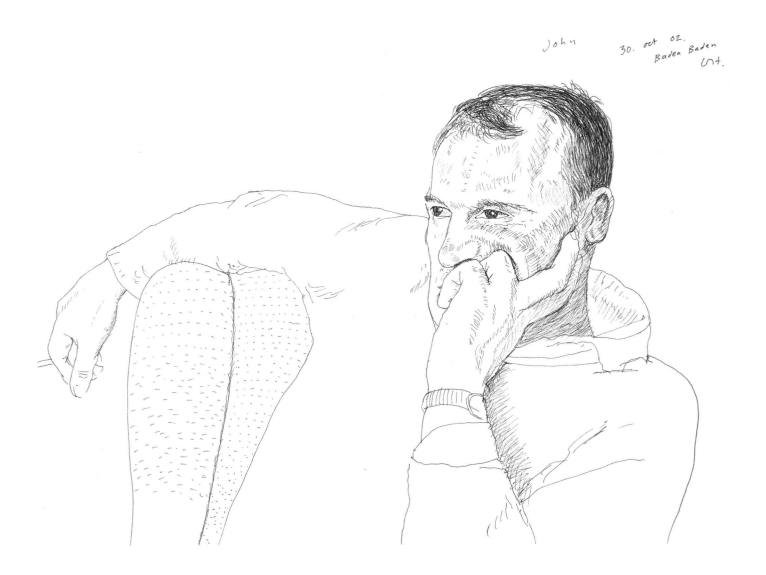

John 30. oct 02.
Baden Baden

John Fitzherbert, Baden Baden 2002

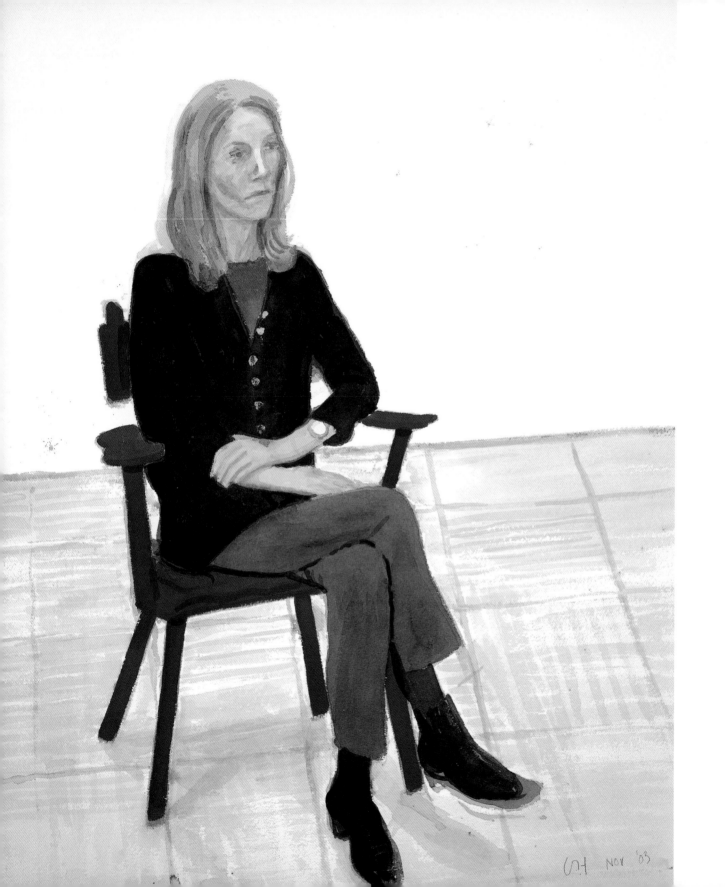

CH NOV '03

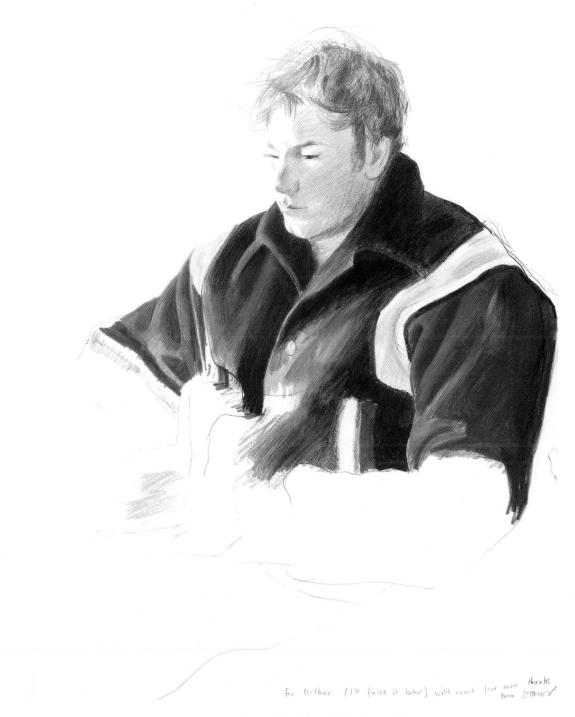

Larry Stanton, Wearing a Colourful Baseball Jacket 1976

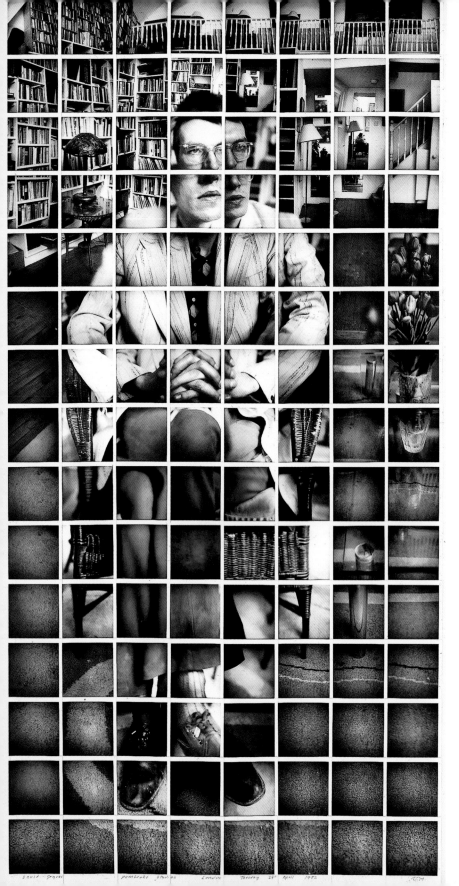

David Graves, Pembroke Studios, London,
Tuesday, 27th April 1982 1982

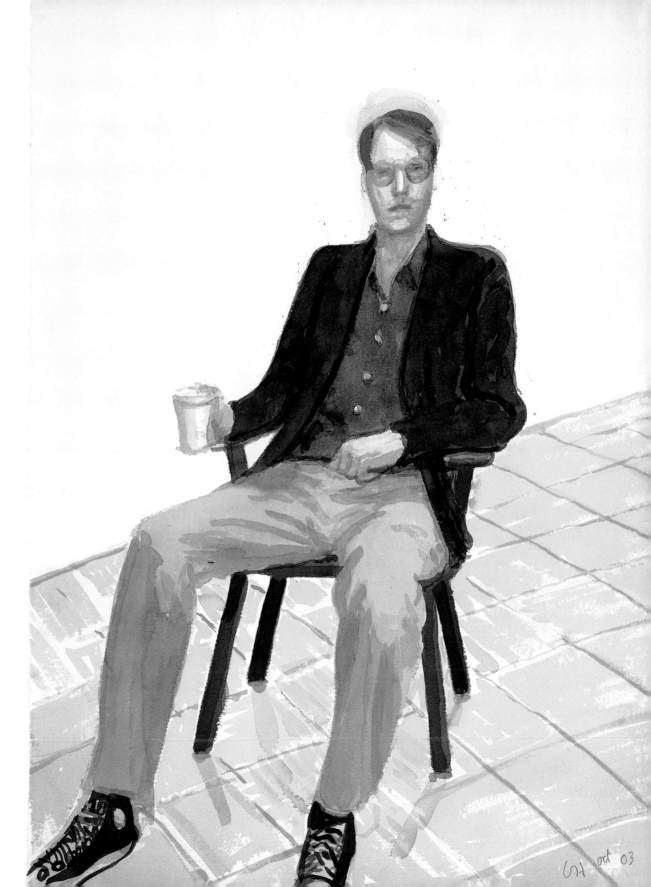

David Graves 2003

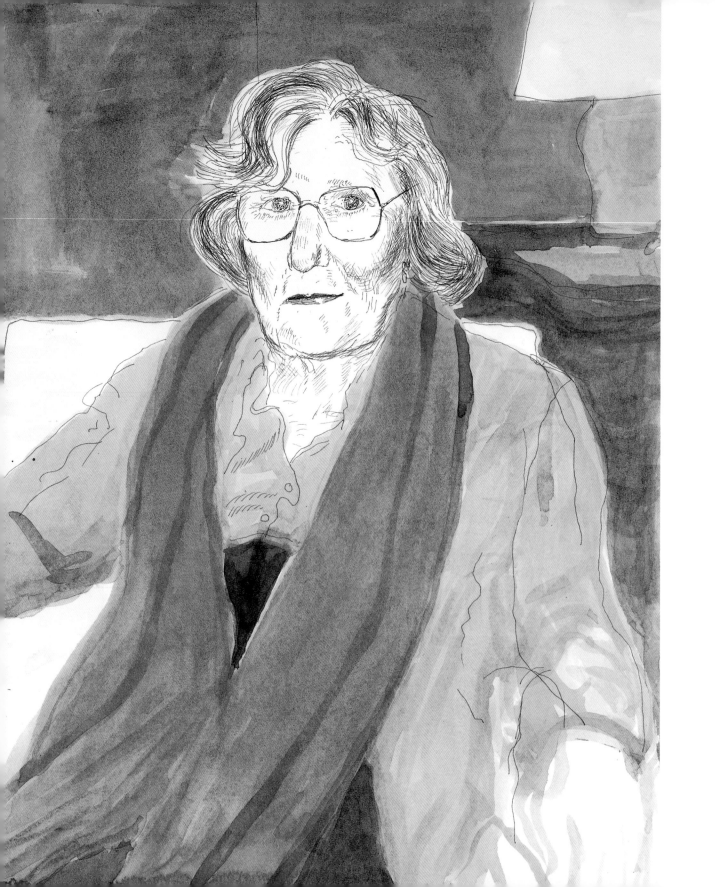

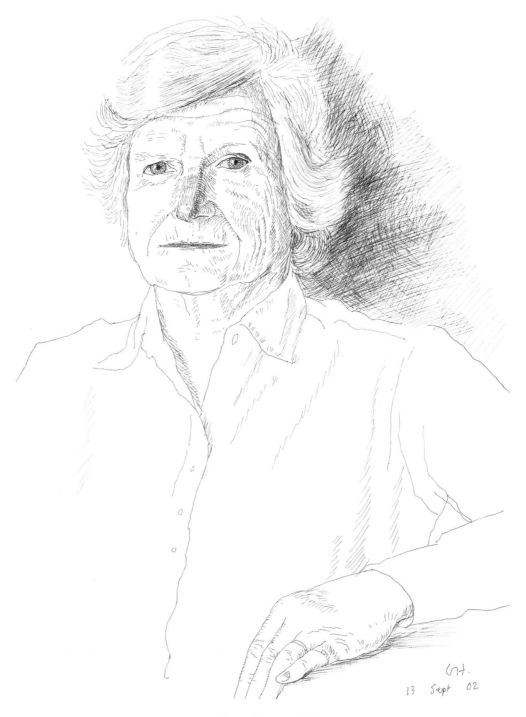

13 Sept 02

Lady Northbourne 2002

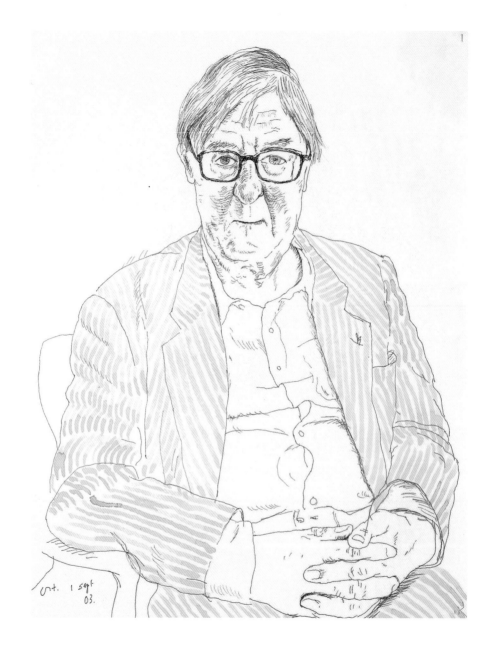

Derwent May 2003

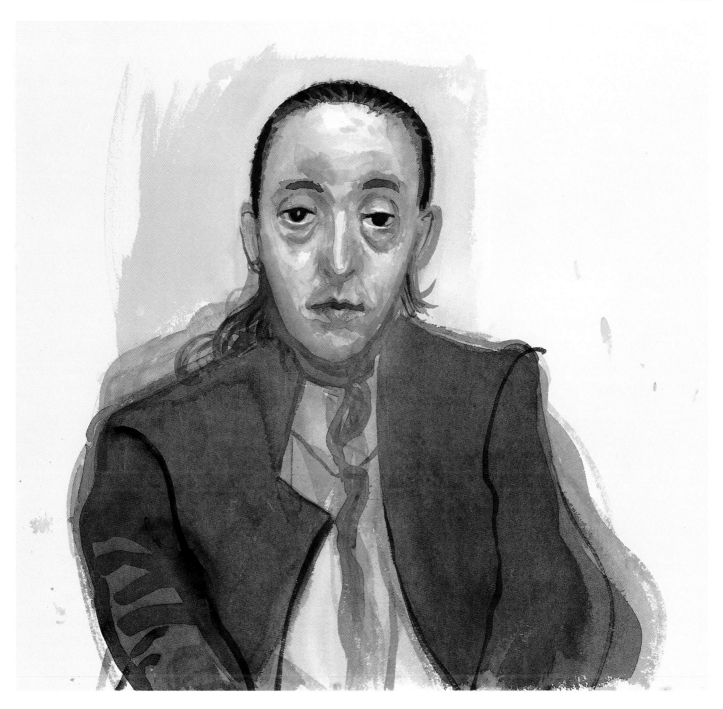

Manuela Rosenthal 2004

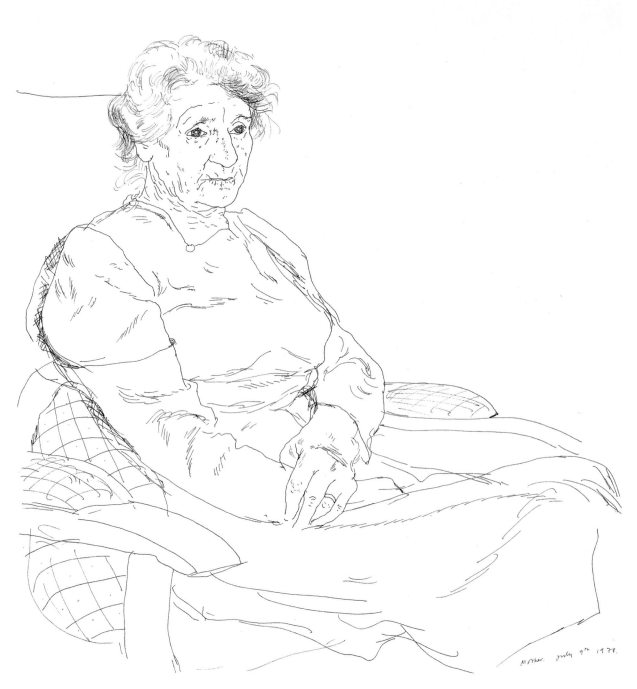

Mother, July 9, 1978 1978

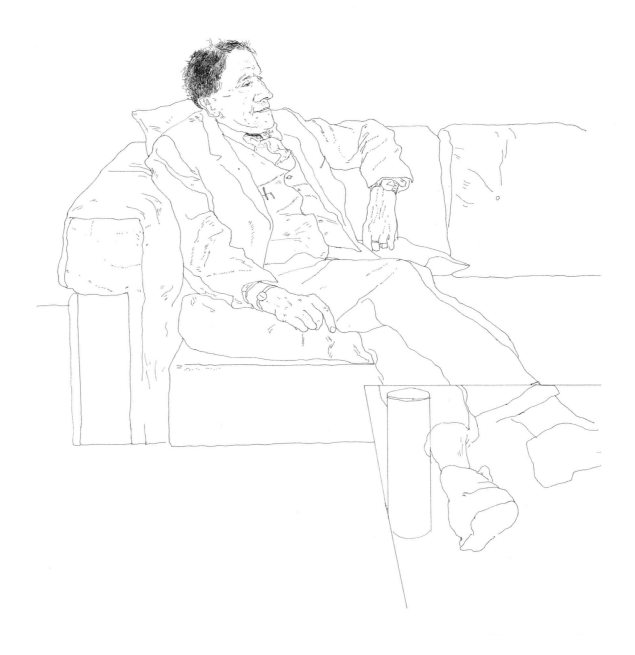

The Artist's Father 1972

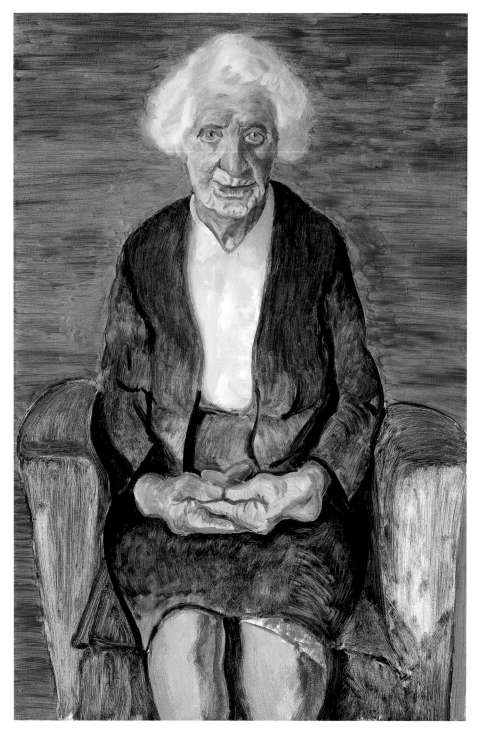

Mum, 1990 1990

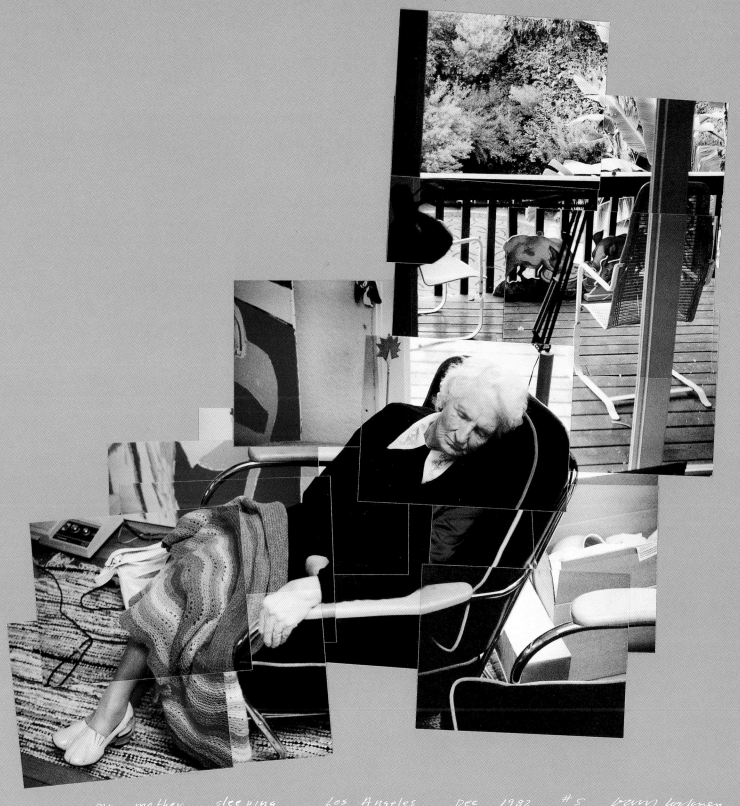

my mother sleeping Los Angeles Dec 1982 #5 David Hockney.

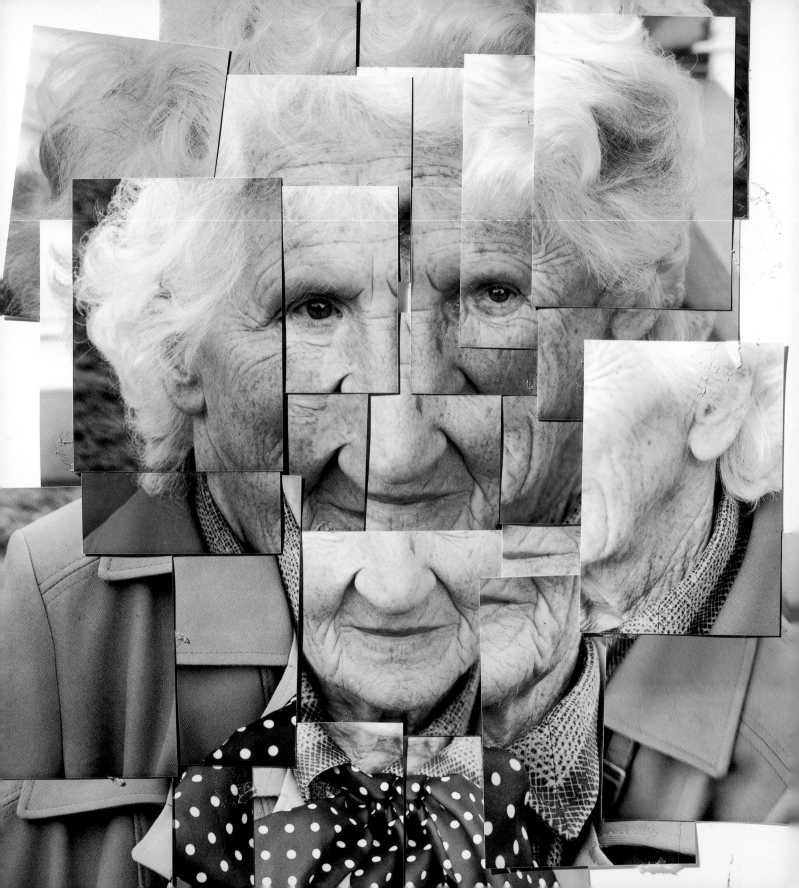

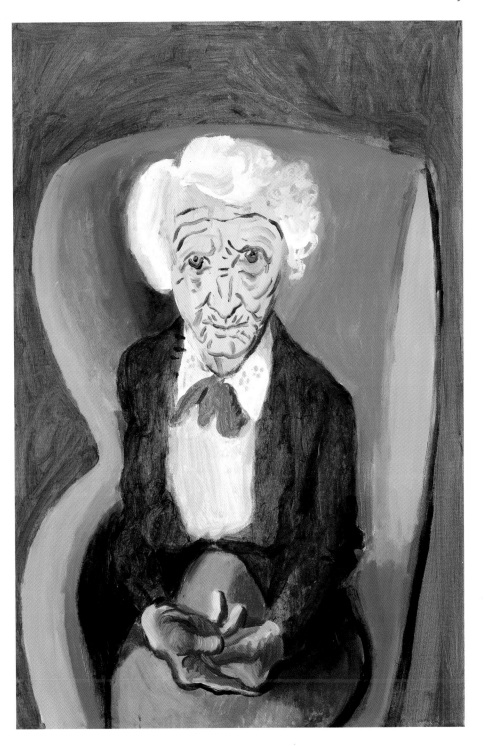

My Mother, Bridlington 1988

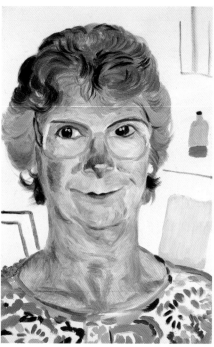

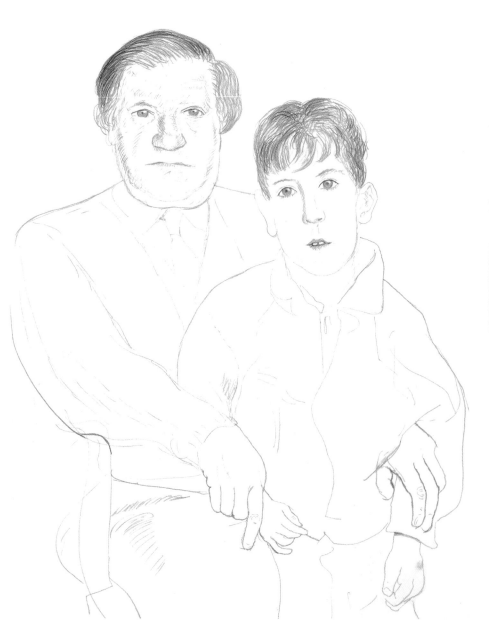

Paul Hockney and Grandson Timothy, 7 March 94 1994

Jean Hockney 1989

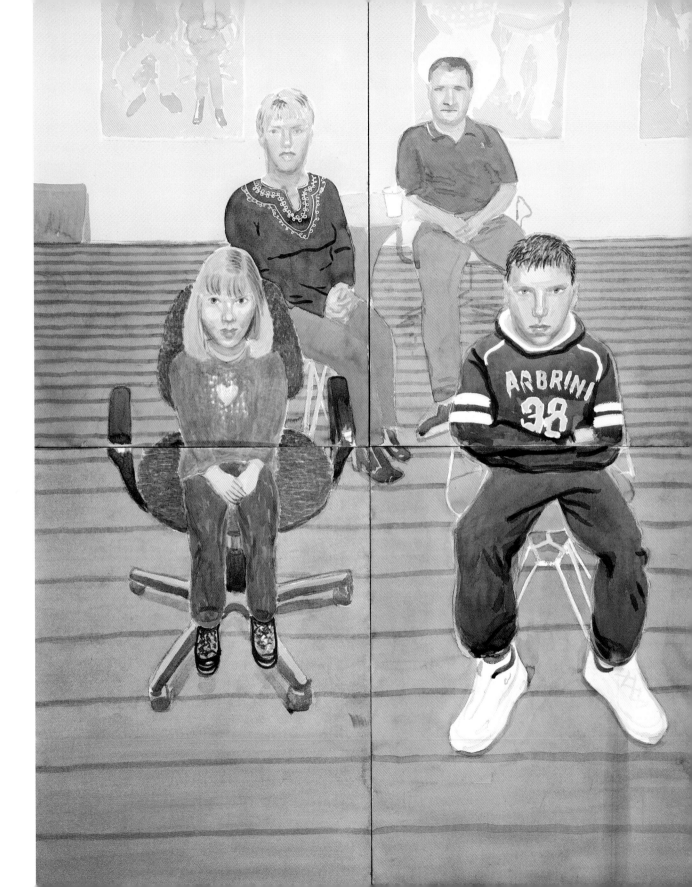

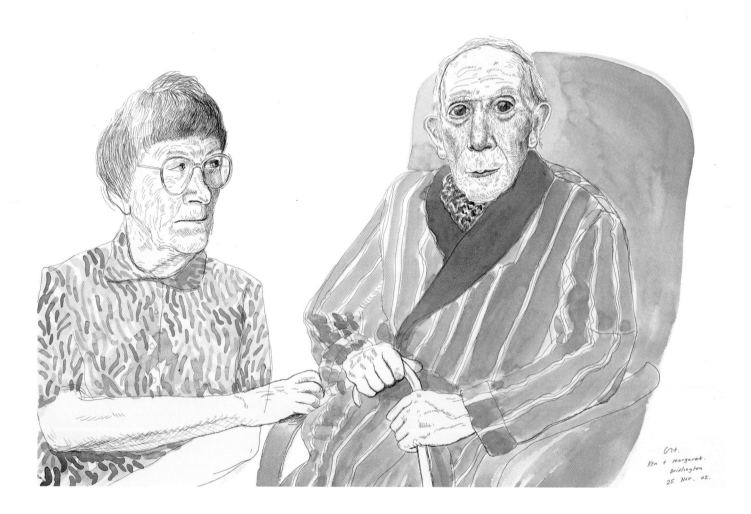

Margaret and Ken 2002

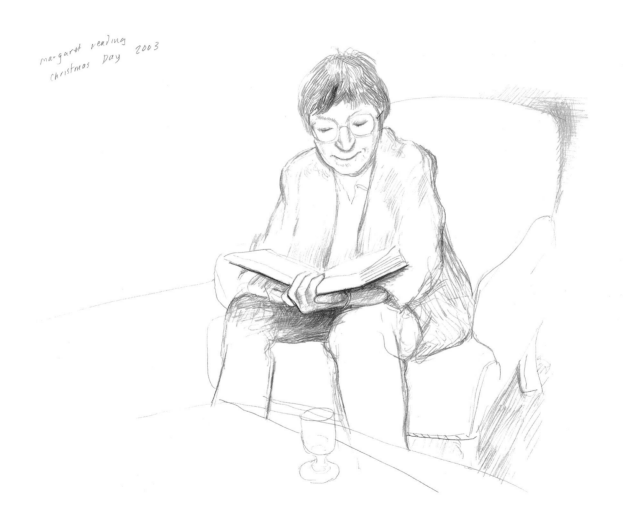

margaret reading
christmas Day 2003

Margaret Reading, Christmas Day 2003

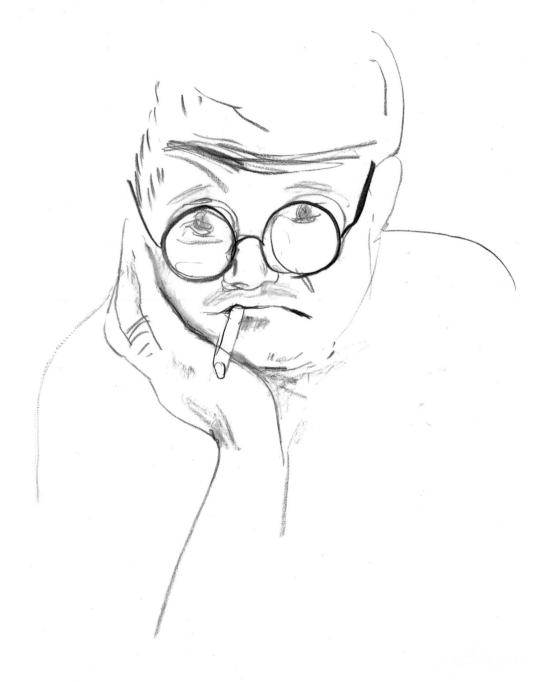

'Every few years I do a
series of self-portraits –
I've been doing them
since the fifties. There
was a rash of them in
1983, when I suddenly
became more aware
of aging.'

Self-portrait with Cigarette 1983

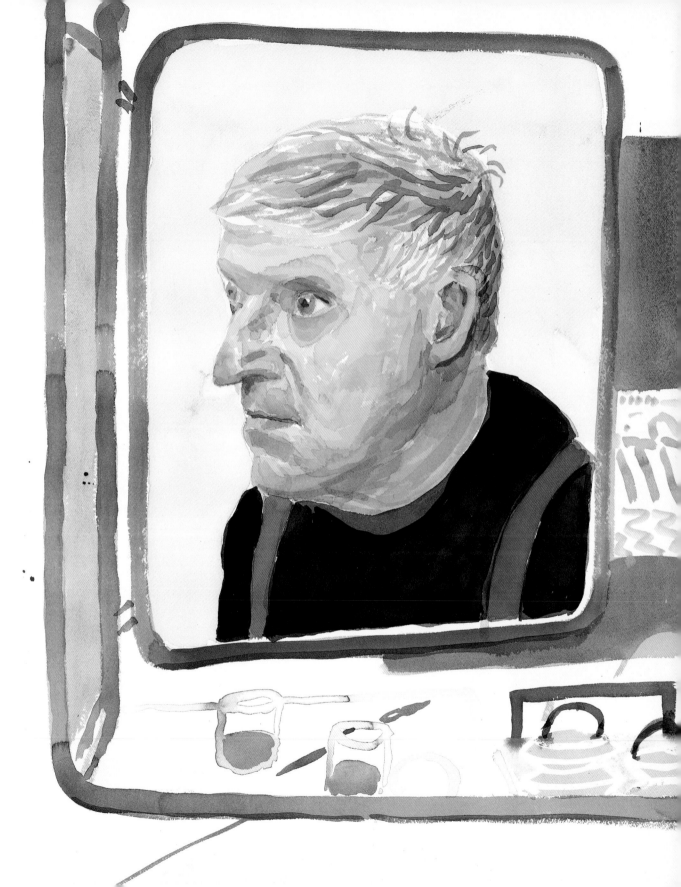

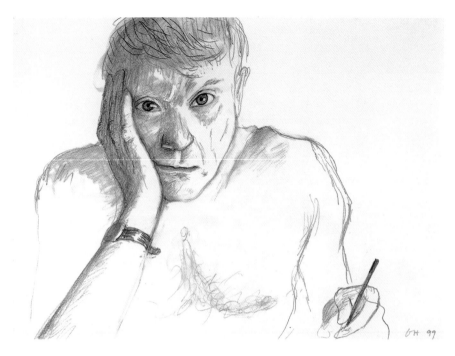

Self-portrait, Baden-Baden, 8th June 1999 1999

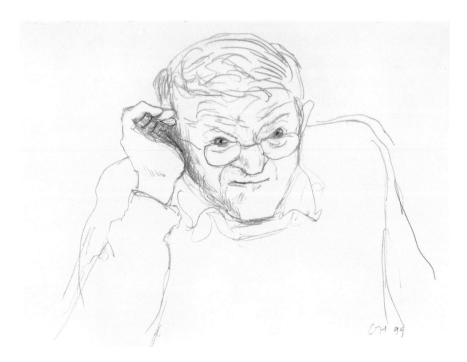

Self-portrait, Baden-Baden, 9th June 1999 1999

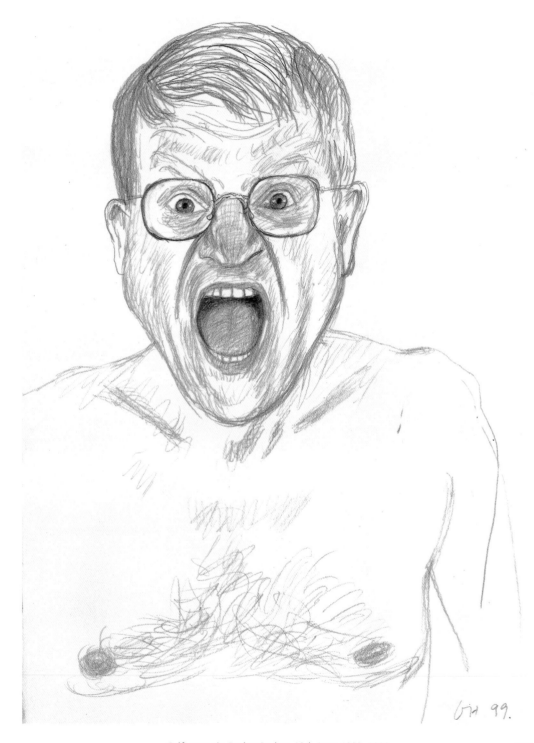

Self-portrait, Baden-Baden, 10th June 1999 1999

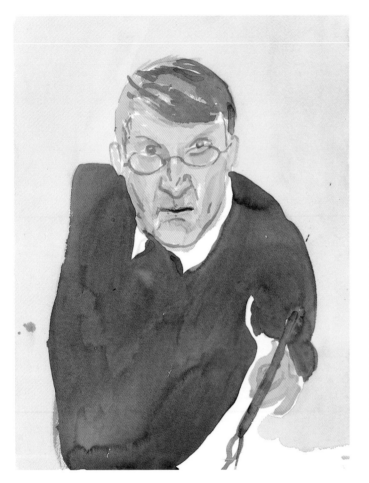

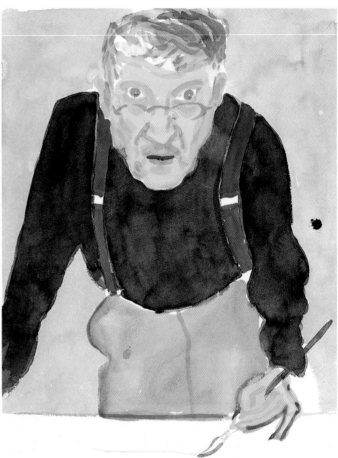

Self-portrait in Black Sweater 2003

Self-portrait with Red Braces 2003

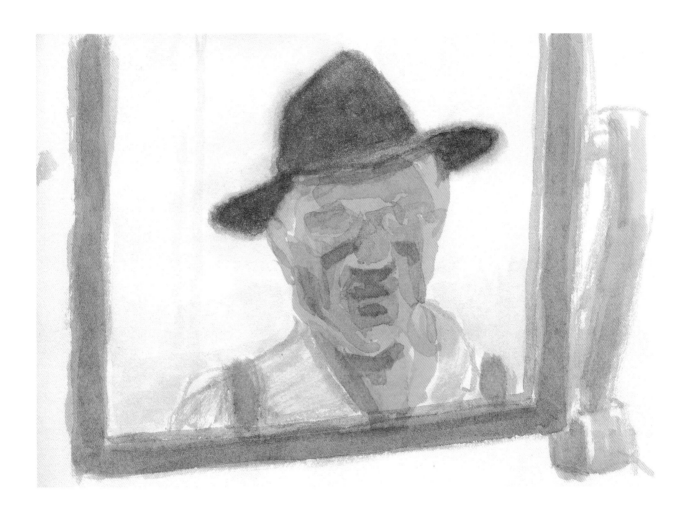

Sketchbook page: 'Self-portrait' 2002

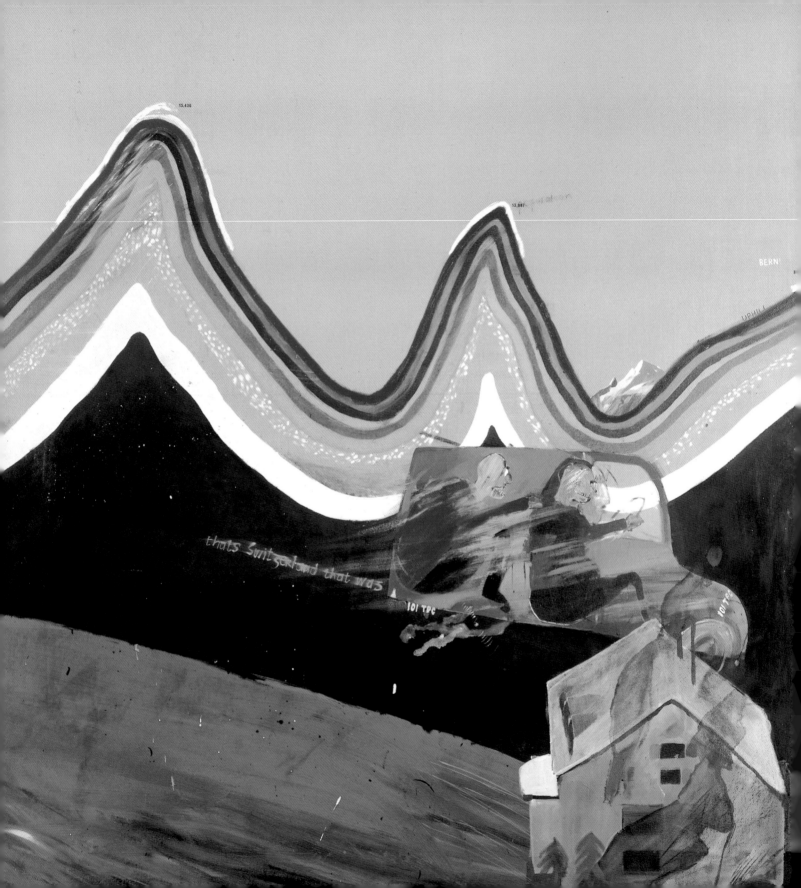

that's Switzerland that was

Space and Light

Space and light have been two of Hockney's lifelong preoccupations. Ever since his childhood days when he escaped the streets of Bradford and explored the moors of Yorkshire on foot and on bike, he has been drawn to the landscape. In California, he found the open expanses and bright light he yearned for, and he soon settled there. But he would make frequent expeditions across the world in search of new ways of depicting space and capturing fleeting light and weather conditions.

His quest has taken him far and wide. In Egypt, the history of the country excited him to paint the famous monuments in the ancient Valley of the Kings, while the bustling streets of the modern Egyptian town fired his youthful imagination. On a trip to China with the poet Stephen Spender, he was entranced by the magical spirit of the east and produced a evocative visual diary of the journey. And whether it be in Seville or Cordova in Spain or in a quiet French or Italian street, the sun and warmth of southern Europe have long attracted him, the strong, undiluted light being a constant inspiration. In the north, in Scandinavia and Iceland, the muted and changing atmosphere presents different challenges and demand different techniques.

Hockney first painted the vast lands of the American West when he arrived in the early sixties. Later works such as *Pacific Coast Highway and Santa Monica* (pages 308–9) and *Nichols Canyon* (page 306) convey with ease the enormous scale of the country he chose as his home, while his wall-sized pictures of the Grand Canyon (pages 310–13) give a dizzying sense of standing on the edge of that gaping void.

As time goes by, Hockney returns increasingly to the places that first thrilled him as a child, the countryside of his native Yorkshire, the landscape of which, with its vast vistas and distant horizons, reminds him of the American West. In works such as *Garrowby Hill* (page 349) and *The Road across the Wolds* (page 347), we have the sensation of sweeping and swooping breathlessly across the land, up hill and down dale, enjoying the beauty of the changing seasonal colours at every turn. In these pictures, as in all his art, Hockney opens up our perspectives and makes us 'see the world bigger'.

'It's just taken from a geography book, what the mountains are like, and there's just a little peak of a real one, taken from a postcard, at the back of the flat representation. What looks like a geological band representing the mountain was influenced by the 1962 paintings of Harold and Bernard Cohen.'

Flight into Italy – Swiss Landscape 1962

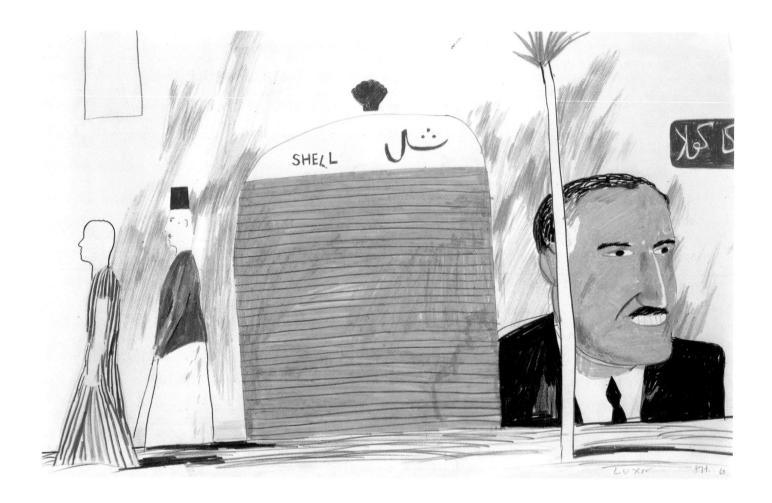

'Egypt is one of the most thrilling countries I've ever been to in the sense that
these monuments are the oldest known buildings anywhere.... I would often
go and sit on the banks of the Nile. In Luxor, where there are lovely sunsets,
I'd sometimes sit and watch the river.... I always find this stimulating
to my imagination. I drew all the time I was there.'

Shell Garage, Luxor 1963

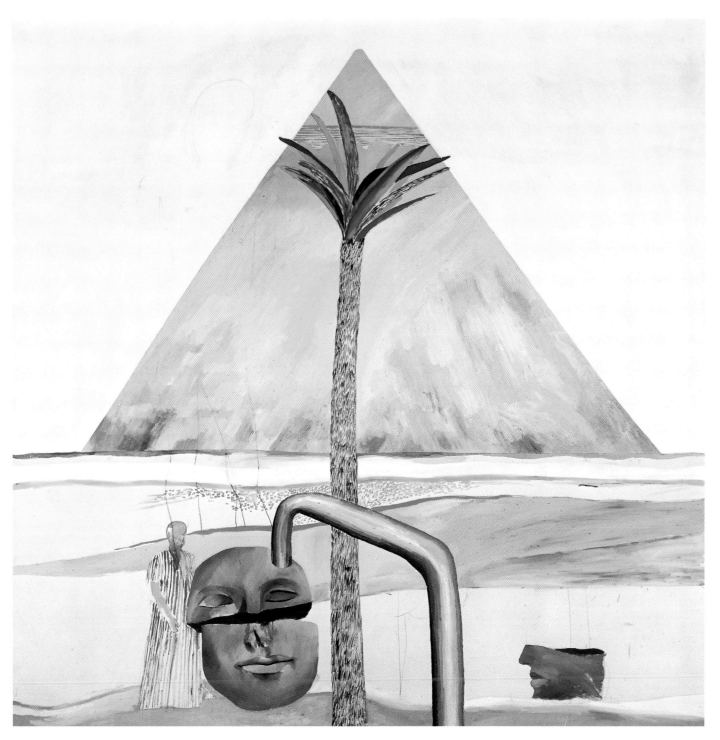

Great Pyramid at Giza with Broken Head from Thebes 1963

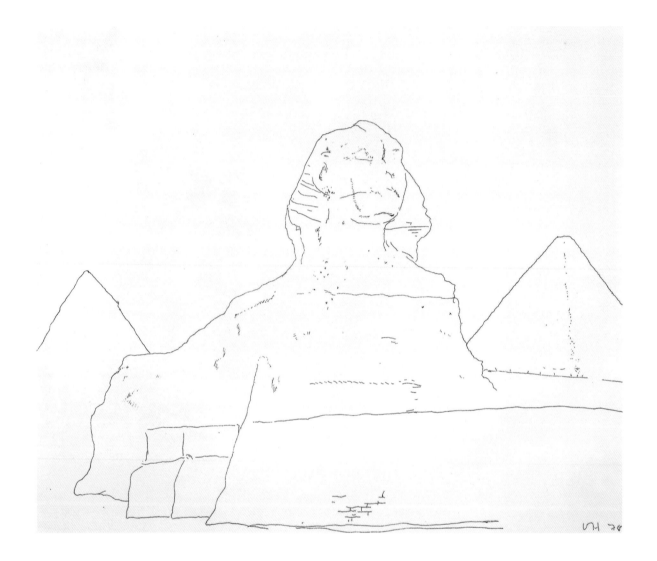

Sphinx in Front of the Pyramids 1978

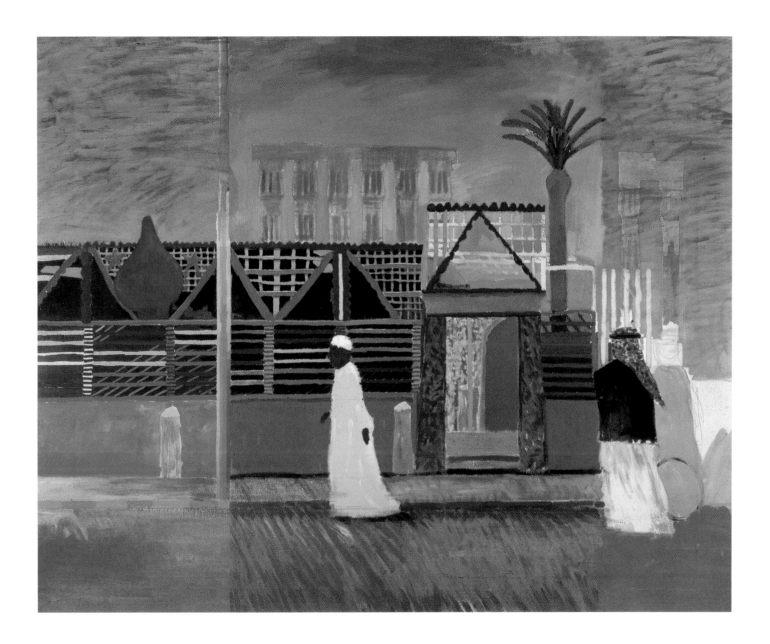

'I like even modern Egypt, the people; my impression of them is that they are
rather gentle.... I made drawings of modern Egypt and when I came back
I painted a picture of a café in Luxor.'

Egyptian Cafe 1978

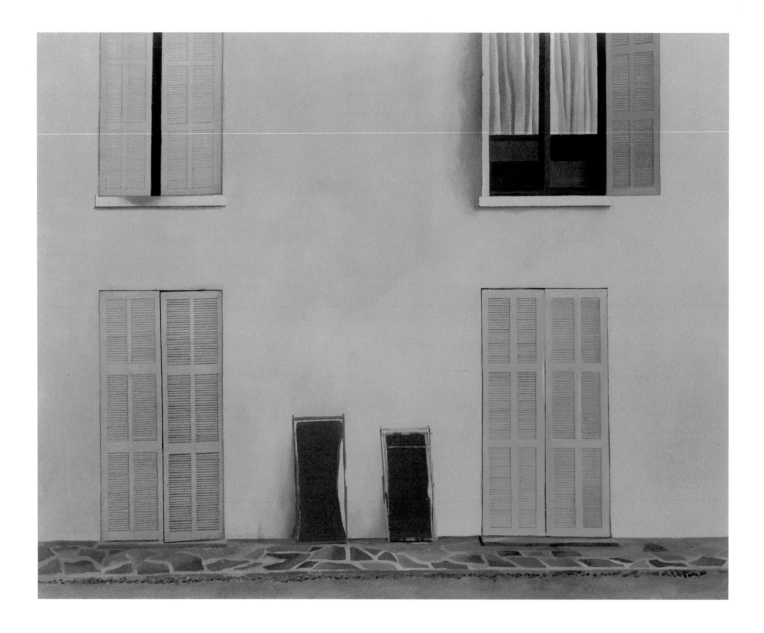

'I painted *Two Deckchairs, Calvi* from a photograph taken when I was in Calvi, in Corsica, for a summer with Henry Geldzahler. Suddenly, seeing the deckchairs closed up for the day and leaning against the wall, I realized they looked even more like poignant sculpture.'

Two Deckchairs, Calvi 1972

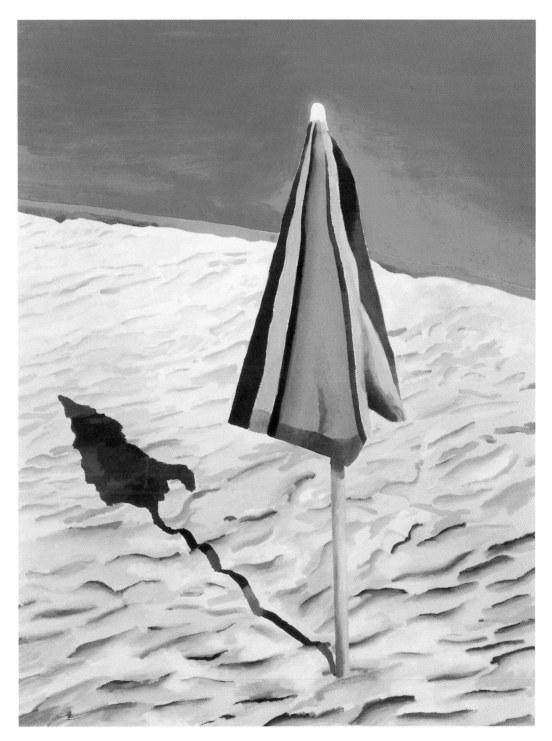

Beach Umbrella 1971

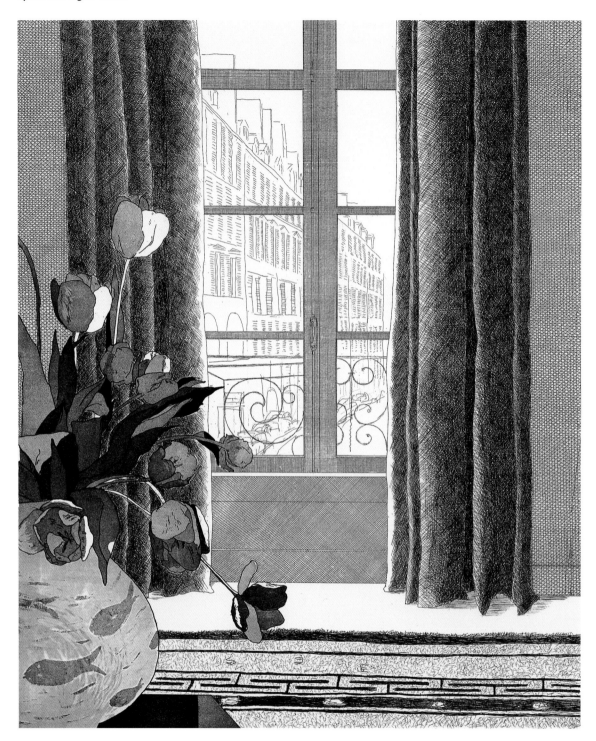

Rue de Seine 1972

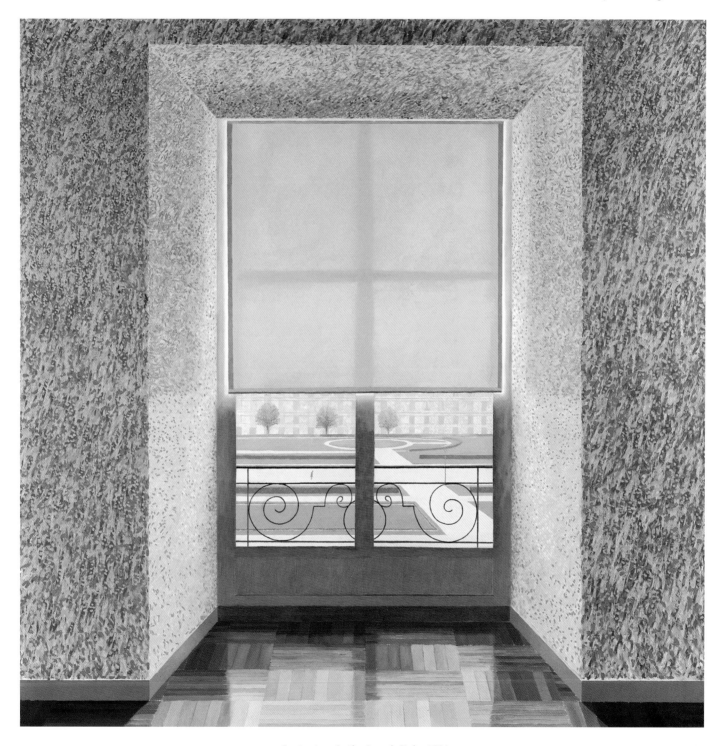

Contre-Jour in the French Style 1974

Place Furstenberg, Paris, August 7th, 8th and 9th, 1985 (detail) 1985

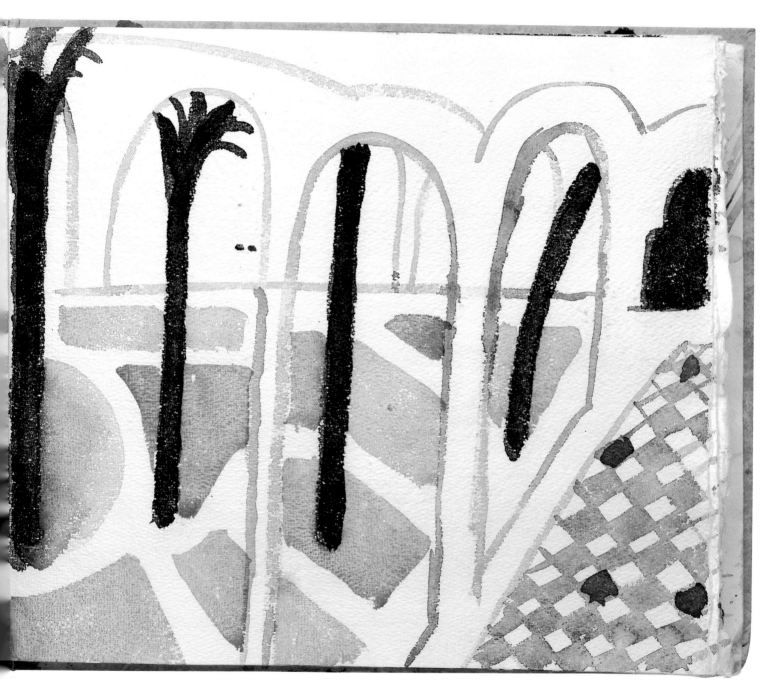

Sketchbook page: 'Courtyard, Seville' 2004

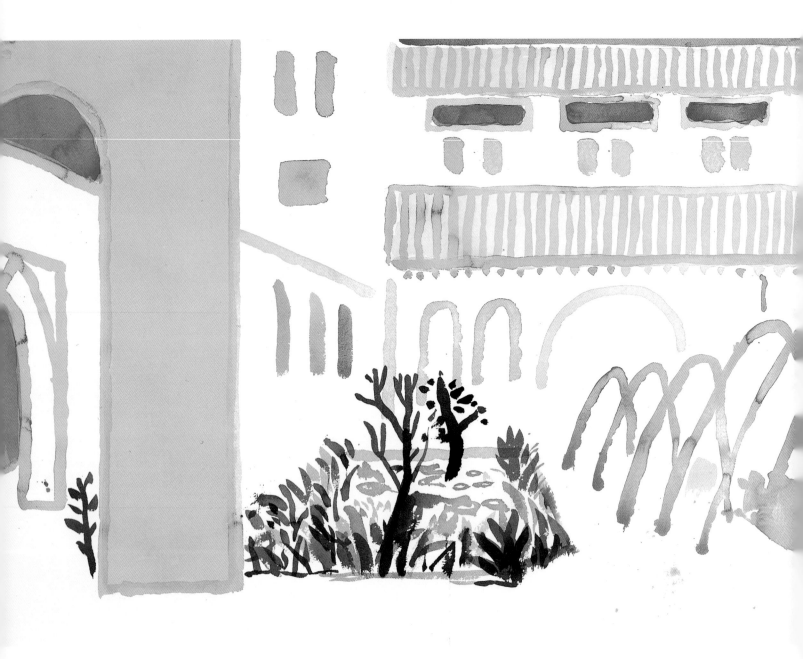

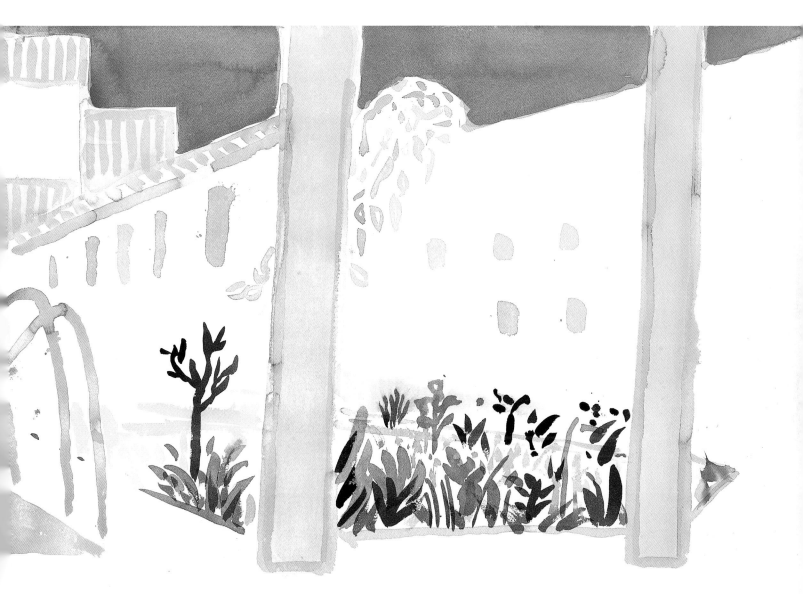

Andalucia. Fountain, Alhambra, Granada 2004

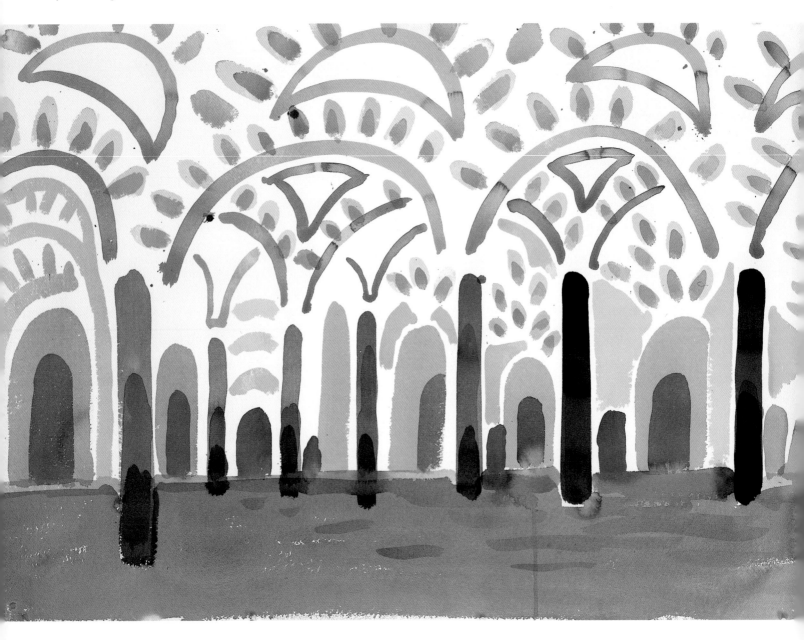

'I went to every place the tourists go. I went off season, so there were
not too many tourists. You should go south in winter and north in
summer, as Queen Victoria did, and she was right. You get great light.'

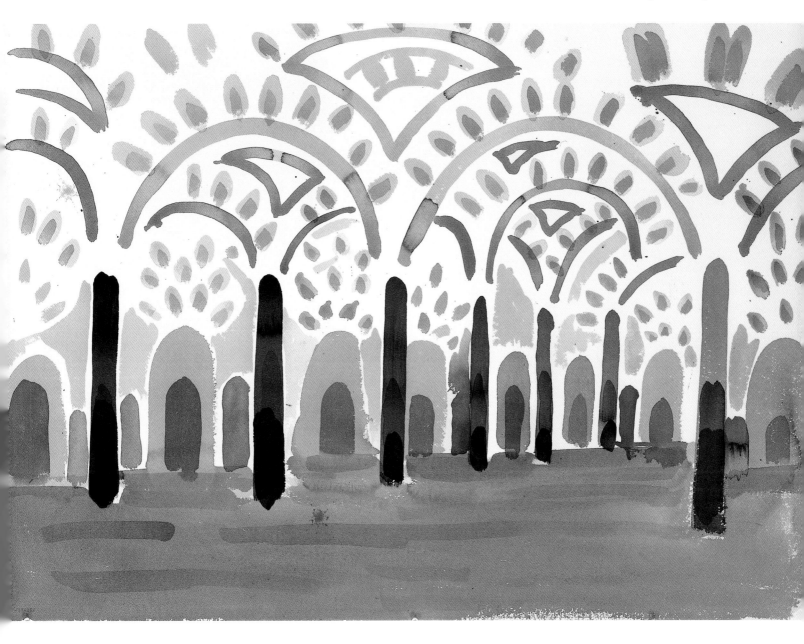

'Sometimes I painted from memory. Sometimes there,
responding to the space. I wouldn't look through cameras.
I took a large brush and responded to the space.'

Andalucia. Mosque, Cordova 2004

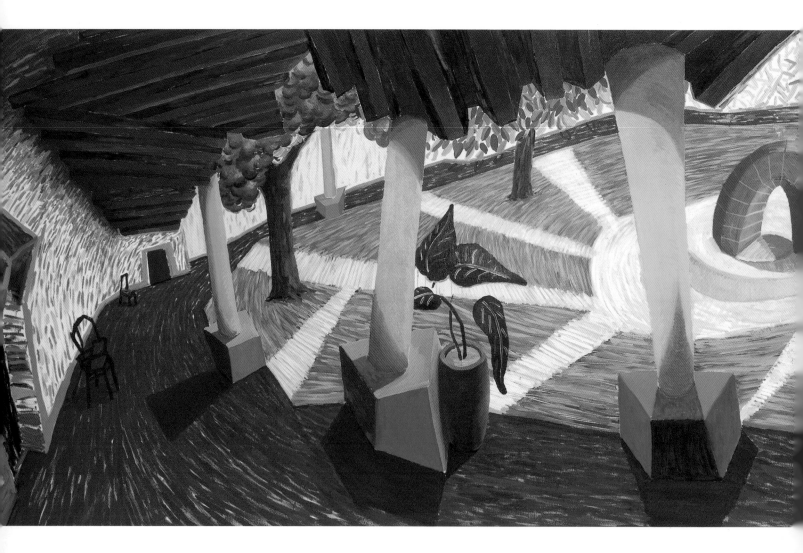

'*A Walk* is not about a hotel, but about an attitude to space. At the same time as you acknowledge the spaces outside, you are still moving round in it. The longer you look, the more spatial it gets.'

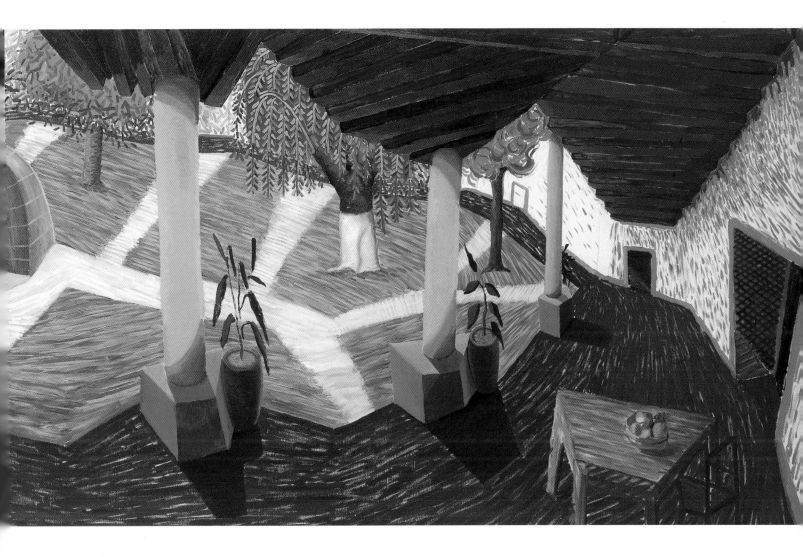

A Walk around the Hotel Courtyard, Acatlan 1985

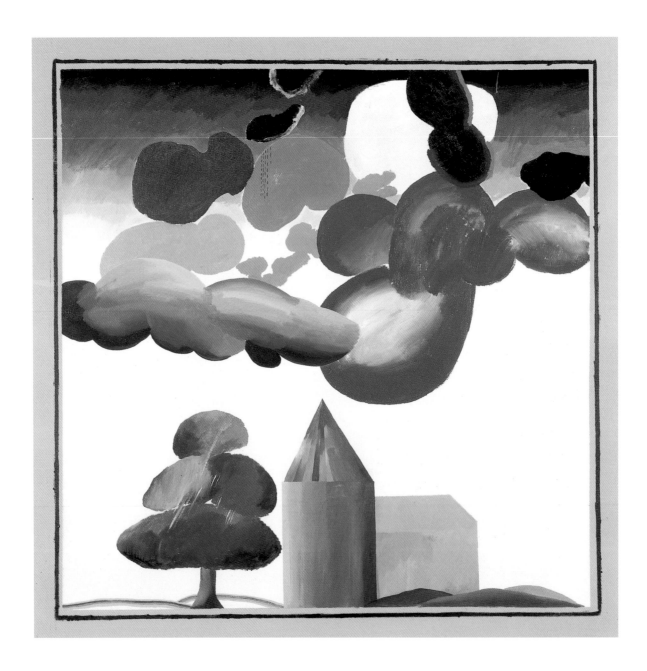

Iowa 1964

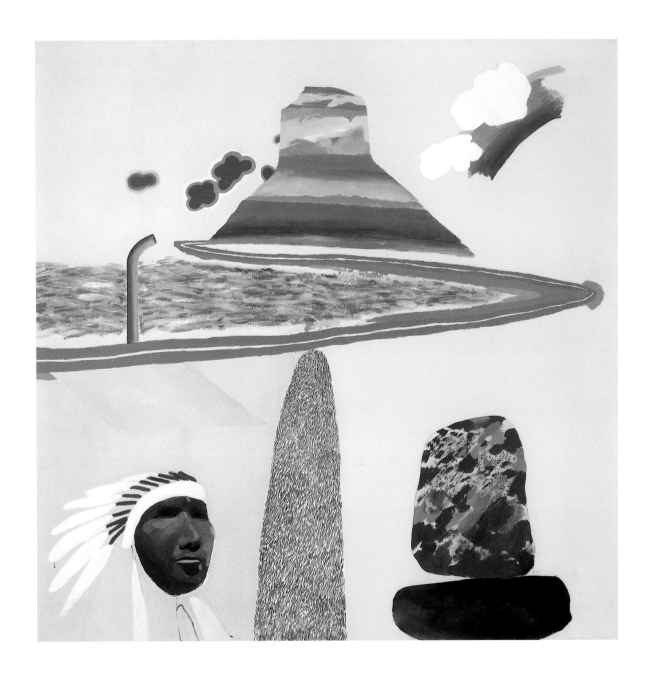

Arizona 1964

'The whole picture is an invention from geological magazines and romantic ideas (the nearest Indians are at least three hundred miles from Boulder, an attractive campus on the edge of the Rocky Mountains where I was teaching at the time). The chair was just put in for compositional purposes, and to explain its being there I called the Indians "tired". In the bird, there's a bit of illusion; it's a wooden bird.'

Rocky Mountains and Tired Indians 1965

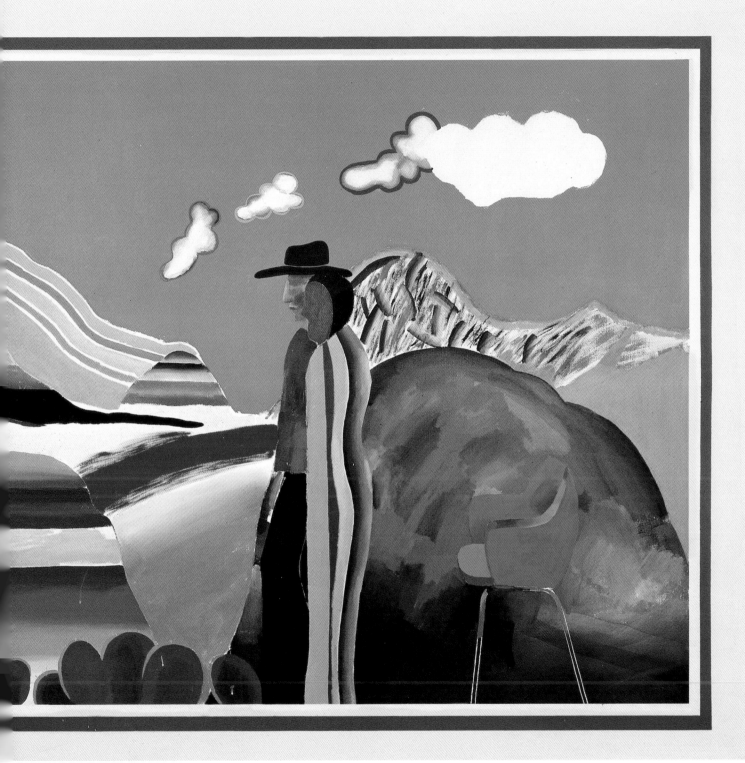

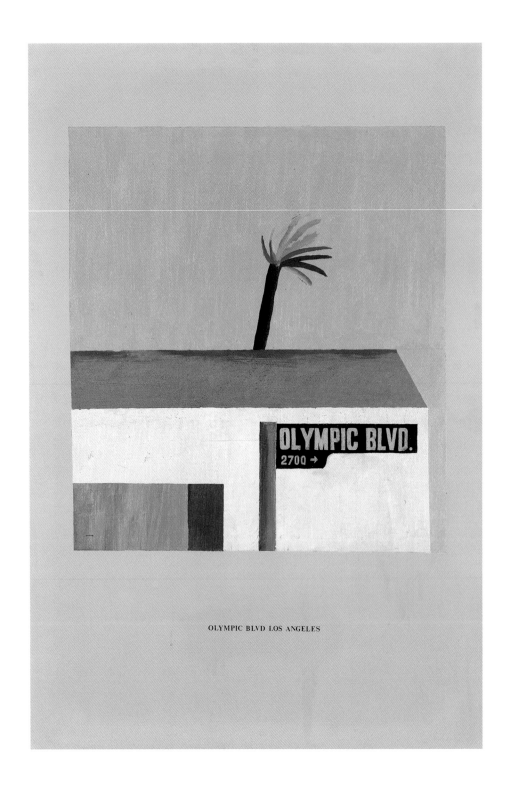

OLYMPIC BLVD LOS ANGELES

Olympic Boulevard 1964

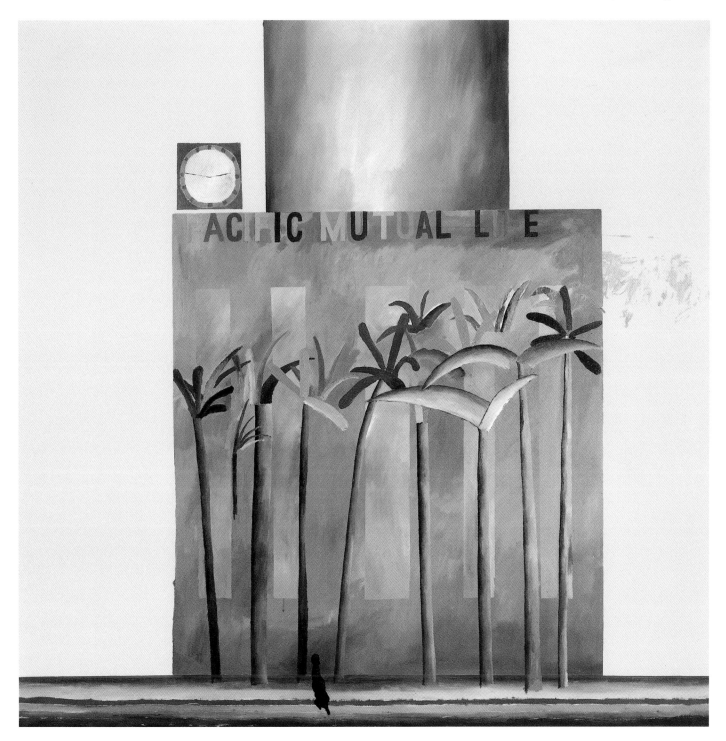

Building Pershing Square, Los Angeles 1964

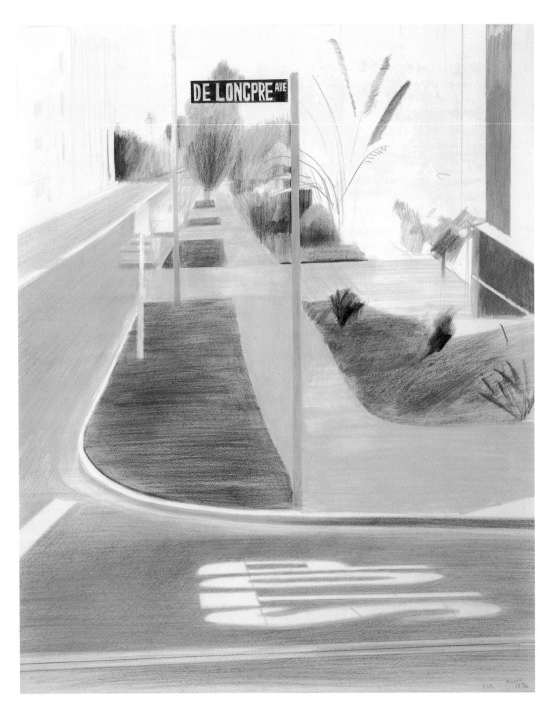

De Longpre Avenue, Hollywood 1976

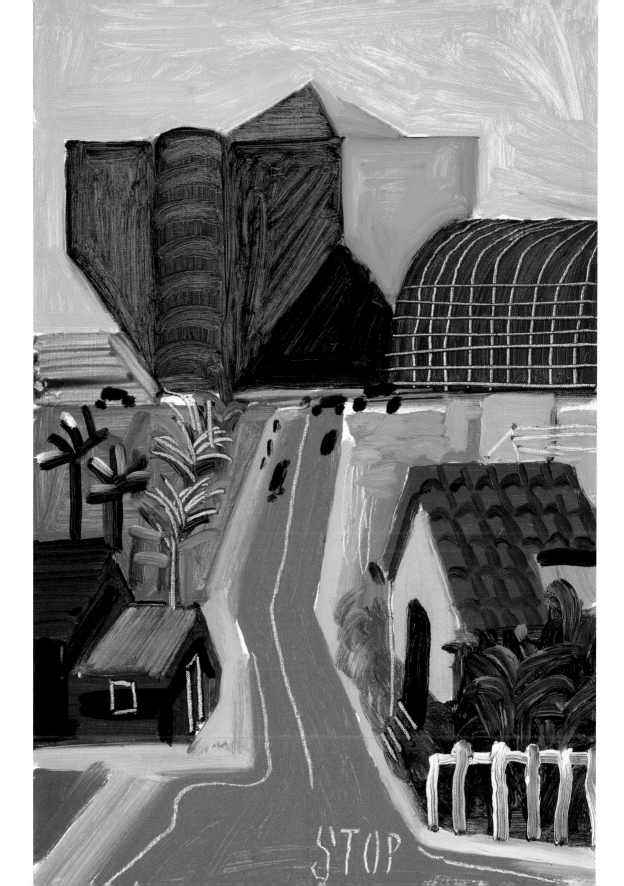

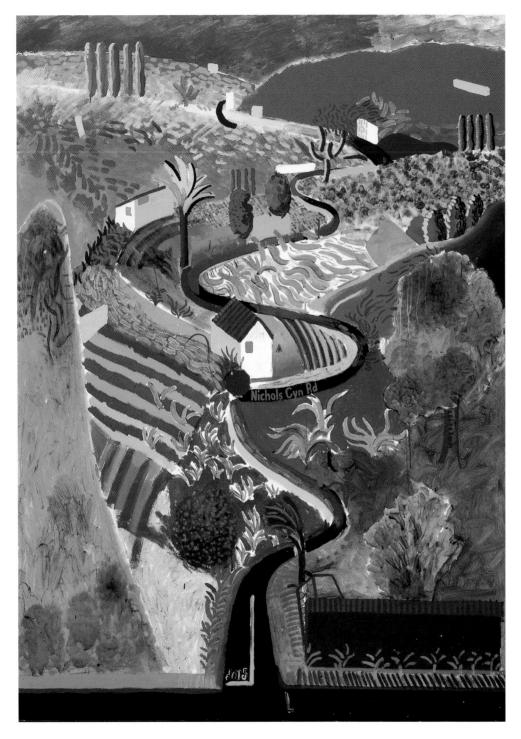

'If you don't know people in the Hollywood Hills you don't come up because it's easy to get lost…. But the moment you live up here, you get a different view of Los Angeles. First of all, these wiggly lines seem to enter your life, and they entered the paintings. I began *Nichols Canyon*. I took a large canvas and drew a wiggly line down the middle which is what the roads seemed to be. I was living up in the hills and painting in my studio down the hills so I was travelling back and forth every day, often two, three, four times a day. I actually *felt* those wiggly lines.'

Nichols Canyon 1980

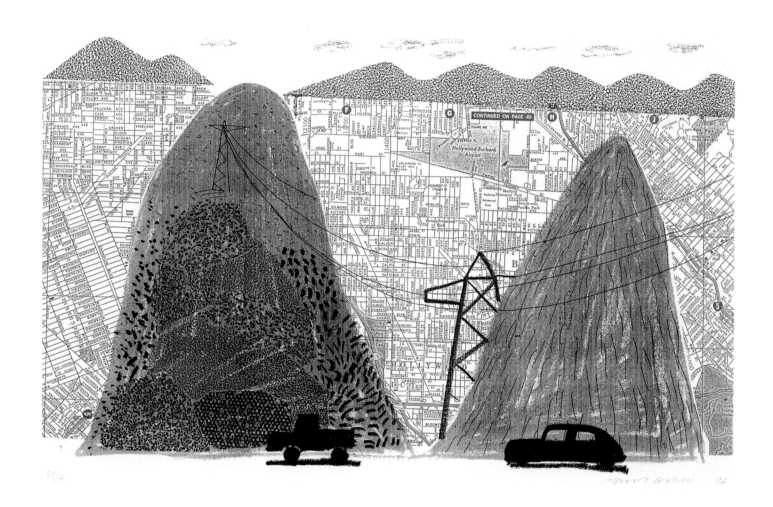

'I often think, you know, why did I go to California all that time ago in the first place? At the time, I always said I'd gone because it was sexy, it was sunny. But Los Angeles is also the most spacey city in the world. You feel the most space. I was always attracted to its spaces as well. Always.'

Mulholland Drive, June 1986 1986

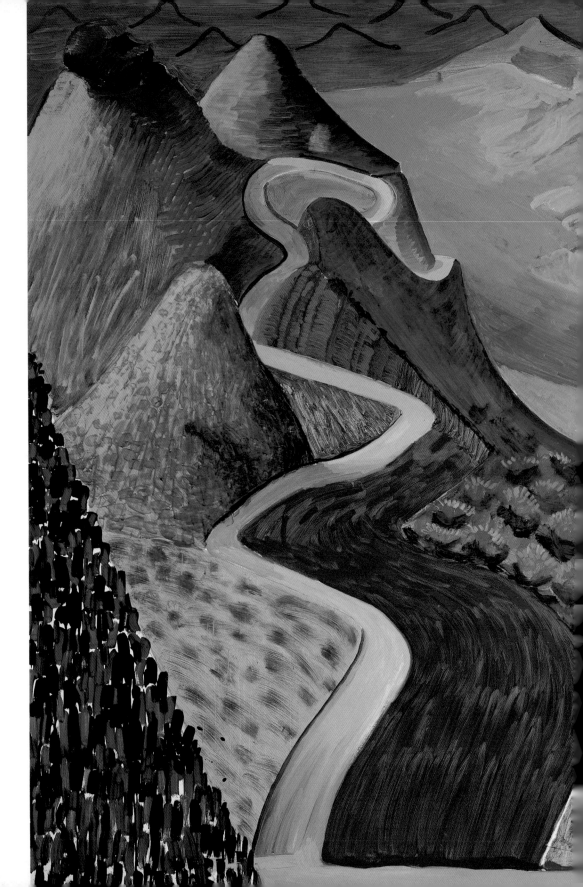

'For anyone who had been on my "Wagner drive", *Pacific Coast Highway* would be recognizable straight away – it is a multiple view of the mountains and Santa Monica bay, the large views you see driving through them.'

Pacific Coast Highway
and Santa Monica 1990

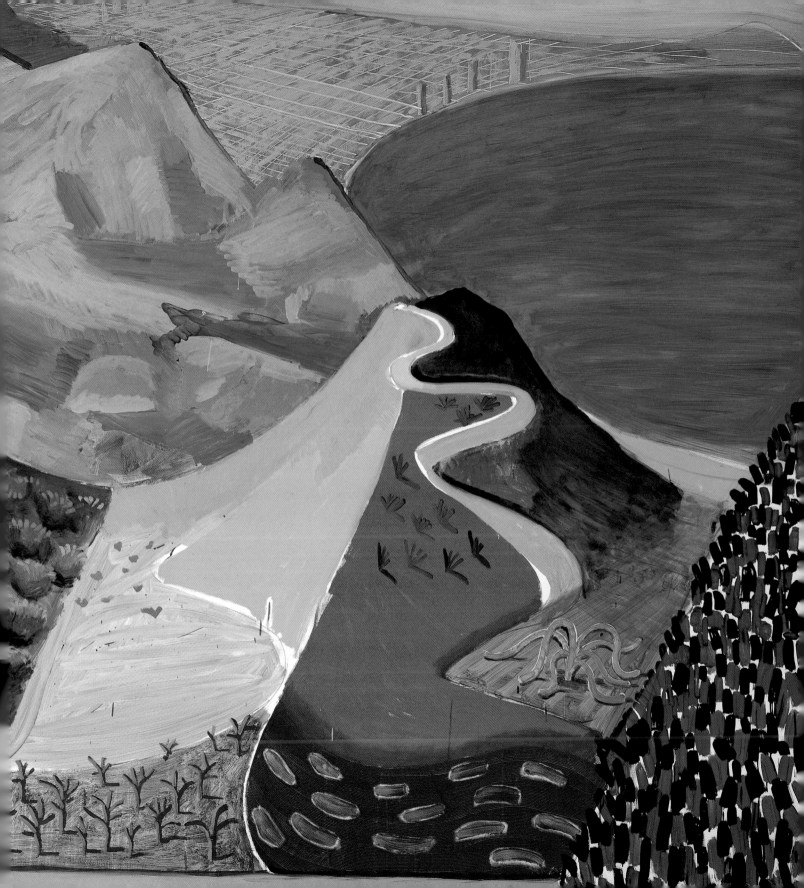

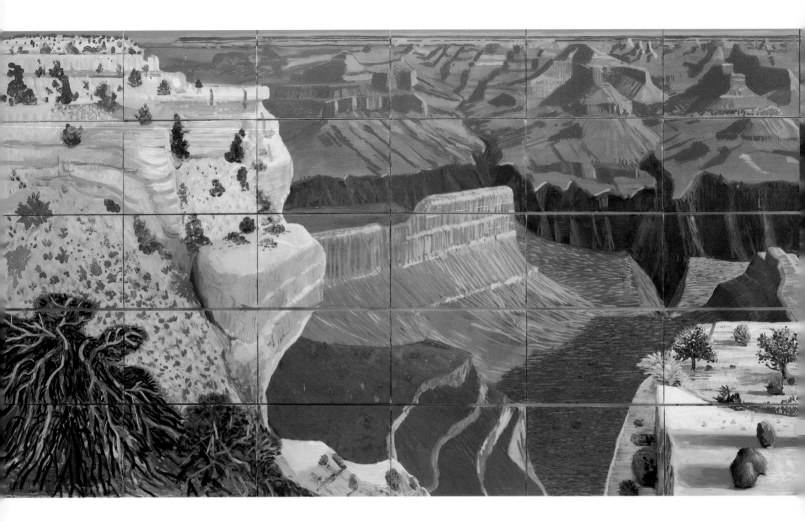

'I decided to do a large wall piece across a grid of sixty small canvases – in part
because it would be more manageable, working in the studio, but also because,
as with the photocollages, such a cubist method, as it were, would allow sixty
separate vantages, sixty separate vanishing points; it would undermine the
one-point perspective and help entice the viewer's eyes to rove about.'

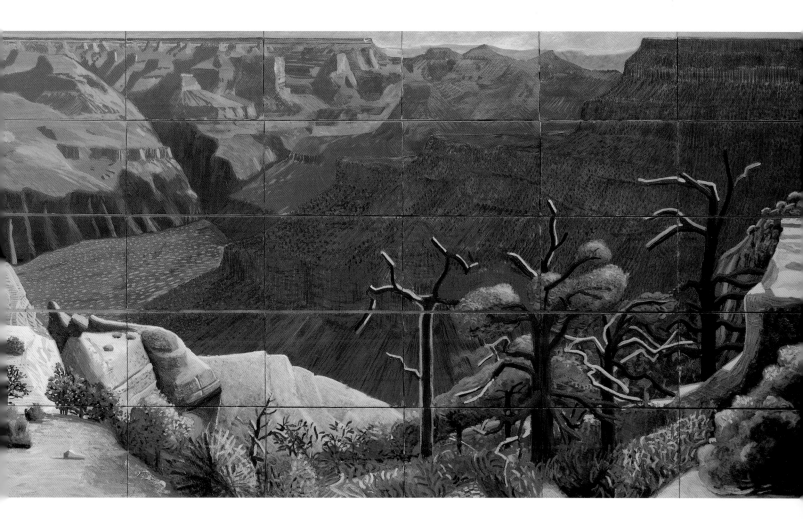

'If you are looking into the Grand Canyon from the edge,
the thrill, I think, is seeing a defined space, a finite space.
I have sat there myself and looked into the Canyon
and felt that as you look, as your eyes move and your
head moves around, you think, what is this space?'

A Bigger Grand Canyon 1998 311

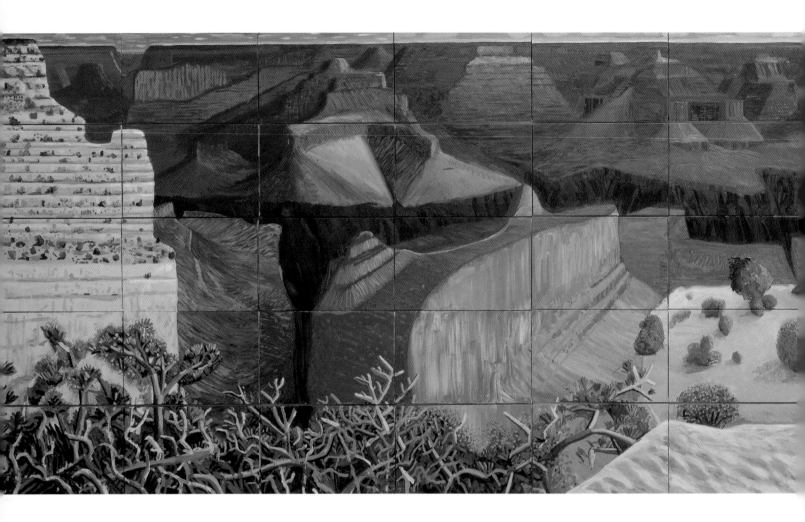

'You're looking probably at a 200-degree angle … where you're looking not just across but down as well, because you're stood on the rim of a very large hole…. Because it's a 200-degree view, it's forced to be about memory, in the sense that once you've turned you've got to remember what you saw, which is part of it. The thrill for me is to be able to see so much space.'

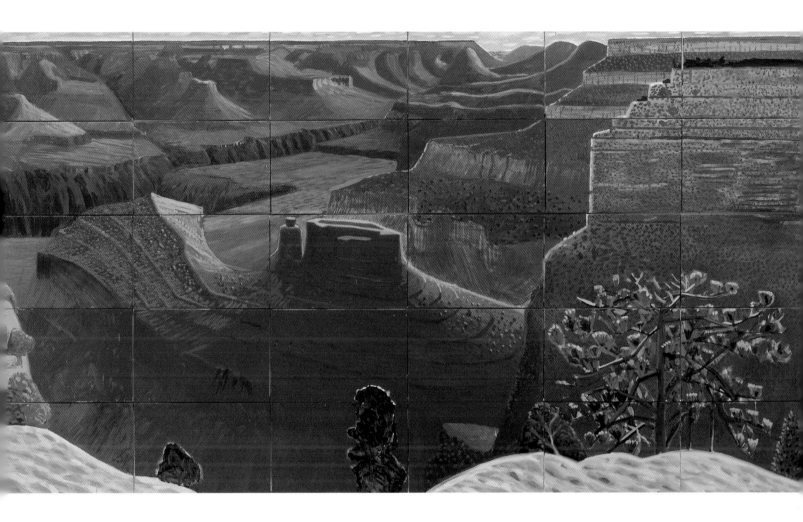

'It is from a specific point of view, Powell Point. It's not necessarily the obvious place, actually. I found a quiet spot for me to sit. The most spectacular is actually further along. There are hundreds of spectacular spots, really. I just found somewhere to put my chair. Most of the time I was alone.'

A Closer Grand Canyon 1998

'In May 1981, Stephen Spender, Gregory and I went to China for three weeks. We had been commissioned to do a collaborative book, *China Diary*.... As time went on my drawings got more and more Chinese: I started using brushes and flicking ink.'

Kweilin Airport, China 1981

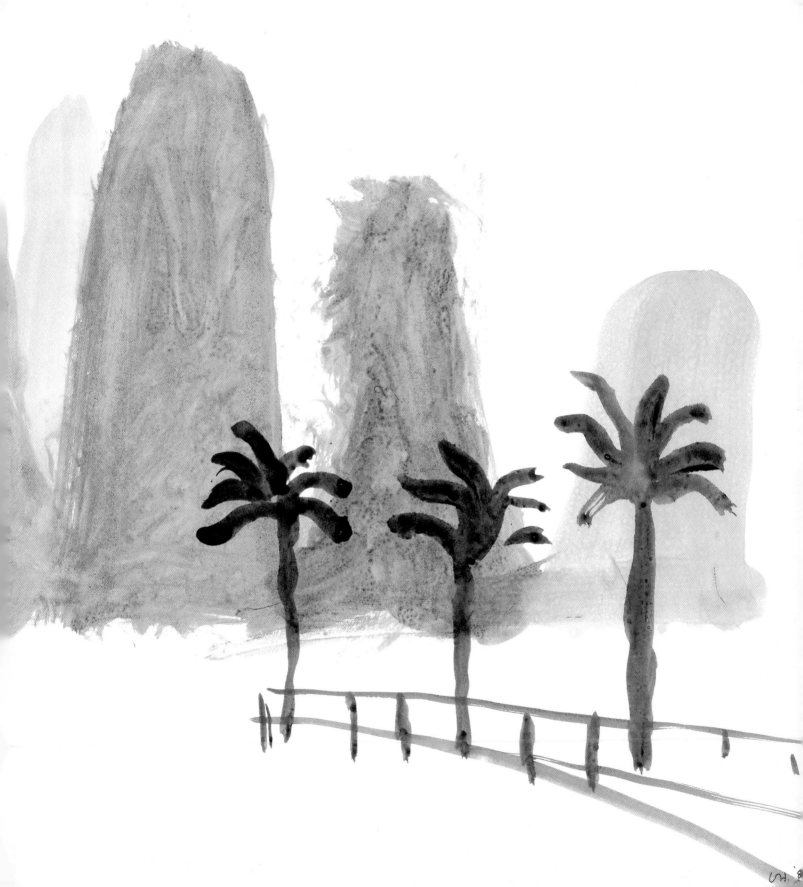

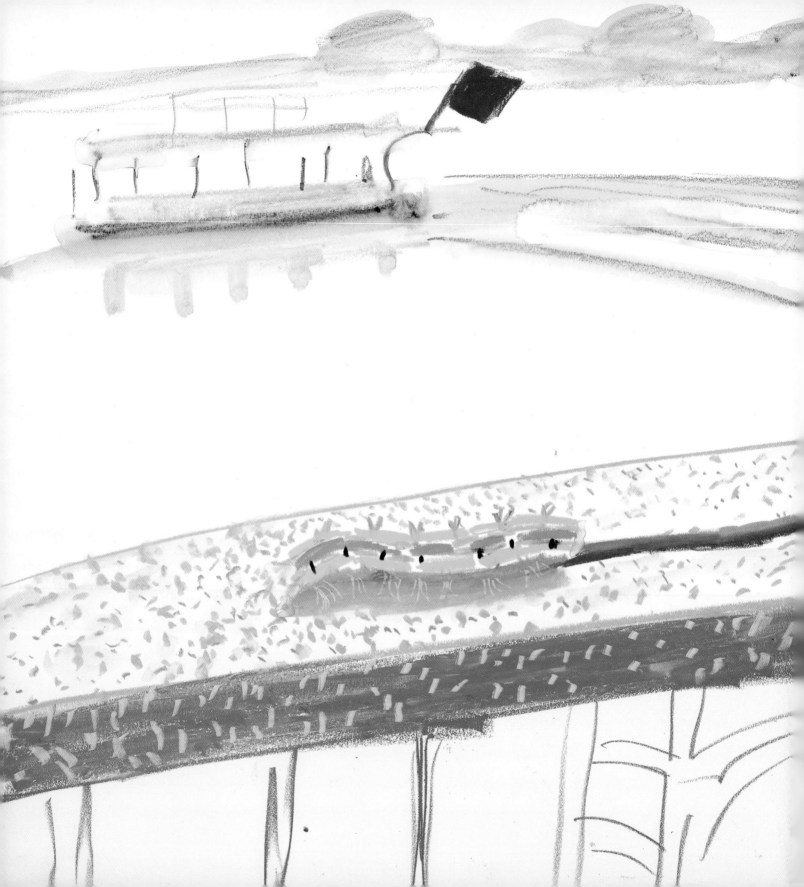

'The one problem was that the trip was organized so we were always moving. There was hardly a time when you had half an hour to sit around; so I realized I had to devise a method of drawing quickly or from memory. I started drawing from memory more and more. I remember arriving in Kweilin [Guilin]. I had no idea it was such a magical, beautiful place. We saw an extraordinary landscape from the plane and we were thrilled…. On the trip down the river – it's all day on the boat – you float through the most magical, beautiful landscape. It is as though children had drawn the mountains. I absolutely loved it.'

Boat with Red Flag and Caterpillar, Kweilin, China 1981

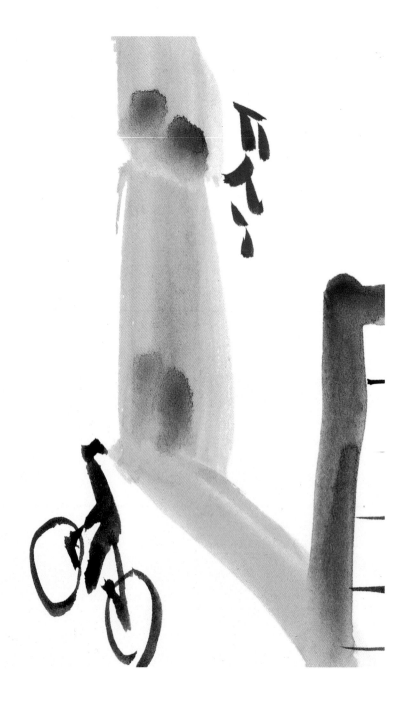

Hotel at Sian, China (detail) 1981

Road from Peking
Airport, China 1981 319

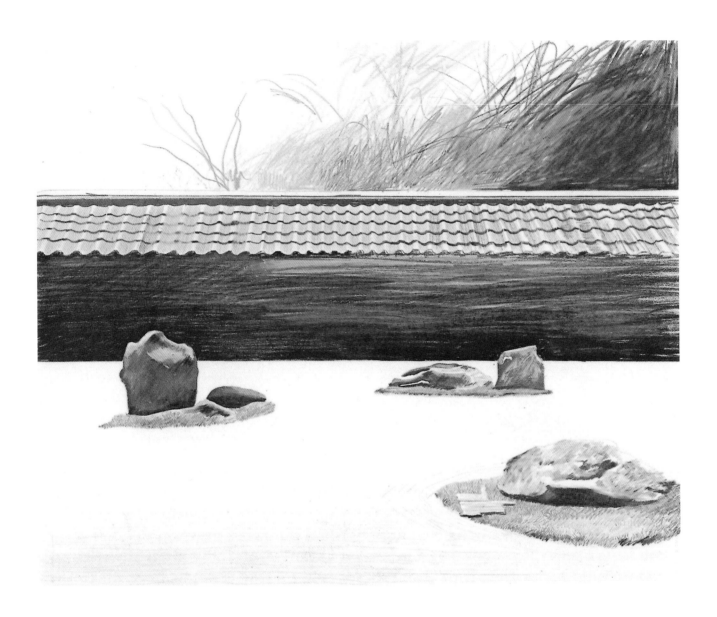

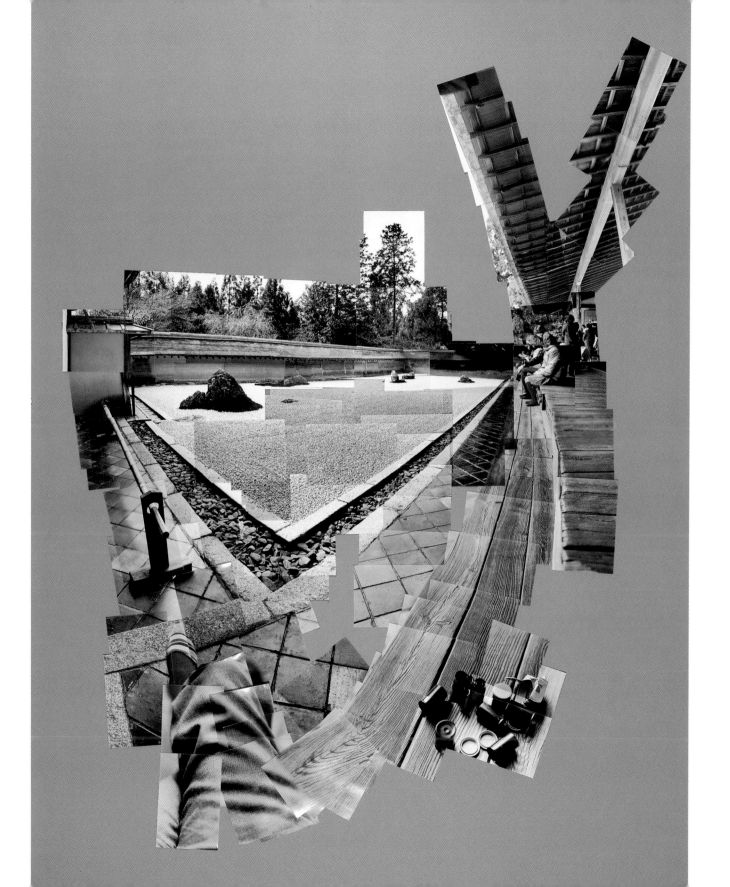

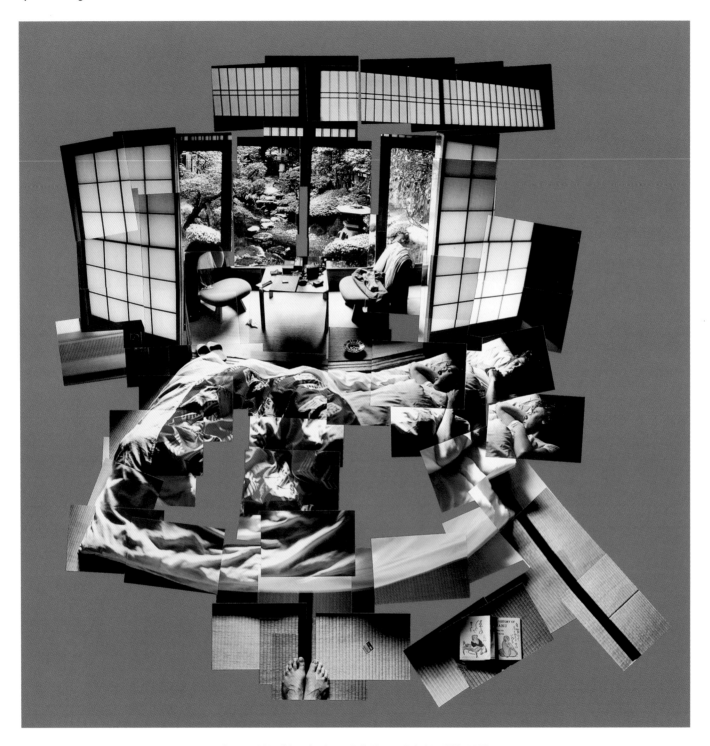

Gregory Watching the Snow Fall, Kyoto, Feb 21, 1983 1983

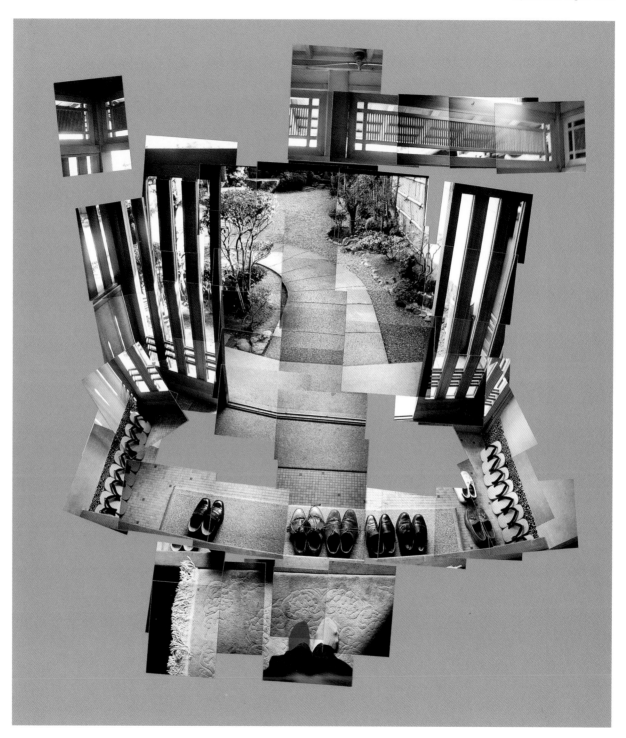

Shoes, Kyoto, Feb. 1983 1983

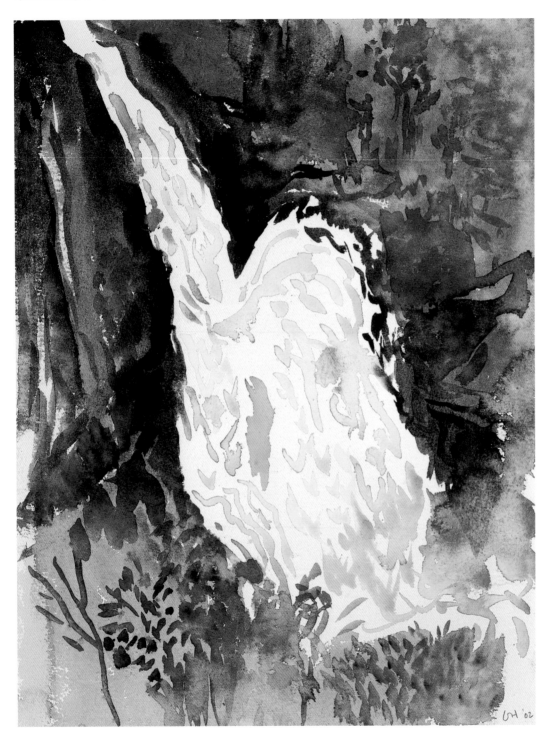

Study of Waterfall, Stalheim 2002

'To have longer periods of twilight (when colour is not bleached but extremely rich) one has to go north. I made a trip to Norway in May 2002, was very taken with the dramatic landscape and returned to go much further north, when in June the sun never sets at all. You can see the landscape at all hours, 24 hours a day. There is no night. I found myself deeply attracted to it, and then went to Iceland twice to tour the island.'

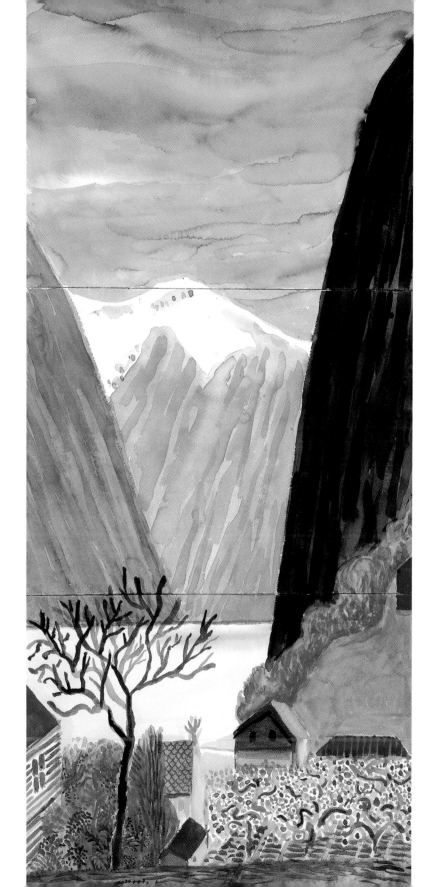

Undredal 2002

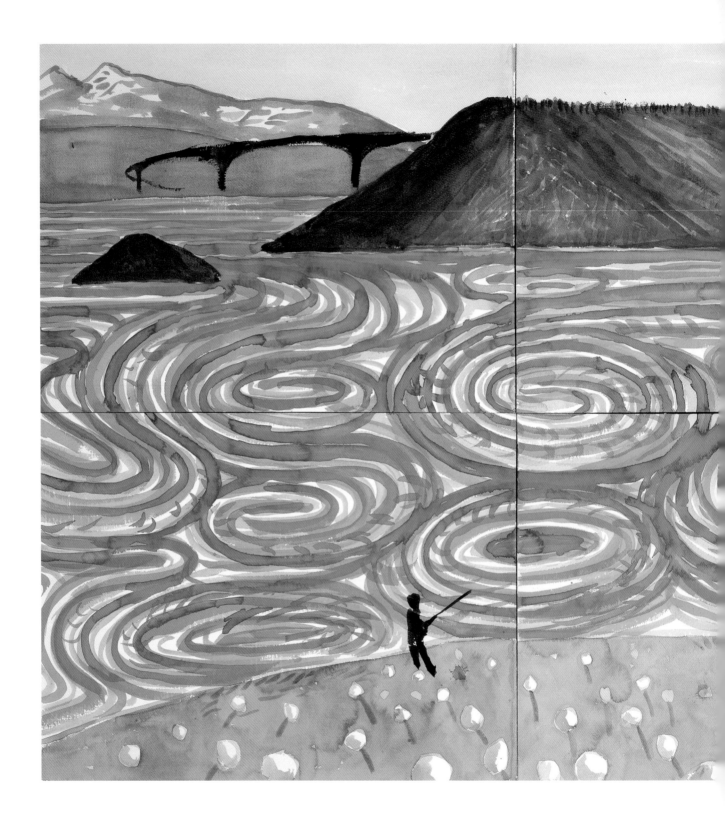

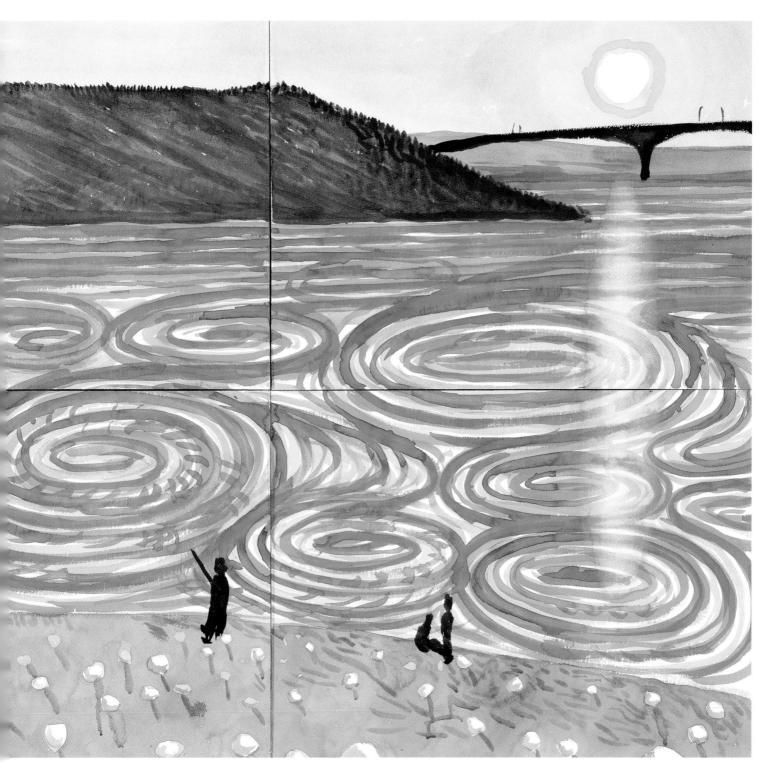

Maelstrom, Bodo 2002

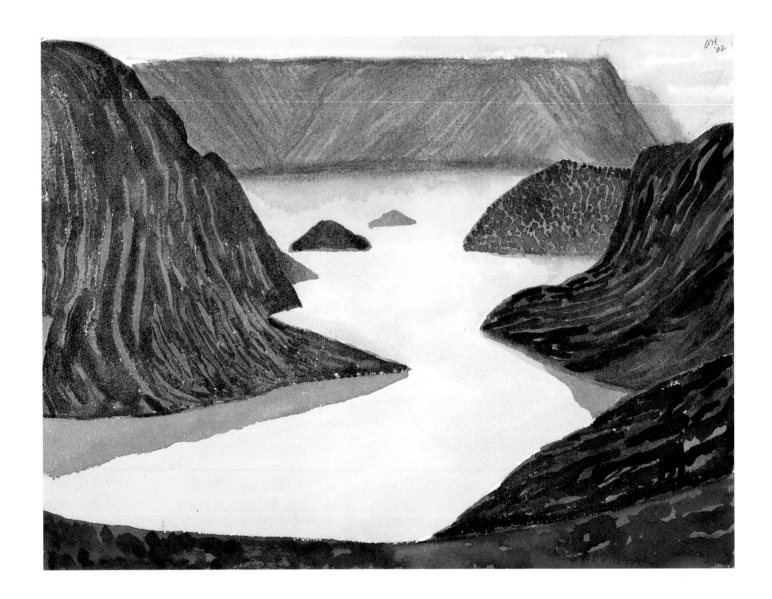

Fjord, Kamøyvær 2002

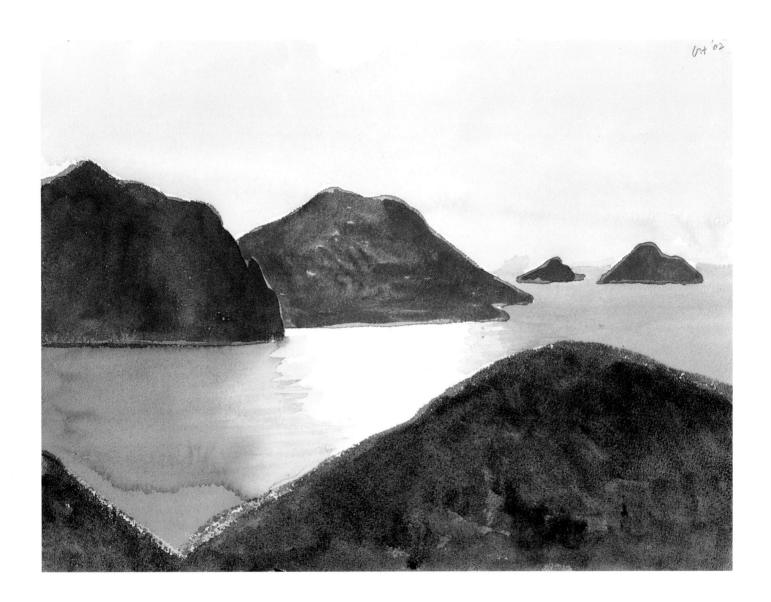

Tujfjorden from near Nordcapp 2002

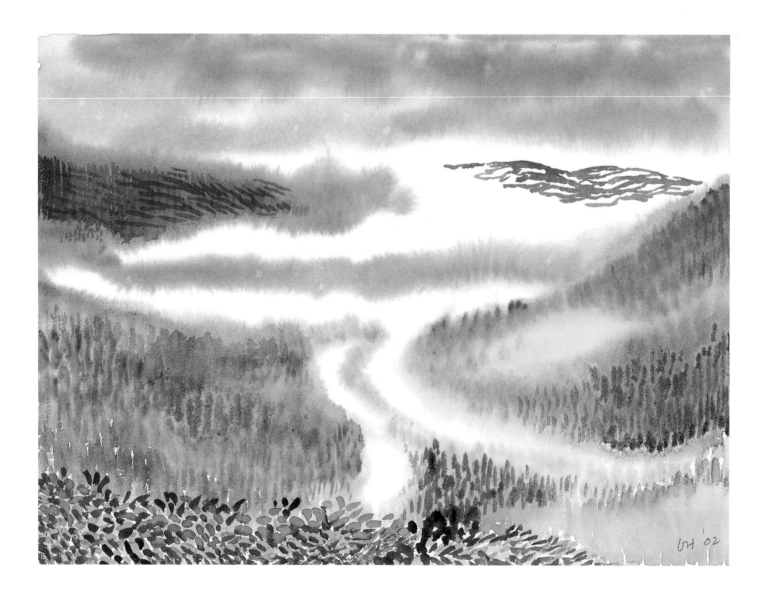

Mist, Stalheim 2002

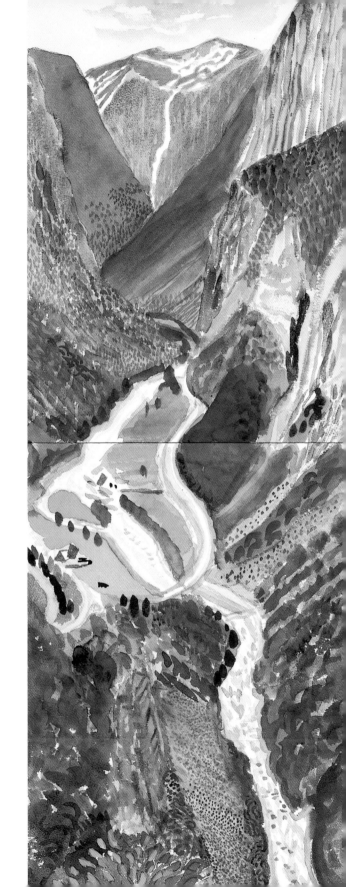

The Valley, Stalheim I 2002

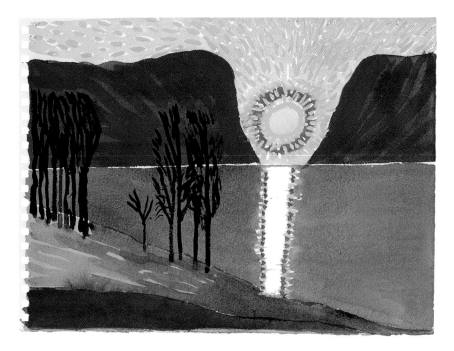

Setting Sun, Midfjord 2003

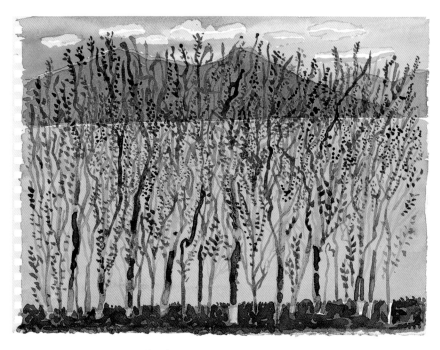

Midfjord, Birches, Second Version 2003

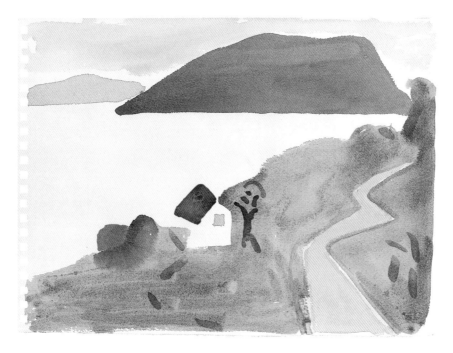

Study for House, Midfjord 2003

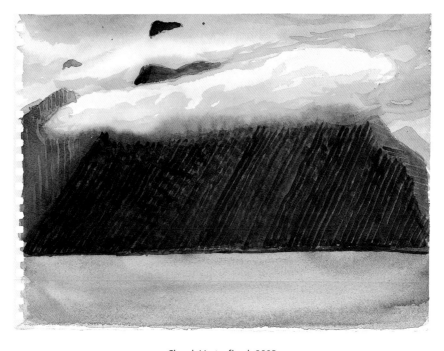

Cloud, Vestrefjord 2003

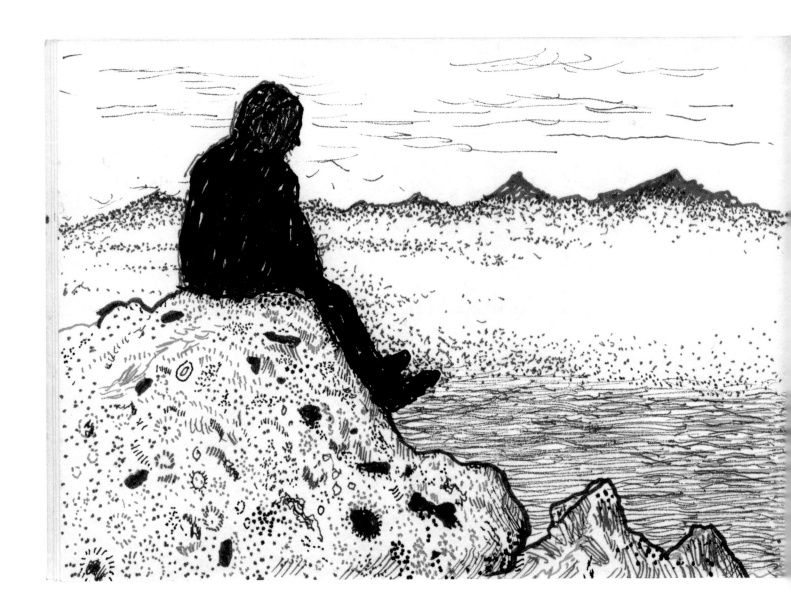

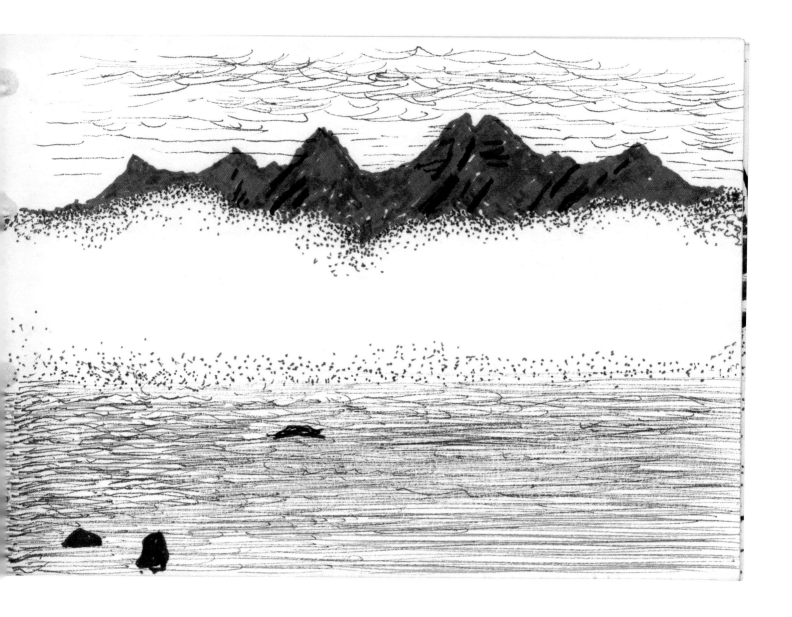

Sketchbook page: 'Mist, Iceland' 2002

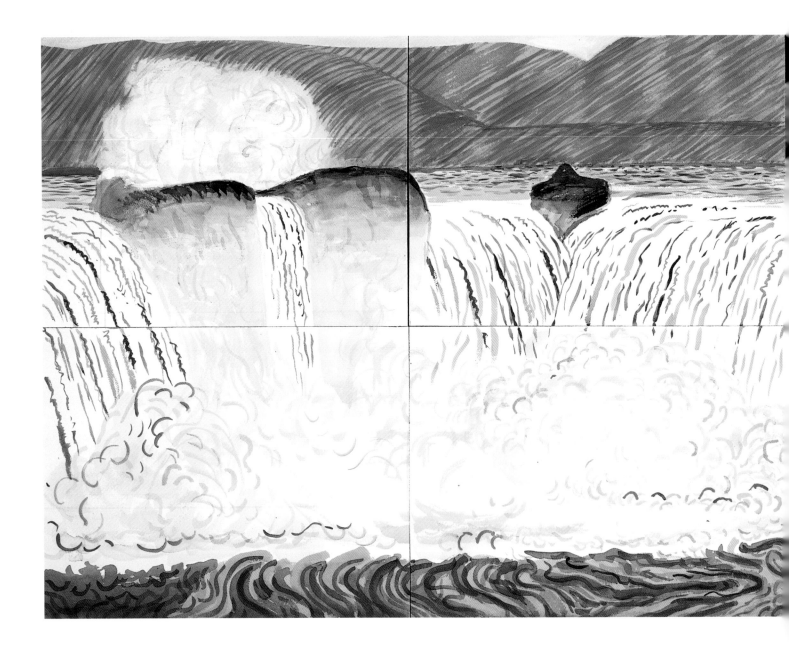

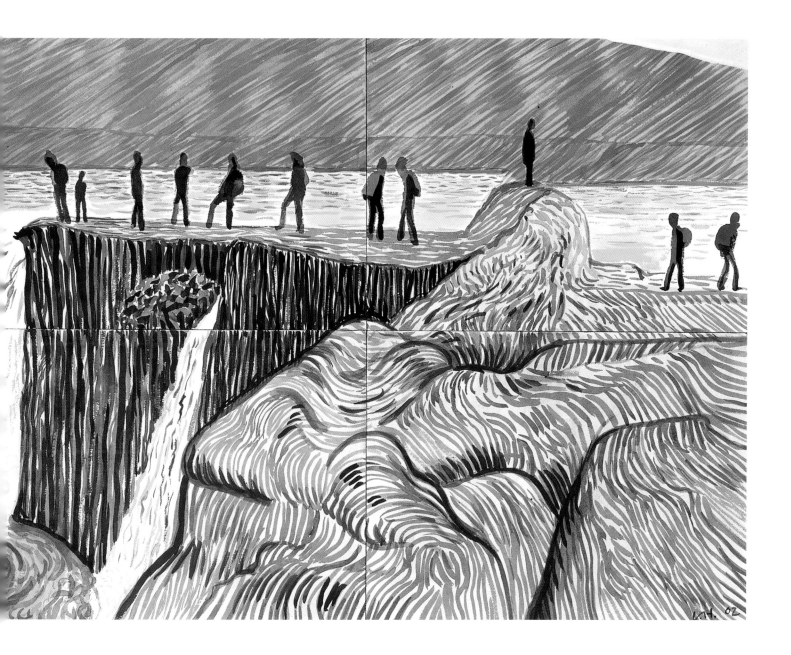

Godafoss, Iceland 2002

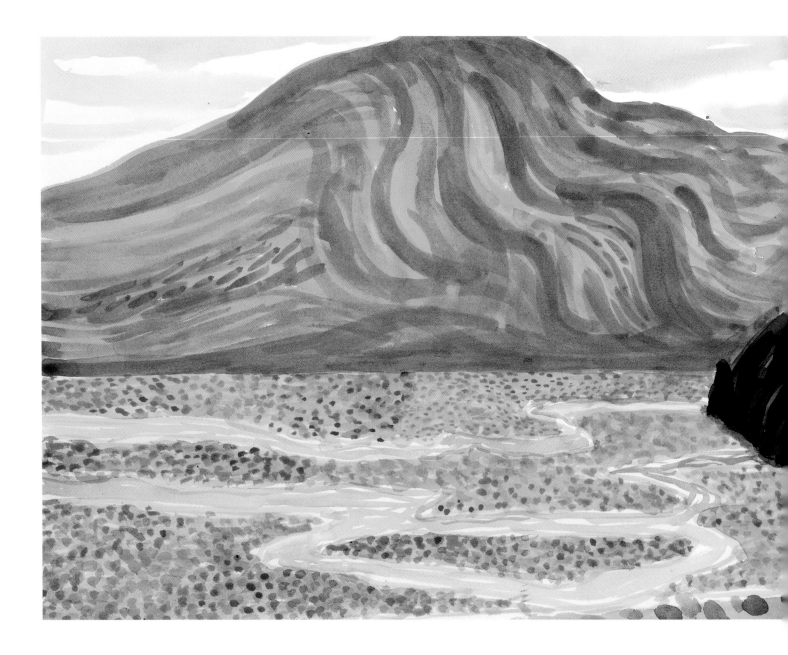

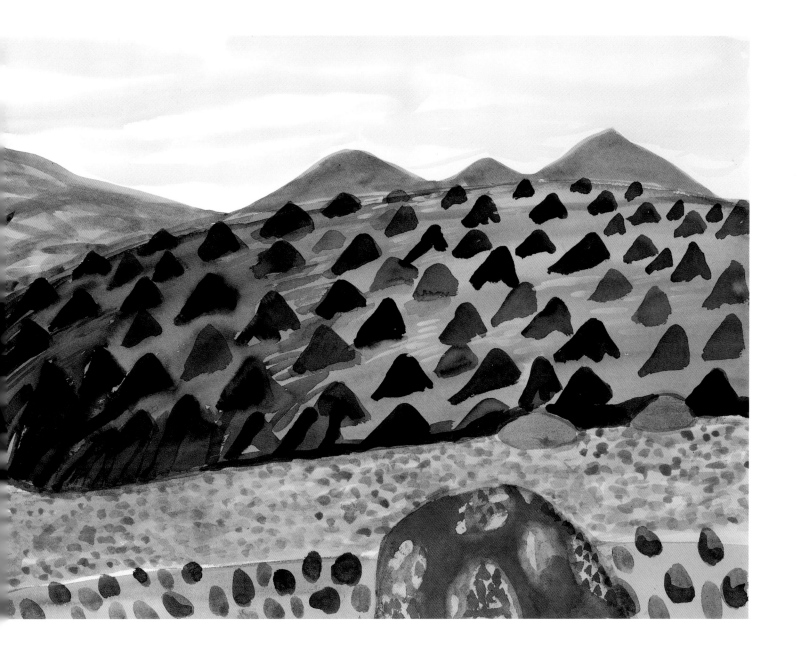

Black Glacier 1 2002

Cherry Blossom 2002

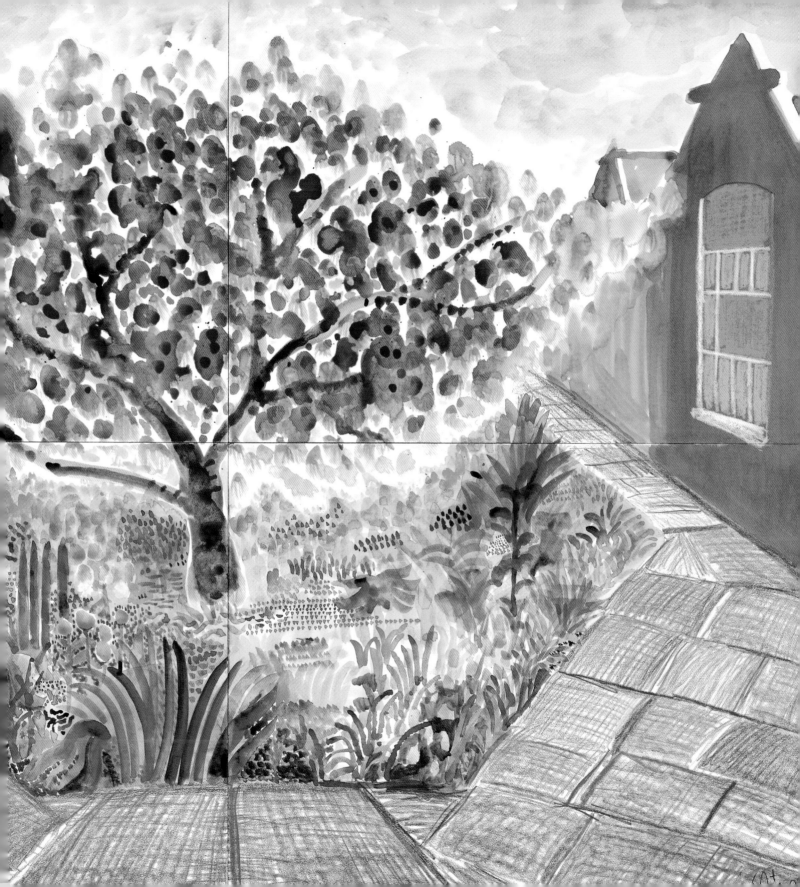

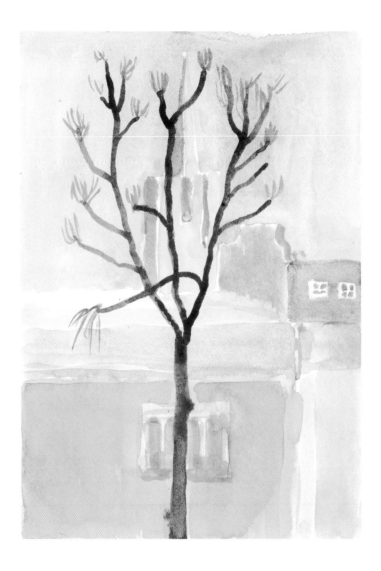

St John's Spire and Tree 2002

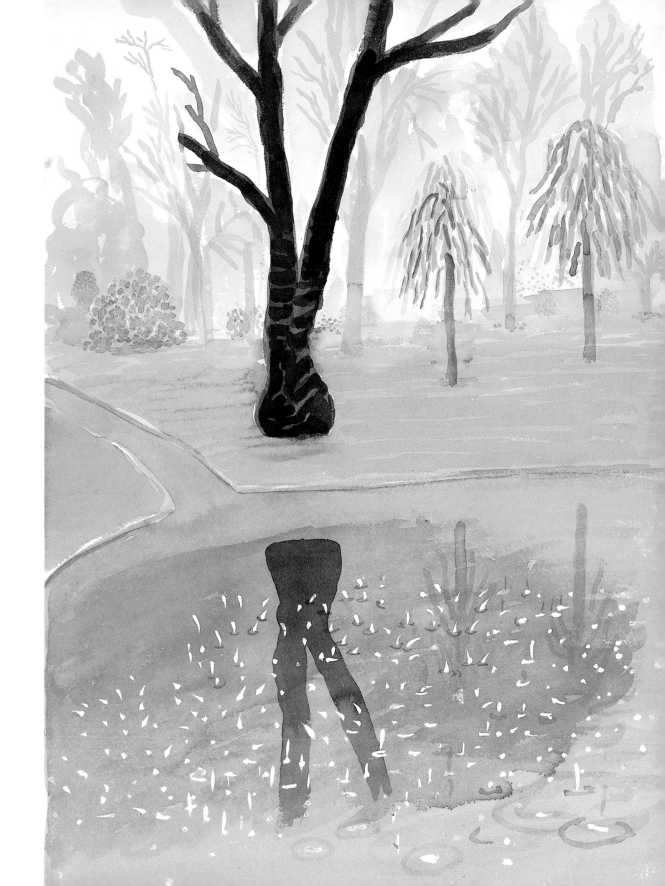

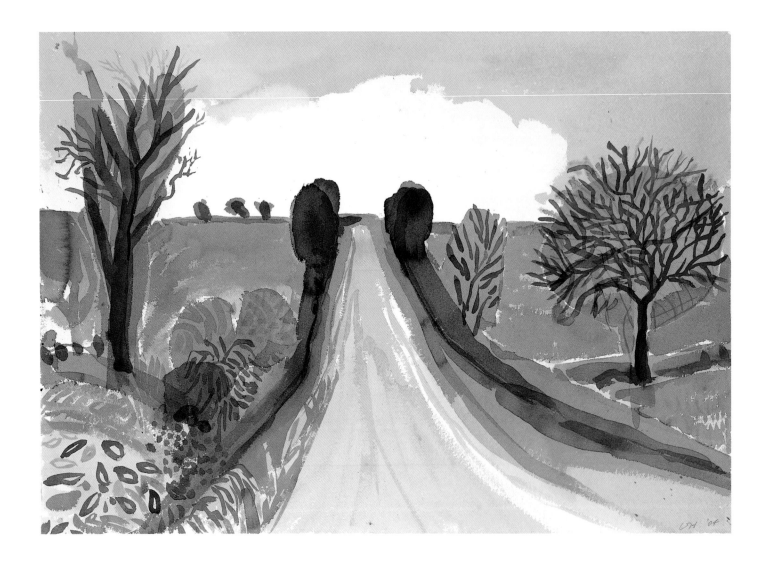

Wolds Way 2003

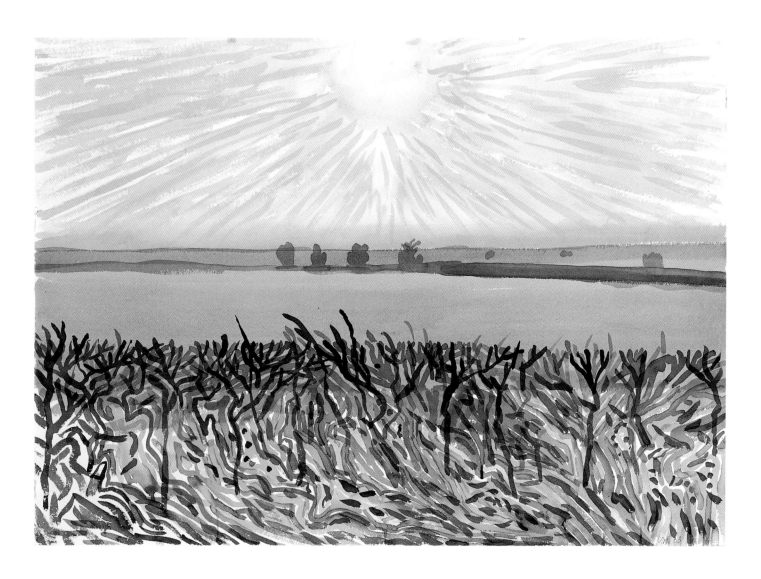

'I've really known this countryside quite intimately since the early fifties, when I came
here to work during breaks from school – helping with the harvesting of corn.
Wheat. Barley. I used to sack them for transport into Bridlington.'

Grey Sun, East Yorkshire 2003

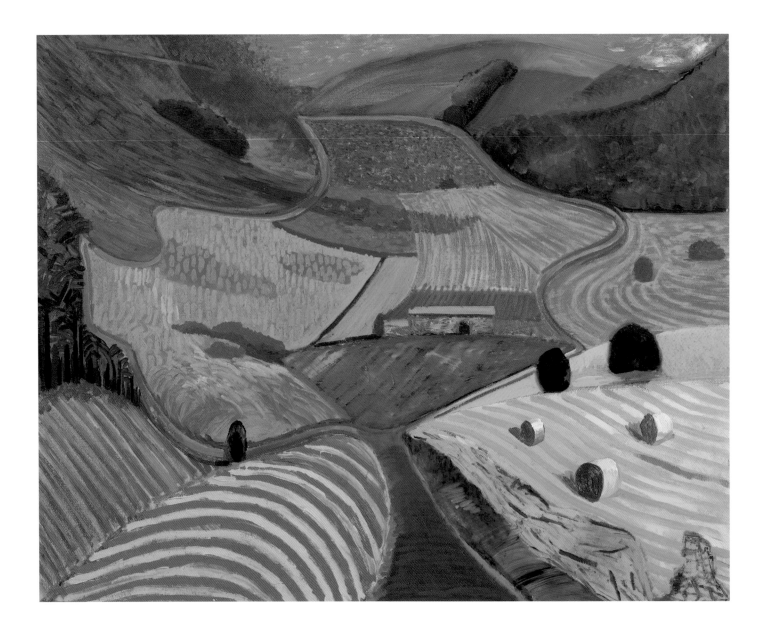

North Yorkshire 1997

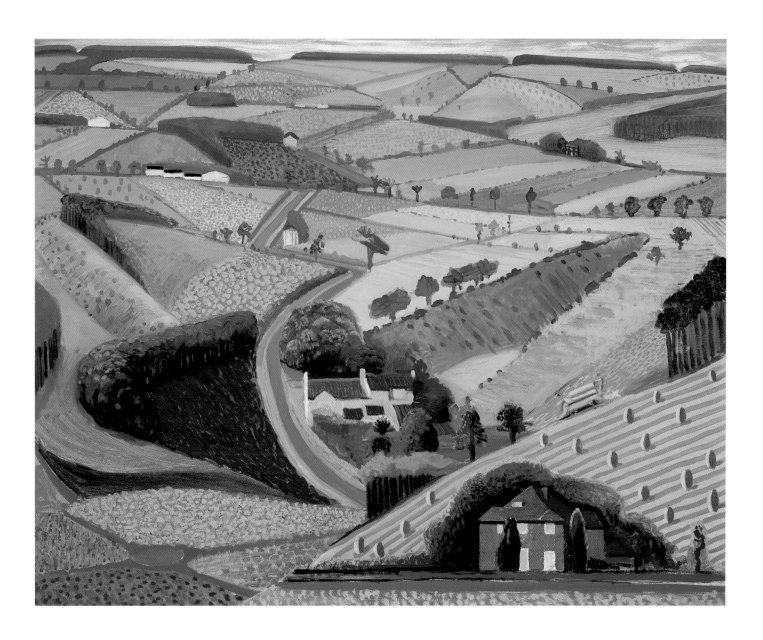

The Road Across the Wolds 1997

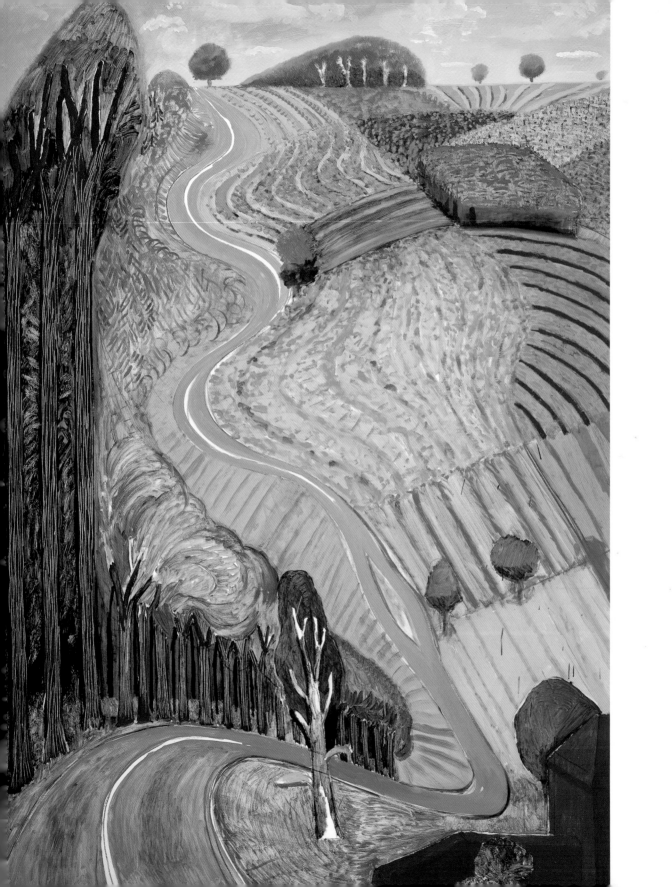

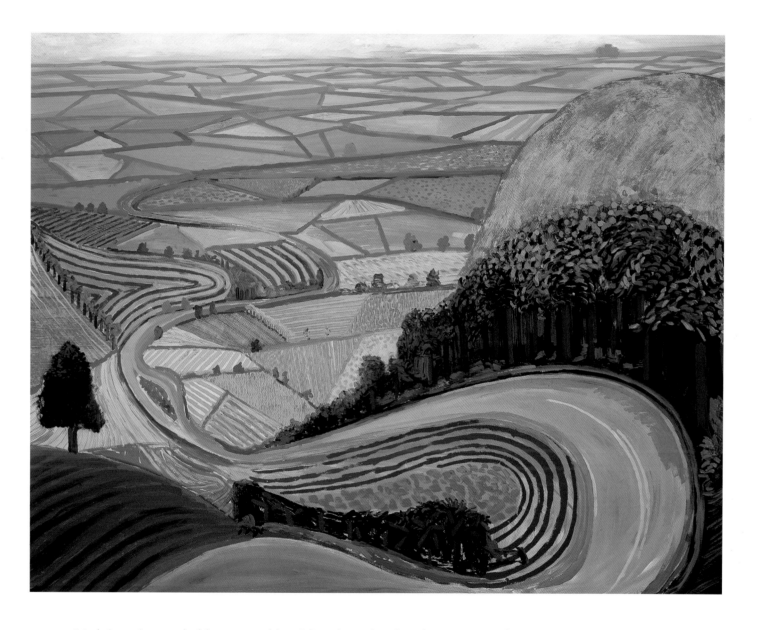

'York is a city nestled in a great big plain. The Vale of York. It is a very flat area. And Garrowby Hill, on the eastern edge of the Vale, is the hill where the chalk Wolds rise up. And go from, probably, sea level to about 800 feet. On clear days, you could probably see fifty, sixty miles, which is a long way for England. And there on the horizon, you could make out the cathedral, York Minster.'

Garrowby Hill 1998

'Sledmere is a village that is
around fifteen miles from
Bridlington that, to my
knowledge, has not changed
one bit in fifty years. The
Edwardian red-brick houses,
with red paint on them,
glorious in their redness those
sunny days of late August,
September. So one was getting
marvellous greens, washed
greens, the land changing,
the very rich soil.'

The Road to York through Sledmere 1997

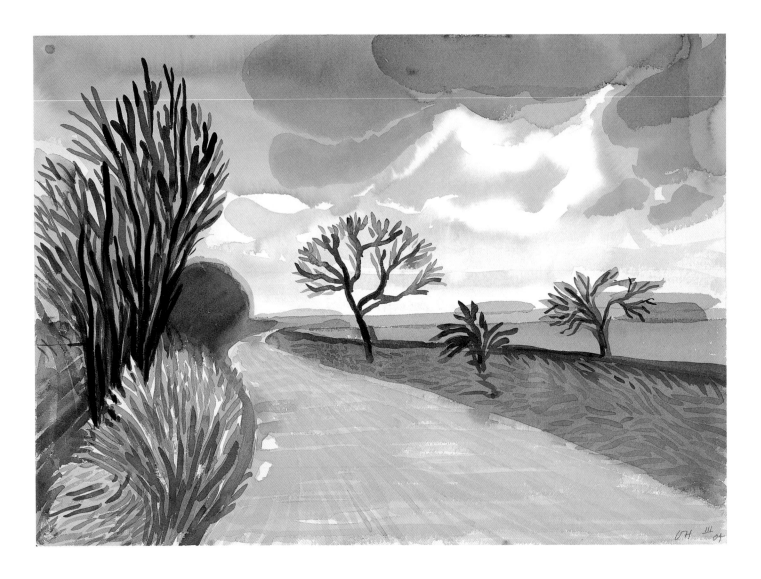

'I have always believed that art should be a deep pleasure. I think there
is a contradiction in an art of total despair, because the very fact that
the art is made seems to contradict despair.'

The Road to Ruston, 23 III 04 2004

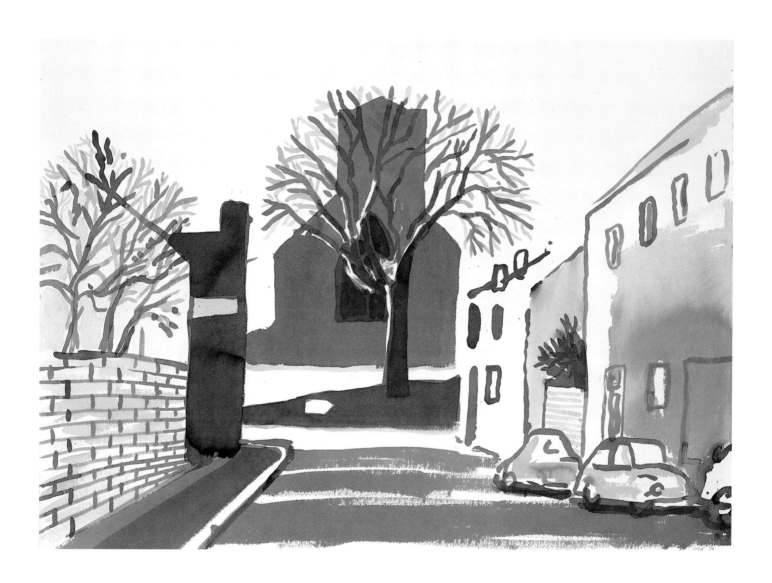

Church and Street. Kilham 2003

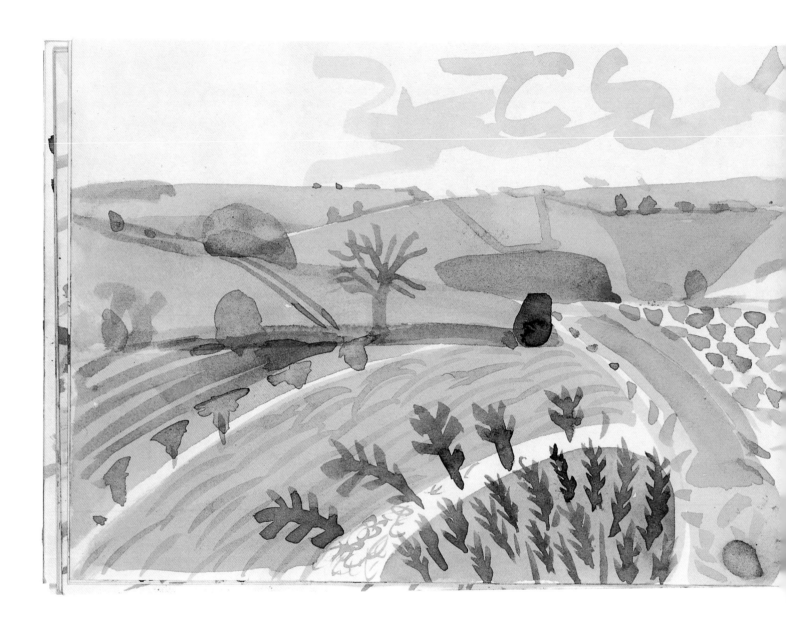

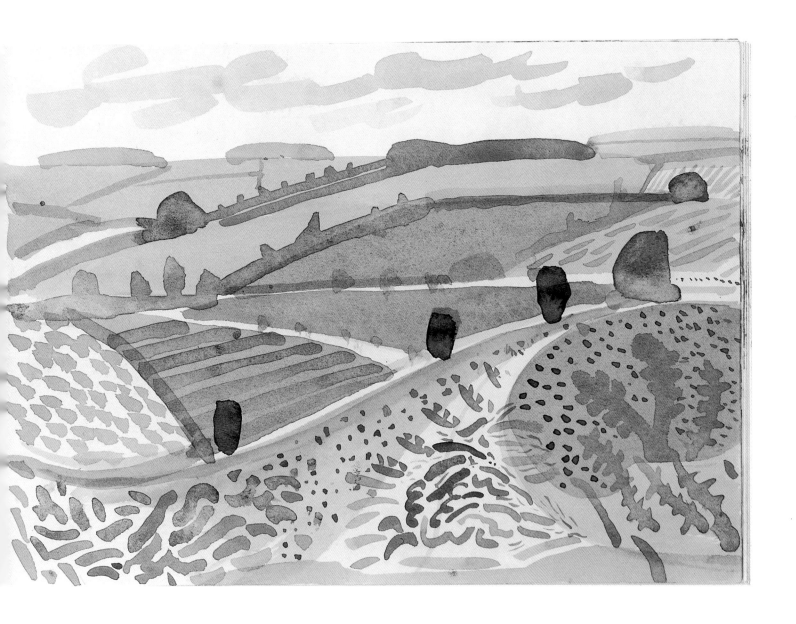

Sketchbook page: 'East Yorkshire, Spring' 2004

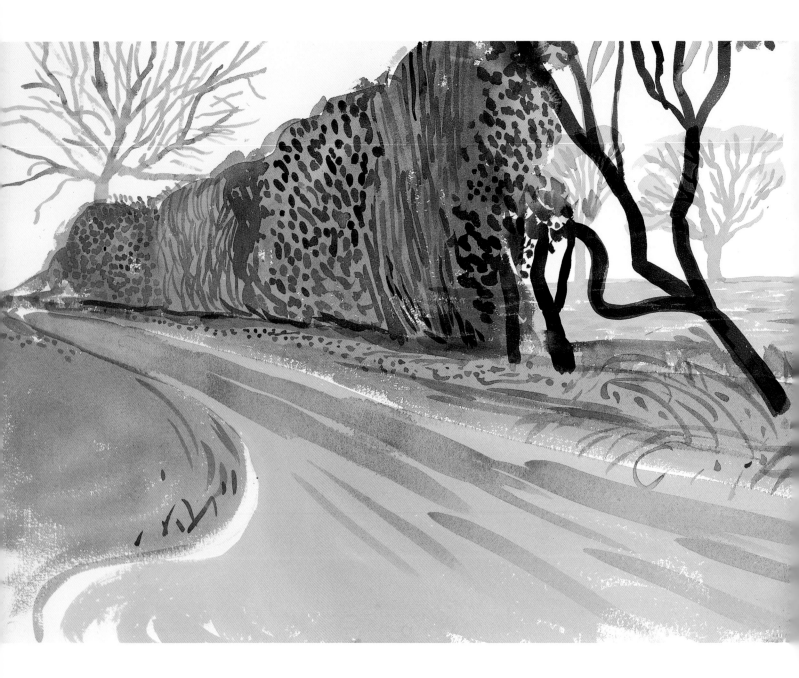

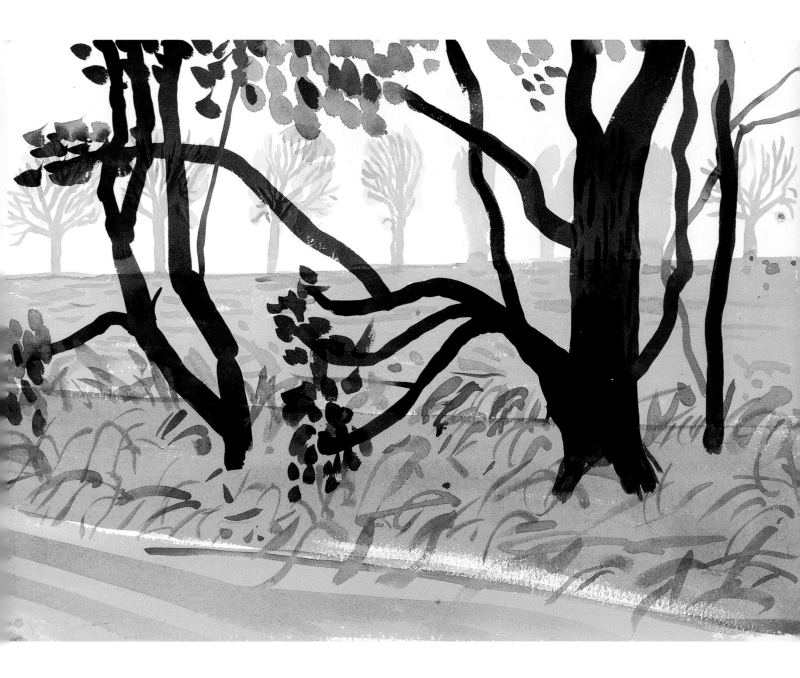

Untitled 2004

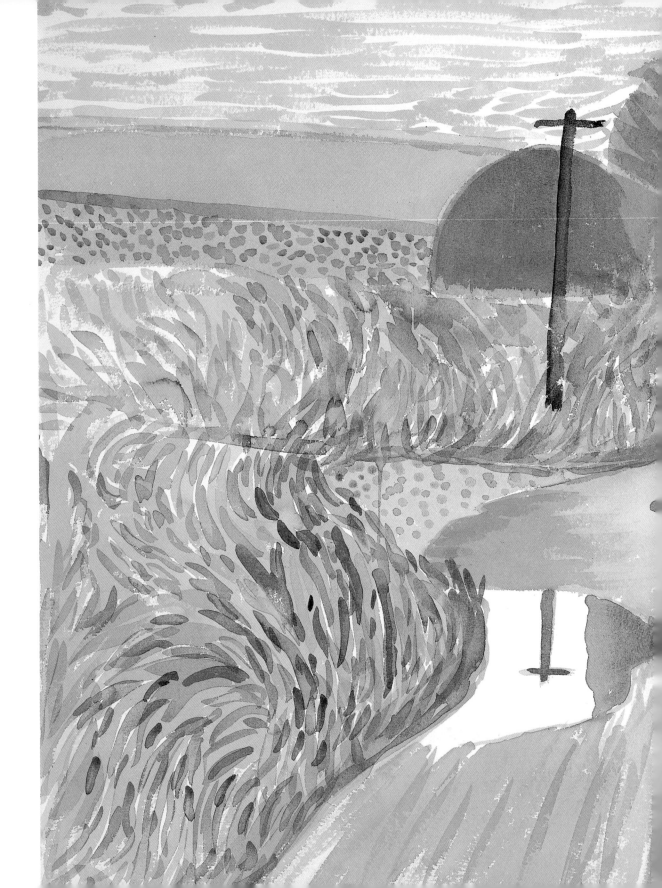

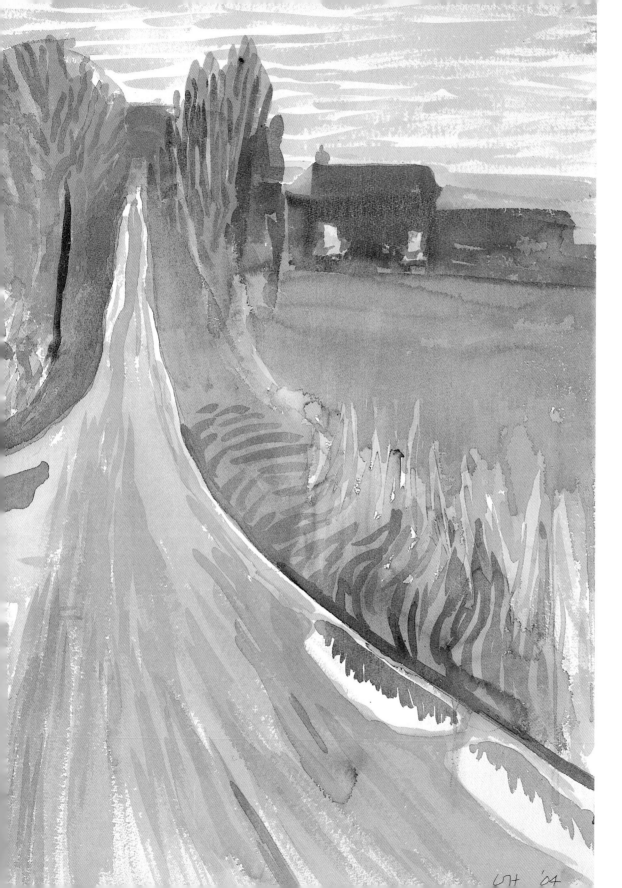

Space and Light **Yorkshire**

'I do believe
that painting
can change the
world. If you
see the world
as beautiful,
thrilling and
mysterious,
as I think I do,
then you feel
quite alive.'

Lovely Day with Puddles,
2 IV 04 2004

Lists of Illustrations

Page-by-page list

Numbers in bold refer to page numbers.
Measurements are given in centimetres, followed
by inches, height before width before depth.

1 *Cactus Garden III*, 2003
watercolour on paper (4 sheets), 92 x 121.9 (36¼ x 48)

2 *Still Life, Taj Hotel Bombay*, 1977
crayon on paper, 43.2 x 35.6 (17 x 14)

6 *Flowers Made of Paper and Black Ink*, 1971
lithograph, 99.7 x 95.3 (39¼ x 37½)

8 *Kerby (After Hogarth). Useful Knowledge*, 1975
oil on canvas, 182.8 x 152.4 (72 x 60)

10 *Three Chairs with a Section of a Picasso Mural*, 1970
acrylic on canvas, 121.9 x 152.4 (48 x 60)

11 *Artist and Model*, 1973–4
etching, 74.9 x 57.2 (29½ x 22½)

12 *Cubistic Bar*, 1980, from *Les Mamelles de Tiresias*
crayon on paper, 47.9 x 60.6 (18⅞ x 23⅞)

13 *Gonzalez and Shadow*, 1971
acrylic on canvas, 121.9 x 91.4 (48 x 36)

14 *Looking at Pictures on a Screen*, 1977
oil on canvas, 187.9 x 187.9 (74 x 74)

15 left *Picture of a Still Life that has an Elaborate Silver Frame*, 1965, from *A Hollywood Collection*
lithograph in seven colours, 76.8 x 56.5 (30¼ x 22¼)

15 right *Picture of Melrose Avenue in an Ornate Gold Frame*, 1965, from *A Hollywood Collection*
lithograph in six colours, 76.8 x 56.5 (30¼ x 22¼)

16–17 *The Great Wall* (detail), 2000
colour laser copies on 18 panels, 20.3 x 182.8 (8 x 72 feet)

18–19 *12 Portraits After Ingres in a Uniform Style*, 1999/2000
pencil, crayon and gouache on grey paper using a camera lucida, 112.3 x 228.6 (44¼ x 90) overall

20–1 *The Expulsion from the Garden of Eden*, 2002
watercolour on paper (6 sheets), 92 x 183.1 (36¼ x 72⅛)

22–3 *A Grand Procession of Dignitaries in the Semi-Egyptian Style*, 1961
oil on canvas, 213.3 x 365.7 (84 x 144)

24 *The First Marriage (A Marriage of Styles I)*, 1962
oil on canvas, 182.8 x 152.4 (72 x 60)

25 *The Second Marriage*, 1963
oil, gouache and collage on canvas, 197.4 x 228.6 (77¾ x 90)

26 *Tea Painting in an Illusionistic Style*, 1961
oil on canvas, 198.1 x 76.2 (78 x 30)

27 *The Second Tea Painting*, 1961
oil on canvas, 154.9 x 91.4 (61 x 36)

28 *The Cruel Elephant*, 1962
oil on canvas, 121.9 x 152.4 (48 x 60)

29 *Cubist Boy with Colourful Tree*, 1964
acrylic on canvas, 166.4 x 166.4 (65½ x 65½)

30 *Colonial Governor*, 1962
crayon and ink on paper, 34.9 x 26 (13¾ x 10¼)

31 *Man in a Museum (or You're in the Wrong Movie)*, 1962
oil on canvas, 152.4 x 152.4 (60 x 60)

32 *Trees, 1964*, 1964
acrylic on two canvases, 72.4 x 76.2 (28½ x 30)

33 *Cubistic Tree*, 1965
crayon on paper, 35.6 x 42.5 (14 x 16¾)

34 *Flowers for a Wedding*, 1962
oil on canvas, 61 x 30.5 (24 x 12)

35 *A Realistic Still Life*, 1965
acrylic on canvas, 121.9 x 121.9 (48 x 48)

36 *Invented Man Revealing Still Life*, 1975
oil on canvas, 91.4 x 72.4 (36 x 28½)

37 *Glass Table with Objects*, 1969
lithograph in 5 colours, 46.4 x 57.8 (18¼ x 22¾)

38 *Serenade*, 1976–7, from *The Blue Guitar*
etching, 52 x 45.7 (20½ x 18)

39 *A Picture of Ourselves*, 1976–7, from *The Blue Guitar*
etching, 45.7 x 52.7 (18 x 20¾)

40 *Still Life with Figure and Curtain*, 1963
oil on canvas, 198.1 x 213.3 (78 x 84)

41 *Seated Woman Drinking Tea, Being Served by a Standing Companion*, 1963
oil on canvas, 198.1 x 213.3 (78 x 84)

42 *The Singer*, 1963
coloured pencil on paper, 31.8 x 25.4 (12½ x 10)

43 *Cubistic Woman*, 1963
coloured pencil on paper, 31.8 x 25.4 (12½ x 10)

44 *The Hypnotist*, 1963
etching and aquatint in two colours
63.5 x 57.2 (25 x 22½)

45 *Closing Scene*, 1963
oil on canvas, 121.9 x 121.9 (48 x 48)

46 *Ordinary Picture*, 1964
acrylic on canvas, 182.8 x 182.8 (72 x 72)

47 *The Actor*, 1964
acrylic on canvas, 166.4 x 166.4 (65½ x 65½)

48 top *Royal Palace and Parade Ground*, 1966
crayon on paper, 36.8 x 49.5 (14½ x 19½)

48 bottom *Curtain for 'Ubu Roi'*, 1966
pencil, crayon on paper, 38.1 x 50.8 (15 x 20)

49 *An Assembly*, 1975, from *The Rake's Progress*
ink, ballpoint and collage, 50.2 x 65.1 (19¾ x 25⅝)

50 *Les Mamelles de Tiresias*, 1980
oil on canvas, 91.4 x 121.9 (36 x 48)

51 *Ravel's Garden with Night Glow*, 1980
from *L'Enfant et les sortilèges*
oil on canvas, 152.4 x 182.8 (60 x 72)

52–3 *Parade Collage*, 1980
gouache, ink and crayon on paper
101.6 x 152.4 (40 x 60)

54–5 *Die Frau ohne Schatten, Act 3, Scene 4*
(scale model), 1992
foamcore, velvet paper, styrofoam, plaster cloth,
gouache, 215.9 x 229.9 x 121.9 (85 x 90½ x 48)

56 *The Sixteenth V. N. Painting*, 1992
oil on canvas, 91.4 x 121.9 (36 x 48)

57 *The Fourth V. N. Painting*, 1992
oil on canvas, 61 x 61 (24 x 24)

58–9 *Snails Space with Vari-Lites, 'Painting as Performance'*, 1995–6
oil on two canvases, acrylic on canvas, covered masonite, 213.9 x 670.5 x 342.9 (84¼ x 264 x 135) overall

60–1 *Near Bruges*, 1995
oil on two canvases, 53.3 x 152.4 (21 x 60)

62–3 *The Sea at Malibu*, 1988
oil on canvas, 91.4 x 121.9 (36 x 48)

64 *Three Green Waves with Orange Sand*, 1989
oil on canvas, 26.7 x 41.9 (10½ x 16½)

65 *Geometric Waves, 1989*, 1989
gouache, ink, felt marker, crayon on paper,
21.6 x 27.9 (8½ x 11)

66 *Atlantic Crossing*, 1965
oil on canvas, 182.8 x 182.8 (72 x 72)

67 *Picture of a Hollywood Swimming Pool*, 1964
acrylic on canvas, 91.4 x 121.9 (36 x 48)

68–9 *Four Different Kinds of Water*, 1967
acrylic on canvas, 36.8 x 105.4 (14½ x 41½)

70 *Study of Water, Phoenix, Arizona*, 1976
crayon on paper, 45.7 x 49.8 (18 x 19⅝)

71 *Rubber Ring Floating in a Swimming Pool*, 1971
acrylic on canvas, 91.4 x 121.9 (36 x 48)

72 *Sunbather*, 1966
acrylic on canvas, 182.8 x 182.8 (72 x 72)

73 *Pool Study II*, 1978
ink on paper, 21.6 x 27.9 (8½ x 11)

74 *Two Boys in a Pool, Hollywood*, 1965
acrylic on canvas, 152.4 x 152.4 (60 x 60)

75 *Plongeoir avec Ombre (Paper Pool 13)*, 1978
coloured and pressed paper pulp, 182.8 x 217.1 (72 x 85½)

76 *Schwimmbad Mitternacht (Paper Pool 11)*, 1978
coloured and pressed paper pulp, 182.8 x 217.1 (72 x 85½)

77 *A Bigger Splash*, 1967
acrylic on canvas, 243.8 x 243.8 (96 x 96)

78–9 *A Large Diver (Paper Pool 27)*, 1978
coloured and pressed paper pulp, 182.8 x 434.3 (72 x 171)

80–1 *Sun on the Pool, Los Angeles, April 13th 1982*, 1982
composite polaroid, 62.9 x 92 (24¾ x 36¼)

82 *Rain*, 1973, from *The Weather Series*
lithograph and screenprint, 99.1 x 77.5 (39 x 30½)

83 *Rain on the Pool, Los Angeles, April 12th 1982*, 1982
composite polaroid, 62.9 x 92.7 (24¾ x 36½)

84 *Cold Water about to Hit the Prince*, 1969, from *Illustrations for Six Fairy Tales from the Brothers Grimm*
etching in black, 62.2 x 45.1 (24½ x 17¾)

85 *A Lawn Sprinkler*, 1967
acrylic on canvas, 121.9 x 121.9 (48 x 48)

86 *Different Kinds of Water Pouring into a Swimming Pool, Santa Monica*, 1965
acrylic on canvas, 182.8 x 152.4 (72 x 60)

87 *Picture Emphasizing Stillness*, 1962
oil and letraset on canvas, 182.8 x 157.5 (72 x 62)

88 *Help*, 1962
oil, ink and letraset on canvas, 31.8 x 24.8 (12½ x 9¾)

89 *The Cha Cha that was Danced in the Early Hours of 24th March, 1961*, 1961
oil on canvas, 172.7 x 153.7 (68 x 60½)

90–1 *Bradford Bounce, Feb. 1987*, 1987
colour newsprint, 38.1 x 55.9 (15 x 22)

92–3 *Two Dancers*, 1980
oil on canvas, 121.9 x 182.8 (48 x 72)

94 *Waltz*, 1980
oil on canvas, 92.7 x 62.5 (36½ x 24⅝)

95 *The Skater, NY, Dec. 1982*, 1982
photographic collage, 59.7 x 43.2 (23½ x 17)

96 *Still Life with T.V.*, 1969
acrylic on canvas, 121.9 x 152.4 (48 x 60)

97 *The Desk, July 1st 1984*, 1984
photographic collage, 121.9 x 116.8 (48 x 46)

98–9 *Mulholland Drive: The Road to the Studio*, 1980
acrylic on canvas, 218.4 x 617.2 (86 x 243)

100–1 *Walking in the Zen Garden at the Ryoanji Temple, Kyoto, Feb. 1983*, 1983
photographic collage, 101.6 x 158.8 (40 x 62½)

102 *Photography Eyes* (detail), 1985
felt pen on paper, 36.8 x 43.2 (14½ x 17)

103 *Yellow Guitar Still Life, Los Angeles, 3rd April 1982*, 1982
composite polaroid, 72.4 x 44.5 (28½ x 17½)

104 *Chair, Jardin de Luxembourg, Paris, 10th August 1985*, 1985
photographic collage, 80 x 64.8 (31½ x 25½)

105 left *The Chair*, 1985
oil on canvas, 121.9 x 91.4 (48 x 36)

105 centre *Van Gogh Chair*, 1988
acrylic on canvas, 121.9 x 91.4 (48 x 36)

105 right *Gauguin's Chair*, 1988
acrylic on canvas, 121.9 x 91.4 (48 x 36)

106 *Two Pembroke Studio Chairs*, 1984
lithograph, 46.9 x 55.9 (18½ x 22)
© David Hockney/Tyler Graphics Ltd

107 *Room 229 Palmdale, Calif., 11th April 1986*, 1986
photographic collage, 101.9 x 85.7 (40⅛ x 33¾)

108–9 *Pearblossom Highway, 11–18th April 1986 (Second Version)*, 1986
photographic collage, 181.6 x 271.8 (71½ x 107)
© David Hockney
collection of the J. Paul Getty Museum, Los Angeles, CA

110 *Yves-Marie and Mark, Paris, Oct 1975*, 1975
red conte on paper, 64.7 x 49.5 (25½ x 19½)

112 *American Boys Showering*, 1963
pencil and crayon on paper, 50.2 x 31.8 (19¾ x 12½)

113 *Two Men in a Shower*, 1963
oil on canvas, 152.4 x 152.4 (60 x 60)

114 *Man Taking Shower*, 1965
acrylic on canvas, 152.4 x 121.9 (60 x 48)

115 *Nude Boy, Los Angeles*, 1964
pencil and crayon on paper, 31.1 x 25.4 (12¼ x 10)

116 *In the Dull Village*, 1966–7, from
Illustrations for Fourteen Poems from C. P. Cavafy
etching, 57.2 x 39.4 (22½ x 15½)

117 *Two Boys Aged 23 or 24*, 1966–7, from
Illustrations for Fourteen Poems from C. P. Cavafy
etching, 80 x 57.2 (31½ x 22½)

118 *Domestic Scene, Los Angeles*, 1963
oil on canvas, 152.4 x 152.4 (60 x 60)

119 *Domestic Scene, Broadchalke, Wilts*, 1963
oil on canvas, 182.8 x 182.8 (72 x 72)

120 *Berlin: A Souvenir*, 1962
oil on canvas, 213.3 x 213.3 (84 x 84)

121 *Going to be a Queen for Tonight*, 1960
oil on board, 121.9 x 91.4 (48 x 36)

122 *Doll Boy*, 1960–1
oil on canvas, 121.9 x 99.1 (48 x 39)

123 *The Fourth Love Painting*, 1961
oil and letraset on canvas, 91.4 x 71.4 (36 x 28⅛)

124 *Christopher Isherwood Talking to Bob Holman, Santa Monica, Mar 14th, 1983* (detail), 1983
photographic collage, 110.5 x 163.8 (43½ x 64½)

125 *Christopher Isherwood and Don Bachardy*, 1968
acrylic on canvas, 212 x 303.5 (83½ x 119½)

126 *California Art Collector*, 1964
acrylic on canvas, 152.4 x 182.8 (60 x 72)

127 *American Collectors (Fred and Marcia Weisman)*, 1968
acrylic on canvas, 213.3 x 304.8 (84 x 120)

128 *Frederick Ashton and Wayne Sleep*, 1968
ink on paper, 43.2 x 35.6 (17 x 14)

129 *Study of George Lawson*, 1977
oil on canvas, 101.6 x 127 (40 x 50)

130–1 *Mr and Mrs Clark and Percy*, 1970–1
acrylic on canvas, 213.3 x 304.8 (84 x 120)

132 *Henry and Mo, Villa Reale*, 1973
coloured pencil on paper, 35.6 x 43.2 (14 x 17)

133 *Nick and Henry on Board. Nice to Calvi, July 18th 1972*, 1972
ink on paper, 43.2 x 35.6 (17 x 14)

134–5 *Shirley Goldfarb and Gregory Masurovsky*, 1974
acrylic on canvas, 114.3 x 213.3 (45 x 84)

136 *Il Pleut sur le Pont des Arts*, 1974
crayon on paper, 43.2 x 35.6 (17 x 14)

137 *Yves-Marie in the Rain*, 1973
oil on canvas, 121.9 x 152.4 (48 x 60)

138–9 Sketchbook page: 'Taxi, Kensington', 2002
ink on paper, 10.8 x 15.2 (4¼ x 6)

140 top Sketchbook page: 'V & A', 2002
ink on paper, 10.8 x 15.2 (4¼ x 6)

140 bottom Sketchbook page:
'Gainsborough exhibition Tate', 2002
ink on paper, 10.8 x 15.2 (4¼ x 6)

141 top Sketchbook page: 'People on the Street', 2003
ink and watercolour on paper, 10.8 x 15.2 (4¼ x 6)

141 bottom Sketchbook page: 'People on the Street', 2003
ink and watercolour on paper, 10.8 x 15.2 (4¼ x 6)

142–3 Sketchbook page: 'Como', 2003
ink on paper, 10.8 x 15.2 (4¼ x 6)

144 *Mirror, Casa Santini*, 1973
oil on canvas, 152.4 x 121.9 (60 x 48)

145 *Vichy Water and 'Howard's End', Carennac*, 1970
ink on paper, 35.6 x 43.2 (14 x 17)

146 *Chairs, Mamounia Hotel, Marrakesh*, 1971
crayon on paper, 35.6 x 43.2 (14 x 17)

147 *Mt. Fuji and Flowers*, 1972
acrylic on canvas, 152.4 x 121.9 (60 x 48)

148 Sketchbook page: 'Still Life with Matisse', 1985
pastel on paper, 33 x 59.1 (13 x 23¼)

149 *View from Mayflower Hotel, New York (Evening)*, 2002
watercolour and crayon on paper, 61 x 46 (24 x 18⅛)

150 *Cyclamen, Mayflower Hotel, New York*, 2002
watercolour and crayon on paper, 50.8 x 35.6 (20 x 14)

151 *The Vittel Bottle*, 1995
oil on canvas, 54.6 x 33 (21½ x 13)

152 *Vase and Flowers*, 1969
etching in black, 90.2 x 71.1 (35½ x 28)

153 *Still Life with Book*, 1973
lithograph, 81.3 x 63.5 (32 x 25)

154 *Dancing Flowers, May 1986*, 1986
home made print executed on a colour copy machine, 55.9 x 64.7 (22 x 25½) (6 panels)

155 *Green and Blue Plant*, 1987
acrylic on canvas, 61 x 91.4 (24 x 36)

156 top *5 Bonsai with Fairy Lights (Mountains)*, 2002
watercolour on paper, 36.8 x 50.8 (14½ x 20)

156 bottom *Red Wire Plant*, 1998
etching, 77.5 x 91.4 (30½ x 36)

157 *Halaconia in Green Vase*, 1996
oil on canvas, 182.8 x 182.8 (72 x 72)

158 *Growing, June 1986*, 1986
home made print executed on a colour copy machine, 27.9 x 21.6 (11 x 8½)

159 *Three Black Flowers, May 1986*, 1986
home made print executed on a colour copy machine, 27.9 x 21.6 (11 x 8½)

160 *Antheriums*, 1996
oil on canvas, 81.3 x 65.4 (32 x 25¼)

161 *Two Pink Flowers*, 1989
oil on canvas, 41.9 x 26.7 (16½ x 10½)

162 *A Pot of Violets*, 2002
watercolour and crayon on paper, 36.2 x 26 (14¼ x 10¼)

163 *Peeled Lemon with Slices*, 1995
oil on canvas, 26 x 41.3 (10¼ x 16¼)

164 *Cactus with Lemons*, 1996
oil on canvas, 121.9 x 91.4 (48 x 36)

165 *Sunflower in Bottle with Ashtray and Oranges*, 1996
oil on canvas, 64.7 x 54.3 (25½ x 21⅜)

166 *Cacti on Terrace*, 1998
etching, 95.3 x 87.6 (37½ x 34½)

167 *Margaret's Conservatory*, 2004
watercolour on paper (2 sheets), 38.1 x 27 (15 x 10⅝) overall

168 *Ladder and Broom II*, 2003
watercolour on paper (2 sheets), 121.9 x 45.7 (48 x 18)

169 top Sketchbook page: 'Ashtray on Studio Floor', 2002
ink on paper, 10.8 x 15.2 (4¼ x 6)

169 bottom Sketchbook page: 'Hole in Studio Floor', 2002
ink on paper, 10.8 x 15.2 (4¼ x 6)

170 Top Hat and Pears on Piano, 2003
watercolour on paper, 31.1 x 41 (12¼ x 16⅛)

171 left Hat on Chair, 1998
etching, 74.9 x 56.5 (29½ x 22¼)

171 right Sketchbook page: 'Jacket on Chair', 2002
ink on paper, 10.8 x 15.2 (4¼ x 6)

172 Cigarettes and Ashtray, 2003
watercolour on paper, 30.5 x 22.7 (12 x 9)

173 Piano and Lamp, 2003
watercolour on paper, 31.1 x 41.3 (12¼ x 16¼)

174 John's Camera, 2003
watercolour on paper, 17.8 x 26 (7 x 10¼)

175 Used Chair, 1988
oil on canvas, 61 x 91.4 (24 x 36)

176 Home, 1969, from Illustrations for Six Fairy Tales
from the Brothers Grimm
etching in black, 43.8 x 31.1 (17¼ x 12¼)

177 John Cooking II, 2003
watercolour on paper, 31.1 x 41 (12¼ x 16⅛)

178 Beach House by Day, 1990
oil on canvas, 61 x 91.4 (24 x 36)

179 Beach House by Night, 1990
oil on canvas, 61 x 91.4 (24 x 36)

180 Breakfast with Stanley in Malibu, Aug 23rd 1989, 1989
fax collage, 129.5 x 142.2 (51 x 56) overall (24 sheets)

181 Breakfast at Malibu, Sunday 1989, 1989
oil on canvas, 61 x 91.4 (24 x 36)

182–3 Hollywood Hills House, 1981–2
oil, charcoal and collage on canvas, 152.4 x 304.8 (60 x 120)

184 Unfinished Painting in Finished Photograph(s),
April 2nd 1982, 1982
composite polaroid, 62.9 x 76.2 (24¾ x 30)

185 Studio, Hollywood Hills House, 1982
gouache on paper, 129.5 x 167 (51 x 65¾)

186–7 Terrace, Pool and Living Room, Feb. 1984, 1984
oil on canvas, 91.4 x 152.4 (36 x 60)

188 Terrace with Shadows, 1985, 1985
photographic collage, 48.3 x 71.1 (19 x 28)

189 Montcalm Interior with Two Dogs, 1988
oil on canvas, 182.8 x 152.4 (72 x 60)

190–1 Large Interior, Los Angeles, 1988, 1988
oil, paper and ink on canvas, 182.8 x 304.8 (72 x 120)

192 My Garden in L.A., London, July 2000, 2000
oil on canvas, 91.4 x 121.9 (36 x 48)

193 left The Red Chair, April 1986, 1986
home made print executed on a colour copy machine
27.9 x 21.6 (11 x 8½)

193 right Saturday Rain II, 2003
watercolour on paper (2 sheets), 122.5 x 45.7 (48¼ x 18)

194 The Gate, 2000
oil on canvas, 152.4 x 193 (60 x 76)

195 Guest House Garden, 2000
oil on canvas, 152.4 x 193 (60 x 76)

196 Cactus Garden IV, 2003
watercolour on paper (4 sheets), 92 x 121.9 (36¼ x 48)

197 Angel Trumpet and Succulents, 2000
charcoal on paper, 56.5 x 76.2 (22¼ x 30)

198 Cactus and Wall, 2000
charcoal on paper, 76.2 x 56.5 (30 x 22¼)

199 Red Pots in the Garden, 2000
oil on canvas, 152.4 x 193 (60 x 76)

200–1 View from Terrace II, 2003
watercolour on paper (8 sheets), 92 x 244.2 (36¼ x 96⅛)

202–3 Four Views of Montcalm Terrace, 2003
watercolour on paper (4 sheets), 87 x 121.9
(34¼ x 48) overall

204 L.A. Studio, 2003
watercolour on paper (6 sheets), 138 x 122.1 (54⁵⁄₁₆ x 48¹⁄₁₆)

205 Pembroke Studio Interior, 1984
lithograph, hand-painted frame, 102.9 x 125.7 (40½ x 49½)
© David Hockney/Tyler Graphics Ltd

206–7 Interior with Lamp, 2003
watercolour on paper (6 sheets), 91.4 x 182.8 (36 x 72)

208 The Room, Manchester Street (detail), 1967
acrylic on canvas, 243.8 x 243.8 (96 x 96)

210 top Boodgie, 1993
crayon on paper, 57.2 x 76.8 (22½ x 30¼)

210 bottom Stanley, 1993
crayon on paper, 57.2 x 76.8 (22½ x 30¼)

211 Dog Painting 30, 1995
oil on canvas, 27.3 x 22.2 (10¾ x 8¾)

212 Peter, 1972
ink on paper, 43.2 x 35.6 (17 x 14)

213 Nicky Rea, 1975
crayon on paper, 64.8 x 50.2 (25½ x 19¾)

214 Dr Eugene Lamb, 1973
crayon on paper, 58.4 x 50.8 (23 x 20)

215 Joe McDonald, 1976
lithograph, 106 x 74.9 (41¾ x 29½)
© David Hockney/Gemini G.E.L.

216 Celia in a Black Slip Reclining, Paris,
December, 1973
crayon on paper, 49.5 x 64.7 (19½ x 25½)

217 Celia with Her Foot on a Chair, 1984
oil on canvas, 76.8 x 57.5 (30¼ x 22 5/8)

218 Portrait of Jean Léger, 1973
pencil on paper, 63.5 x 48.3 (25 x 19)

219 Man Ray, 1973
crayon on paper, 43.2 x 35.6 (17 x 14)

220 Lila di Nobilis, Paris 1973, 1973
crayon on paper, 66 x 50.8 (26 x 20)

221 The Connoisseur, 1969
lithograph in grey, 80.6 x 57.8 (31¾ x 22¾)

222 An Image of Gregory (detail), 1984
lithograph, 198.1 x 88.9 (78 x 35); top 81.3 x 64.7
(32 x 25½); bottom 116.8 x 88.9 (46 x 35)
© David Hockney/Tyler Graphics Ltd

223 Gregory, 1978
crayon on paper, 43.2 x 35.6 (17 x 14)

224 Pierre Saint-Jean, London, June 2000, 2000
oil on canvas, 55.2 x 33 (21¾ x 13)

225 Pierre Saint-Jean No. 3, 1984
charcoal on paper, 76.2 x 57.2 (30 x 22½)

226 Kasmin, 1988
oil on canvas, 61 x 61 (24 x 24)

227 Kasmin Los Angeles 28th March 1982, 1982
composite polaroid, 106 x 75.6 (41¾ x 29¾)

228 Henry Sleeping, 1978
ink on paper, 35.6 x 43.2 (14 x 17)

229 Henry, 1988
oil on canvas, 61 x 61 (24 x 24)

230 Ann Putting on Lipstick, 1979
lithograph, 119.4 x 46.9 (47 x 18½)

231 Ann Graves, 2003
watercolour on paper, 106 x 74.9 (41¾ x 29½)

232 Dr Wilbur Schwartz, 15th Feb 1994, 1994
crayon on paper, 76.8 x 57.2 (30¼ x 22½)

233 Mo McDermott II, 1984
charcoal on paper, 76.2 x 57.2 (30 x 22½)

234 Maurice Payne, 1971
etching, 88.9 x 71.1 (35 x 28)

235 Maurice Payne, 6th Feb 1994, 1994
crayon on paper, 76.8 x 57.2 (30¼ x 22½)

236 Jonathan Silver, Dec 30th 1993, 1993
crayon on paper, 76.8 x 57.2 (30¼ x 22½)

237 Jonathan Silver, February 27, 1997, 1997
oil on canvas, 34.9 x 27.3 (13¾ x 10¾)

238 Norman Rosenthal. London. 29th May 1999, 1999
pencil and white crayon on grey paper using a camera
lucida, 49.5 x 39.4 (19½ x 15½)

239 top, left Edna O'Brien. London. 28th May 1999, 1999
pencil on grey paper using a camera lucida, 54.3 x 38.4
(21⅜ x 15⅛)

239 top, right Don Bachardy. Los Angeles.
28th July 1999 (detail), 1999
pencil, white crayon and grey pencil on grey paper
using a camera lucida, 56.5 x 38.1 (22¼ x 15)

239 bottom, left Richard Schmidt. Los Angeles.
16th July 1999, 1999
pencil on grey paper using a camera lucida, 56.5 x 37.5
(22¼ x 14¾)

239 bottom, right Philip Hockney. Australia.
7th October 1999 (detail), 1999
pencil on grey paper using a camera lucida, 50.8 x 38.1
(20 x 15)

240 left Nikos Stangos, 1989
oil on canvas, 41.9 x 26.7 (16½ x 10½)

240 right George Clark II, 1989
oil on canvas, 41.9 x 26.7 (16½ x 10½)

241 Karen Wright, 2002
watercolour on paper, 61 x 46 (24 x 18⅛)

242 Mike Izzo IV, 2003
watercolour on paper (2 sheets), 61 x 92 (24 x 36¼)

243 left Andrew Marr, 2002
watercolour on paper (2 sheets), 121.9 x 46 (48 x 18⅛)

243 right *Lindy Watching Paint Dry*, 2003
watercolour on paper (2 sheets), 121.9 x 46 (48 x 18⅛)

244 *George Mulder*, 2002
ink and watercolour on paper, 61 x 46 (24 x 18⅛)

245 *George and Mary Christie*, 2002
watercolour on paper (4 sheets), 121.9 x 91.4 (48 x 36)

246 *Randall Wright*, 2002
ink and watercolour on paper, 36.5 x 26 (14⅜ x 10¼)

247 *Bing, Baden Baden*, 2002
ink on paper (2 sheets), 59.7 x 26 (23½ x 10¼)

248 *Francis Russell*, 2003
ink and watercolour on paper, 41 x 31.1 (16⅛ x 12¼)

249 *Jeremy Lewis, Como, April 2004*, 2004
ink and watercolour on paper, 41 x 31 (16⅛ x 12³⁄₁₆)

250 *John Fitzherbert*, 2003
watercolour on paper, 106 x 75.6 (41¾ x 29¾)

251 *Gregory Evans II*, 2003
watercolour on paper, 106 x 75.6 (41¾ x 29¾)

252 top *John Fitzherbert*, 2002
ink on paper, 36.2 x 26 (14¼ x 10¼)

252 bottom Sketchbook page: 'John', 2003
ink on paper, 10.8 x 15.2 (4¼ x 6)

253 *John Fitzherbert, Baden Baden*, 2002
ink on paper, 26 x 36.2 (10¼ x 14¼)

254 *Karen S. Kuhlman*, 2003
watercolour on paper, 105.7 x 75.6 (41⅝ x 29¾)

255 *Larry Stanton, Wearing a Colourful Baseball Jacket*, 1976
coloured crayon on paper, 43.2 x 35.6 (17 x 14)

256 *David Graves, Pembroke Studios, London, Tuesday, 27th April 1982*, 1982
composite polaroid, 131.4 x 66.7 (51¾ x 26¼)

257 *David Graves*, 2003
watercolour on paper, 105.4 x 75.2 (41½ x 29⅝)

258 *Drue Heinz, Como, April 2004*, 2004
ink and watercolour on paper, 41 x 31 (16⅛ x 12³⁄₁₆)

259 *Lady Northbourne*, 2002
ink on paper, 36.2 x 26 (14¼ x 10¼)

260 *Derwent May*, 2003
ink and watercolour on paper, 41 x 31.1 (16⅛ x 12¼)

261 *Manuela Rosenthal*, 2004
watercolour on paper, 74.9 x 105.4 (29½ x 41½)

262 *Mother, July 9, 1978*, 1978
ink on paper, 43.2 x 35.6 (17 x 14)

263 *The Artist's Father*, 1972
ink on paper, 43.2 x 35.6 (17 x 14)

264 *Mum, 1990*, 1990
oil on canvas, 91.4 x 61 (36 x 24)

265 *My Mother Sleeping, Los Angeles, Dec. 1982*, 1982
photographic collage, 58.4 x 58.4 (23 x 23)

266 *Mother I, Yorkshire Moors, August 1985*, 1985
photographic collage, 46.9 x 33 (18½ x 13)

267 *My Mother, Bridlington*, 1988
oil on canvas, 76.2 x 50.8 (30 x 20)

268 left *Paul Hockney and Grandson Timothy, 7 March 94*, 1994
crayon on paper, 76.8 x 57.2 (30¼ x 22½)

268 right *Jean Hockney*, 1989
oil on canvas, 41.9 x 26.7 (16½ x 10½)

269 *Lauren, Dawn, Simon and Matthew Hockney*, 2003
watercolour on paper (4 sheets), 121.9 x 92 (48 x 36¼)

270 *Margaret and Ken*, 2002
ink and watercolour on paper, 46 x 61 (18⅛ x 24)

271 *Margaret Reading, Christmas Day*, 2003
pencil on paper, 35.9 x 50.8 (14⅛ x 20)

272 *Self-portrait with Cigarette*, 1983
charcoal on paper, 76.2 x 57.2 (30 x 22½)

273 *Self-portrait in Mirror*, 2003
watercolour on paper, 61 x 46 (24 x 18⅛)

274 top *Self-portrait, Baden-Baden, 8th June 1999*, 1999
pencil on grey paper, 28.6 x 38.1 (11¼ x 15)

274 bottom *Self-portrait, Baden-Baden, 9th June 1999*, 1999
pencil on grey paper, 28.6 x 38.1 (11¼ x 15)

275 *Self-portrait, Baden-Baden, 10th June 1999*, 1999
pencil on grey paper, 38.1 x 28.6 (15 x 11¼)

276 left *Self-portrait in Black Sweater*, 2003
watercolour on paper, 61 x 46 (24 x 18⅛)

276 right *Self-portrait with Red Braces*, 2003
watercolour on paper, 61 x 46 (24 x 18⅛)

277 Sketchbook page: 'Self-portrait', 2002
ink on paper, 10.8 x 15.2 (4¼ x 6)

278 *Flight into Italy – Swiss Landscape*, 1962
oil on canvas, 182.8 x 182.8 (72 x 72)

280 *Shell Garage, Luxor*, 1963
crayon, 31.1 x 48.9 (12¼ x 19¼)

281 *Great Pyramid at Giza with Broken Head from Thebes*, 1963
oil on canvas, 182.8 x 182.8 (72 x 72)

282 *Sphinx in Front of the Pyramids*, 1978
sepia ink on paper, 35.6 x 43.2 (14 x 17)

283 *Egyptian Cafe*, 1978
oil on canvas, 91.4 x 121.9 (36 x 48)

284 *Two Deckchairs, Calvi*, 1972
acrylic on canvas, 121.9 x 152.4 (48 x 60)

285 *Beach Umbrella*, 1971
acrylic on canvas, 121.9 x 90.8 (48 x 35¾)

286 *Rue de Seine*, 1972
etching, aquatint, 53.3 x 44.5 (21 x 17½)

287 *Contre-Jour in the French Style*, 1974
etching, 99.1 x 91.4 (39 x 36)

288–9 *Place Furstenberg, Paris, August 7th, 8th and 9th, 1985* (detail), 1985
photographic collage, 110.5 x 155.8 (43½ x 61⅜)

290–1 Sketchbook page: 'Courtyard, Seville', 2004
watercolour on paper, 10.8 x 15.2 (4¼ x 6)

292–3 *Andalucia. Fountain, Alhambra, Granada*, 2004
watercolour on paper (2 sheets), 74.9 x 210.8 (29½ x 83)

294–5 *Andalucia. Mosque, Cordova*, 2004
watercolour on paper (2 sheets), 74.9 x 210.8 (29½ x 83)

296–7 *A Walk around the Hotel Courtyard, Acatlan*, 1985
oil on two canvases, 182.8 x 609.6 (72 x 240)

298 *Iowa*, 1964
acrylic on canvas, 152.4 x 152.4 (60 x 60)

299 *Arizona*, 1964
acrylic on canvas, 152.4 x 152.4 (60 x 60)

300–1 *Rocky Mountains and Tired Indians*, 1965
acrylic on canvas, 170.2 x 252.7 (67 x 99½)

302 *Olympic Boulevard*, 1964
acrylic on canvas, 91.4 x 61 (36 x 24)

303 *Building Pershing Square, Los Angeles*, 1964
acrylic on canvas, 147.3 x 147.3 (58 x 58)

304 *De Longpre Avenue, Hollywood*, 1976
crayon and pencil on paper, 43.2 x 35.6 (17 x 14)

305 *Hancock St, West Hollywood, I*, 1989
oil on canvas, 41.9 x 26.7 (16½ x 10½)

306 *Nichols Canyon*, 1980
acrylic on canvas, 213.3 x 152.4 (84 x 60)

307 *Mulholland Drive, June 1986*, 1986
home made print executed on a colour copy machine, 27.9 x 43.2 (11 x 17)

308–9 *Pacific Coast Highway and Santa Monica*, 1990
oil on canvas, 198.1 x 304.8 (78 x 120)

310–11 *A Bigger Grand Canyon*, 1998
oil on 60 canvases, 207 x 744 (81½ x 293) overall

312–13 *A Closer Grand Canyon*, 1998
oil on 60 canvases, 207 x 744 (81½ x 293) overall

314–15 *Kweilin Airport, China*, 1981
watercolour on paper, 35.6 x 43.2 (14 x 17)

316–17 *Boat with Red Flag and Caterpillar, Kweilin, China*, 1981
wash and crayon on paper, 35.6 x 43.2 (14 x 17)

318 *Hotel at Sian, China* (detail), 1981
watercolour on paper, 35.6 x 43.2 (14 x 17)

319 *Road from Peking Airport, China*, 1981
crayon on paper, 86.4 x 35.6 (34 x 14)

320 *Kyoto*, 1971
coloured pencil on paper, 35.6 x 43.2 (14 x 17)

321 *Sitting in the Zen Garden at the Ryoanji Temple, Kyoto, Feb 19, 1983*, 1983
photographic collage, 144.8 x 116.8 (57 x 46)

322 *Gregory Watching the Snow Fall, Kyoto, Feb 21, 1983*, 1983
photographic collage, 110.5 x 118.1 (43½ x 46½)

323 *Shoes, Kyoto, Japan, Feb. 1983*, 1983
photographic collage, 111.8 x 99.1 (44 x 39)

324 *Study of Waterfall, Stalheim*, 2002
watercolour on paper, 41 x 30.8 (16⅛ x 12⅛)

325 *Undredal*, 2002
watercolour on paper (3 sheets), 138.4 x 61 (54½ x 24)

326–7 *Maelstrom, Bodo*, 2002
watercolour on paper (6 sheets), 91.5 x 183 (36 x 72)

328 *Fjord, Kamøyvær*, 2002
watercolour on paper, 30.8 x 41 (12⅛ x 16⅛)

329 *Tufjorden from near Nordcapp*, 2002
watercolour on paper, 30.8 x 41 (12⅛ x 16⅛)

330 *Mist, Stalheim*, 2002
watercolour on paper, 30.8 x 41 (12⅛ x 16⅛)

331 *The Valley, Stalheim I*, 2002
watercolour on paper (2 sheets), 81.9 x 30.8 (32¼ x 12⅛)

332 top *Setting Sun, Midfjord*, 2003
watercolour on paper, 27.9 x 37.8 (11 x 14⅞)

332 bottom *Midfjord, Birches, Second Version*, 2003
watercolour on paper, 27.9 x 37.8 (11 x 14⅞)

333 top *Study for House, Midfjord*, 2003
watercolour on paper, 27.9 x 37.8 (11 x 14⅞)

333 bottom *Cloud, Vestrefjord*, 2003
watercolour on paper, 27.9 x 37.8 (11 x 14⅞)

334–5 Sketchbook page: 'Mist, Iceland', 2002
ink on paper, 10.8 x 15.2 (4¼ x 6)

336–7 *Godafoss, Iceland*, 2002
watercolour on paper (8 sheets)
91.4 x 243.8 (36 x 96)

338–9 *Black Glacier 1*, 2002
watercolour on paper (2 sheets)
45.7 x 121.9 (18 x 48)

340–1 *Cherry Blossom*, 2002
watercolour and crayon on paper (4 sheets)
91.4 x 121.9 (36 x 48)

342 *St John's Spire and Tree*, 2002
watercolour on paper, 26.7 x 17.8 (10½ x 7)

343 *Rainy Morning, Holland Park*, 2004
watercolour on paper, 105.4 x 74.9 (41½ x 29½)

344 *Wolds Way*, 2003
watercolour on paper, 74.9 x 105.4 (29½ x 41½)

345 *Grey Sun, East Yorkshire*, 2003
watercolour on paper, 74.9 x 105.4 (29½ x 41½)

346 *North Yorkshire*, 1997
oil on canvas, 121.9 x 152.4 (48 x 60)

347 *The Road Across The Wolds*, 1997
oil on canvas, 121.9 x 152.4 (48 x 60)

348 *Going up Garrowby Hill*, 2000
oil on canvas, 213.3 x 152.4 (84 x 60)

349 *Garrowby Hill*, 1998
oil on canvas, 152.4 x 193 (60 x 76)
framed 156.2 x 196.9 (61½ x 77½)

350–1 *The Road to York through Sledmere*, 1997
oil on canvas, 121.9 x 152.4 (48 x 60)

352 *The Road to Ruston, 23 III 04*, 2004
watercolour on paper, 74.9 x 105.4 (29½ x 41½)

353 *Church and Street. Kilham*, 2003
watercolour on paper, 74.9 x 105.4 (29½ x 41½)

354–5 Sketchbook page: 'East Yorkshire, Spring', 2004
watercolour on paper, 10.8 x 15.2 (4¼ x 6)

356–7 *Untitled*, 2004
watercolour on paper (2 sheets)
75.2 x 210.2 (29⅝ x 82¾)

358–9 *Lovely Day with Puddles, 2 IV 04*, 2004
watercolour on paper, 74.9 x 105.4 (29½ x 41½)

Year-by-year list

Works appear in chronological order, where known, and then alphabetically. Numbers in bold refer to page numbers. Measurements are given in centimetres, followed by inches, height before width before depth.

1960
121 *Going to be a Queen for Tonight*, 1960
oil on board, 121.9 x 91.4 (48 x 36)

1960–1
122 *Doll Boy*, 1960–1
oil on canvas, 121.9 x 99.1 (48 x 39)

1961
89 *The Cha Cha that was Danced in the Early Hours of 24th March, 1961*, 1961
oil on canvas, 172.7 x 153.7 (68 x 60½)

22–3 *A Grand Procession of Dignitaries in the Semi-Egyptian Style*, 1961
oil on canvas, 213.3 x 365.7 (84 x 144)

26 *Tea Painting in an Illusionistic Style*, 1961
oil on canvas, 198.1 x 76.2 (78 x 30)

123 *The Fourth Love Painting*, 1961
oil and letraset on canvas, 91.4 x 71.4 (36 x 28⅛)

27 *The Second Tea Painting*, 1961
oil on canvas, 154.9 x 91.4 (61 x 36)

1962
120 *Berlin: A Souvenir*, 1962
oil on canvas, 213.3 x 213.3 (84 x 84)

30 *Colonial Governor*, 1962
crayon and ink on paper, 34.9 x 26 (13¾ x 10¼)

278 *Flight into Italy – Swiss Landscape*, 1962
oil on canvas, 182.8 x 182.8 (72 x 72)

34 *Flowers for a Wedding*, 1962
oil on canvas, 61 x 30.5 (24 x 12)

88 *Help*, 1962
oil, ink and letraset on canvas, 31.8 x 24.8 (12½ x 9¾)

31 *Man in a Museum*
(or You're in the Wrong Movie), 1962
oil on canvas, 152.4 x 152.4 (60 x 60)

87 *Picture Emphasizing Stillness*, 1962
oil and letraset on canvas, 182.8 x 157.5 (72 x 62)

28 *The Cruel Elephant*, 1962
oil on canvas, 121.9 x 152.4 (48 x 60)

24 *The First Marriage (A Marriage of Styles I)*, 1962
oil on canvas, 182.8 x 152.4 (72 x 60)

1963
112 *American Boys Showering*, 1963
pencil and crayon on paper, 50.2 x 31.8 (19¾ x 12½)

45 *Closing Scene*, 1963
oil on canvas, 121.9 x 121.9 (48 x 48)

43 *Cubistic Woman*, 1963
coloured pencil on paper, 31.8 x 25.4 (12½ x 10)

119 *Domestic Scene, Broadchalke, Wilts*, 1963
oil on canvas, 182.8 x 182.8 (72 x 72)

118 *Domestic Scene, Los Angeles*, 1963
oil on canvas, 152.4 x 152.4 (60 x 60)

281 *Great Pyramid at Giza with Broken Head from Thebes*, 1963
oil on canvas, 182.8 x 182.8 (72 x 72)

41 *Seated Woman Drinking Tea, Being Served by a Standing Companion*, 1963
oil on canvas, 198.1 x 213.3 (78 x 84)

280 *Shell Garage, Luxor*, 1963
crayon, 31.1 x 48.9 (12¼ x 19¼)

40 *Still Life with Figure and Curtain*, 1963
oil on canvas, 198.1 x 213.3 (78 x 84)

44 *The Hypnotist*, 1963
etching and aquatint in two colours, 63.5 x 57.2 (25 x 22½)

25 *The Second Marriage*, 1963
oil, gouache and collage on canvas, 197.4 x 228.6 (77¾ x 90)

42 *The Singer*, 1963
coloured pencil on paper, 31.8 x 25.4 (12½ x 10)

113 *Two Men in a Shower*, 1963
oil on canvas, 152.4 x 152.4 (60 x 60)

1964
299 *Arizona*, 1964
acrylic on canvas, 152.4 x 152.4 (60 x 60)

303 *Building Pershing Square, Los Angeles*, 1964
acrylic on canvas, 147.3 x 147.3 (58 x 58)

126 *California Art Collector*, 1964
acrylic on canvas, 152.4 x 182.8 (60 x 72)

29 *Cubist Boy with Colourful Tree*, 1964
acrylic on canvas, 166.4 x 166.4 (65½ x 65½)

298 *Iowa*, 1964
acrylic on canvas, 152.4 x 152.4 (60 x 60)

302 *Olympic Boulevard*, 1964
acrylic on canvas, 91.4 x 61 (36 x 24)

46 *Ordinary Picture*, 1964
acrylic on canvas, 182.8 x 182.8 (72 x 72)

115 *Nude Boy, Los Angeles*, 1964
pencil and crayon on paper, 31.1 x 25.4 (12¼ x 10)

67 *Picture of a Hollywood Swimming Pool*, 1964
acrylic on canvas, 91.4 x 121.9 (36 x 48)

47 *The Actor*, 1964
acrylic on canvas, 166.4 x 166.4 (65½ x 65½)

32 *Trees, 1964*, 1964
acrylic on two canvases, 72.4 x 76.2 (28½ x 30)

1965
35 *A Realistic Still Life*, 1965
acrylic on canvas, 121.9 x 121.9 (48 x 48)

66 *Atlantic Crossing*, 1965
oil on canvas, 182.8 x 182.8 (72 x 72)

33 *Cubistic Tree*, 1965
crayon on paper, 35.6 x 42.5 (14 x 16¾)

86 *Different Kinds of Water Pouring into a Swimming Pool, Santa Monica*, 1965
acrylic on canvas, 182.8 x 152.4 (72 x 60)

114 *Man Taking Shower*, 1965
acrylic on canvas, 152.4 x 121.9 (60 x 48)

15 left *Picture of a Still Life that has an Elaborate Silver Frame*, 1965, from *A Hollywood Collection*
lithograph in seven colours, 76.8 x 56.5 (30¼ x 22¼)

15 right *Picture of Melrose Avenue in an Ornate Gold Frame*, 1965, from *A Hollywood Collection*
lithograph in six colours, 76.8 x 56.5 (30¼ x 22¼)

300–1 *Rocky Mountains and Tired Indians*, 1965
acrylic on canvas, 170.2 x 252.7 (67 x 99½)

74 *Two Boys in a Pool, Hollywood*, 1965
acrylic on canvas, 152.4 x 152.4 (60 x 60)

1966
48 bottom *Curtain for 'Ubu Roi'*, 1966
pencil, crayon on paper, 38.1 x 50.8 (15 x 20)

48 top *Royal Palace and Parade Ground*, 1966
crayon on paper, 36.8 x 49.5 (14½ x 19½)

72 *Sunbather*, 1966
acrylic on canvas, 182.8 x 182.8 (72 x 72)

1966–7
116 *In the Dull Village*, 1966–7, from *Illustrations for Fourteen Poems from C. P. Cavafy*
etching, 57.2 x 39.4 (22½ x 15½)

117 *Two Boys Aged 23 or 24*, 1966–7, from *Illustrations for Fourteen Poems from C. P. Cavafy*
etching, 80 x 57.2 (31½ x 22½)

1967
77 *A Bigger Splash*, 1967
acrylic on canvas, 243.8 x 243.8 (96 x 96)

85 *A Lawn Sprinkler*, 1967
acrylic on canvas, 121.9 x 121.9 (48 x 48)

68–9 *Four Different Kinds of Water*, 1967
acrylic on canvas, 36.8 x 105.4 (14½ x 41½)

208 *The Room, Manchester Street* (detail), 1967
acrylic on canvas, 243.8 x 243.8 (96 x 96)

1968
127 *American Collectors (Fred and Marcia Weisman)*, 1968
acrylic on canvas, 213.3 x 304.8 (84 x 120)

125 *Christopher Isherwood and Don Bachardy*, 1968
acrylic on canvas, 212 x 303.5 (83½ x 119½)

128 *Frederick Ashton and Wayne Sleep*, 1968
ink on paper, 43.2 x 35.6 (17 x 14)

1969
84 *Cold Water about to Hit the Prince*, 1969, from *Illustrations for Six Fairy Tales from the Brothers Grimm*
etching in black, 62.2 x 45.1 (24½ x 17¾)

37 *Glass Table with Objects*, 1969
lithograph in 5 colours, 46.4 x 57.8 (18¼ x 22¾)

176 *Home*, 1969, from *Illustrations for Six Fairy Tales from the Brothers Grimm*
etching in black, 43.8 x 31.1 (17¼ x 12¼)

96 *Still Life with T.V.*, 1969
acrylic on canvas, 121.9 x 152.4 (48 x 60)

221 *The Connoisseur*, 1969
lithograph in grey, 80.6 x 57.8 (31¾ x 22¾)

152 *Vase and Flowers*, 1969
etching in black, 90.2 x 71.1 (35½ x 28)

1970
10 *Three Chairs with a Section of a Picasso Mural*, 1970
acrylic on canvas, 121.9 x 152.4 (48 x 60)

145 *Vichy Water and 'Howard's End', Carennac*, 1970
ink on paper, 35.6 x 43.2 (14 x 17)

1970–1
130–1 *Mr and Mrs Clark and Percy*, 1970–1
acrylic on canvas, 213.3 x 304.8 (84 x 120)

1971
285 *Beach Umbrella*, 1971
acrylic on canvas, 121.9 x 90.8 (48 x 35¾)

146 *Chairs, Mamounia Hotel, Marrakesh*, 1971
crayon on paper, 35.6 x 43.2 (14 x 17)

6 *Flowers Made of Paper and Black Ink*, 1971
lithograph, 99.7 x 95.3 (39¼ x 37½)

13 *Gonzalez and Shadow*, 1971
acrylic on canvas, 121.9 x 91.4 (48 x 36)

320 *Kyoto*, 1971
coloured pencil on paper, 35.6 x 43.2 (14 x 17)

234 *Maurice Payne*, 1971
etching, 88.9 x 71.1 (35 x 28)

71 *Rubber Ring Floating in a Swimming Pool*, 1971
acrylic on canvas, 91.4 x 121.9 (36 x 48)

1972
133 *Nick and Henry on Board. Nice to Calvi July 18th 1972*, 1972
ink on paper, 43.2 x 35.6 (17 x 14)

147 *Mt. Fuji and Flowers*, 1972
acrylic on canvas, 152.4 x 121.9 (60 x 48)

212 *Peter*, 1972
ink on paper, 43.2 x 35.6 (17 x 14)

286 *Rue de Seine*, 1972
etching, aquatint, 53.3 x 44.5 (21 x 17½)

263 *The Artist's Father*, 1972
ink on paper, 43.2 x 35.6 (17 x 14)

284 *Two Deckchairs, Calvi*, 1972
acrylic on canvas, 121.9 x 152.4 (48 x 60)

1973
216 *Celia in a Black Slip Reclining, Paris, December*, 1973
crayon on paper, 49.5 x 64.7 (19½ x 25½)

214 *Dr Eugene Lamb*, 1973
crayon on paper, 58.4 x 50.8 (23 x 20)

132 *Henry and Mo, Villa Reale*, 1973
coloured pencil on paper, 35.6 x 43.2 (14 x 17)

220 *Lila di Nobilis, Paris 1973*, 1973
crayon on paper, 66 x 50.8 (26 x 20)

219 *Man Ray*, 1973
crayon on paper, 43.2 x 35.6 (17 x 14)

144 *Mirror, Casa Santini*, 1973
oil on canvas, 152.4 x 121.9 (60 x 48)

218 *Portrait of Jean Léger*, 1973
pencil on paper, 63.5 x 48.3 (25 x 19)

82 *Rain*, 1973, from *The Weather Series*
lithograph and screenprint, 99.1 x 77.5 (39 x 30½)

153 *Still Life with Book*, 1973
lithograph, 81.3 x 63.5 (32 x 25)

137 *Yves-Marie in the Rain*, 1973
oil on canvas, 121.9 x 152.4 (48 x 60)

1973–4
11 *Artist and Model*, 1973–4
etching, 74.9 x 57.2 (29½ x 22½)

1974
287 *Contre-Jour in the French Style*, 1974
etching, 99.1 x 91.4 (39 x 36)

136 *Il Pleut sur le Pont des Arts*, 1974
crayon on paper, 43.2 x 35.6 (17 x 14)

134–5 *Shirley Goldfarb and Gregory Masurovsky*, 1974
acrylic on canvas, 114.3 x 213.3 (45 x 84)

1975
110 *Yves-Marie and Mark, Paris, Oct 1975*, 1975
red conte on paper, 64.7 x 49.5 (25½ x 19½)

49 *An Assembly*, 1975, from *The Rake's Progress*
ink, ballpoint and collage, 50.2 x 65.1 (19¾ x 25⅝)

36 *Invented Man Revealing Still Life*, 1975
oil on canvas, 91.4 x 72.4 (36 x 28½)

8 *Kerby (After Hogarth). Useful Knowledge*, 1975
oil on canvas, 182.8 x 152.4 (72 x 60)

213 *Nicky Rea*, 1975
crayon on paper, 64.8 x 50.2 (25½ x 19¾)

1976
304 *De Longpre Avenue, Hollywood*, 1976
crayon and pencil on paper, 43.2 x 35.6 (17 x 14)

215 *Joe McDonald*, 1976
lithograph, 106 x 74.9 (41¾ x 29½)
© David Hockney/Gemini G.E.L.

255 *Larry Stanton, Wearing a Colourful Baseball Jacket*, 1976
coloured crayon on paper, 43.2 x 35.6 (17 x 14)

70 *Study of Water, Phoenix, Arizona*, 1976
crayon on paper, 45.7 x 49.8 (18 x 19⅝)

1976–7
39 *A Picture of Ourselves*, 1976–7, from *The Blue Guitar*
etching, 45.7 x 52.7 (18 x 20¾)

38 *Serenade*, 1976–7, from *The Blue Guitar*
etching, 52 x 45.7 (20½ x 18)

1977
14 *Looking at Pictures on a Screen*, 1977
oil on canvas, 187.9 x 187.9 (74 x 74)

2 *Still Life, Taj Hotel Bombay*, 1977
crayon on paper, 43.2 x 35.6 (17 x 14)

129 *Study of George Lawson*, 1977
oil on canvas, 101.6 x 127 (40 x 50)

1978
262 *Mother, July 9, 1978*, 1978
ink on paper, 43.2 x 35.6 (17 x 14)

78–9 *A Large Diver (Paper Pool 27)*, 1978
coloured and pressed paper pulp, 182.8 x 434.3 (72 x 171)

283 *Egyptian Cafe*, 1978
oil on canvas, 91.4 x 121.9 (36 x 48)

223 *Gregory*, 1978
crayon on paper, 43.2 x 35.6 (17 x 14)

228 *Henry Sleeping*, 1978
ink on paper, 35.6 x 43.2 (14 x 17)

75 *Plongeoir avec Ombre (Paper Pool 13)*, 1978
coloured and pressed paper pulp, 182.8 x 217.1 (72 x 85½)

73 *Pool Study II*, 1978
ink on paper, 21.6 x 27.9 (8½ x 11)

76 *Schwimmbad Mitternacht (Paper Pool 11)*, 1978
coloured and pressed paper pulp, 182.8 x 217.1 (72 x 85½)

282 *Sphinx in Front of the Pyramids*, 1978
sepia ink on paper, 35.6 x 43.2 (14 x 17)

1979
230 *Ann Putting on Lipstick*, 1979
lithograph, 119.4 x 46.9 (47 x 18½)

1980
12 *Cubistic Bar*, 1980, from *Les Mamelles de Tiresias*
crayon on paper, 47.9 x 60.6 (18⅞ x 23⅞)

50 *Les Mamelles de Tiresias*, 1980
oil on canvas, 91.4 x 121.9 (36 x 48)

98–9 *Mulholland Drive: The Road to the Studio*, 1980
acrylic on canvas, 218.4 x 617.2 (86 x 243)

306 *Nichols Canyon*, 1980
acrylic on canvas, 213.3 x 152.4 (84 x 60)

52–3 *Parade Collage*, 1980
gouache, ink and crayon on paper, 101.6 x 152.4 (40 x 60)

51 *Ravel's Garden with Night Glow*, 1980
from *L'Enfant et les sortilèges*
oil on canvas, 152.4 x 182.8 (60 x 72)

92–3 *Two Dancers*, 1980
oil on canvas, 121.9 x 182.8 (48 x 72)

94 *Waltz*, 1980
oil on canvas, 92.7 x 62.5 (36½ x 24⅝)

1981
316–17 *Boat with Red Flag and Caterpillar, Kweilin, China*, 1981
wash and crayon on paper, 35.6 x 43.2 (14 x 17)

318 *Hotel at Sian, China* (detail), 1981
watercolour on paper, 35.6 x 43.2 (14 x 17)

314–15 *Kweilin Airport, China*, 1981
watercolour on paper, 35.6 x 43.2 (14 x 17)

319 *Road from Peking Airport, China*, 1981
crayon on paper, 86.4 x 35.6 (34 x 14)

1981–2
182–3 *Hollywood Hills House*, 1981–2
oil, charcoal and collage on canvas, 152.4 x 304.8 (60 x 120)

1982
227 *Kasmin Los Angeles 28th March 1982*, 1982
composite polaroid, 106 x 75.6 (41¾ x 29¾)

184 *Unfinished Painting in Finished Photograph(s), April 2nd 1982*, 1982
composite polaroid, 62.9 x 76.2 (24¾ x 30)

103 *Yellow Guitar Still Life, Los Angeles, 3rd April 1982*, 1982
composite polaroid, 72.4 x 44.5 (28½ x 17½)

83 *Rain on the Pool, Los Angeles, April 12th 1982*, 1982
composite polaroid, 62.9 x 92.7 (24¾ x 36½)

80–1 *Sun on the Pool, Los Angeles, April 13th 1982*, 1982
composite polaroid, 62.9 x 92 (24¾ x 36¼)

256 *David Graves, Pembroke Studios, London, Tuesday, 27th April 1982*, 1982
composite polaroid, 131.4 x 66.7 (51¾ x 26¼)

265 *My Mother Sleeping, Los Angeles, Dec. 1982*, 1982
photographic collage, 58.4 x 58.4 (23 x 23)

95 *The Skater, NY, Dec. 1982*, 1982
photographic collage, 59.7 x 43.2 (23½ x 17)

185 *Studio, Hollywood Hills House*, 1982
gouache on paper, 129.5 x 167 (51 x 65¾)

1983
321 *Sitting in the Zen Garden at the Ryoanji Temple, Kyoto, Feb 19, 1983*, 1983
photographic collage, 144.8 x 116.8 (57 x 46)

322 *Gregory Watching the Snow Fall, Kyoto, Feb 21, 1983*, 1983
photographic collage, 110.5 x 118.1 (43½ x 46½)

323 *Shoes, Kyoto, Japan, Feb. 1983*, 1983
photographic collage, 111.8 x 99.1 (44 x 39)

100–1 *Walking in the Zen Garden at the Ryoanji Temple, Kyoto, Feb. 1983*, 1983
photographic collage, 101.6 x 158.8 (40 x 62½)

124 *Christopher Isherwood Talking to Bob Holman, Santa Monica, Mar 14th, 1983* (detail), 1983
photographic collage, 110.5 x 163.8 (43½ x 64½)

272 *Self-portrait with Cigarette*, 1983
charcoal on paper, 76.2 x 57.2 (30 x 22½)

1984
186–7 *Terrace, Pool and Living Room, Feb. 1984*, 1984
oil on canvas, 91.4 x 152.4 (36 x 60)

97 *The Desk, July 1st 1984*, 1984
photographic collage, 121.9 x 116.8 (48 x 46)

222 *An Image of Gregory* (detail), 1984
lithograph, 198.1 x 88.9 (78 x 35); top 81.3 x 64.7 (32 x 25½); bottom 116.8 x 88.9 (46 x 35)
© David Hockney/Tyler Graphics Ltd

217 *Celia with Her Foot on a Chair*, 1984
oil on canvas, 76.8 x 57.5 (30¼ x 22 5/8)

233 *Mo McDermott II*, 1984
charcoal on paper, 76.2 x 57.2 (30 x 22½)

205 *Pembroke Studio Interior*, 1984
lithograph, hand-painted frame
102.9 x 125.7 (40½ x 49½)
© David Hockney/Tyler Graphics Ltd

225 *Pierre Saint-Jean No. 3*, 1984
charcoal on paper, 76.2 x 57.2 (30 x 22½)

106 *Two Pembroke Studio Chairs*, 1984
lithograph, 46.9 x 55.9 (18½ x 22)
© David Hockney/Tyler Graphics Ltd

1985
288–9 *Place Furstenberg, Paris, August 7th, 8th and 9th, 1985* (detail), 1985
photographic collage, 110.5 x 155.8 (43½ x 61⅜)

104 *Chair, Jardin de Luxembourg, Paris, 10th August 1985*, 1985
photographic collage, 80 x 64.8 (31½ x 25½)

266 *Mother I, Yorkshire Moors, August 1985*, 1985
photographic collage, 46.9 x 33 (18½ x 13)

296–7 *A Walk around the Hotel Courtyard, Acatlan*, 1985
oil on two canvases, 182.8 x 609.6 (72 x 240)

102 *Photography Eyes* (detail), 1985
felt pen on paper, 36.8 x 43.2 (14½ x 17)

148 Sketchbook page: 'Still Life with Matisse', 1985
pastel on paper, 33 x 59.1 (13 x 23¼)

188 *Terrace with Shadows, 1985*, 1985
photographic collage, 48.3 x 71.1 (19 x 28)

105 left *The Chair*, 1985
oil on canvas, 121.9 x 91.4 (48 x 36)

1986
108–9 *Pearblossom Highway, 11–18th April 1986 (Second Version)*, 1986
photographic collage, 181.6 x 271.8 (71½ x 107)
© David Hockney
collection of the J. Paul Getty Museum, Los Angeles, CA

107 *Room 229 Palmdale, Calif., 11th April 1986*, 1986
photographic collage, 101.9 x 85.7 (40⅛ x 33¾)

193 left *The Red Chair, April 1986*, 1986
home made print executed on a colour copy machine
27.9 x 21.6 (11 x 8½)

154 *Dancing Flowers, May 1986*, 1986
home made print executed on a colour copy machine
55.9 x 64.7 (22 x 25½) (6 panels)

159 *Three Black Flowers, May 1986*, 1986
home made print executed on a colour copy machine
27.9 x 21.6 (11 x 8½)

158 *Growing, June 1986*, 1986
home made print executed on a colour copy machine
27.9 x 21.6 (11 x 8½)

307 *Mulholland Drive, June 1986*, 1986
home made print executed on a colour copy machine
27.9 x 43.2 (11 x 17)

1987
90–1 *Bradford Bounce, Feb. 1987*, 1987
colour newsprint, 38.1 x 55.9 (15 x 22)

155 *Green and Blue Plant*, 1987
acrylic on canvas, 61 x 91.4 (24 x 36)

1988
105 right *Gauguin's Chair*, 1988
acrylic on canvas, 121.9 x 91.4 (48 x 36)

229 *Henry*, 1988
oil on canvas, 61 x 61 (24 x 24)

226 *Kasmin*, 1988
oil on canvas, 61 x 61 (24 x 24)

190–1 *Large Interior, Los Angeles, 1988*, 1988
oil, paper and ink on canvas, 182.8 x 304.8 (72 x 120)

189 *Montcalm Interior with Two Dogs*, 1988
oil on canvas, 182.8 x 152.4 (72 x 60)

267 *My Mother, Bridlington*, 1988
oil on canvas, 76.2 x 50.8 (30 x 20)

62–3 *The Sea at Malibu*, 1988
oil on canvas, 91.4 x 121.9 (36 x 48)

175 *Used Chair*, 1988
oil on canvas, 61 x 91.4 (24 x 36)

105 centre *Van Gogh Chair*, 1988
acrylic on canvas, 121.9 x 91.4 (48 x 36)

1989

180 *Breakfast with Stanley in Malibu,*
Aug 23rd 1989, 1989
fax collage, 129.5 x 142.2 (51 x 56) overall (24 sheets)

181 *Breakfast at Malibu, Sunday 1989*, 1989
oil on canvas, 61 x 91.4 (24 x 36)

65 *Geometric Waves, 1989*, 1989
gouache, ink, felt marker, crayon on paper,
21.6 x 27.9 (8½ x 11)

240 right *George Clark II*, 1989
oil on canvas, 41.9 x 26.7 (16½ x 10½)

305 *Hancock St, West Hollywood, I*, 1989
oil on canvas, 41.9 x 26.7 (16½ x 10½)

268 right *Jean Hockney*, 1989
oil on canvas, 41.9 x 26.7 (16½ x 10½)

240 left *Nikos Stangos*, 1989
oil on canvas, 41.9 x 26.7 (16½ x 10½)

64 *Three Green Waves with Orange Sand*, 1989
oil on canvas, 26.7 x 41.9 (10½ x 16½)

161 *Two Pink Flowers*, 1989
oil on canvas, 41.9 x 26.7 (16½ x 10½)

1990

178 *Beach House by Day*, 1990
oil on canvas, 61 x 91.4 (24 x 36)

179 *Beach House by Night*, 1990
oil on canvas, 61 x 91.4 (24 x 36)

264 *Mum, 1990*, 1990
oil on canvas, 91.4 x 61 (36 x 24)

308–9 *Pacific Coast Highway and Santa Monica*, 1990
oil on canvas, 198.1 x 304.8 (78 x 120)

1992

54–5 *Die Frau ohne Schatten, Act 3, Scene 4*
(scale model), 1992
foamcore, velvet paper, styrofoam, plaster cloth,
gouache, 215.9 x 229.9 x 121.9 (85 x 90½ x 48)

57 *The Fourth V. N. Painting*, 1992
oil on canvas, 61 x 61 (24 x 24)

56 *The Sixteenth V. N. Painting*, 1992
oil on canvas, 91.4 x 121.9 (36 x 48)

1993

236 *Jonathan Silver, Dec 30th 1993*, 1993
crayon on paper, 76.8 x 57.2 (30¼ x 22½)

210 top *Boodgie*, 1993
crayon on paper, 57.2 x 76.8 (22½ x 30¼)

210 bottom *Stanley*, 1993
crayon on paper, 57.2 x 76.8 (22½ x 30¼)

1994

235 *Maurice Payne, 6th Feb 1994*, 1994
crayon on paper, 76.8 x 57.2 (30¼ x 22½)

232 *Dr Wilbur Schwartz, 15th Feb 1994*, 1994
crayon on paper, 76.8 x 57.2 (30¼ x 22½)

268 left *Paul Hockney and Grandson Timothy,*
7 March 94, 1994
crayon on paper, 76.8 x 57.2 (30¼ x 22½)

1995

211 *Dog Painting 30*, 1995
oil on canvas, 27.3 x 22.2 (10¾ x 8¾)

60–1 *Near Bruges*, 1995
oil on two canvases, 53.3 x 152.4 (21 x 60)

163 *Peeled Lemon with Slices*, 1995
oil on canvas, 26 x 41.3 (10¼ x 16¼)

151 *The Vittel Bottle*, 1995
oil on canvas, 54.6 x 33 (21½ x 13)

1995–6

58–9 *Snails Space with Vari-Lites,*
'Painting as Performance', 1995–6
oil on two canvases, acrylic on canvas, covered masonite,
213.9 x 670.5 x 342.9 (84¼ x 264 x 135) overall

1996

160 *Antheriums*, 1996
oil on canvas, 81.3 x 65.4 (32 x 25¾)

164 *Cactus with Lemons*, 1996
oil on canvas, 121.9 x 91.4 (48 x 36)

157 *Halaconia in Green Vase*, 1996
oil on canvas, 182.8 x 182.8 (72 x 72)

165 *Sunflower in Bottle with Ashtray and Oranges*, 1996
oil on canvas, 64.7 x 54.3 (25½ x 21⅜)

1997

237 *Jonathan Silver, February 27, 1997*, 1997
oil on canvas, 34.9 x 27.3 (13¾ x 10¾)

346 *North Yorkshire*, 1997
oil on canvas, 121.9 x 152.4 (48 x 60)

347 *The Road Across The Wolds*, 1997
oil on canvas, 121.9 x 152.4 (48 x 60)

350–1 *The Road to York through Sledmere*, 1997
oil on canvas, 121.9 x 152.4 (48 x 60)

1998

310–11 *A Bigger Grand Canyon*, 1998
oil on 60 canvases, 207 x 744 (81½ x 293) overall

312–13 *A Closer Grand Canyon*, 1998
oil on 60 canvases, 207 x 744 (81½ x 293) overall

166 *Cacti on Terrace*, 1998
etching, 95.3 x 87.6 (37½ x 34½)

349 *Garrowby Hill*, 1998
oil on canvas, 152.4 x 193 (60 x 76)
framed 156.2 x 196.9 (61½ x 77½)

171 left *Hat on Chair*, 1998
etching, 74.9 x 56.5 (29½ x 22¼)

156 bottom *Red Wire Plant*, 1998
etching, 77.5 x 91.4 (30½ x 36)

1999

239 top, left *Edna O'Brien. London. 28th May 1999*, 1999
pencil on grey paper using a camera lucida, 54.3 x 38.4
(21⅜ x 15⅛)

238 *Norman Rosenthal. London. 29th May 1999*, 1999
pencil and white crayon on grey paper using a camera
lucida, 49.5 x 39.4 (19½ x 15½)

274 top *Self-portrait, Baden-Baden, 8th June 1999*, 1999
pencil on grey paper, 28.6 x 38.1 (11¼ x 15)

274 bottom *Self-portrait, Baden-Baden, 9th June 1999*
1999, pencil on grey paper, 28.6 x 38.1 (11¼ x 15)

275 *Self-portrait, Baden-Baden, 10th June 1999*, 1999
pencil on grey paper, 38.1 x 28.6 (15 x 11¼)

239 bottom, left *Richard Schmidt. Los Angeles.*
16th July 1999, 1999
pencil on grey paper using a camera lucida, 56.5 x 37.5
(22¼ x 14¾)

239 top, right *Don Bachardy. Los Angeles.*
28th July 1999 (detail), 1999
pencil, white crayon and grey pencil on grey paper
using a camera lucida, 56.5 x 38.1 (22¼ x 15)

239 bottom, right *Philip Hockney. Australia.*
7th October 1999 (detail), 1999
pencil on grey paper using a camera lucida
50.8 x 38.1 (20 x 15)

1999–2000

18–19 *12 Portraits After Ingres in a Uniform Style*,
1999/2000
pencil, crayon and gouache on grey paper using
a camera lucida, 112.3 x 228.6 (44¼ x 90) overall

2000

224 *Pierre Saint-Jean, London, June 2000*, 2000
oil on canvas, 55.2 x 33 (21¾ x 13)

192 *My Garden in L.A., London, July 2000*, 2000
oil on canvas, 91.4 x 121.9 (36 x 48)

197 *Angel Trumpet and Succulents*, 2000
charcoal on paper, 56.5 x 76.2 (22¼ x 30)

198 *Cactus and Wall*, 2000
charcoal on paper, 76.2 x 56.5 (30 x 22¼)

348 *Going up Garrowby Hill*, 2000
oil on canvas, 213.3 x 152.4 (84 x 60)

195 *Guest House Garden*, 2000
oil on canvas, 152.4 x 193 (60 x 76)

199 *Red Pots in the Garden*, 2000
oil on canvas, 152.4 x 193 (60 x 76)

194 *The Gate*, 2000
oil on canvas, 152.4 x 193 (60 x 76)

16–17 *The Great Wall* (detail), 2000
colour laser copies on 18 panels, 20.3 x 182.8 (8 x 72 feet)

2002

243 left *Andrew Marr*, 2002
watercolour on paper (2 sheets), 121.9 x 46 (48 x 18⅛)

162 *A Pot of Violets*, 2002
watercolour and crayon on paper, 36.2 x 26 (14¼ x 10¼)

247 *Bing, Baden Baden*, 2002
ink on paper (2 sheets), 59.7 x 26 (23½ x 10¼)

338–9 *Black Glacier 1*, 2002
watercolour on paper (2 sheets), 45.7 x 121.9 (18 x 48)

340–1 *Cherry Blossom*, 2002
watercolour and crayon on paper (4 sheets)
91.4 x 121.9 (36 x 48)

150 *Cyclamen, Mayflower Hotel, New York*, 2002
watercolour and crayon on paper, 50.8 x 35.6 (20 x 14)

156 top *5 Bonsai with Fairy Lights (Mountains)*, 2002
watercolour on paper, 36.8 x 50.8 (14½ x 20)

328 *Fjord, Kamøyvær*, 2002
watercolour on paper, 30.8 x 41 (12⅛ x 16⅛)

245 *George and Mary Christie*, 2002
watercolour on paper (4 sheets), 121.9 x 91.4 (48 x 36)

244 *George Mulder*, 2002
ink and watercolour on paper, 61 x 46 (24 x 18⅛)

336–7 *Godafoss, Iceland*, 2002
watercolour on paper (8 sheets), 91.4 x 243.8 (36 x 96)

252 top *John Fitzherbert*, 2002
ink on paper, 36.2 x 26 (14¼ x 10¼)

253 *John Fitzherbert, Baden Baden*, 2002
ink on paper, 26 x 36.2 (10¼ x 14¼)

241 *Karen Wright*, 2002
watercolour on paper, 61 x 46 (24 x 18⅛)

259 *Lady Northbourne*, 2002
ink on paper, 36.2 x 26 (14¼ x 10¼)

270 *Margaret and Ken*, 2002
ink and watercolour on paper, 46 x 61 (18⅛ x 24)

330 *Mist, Stalheim*, 2002
watercolour on paper, 30.8 x 41 (12⅛ x 16⅛)

246 *Randall Wright*, 2002
ink and watercolour on paper, 36.5 x 26 (14⅜ x 10¼)

326–7 *Maelstrom, Bodo*, 2002
watercolour on paper (6 sheets), 91.5 x 183 (36 x 72)

169 top Sketchbook page: 'Ashtray on Studio Floor', 2002
ink on paper, 10.8 x 15.2 (4¼ x 6)

140 bottom Sketchbook page: 'Gainsborough
exhibition Tate', 2002
ink on paper, 10.8 x 15.2 (4¼ x 6)

169 bottom Sketchbook page: 'Hole in Studio Floor', 2002
ink on paper, 10.8 x 15.2 (4¼ x 6)

171 right Sketchbook page: 'Jacket on Chair', 2002
ink on paper, 10.8 x 15.2 (4¼ x 6)

334–5 Sketchbook page: 'Mist, Iceland', 2002
ink on paper, 10.8 x 15.2 (4¼ x 6)

277 Sketchbook page: 'Self-portrait', 2002
ink on paper, 10.8 x 15.2 (4¼ x 6)

138–9 Sketchbook page: 'Taxi, Kensington', 2002
ink on paper, 10.8 x 15.2 (4¼ x 6)

140 top Sketchbook page: 'V & A', 2002
ink on paper, 10.8 x 15.2 (4¼ x 6)

342 *St John's Spire and Tree*, 2002
watercolour on paper, 26.7 x 17.8 (10½ x 7)

324 *Study of Waterfall, Stalheim*, 2002
watercolour on paper, 41 x 30.8 (16⅛ x 12⅛)

20–1 *The Expulsion from the Garden of Eden*, 2002
watercolour on paper (6 sheets), 92 x 183.1 (36¼ x 72⅛)

331 *The Valley, Stalheim I*, 2002
watercolour on paper (2 sheets), 81.9 x 30.8 (32¼ x 12⅛)

329 *Tujfjorden from near Nordcapp*, 2002
watercolour on paper, 30.8 x 41 (12⅛ x 16⅛)

325 *Undredal*, 2002
watercolour on paper (3 sheets), 138.4 x 61 (54½ x 24)

149 *View from Mayflower Hotel, New York (Evening)*, 2002
watercolour and crayon on paper, 61 x 46 (24 x 18⅛)

2003

271 *Margaret Reading, Christmas Day*, 2003
pencil on paper, 35.9 x 50.8 (14⅛ x 20)

231 *Ann Graves*, 2003
watercolour on paper, 106 x 74.9 (41¾ x 29½)

1 *Cactus Garden III*, 2003
watercolour on paper (4 sheets), 92 x 121.9 (36¼ x 48)

196 *Cactus Garden IV*, 2003
watercolour on paper (4 sheets), 92 x 121.9 (36¼ x 48)

353 *Church and Street. Kilham*, 2003
watercolour on paper, 74.9 x 105.4 (29½ x 41½)

172 *Cigarettes and Ashtray*, 2003
watercolour on paper, 30.5 x 22.7 (12 x 9)

333 bottom *Cloud, Vestrefjord*, 2003
watercolour on paper, 27.9 x 37.8 (11 x 14⅞)

257 *David Graves*, 2003
watercolour on paper, 105.4 x 75.2 (41½ x 29⅝)

260 *Derwent May*, 2003
ink and watercolour on paper, 41 x 31.1 (16⅛ x 12¼)

202–3 *Four Views of Montcalm Terrace*, 2003
watercolour on paper (4 sheets), 87 x 121.9
(34¼ x 48) overall

248 *Francis Russell*, 2003
ink and watercolour on paper, 41 x 31.1 (16⅛ x 12¼)

251 *Gregory Evans II*, 2003
watercolour on paper, 106 x 75.6 (41¾ x 29¾)

345 *Grey Sun, East Yorkshire*, 2003
watercolour on paper, 74.9 x 105.4 (29½ x 41½)

206–7 *Interior with Lamp*, 2003
watercolour on paper (6 sheets), 91.4 x 182.8 (36 x 72)

177 *John Cooking II*, 2003
watercolour on paper, 31.1 x 41 (12¼ x 16⅛)

250 *John Fitzherbert*, 2003
watercolour on paper, 106 x 75.6 (41¾ x 29¾)

174 *John's Camera*, 2003
watercolour on paper, 17.8 x 26 (7 x 10¼)

254 *Karen S. Kuhlman*, 2003
watercolour on paper, 105.7 x 75.6 (41⅝ x 29¾)

168 *Ladder and Broom II*, 2003
watercolour on paper (2 sheets), 121.9 x 45.7 (48 x 18)

204 *L.A. Studio*, 2003
watercolour on paper (6 sheets), 138 x 122.1
(54⁵⁄₁₆ x 48¹⁄₁₆)

269 *Lauren, Dawn, Simon and Matthew Hockney*, 2003
watercolour on paper (4 sheets), 121.9 x 92 (48 x 36¼)

243 right *Lindy Watching Paint Dry*, 2003
watercolour on paper (2 sheets), 121.9 x 46 (48 x 18⅛)

332 bottom *Midfjord, Birches, Second Version*, 2003
watercolour on paper, 27.9 x 37.8 (11 x 14⅞)

242 *Mike Izzo IV*, 2003
watercolour on paper (2 sheets), 61 x 92 (24 x 36¼)

173 *Piano and Lamp*, 2003
watercolour on paper, 31.1 x 41.3 (12¼ x 16¼)

193 right *Saturday Rain II*, 2003
watercolour on paper (2 sheets), 122.5 x 45.7 (48¼ x 18)

276 left *Self-portrait in Black Sweater*, 2003
watercolour on paper, 61 x 46 (24 x 18⅛)

273 *Self-portrait in Mirror*, 2003
watercolour on paper, 61 x 46 (24 x 18⅛)

276 right *Self-portrait with Red Braces*, 2003
watercolour on paper, 61 x 46 (24 x 18⅛)

332 top *Setting Sun, Midfjord*, 2003
watercolour on paper, 27.9 x 37.8 (11 x 14⅞)

142–3 Sketchbook page: 'Como', 2003
ink on paper, 10.8 x 15.2 (4¼ x 6)

252 bottom Sketchbook page: 'John', 2003
ink on paper, 10.8 x 15.2 (4¼ x 6)

141 top Sketchbook page: 'People on the Street', 2003
ink and watercolour on paper, 10.8 x 15.2 (4¼ x 6)

141 bottom Sketchbook page: 'People on the Street', 2003
ink and watercolour on paper, 10.8 x 15.2 (4¼ x 6)

333 top *Study for House, Midfjord*, 2003
watercolour on paper, 27.9 x 37.8 (11 x 14⅞)

170 *Top Hat and Pears on Piano*, 2003
watercolour on paper, 31.1 x 41 (12¼ x 16⅛)

200–1 *View from Terrace II*, 2003
watercolour on paper (8 sheets), 92 x 244.2 (36¼ x 96⅛)

344 *Wolds Way*, 2003
watercolour on paper, 74.9 x 105.4 (29½ x 41½)

2004

352 *The Road to Ruston, 23 III 04*, 2004
watercolour on paper, 74.9 x 105.4 (29½ x 41½)

358–9 *Lovely Day with Puddles, 2 IV 04*, 2004
watercolour on paper, 74.9 x 105.4 (29½ x 41½)

258 *Drue Heinz, Como, April 2004*, 2004
ink and watercolour on paper, 41 x 31 (16⅛ x 12³⁄₁₆)

249 *Jeremy Lewis, Como, April 2004*, 2004
ink and watercolour on paper, 41 x 31 (16⅛ x 12³⁄₁₆)

354–5 Sketchbook page: 'East Yorkshire, Spring', 2004
watercolour on paper, 10.8 x 15.2 (4¼ x 6)

292–3 *Andalucia. Fountain, Alhambra, Granada*, 2004
watercolour on paper (2 sheets), 74.9 x 210.8 (29½ x 83)

294–5 *Andalucia. Mosque, Cordova*, 2004
watercolour on paper (2 sheets), 74.9 x 210.8 (29½ x 83)

261 *Manuela Rosenthal*, 2004
watercolour on paper, 74.9 x 105.4 (29½ x 41½)

167 *Margaret's Conservatory*, 2004
watercolour on paper, 38.1 x 27 (15 x 10⅝) overall

343 *Rainy Morning, Holland Park*, 2004
watercolour on paper, 105.4 x 74.9 (41½ x 29½)

290–1 Sketchbook page: 'Courtyard, Seville', 2004
watercolour on paper, 10.8 x 15.2 (4¼ x 6)

356–7 *Untitled*, 2004
watercolour on paper (2 sheets), 75.2 x 210.2 (29⅝ x 82¾)